RENOIR

Kunsthalle Tübingen
January 20 – May 27, 1996

Götz Adriani

RENOIR

DUMONT

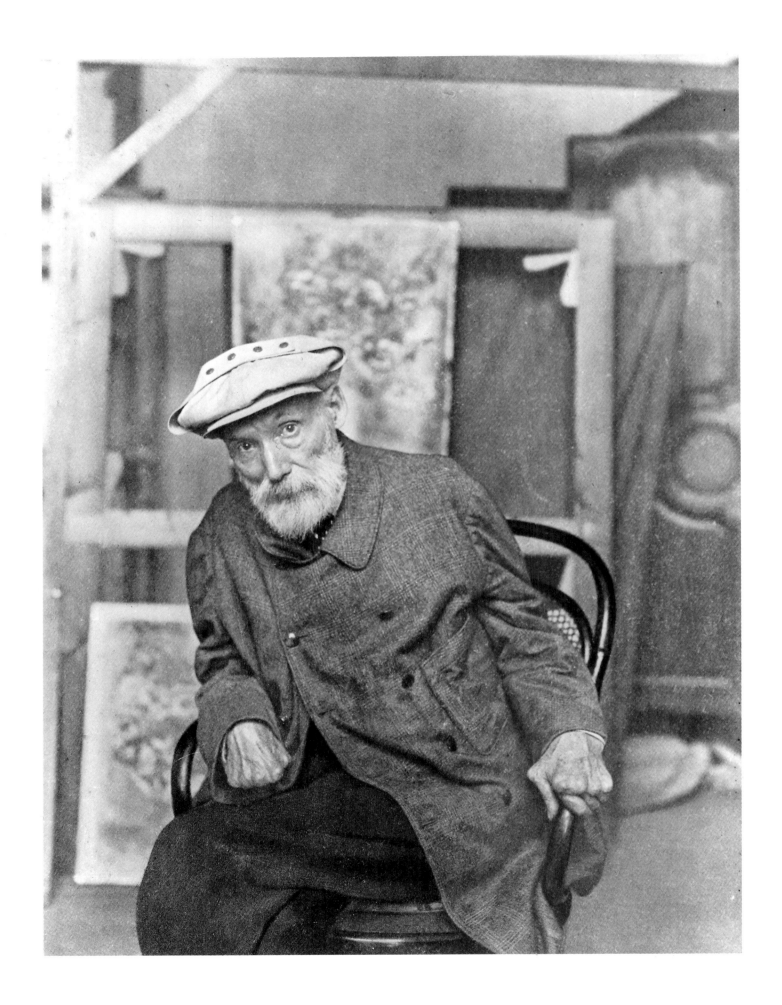

Renoir in his studio, 1912

Pablo Picasso, *Renoir*, pencil drawing, 1919. Musée Picasso, Paris

This book was first published to accompany the exhibition
"RENOIR. GEMÄLDE 1860–1917",
20 January to 27 May 1996 at Kunsthalle Tübingen
Exhibition concept and catalogue by Götz Adriani

This exhibition was supported by Daimler-Benz AG

Cover
front: *Madame Monet and her Son Jean in the Garden at Argenteuil (Madame Claude Monet avec son fils Jean dans le jardin à Argenteuil)*,
1874, detail (No. 24, p. 125)
back: *Children's Afternoon in Wargemont (L'après-midi des enfants à Wargemont),* 1884, detail (No. 70, p. 228/29)
Page 9: Renoir, ca. 1875

Editing: Karin Thomas assisted by Gerlinde Engelhardt
English copy editing: Melissa Thorson Hause
Translation: John S. Southard
Production: Peter Dreesen
Cover Design: Birgit Haermeyer
Lithography: Grafikatelier 13, Kaarst
Composition and Printing: Rasch, Bramsche
Binding: Bramscher Buchbinder Betriebe

Distributed throughout the world by: Yale University Press

Library of Congress Catalog Card Number: 99-60273
A catalog record for this book is available from the British Library

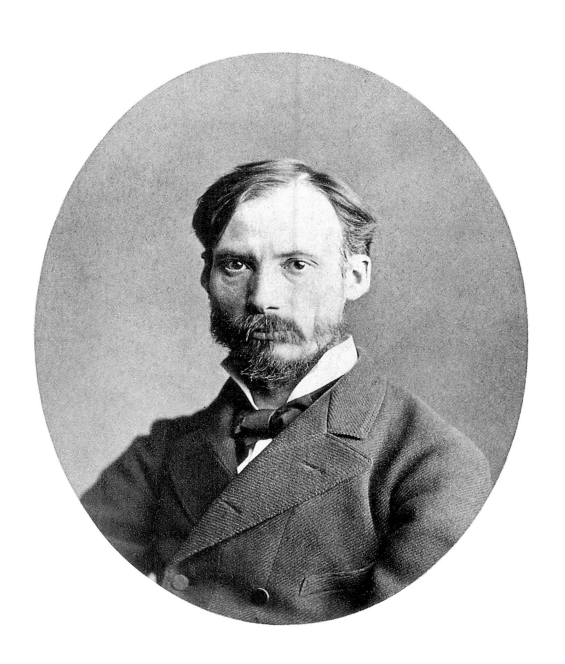

Preface

It has become fashionable among progressive connoisseurs of art in our day to make light of Renoir and his Impressionist friends. German art lovers in particular tend to bemoan an excess of surface and a lack of depth. Many are put off by the apparent absence of ideological commitment and innovation. Even more appalling, however, is the fact that Renoir has become a favorite among devotees of calendar art, whose protagonists make it all too easy to delight in the delightful. The stereotyped prettiness of his young girls and the popularity of his everyday physiognomies threaten to become the sole criteria for an assessment of his art.

Because my own perception of Renoir had formed along similar lines, I felt challenged by the opportunity to break through these clichés with an exhibition of carefully selected works and to offer a view of his diverse and exemplary painterly potential. For reasons of conservation, it was impossible to exhibit the two major large-scale works *Le bal du Moulin de la Galette* and *Le déjeuner des canotiers*. Nonetheless, I hope that with our concentrated selection of masterpieces, including a number of lesser-known works, we have succeeded in focusing on the real qualities that make Renoir a great artist and in rescuing him from the flood of his own—primarily later—production. I hope also to have demonstrated that such artists as Cézanne, Monet, Toulouse-Lautrec and van Gogh were entirely justified in their admiration of Renoir and that his art rightly became an unimpeachable standard for figures including Matisse, Bonnard, Apollinaire and Picasso.

Like the great Cézanne and Degas retrospectives presented by the Kunsthalle Tübingen in recent years, this exhibition is the first extensively researched, comprehensive retrospective ever devoted to Renoir in Germany. This fact is all the more astonishing in light of past exhibi-

tion history. As early as 1901, Paul Cassirer presented 23 paintings by Renoir at his gallery in Berlin; that show was followed by a presentation of 41 Renoirs at Cassirer's gallery in 1912 and at the Moderne Galerie Heinrich Thannhauser in Munich in 1913. Alfred Flechtheim exhibited 70 paintings from Renoir's late œuvre in Berlin in 1927.

The presentation of an exhibition of this magnitude and significance at the Kunsthalle Tübingen was made possible by the generous support of many friends and colleagues, who provided valuable assistance in the form of advice and works on loan. I wish to express my gratitude to them all. Without their trust and commitment, this project could not have been realized in its present form. I was fortunate in being able to rely from the outset upon information provided by François Daulte, the Nestor of Renoir scholarship and author of the catalogue raisonée; my first thanks, therefore, are due to him. For their always reliable friendship and assistance, I also wish to thank Ev and Walther Scharf, Wolf-Dieter Dube, Hortense Anda-Bührle, Peter Nathan, Ingrid and Bernd Gottschalk, Peter Littmann, Heide Rentschler and especially Jörg-Michael Bertz, who tapped the worldwide resources of the auction house Christie's in the service of our needs. I am also grateful to the publisher Ernst Brücher as well as to Karin Thomas and Peter Dreesen for producing the excellent catalogue, in which many of the works are authentically reproduced and thoroughly described for the first time. I owe a debt of thanks to Daimler-Benz AG and to Hans J. Baumgart for their interest in and support of the exhibition project. Last but not least, I wish to thank my small staff, above all Gerlinde Engelhardt, for their admirable commitment and the hard work they invested in the preparation and realization of the exhibition.

G.A.

Lenders

Baden	Stiftung Langmatt, Sidney and Jenny Brown
	Eva-Maria Preiswerk-Lösel
Basle	Öffentliche Kunstsammlung Basel, Kunstmuseum
	Katharina Schmidt
Basle	Galerie Beyeler, Ernst Beyeler
Berlin	Staatliche Museen zu Berlin, Nationalgalerie
	Wolf-Dieter Dube, Peter-Klaus Schuster
Bremen	Kunsthalle
	Wulf Herzogenrath, Dorothee Hansen
Buffalo	Albright-Knox Art Gallery
	Douglas G. Schultz
Cambridge	The Syndics of the Fitzwilliam Museum
	Simon Jervis, David E. Scrase
Cambridge, Mass.	Fogg Art Museum, Harvard University Art Museums
	James Cuno
Cleveland	Cleveland Museum of Art
	Robert P. Bergman
Columbus, Ohio	Columbus Museum of Art
	Irvin M. Lippman
Copenhagen	Ordrupgaardsamlingen
	Anne-Birgitte Fonsmark, Mikael Wivel
Dresden	Gemäldegalerie Neue Meister,
	Staatliche Kunstsammlungen
	Werner Schmidt
Düsseldorf	Christie's GmbH, Jörg-Michael Bertz
Frankfurt am Main	Städtische Galerie im Städelschen Kunstinstitut
	Herbert Beck
Hamburg	Hamburger Kunsthalle
	Uwe M. Schneede, Helmut R. Leppien
Hamburg	Prof. Dr. h. c. Hermann Schnabel
Herrliberg	Erwin Bernheim
Hiroshima	Hiroshima Museum of Art
	Osamu Hashiguchi, Junko Watanabe
Houston	The Museum of Fine Arts
	Peter C. Marzio
Karlsruhe	Staatliche Kunsthalle, Siegmar Holsten
Limoges	Musée Municipal de l'Evêche
	Véronique Notin
London	Artemis Group, Sebastian Goetz
London	Alex Reid & Lefevre, LTD
	Desmond Corcoran, Martin Summers
Lucerne	Galerie Rosengart, Angela Rosengart
Madrid	Fundaçion Colección Thyssen-Bornemisza
	Tomás Llorens
Montreal	Maxwell Cummings

Munich	Bayerische Staatsgemäldesammlungen, Neue Pinakothek
	Johann Georg Prinz von Hohenzollern, Christian Lenz
Munich	Ernst von Siemens-Kunstfonds
New York	The Metropolitan Museum of Art
	Philippe de Montebello
Oslo	Nasjonalgalleriet
	Glenny Alfsen
Paris	Durand-Ruel et Cie.
	Caroline Durand-Ruel Godfroy
Paris	Musée Picasso, Donation Picasso
	Gérard Regnier
Paris	Musée d'Orsay
	Henri Loyrette
Philadelphia	The Philadelphia Museum of Art
	Anne d'Harnoncourt, Joseph J. Rishel
Saarbrücken	Saarland Museum, Stiftung Saarländischer Kulturbesitz, Ernst-Gerhard Güse
Salzburg	Galerie Salis & Vertes, Thomas Salis-Samaden
São Paulo	Museu de Arte de São Paulo Assis Chateaubriand
	Luiz Marques
Stockholm	Nationalmuseum
	Olle Granath, Görel Cavalli-Björkman
St. Petersburg	The State Hermitage
	Mikhail Piotrovsky
Strasbourg	Musée d'Art Moderne et Contemporain
	Nadine Lehni
Stuttgart	Staatsgalerie
	Christian von Holst, Christoph Becker
Tokyo	Nippon Television Network Corporation
	Yosoji Kobayashi
Washington	National Gallery of Art
	Earl A. Powell III
Williamstown	Sterling and Francine Clark Art Institute
	Michael Conforti, Steven Kern
Winterthur	Kunstmuseum
	Dieter Schwarz
Zurich	Kunsthaus
	Felix Baumann
Zurich	Stiftung Sammlung E. G. Bührle
	Hortense Anda-Bührle
Zurich	Barbara and Peter Nathan
Zurich	Heidi and Roland Römer
Zurich	Werner and Gabrielle Merzbacher
Zurich	Fondation Rau, Robert Clémentz
	and numerous other lenders who prefer to remain anonymous

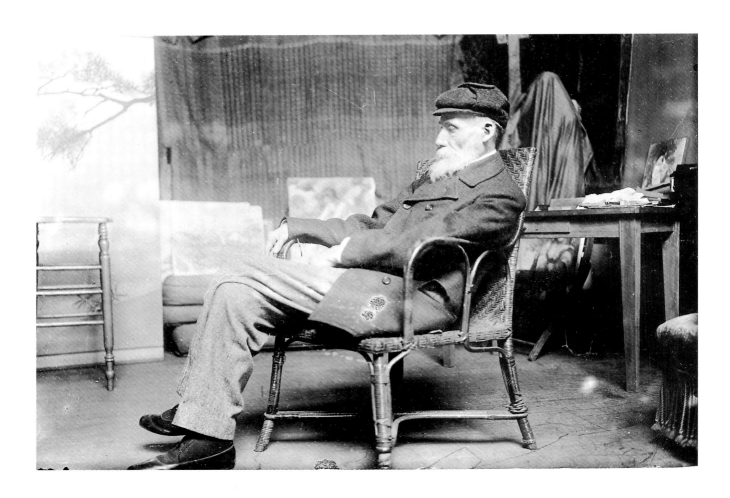

Renoir in his studio,
Paris, 1912

Auguste Renoir: Realist of Beautiful Illusions

I

Renoir is undoubtedly the most popular of the so-called Impressionists. His work has been received with almost euphoric enthusiasm for more than a century. Even his own fellow artists and friends admired him greatly, their praise exemplified in the words of Cézanne (1839–1906): "I feel nothing but contempt for all living painters, with the exception of Monet [1840–1920] and Renoir"[1] On another occasion, Cézanne emphasized that "his genius makes him demanding in his use of resources."[2] Even artists of such strikingly different temperament as Matisse (1869–1954) and Picasso (1881–1973) were united in their admiration for Renoir (cat. no. 85). "Renoir's spirit, by its modesty as well as by its confidence in life, once the effort is made, has allowed him to reveal himself with all the generosity with which he has been endowed and undiminished by second thoughts. The appearance of his work lets us see an artist who has received the greatest gifts, which he has been grateful enough to respect," wrote Matisse in 1918 in an homage to Renoir, only a year before the latter's death.[3]

This unqualified declaration of esteem on the part of his fellow artists, however, derives little support from the sugary popularity still widely associated with the name of Renoir. It is this popular conception that often interferes with a detached critical approach to a highly diverse œuvre spanning more than half a century of history. Renoir, an Impressionist whose devotion to Impressionist objectives was by no means unqualified, introduced many of the icons of cult and longing that typify Impressionism and eventually became a public favorite thanks to a mode of reception focused on immediate gratification. For this reason, it is difficult from a contemporary vantage point to do justice to his world of images, a realm of vision fully content with its place on the sunny side of life. Renoir's ideal image of beauty, moreover—his enchanting, red-cheeked, softly rounded figures of young girls—has deteriorated into a kind of trademark. What remains is a sense of uncertainty, an uneasiness based to some extent, at least, on the suspicion that chronological and emotional distance may render an adequate response impossible. Nor can it be denied that the artist occasionally overestimated his own creative potential, exposing the quality of his art to doubt for the sake of quantity in works of little merit done simply because they were in demand.

Nonetheless, we should not fail to recognize that Renoir drew his fundamental motivation not only from an appreciation of the object itself, but to an even greater extent from his love of color. The oft-cited charm of his subjects is the one side of his art; the other is a truly grandiose body of painting. It was with good reason that the apologists of modernism praised the eminently painterly qualities of an œuvre

For the references abbreviated here, see the Bibliography pp. 312ff.

1 Cézanne 1962, p. 272.

2 Jules Borély, "Cézanne à Aix," in L'Art Vivant, 2, 1926, pp. 491ff.

3 Matisse wrote an article on Renoir for the catalogue accompanying the exhibition Den Frankske Utstilling presented at the Nasjonalgalleriet Oslo from January 18 to late February 1918. Thirteen works by Renoir were shown at the exhibition (Ehrlich White 1984, p. 280).

whose figures, objects and landscapes appeared to derive their individuality solely from the weightlessness of their color. No other artist succeeded in clothing his love of form so magnificently in the splendor of color. And no one else could visualize so vividly the fleeting moment ᶜʰeauty, sublimating in his art the state of happiness which life, for st part, denied him. And so he was not at all hesitant to declare painting should be congenial, cheerful and pretty: "Yes, pretty! Lɪ orings enough unpleasantness; why not approach it from the light side once in a while? I know it is difficult to understand that truly great painting can also be lighthearted. Because Fragonard [1732–1806] could laugh, people rushed to the conclusion that he was but an insignificant painter. People who laugh aren't taken seriously. Art in Sunday clothes, whether painting, literature or music, will always astonish."[4]

In the wake of the profound changes of the modern period and postmodern attempts to effect its revival, we look upon Renoir as the painter of a lost paradise. His "fêtes galantes" (cat. no. 39), based on popular activities in the parks and gardens of Montmartre, are as rapturous as those of the rococo, whose great protagonists were so dear to his heart. Although his life's work with its idealized view of reality extends like a monolith well into the 20th century, he was indeed a man of the 19th century, an artist who never totally abandoned its aesthetic categories. He had recourse neither to the rebellious pathos of Courbet (1819–1877) nor to the scandalous energies of the young Cézanne during the latter's years of struggle. Nor was Renoir among the pioneers of modernism who—like Manet (1832–1883) and Degas (1834–1917)—expanded traditional modes of visual perception by developing a view of the momentary character of modern life extending to the present, or—like the later Cézanne and Monet—directed their gaze towards the reality of the pictorial image *per se* as the measure of all things. As the fulcrum between those two points, Renoir was a consummation rather than a guide pointing the way to the shocks and detonations of later generations of artists. Referred to as a "little Rubens" even during his early years as a porcelain painter, Renoir drew inspiration from the "royal road" of French painting that began with Rubens (1577–1640) and proceeded to Watteau (1684–1721), Boucher (1703–1770) and Fragonard, Delacroix (1798–1863) and on into the new century to Matisse and Bonnard (1867–1947). As Bonnard himself stated, "Renoir created a wonderful universe for himself. He worked from within his own nature and had the capacity to take a model or a light that at times seemed dull and imprint it with the memory of thrilling moments."[5]

The aesthetic challenges of the decades between 1890 and 1914, with their striking debuts in photography, poster art and cinematography—media that were revolutionizing human perception—appear to have passed by Renoir without leaving a trace. This is made vividly clear in a conversation between the aging Matisse and Picasso about Pollock (1912–1956) and Renoir. The discussion is cited here from the

4 André 1919, pp. 30, 32.

5 Pierre Bonnard, "Pierre-Auguste Renoir," in *Comedia*, October 18, 1941, p. 1.

16

recollections of Françoise Gilot, Picasso's companion of many years. It bears witness not only to Matisse's great respect for Renoir but also to the problem of doing justice to the statements of artists vehemently intent upon distancing themselves from the accomplishments of their own generation. "One day we visited Matisse, and he showed us a few catalogues he had received from his son Pierre. Pierre was an art dealer in New York. The catalogues contained reproductions of paintings by Jackson Pollock and other painters who pursued much the same direction. 'I do not think I am fit to judge this kind of painting,' remarked Matisse after we had looked through the catalogues, 'because one is never

Matisse (left) and Renoir (seated, middle) in Cagnes, 1918

capable of judging what follows one's own work fairly When I was young, I loved Renoir's painting very much. Near the end of the First World War, I was in southern France. Renoir was still alive, but he had grown quite old. I still admired him, and I decided to pay him a visit at Les Collettes, his house in Cagnes [the first visit took place on December 31, 1917, Matisse's 48th birthday; further visits followed in late January 1918, and the two met again on April 11 and May 4 of the same year in Nice]. He received me very cordially, and so, after several more visits, I brought him a few of my paintings, to hear what he had to say about them. He regarded them rather disapprovingly. Finally, he said, "Well, to tell you the truth, I don't like what you paint. There are different reasons for that. I would almost want to say that you really aren't a very good painter, perhaps even that you are quite a bad painter. But something keeps me from saying that. When you apply a little bit of black, it actually remains visible on the canvas. All my life I've been saying that one can't use black any longer without making a hole in the canvas—that black is not a color. Yet you express yourself in the language of color. And you use black, and it sticks. And that is why I believe that you are a painter after all, even though I don't like what you paint and would almost rather tell you that you are a bad painter".' Matisse smiled. 'You see? It is very hard to understand the next generation and to judge it properly. Little by little, one goes through life and develops not only a language of one's own, but a personal aesthetic doctrine as well. In other words, one doesn't set up values for oneself alone but elevates them instead, at least to a certain degree, to the level of absolute standards. And thus it becomes all the more difficult to comprehend a kind of painting whose point of departure lies beyond one's own final destination. It is based upon totally different principles'."[6]

6 Françoise Gilot and Carlton Lake, *Leben mit Picasso*, Munich 1980, pp. 223f.; see Jack Flam, *Matisse, the Man and his Art 1869–1918*, Ithaca/London 1986, pp. 468f., 473ff.

II

Several weeks before his death, Eugène Delacroix closed his diary entries for June 22, 1863 by remarking that "a painting can accomplish nothing greater than to be a feast for the eyes."[7] At the time, Renoir, who would remain loyal to his predecessor's maxim throughout his life, was embarking upon his career. He had just previously joined a group of like-minded artists who—inspired by Delacroix's glowing colors—would close ranks as Impressionists in opposition to outmoded aesthetic principles. Fifty years later, when Guillaume Apollinaire (1880–1918), the most committed advocate of modernism, referred to Renoir as the greatest painter of his time and claimed in a review of the Paris Autumn Salon of 1913 that "voluptuousness" had "almost completely disappeared from contemporary art" and could be found only "in the magnificent, sensual paintings of the aged Renoir,"[8] the end of his career was already in sight. What lay between was the life of a perpetual nomad, a native of Limoges who became a Parisian. Moving restlessly from place to place, Renoir created an œuvre whose historical context extended from the Second Empire to the First World War. Along that way with all its peaks and valleys, a course plotted by painting alone, he never lost his eye for the beauty that is inherent in the natural. His profound sense of human empathy prompted him to imbue even the trivial with beauty, to make fashionable young ladies into tools for an aesthetic fervor that neglected not a single nuance of color.

Renoir, a temperamental spirit for whom every externalization of feeling was suspect, drew his visions from the platitudes of everyday life. Spurred on by his own vitality, he conceived the grace and beauty of his themes. Seeing and painting were one in his view. His motto: "What goes on in my head is of no interest to me. I want to touch . . . or at least to see . . . !"[9] True to himself, Renoir made his painting the contented expression of a life of human warmth and security. Altogether, the Paris environment, friends, family and Mediterranean landscapes contributed to the growth of a pictorial reality that accepted a plausible detail for the whole. His paintings always retained a residue of simplicity, even naiveté, despite their excessive opulence. Renoir sought to achieve fulfillment in life and to do justice to the powers of nature in all its manifestations through the pleasure he experienced in his work. It was never his wish to leap over his own shadow, either as a man or as an artist. "I have always submitted to my fate. I have never been a fighter, and I would have given up on more than one occasion if my old Monet—*he* was a fighter—had not vigorously propped me up again."[10]

Devoid of ambitions to social status, the painter felt himself at one with the people and things that accompanied him in life. And that is why his rather uneventful existence and the traces it left behind offer little material for psychological interpretation. The search for hidden conflicts or inhibitions remains a fruitless undertaking. Much like Pissarro (1830–1903) in his uncomplicated concentration on the task at

7 Kuno Mittelstädt (ed.), *Eugène Delacroix. Dem Auge ein Fest. Aus den Tagebüchern des Malers*, Berlin 1979, p. 285.

8 Le Roy C. Breunig (ed.), *Apollinaire on Art. Essays and Reviews 1902–1918*, New York 1972, pp. 376, 425; see Guillaume Apollinaire, "Salon d'Automne: Henri Matisse," in Jack Flam (ed.), *Henri Matisse 1869–1954*, Cologne 1994, p. 151.

9 Renoir 1981, p. 56.

10 André 1919, p. 60.

hand, Renoir had little patience with Cézanne's desperate self-glorification or Degas' sometimes arrogant mercilessness. He never exposed himself to the risks of their failure. His own doubts were held in check by his convictions and a healthy dose of self-confidence. His visual creations, those inviting feasts for the eyes, reveal little or no evidence of breaking points legitimized by scruples. Despite the many disappointments and setbacks he experienced, and despite the lack of recognition that characterized his career for many years, Renoir appears to have been a happy man. His entire soul was devoted to art as the highest expression of *joie de vivre*. "It is wonderful to give in to the joys of painting," remarked the old master, who even as a young man had responded to the comment by his mentor Gleyre (1806–1874) that "painting appeared to give [him] pleasure" by saying: "But of course. If it gave me no pleasure, then I wouldn't paint, believe me."[11]

Renoir's pictures reveal nothing of the trials and worries that marked his personal life. He experienced firsthand the harshness of the social conditions of his time, yet he did not reflect them in his art, much less subject them to critical scrutiny. He regarded expressions of criticism as inappropriate in general. Renoir, who has gone down in art history as the spokesman of an uninhibited, gregarious *joie de vivre*, who revered the sensual aspects of a bourgeois image of the ideal life, was unwilling to pass judgment on the world's injustice. He did not share Emile Zola's (1840–1902) critical approach to social issues. The writer once complained that Corot (1796–1875) populated his landscapes with nymphs instead of peasant women; Renoir was at a loss to see a difference, as long as he liked Corot's paintings.[12] His own pictorial reality remained untainted by social inequalities and problems—an enchanted world clearly beyond the reach of life's social dissonances. Undoubtedly, Daumier (1808–1879), Manet and Degas offered a more detached, comprehensive view of urban humanity; Renoir's achievements, however, lay in the development of new standards for what an artist could express about an era with canvas and paint.

Any attempt to find pictorial contents intended to achieve meaningful effects would be in vain. Based solely on visual experience, Renoir's iconography subordinates time to nature, dispensing for the most part with history, mythology and anecdote. In varying degrees of intensity, it focuses on the classical themes of portraiture, the human figure, landscapes and still life. Quantitatively speaking, the latter remained a secondary concern, although Renoir's training as a porcelain painter would appear to have qualified him eminently to cater to bourgeois tastes with decorative arrangements as a still-life painter. While the landscape, with or without human figures, played a more important role in his work than the still life, Renoir never permitted doubts about his true profession—that of a portrait and figure painter—to arise. In late January 1884 he wrote to Monet: "I am tied to Paris, where I am bored to death, and I run about in search of the model I cannot find, but alas, I am simply a painter of figures! Oh, it is pleasant

11 Ibid., p. 8.

12 Rewald 1965, p. 130.

enough sometimes, but not when you find only models who don't suit you at all."[13]

A child of the Second Empire, Renoir become the portraitist of the first decades of the Third Republic. He analyzed the representatives of both its *petite* and *haute bourgeoisie* with great affection. Unlike Pissarro, Monet or Sisley (1839–1899), it was not so much the landscape that offered him a field for experimentation and invention, but rather—like Degas—the portrait and the figure painting. He mastered the tightrope walk between the merciless gaze of contemporaries and the presumptions of a wealthy clientele whose favor he was forced to seek in order to survive. Although a painter of society and dependent upon commissions, Renoir was never a society painter.

His images of the bourgeois infallibility of bankers' and publishers' wives in their elegant clothes, of artist-friends and actresses, of little girls from wealthy families or young women from the streets of the Butte Montmartre were, as stated above, first and foremost explosive painterly accomplishments and had little in common with the sophisticated smoothness and typified elegance of some of his fellow portraitists. In a society dominated by the business of men, Renoir memorialized more than anything else the essential life-affirming strength of the feminine. He developed an unmistakable and increasingly exclusive preference for young women, or rather for their metamorphic phases as girls or mothers, actresses, grisettes, coquettes or middle-class wives. Such figures inspired his imagination for decades. To be sure, there was no place for age, tragedy, ugliness or problems "in the shadow of a young girl's bloom." "What do you expect? He painted the Parisian woman," Cézanne remarked with a hint of contempt in an interview with Maurice Denis (1870–1943).[14] Concerned more with the vision of happiness in the affirmation of life than the disclosure of social truths, Renoir continued to paint images of perpetually youthful girls, rich landscape vegetation or magnificent bouquets of blossoms and fruits well into old age. Supported by an aura of peaceful contentment, this one-sided view, which avoided both social criticism of urban life and reflections on his own modest circumstances, drew strength from the Impressionist vision and developed into an unshakable love of life.

For Renoir, the decisive criterion of Impressionist aesthetics in its highest form was that it liberated the artist from theme. "I can paint flowers, and I need only call them 'flowers'; they do not need a story." On another occasion, he emphasized that ". . . what is essential [is] escaping the motif, avoiding the creation of literature, and thus selecting an object with which everyone is familiar—ideally, in other words, to have no story at all!"[15] Renoir left it to others to agonize over the "theme in painting." In his brilliantly written reminiscences of his father, Jean Renoir (1894–1979), himself a prominent figure in the history of film, recalls an amusing incident that took place in the Théâtre des Variétés. The elder Renoir enjoyed the Théâtre des Variétés immensely and often went there in the company of Jacques Offenbach (1819–1880). Jean Renoir writes: "On one occasion, Zola and my uncle

13 Gustave Geffroy, *Claude Monet, sa vie, son temps, son œuvre*, Paris 1924, II, pp. 24f.

14 Maurice Denis, *Nouvelles Théories 1914–1921*, Paris 1921, p. 107.

15 Renoir 1981, pp. 162, 60.

Edmond [of the four siblings, Edmond (1849–1944) was closest to Auguste; as a journalist, he had taken up the cause of Impressionism] were sitting in their theater box discussing the issue of theme in painting. Renoir, who was bored by theories, turned to Hortense Schneider, herself barely able to stifle a yawn, and said, 'That's all very nice, but let us talk about serious matters. Is your bosom holding up?'—'What a silly question!' the diva answered. She then opened her corset and exposed the irrefutable evidence of the firmness of her charms. My father, his brother and Offenbach burst into resounding laughter. Zola turned 'red as a rose,' stammered something incomprehensible and took flight. 'He was a true provincial.' Renoir admired him but could never forgive him his incapacity to understand Cézanne. 'And what a strange idea of his it was to insist that workers have to say 'shit'."[16]

The painter did not involve himself in the aesthetic discussions of his day; he found them a waste of time. He felt nothing but contempt for doctrinaire aesthetic profundity and its interpreters. He saw painting primarily as the domain of the imagination and skilled craftsmanship. Many of his own statements suggest how strongly he felt about the need for a solid foundation of technique: "The only thing that counts for a painter is what he puts on the canvas. And that has nothing to do with dreams. What he needs is good paints, good linseed oil and a little turpentine." Or: "Unfortunately, the artist is in danger as soon as he realizes that he has genius! All that is left to him then is to work like a craftsman and refuse to succumb to delusions of grandeur."[17] The *ouvrier de la peinture* consistently professed his devotion to the modest means of a craft he had learned during his early years as a porcelain painter. Well into old age he retained many of its unique features in the soft, rounded suppleness of his brushwork and his preference for light, transparent colors that allowed the ground to shine through. He experimented with a wide variety of techniques in the course of his development, as the following remark makes clear: "In order to achieve the result I was looking for . . . and which I am always looking for, I tried out every possible technique I did two or three paintings with the palette knife, employing the method Courbet loved so much [cat. no. 7]. Then I painted impasto, using a brush. I tried painting with small brushstrokes . . . but that approach produces uneven painting And then dust gets into the spaces and destroys the color tones. A painting must be able to withstand varnishes, dirt and all the evil that time and restorers are capable of inflicting upon it"[18]

16 Ibid., p. 166; on Edmond Renoir see pp. 159, 371.

17 Ibid., pp. 95, 216.

18 André 1919, pp. 43ff.

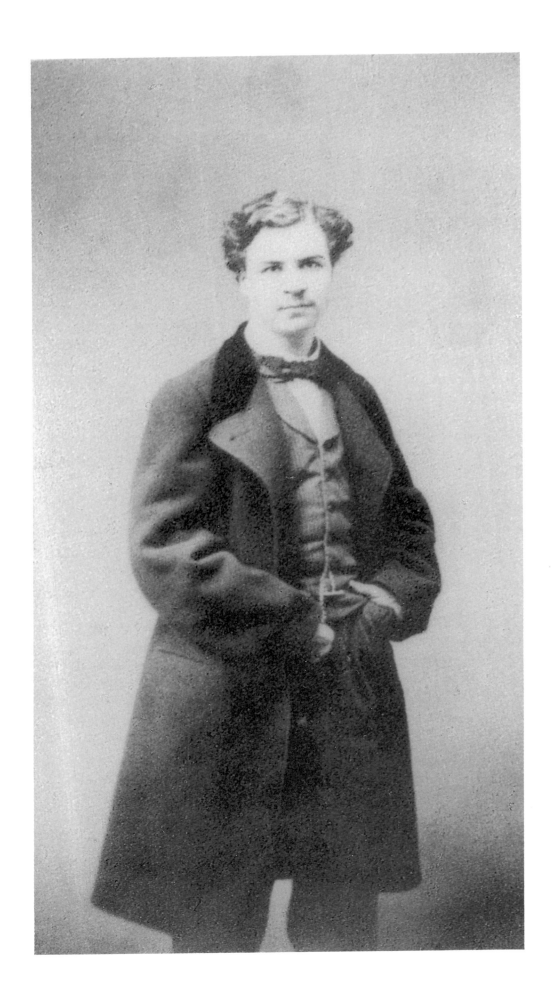

Renoir, ca. 1860

III

Born in 1841, Pierre-Auguste Renoir grew up in a Paris that was prospering at a breathtaking pace. Following his successful coup d'état in December 1851, Louis Napoleon (1808–1873) had made the *transformation de Paris*—the redesign and renewal of the capital focused on traffic and transportation technology, strategy, economic welfare and demography, an objective of the highest order. Napoleon III regarded the modernization of the capital as the most effective approach to preserving and protecting his regime. He was assisted in this endeavor by Georges Eugène Haussmann (1809–1891), whom he appointed to manage his campaign to realize a truly epoch-making urbanistic concept. Within a period of only 17 years, they transformed the medieval city of Paris into the greatest modern metropolis of its time.

In 1844, the Renoir family had moved from Limoges to Paris, where they lived in modest circumstances. The tailor Léonard Renoir (1799–1874), his wife Marguerite Merlet (1807–1896, cat. no. 1) and their first four children had originally occupied rooms in the heart of the ancient quarter immediately adjacent to the Louvre, a district that eventually fell victim to Haussmann's urban renewal program in the course of the construction of the Cour du Carrousel.[19] Even as an old man, Renoir looked back with great sadness upon the destruction of the world of his childhood, remarking with reference to Haussmann that he had "transformed Paris with such brutality." In his eyes, the evil was the result of greed for profit, the willingness to sacrifice everything in order to raise land prices. He hated the industrialists and the speculators who had wielded considerable influence since the Second Empire: "Look at what they made of my poor old Paris!"[20]

Renoir's parents did not allow their son to embark upon a promising career as a singer, a course recommended by a no less prominent figure than Charles Gounod (1818–1893), the organist at the church of St. Eustache for many years. Instead, they decided that Auguste, a youngster with fine voice enrolled in the school of the Frères des Ecoles Chrètiennes, would be trained as a porcelain painter. Limoges porcelain was in great demand at the time, and the craftsmen who decorated it seemed assured of a good living. During his years of apprenticeship and work for the Lévy brothers from 1854 to 1858, Renoir learned technical skills that would later stand him in good stead.[21] It was not long, however, before the introduction of cheap reproduction methods stifled the demand for hand-painted porcelain, leaving future prospects for the profession looking rather bleak. Yet by that time Renoir's restless spirit had long since found a new orientation. The lack of perspective in his trade offered him the opportunity to develop his true artistic gifts and to place them on a firm foundation of academic training. Having saved enough money to finance the undertaking, he registered for a course at the Ecole des Beaux-Arts in early April of 1862.

During the preceding year, Renoir had already joined a class at the studio of Charles Gleyre, one of the most popular teachers at the Ecole

19 Balzac set the plot of his novel *Père Goriot* in this ill-reputed district: "At that time, the Place du Carrousel, a hopelessly confused labyrinth of small streets only poorly illuminated by a few oil lanterns, was transformed into a genuine murderers' den at nightfall. People hardly dared to venture there alone for fear of the unwholesome clientele that frequented the disreputable dives in the area. During the day, peddlers, book merchants and sellers of birds occupied even the smallest parcel of space with their stands, which they put up against the wooden fences. Grass grew through the gaping spaces between the paving stones, and along the worm-eaten fences a disgusting open sewer wound its way, putting the final touch on the lamentable condition of the quarter" (quoted in Gauthier 1977, p. 6).

Zola's novel *La Curée* provides a commentary on the "transformation of Paris": "Yes, the great transept of Paris, as they call it. They're clearing away the buildings around the Louvre and the Hotel de Ville. That's mere child's play. It serves to awaken the public's appetite When the first network is finished, the fun will begin. The second network will pierce the city in every direction so as to connect the suburbs with the first Look, just follow my hand. From the Boulevard du Temple to the Barrière du Trone, that's one cutting; then on this side another, from the Madeleine to the Plaine Monceau: and a third cutting this way, another that way, a cutting there, one further on, cuttings on every side, Paris slashed with sabre cuts, its veins opened, giving sustenance to a hundred thousand navvies and bricklayers, traversed by splendid military roads which will bring the forts into the very heart of the old quarters of the town" (cited in Johannes Willms, *Paris. Hauptstadt Europas 1789-1914*, Munich 1988, p. 354; here quoted after the English translation of *La*

Curée by A. Teixeira de Mattos, vol. I, London 1904, pp. 106-107).

20 Renoir 1981, p. 41.

21 "Because my father came from a city famous for porcelain, he saw a career as a porcelain painter as the most wonderful thing in the world, even more wonderful than music, the direction in which my music teacher wanted to point me; he was none other than Gounod, about thirty years of age at the time and organist at the church of Saint-Eustache. It was determined that I would become an 'artist,' and I was apprenticed to a ceramics factory. At the age of 13, I was expected to earn my own living. My work involved painting small bouquets of flowers on a white background, and I received five sous per dozen When I had grown more confident, I abandoned the little bouquets and ventured into figures, always for the same starvation wage; I remember earning eight sous for a profile of Marie-Antoinette. The factory was on the Rue du Temple" (Vollard 1961, p. 11; see Renoir 1981, pp. 54f., 62f.).

22 "Back then, the Ecole des Beaux-Arts was not nearly what it is today. There were only two courses, a drawing course from eight until ten in the evening and an anatomy course, for which the nearby Ecole de Médecine kindly provided cadavers. I sometimes attended both courses, but I learned the painter's trade from Gleyre" (Vollard 1961, p. 20; see Rewald 1965, pp. 48ff.).

23 Baudelaire had already poked fun at Gleyre's paintings in a Salon review of 1845: "He had conquered the hearts of the sentimental public with his painting *Evening*. As long as it was important only to paint women on a barge playing romantic ballads, people were content with that sort of thing, in much the same way that a mediocre opera triumphs over its own music with the aid of creatures in attractive

des Beaux-Arts and an artist who also gave private instruction.[22] Gleyre, a native of Switzerland, took on 30 to 40 students who practiced drawing from models and presented their work to him twice each week for correction. Besides instructing his students in the mixing of paints, he also taught them basic principles of anatomy and composition. Gleyre did not attempt to impose the cold grace of his own products on his students' work;[23] rather, he permitted them a certain degree of freedom while insisting at the same time on correctness in drawing and moderate use of color. In addition to Renoir, his studio produced such painters as Monet, Sisley and Bazille (1841–1870)—a mark of distinction for a teacher whose unselfish tutelage allowed friendships to develop among figure and landscape painters who would later oppose outmoded artistic standards by shifting their attention primarily to color.

Gleyre was forced to close his studio in early 1864, as the fees paid by his students no longer provided sufficient income to pay his models. Yet he encouraged the friends to carry on their work without his guidance. The respect Renoir felt for his mentor and his methods may have been one of the reasons why he retained a preference for the studio setting to complete his works, as opposed to the open-air approach propagated by his fellow students Monet and Sisley. All in all, Renoir remained a studio painter. Although he worked as an Impressionist at times, he consistently strove to translate the insights gained from open-air painting into his studio work.

Alongside his formal academic training, Renoir also spent hours in the Louvre copying paintings by Rubens (cat. no. 3)[24] and others or studying the works of the French masters of the 17th and 18th centuries, especially those of Watteau, Lancret (1690–1745), Boucher and Fragonard.[25] From this time on, his love of French baroque and rococo painting would remain as strong as Cézanne's for the sculpture of the same period. A great admirer of his countryman Puget (1620–1694), Cézanne, as we know, took advantage of his rare stays in Paris to work in the Louvre, drawing from rococo busts. Renoir felt much the same kind of loyalty to the traditions of art. In his view, the masterpieces of art history assumed an essential regulative function. Unlike Pissarro, Monet or Sisley, he never regarded the historical legacy of the past as a barrier to his own originality or to the development of a contemporary approach. Whereas Goya's (1746–1828) abysmal nightmares, populated by monsters, witches and demons, emphasized the supernatural aspects of rococo art, Renoir sought to transpose them into the worldly realm of momentary reality. His trips to the Louvre were as important to him in this context as his work with his own motifs. That is why he advised Bonnard, one of his greatest admirers, to learn painting in the museum, adding the following qualification: "When I say that one can learn to paint in the Louvre, I don't mean to suggest that one should go there to imitate the old masters. . . . One has to paint for one's own time. But there in the museum one develops a real urge to paint that nature alone cannot give. The idea 'I shall become a painter' is engen-

dered not by a beautiful view, but by paintings."[26] Renoir was never a rebel.[27] He appreciated tradition, without ever becoming a traditionalist himself. Manet's elegant revolt and Cézanne's youthful revolutionary fervor were alien to him; Pissarro's scandalous proposal that the Louvre be burned to the ground as a relic of time-worn tradition must have struck him as particularly dubious. Instead, he sided with Monet, who distrusted Gleyre's teachings and expanded his friend Renoir's horizons by introducing him to the realism of Courbet and telling him about his work on the landscape motif with Boudin (1824–1898) and Jongkind (1819–1891). The young artists were greatly impressed by the boldness with which Courbet with his palette knife or Delacroix with his glowing colors attacked the prevailing conventions of the Paris Salon exhibitions. Indeed, the Salon, an event presented annually at the Palais de l'Industrie since 1855, and its jurors represented a virtually impregnable bastion of authority and exercised a determining influence upon developments in contemporary art in France for decades. Favoring the popular tastes of a given year, the Salon exhibition, which Baudelaire (1821–1867) contemptuously referred to as "a warehouse of false votive offerings" and "a monstrous Milky Way of plaster follies,"[28] regularly staged excellent presentations of more or less monotonous art to which the public had grown accustomed over the years. Delacroix and Courbet registered their militant opposition with their own unique styles. And it was this tendency to which younger artists oriented themselves during the 1860s, though not ɿ out a view to Baudelaire, who had opened their eyes to themes ʌ modern-day life,[29] or Corot, for whom the landscape became ɑ focus of attention.

Seeking ways to distinguish themselves amidst the flooɑ ᴊiocrity, Renoir and Monet initially embraced the dictates of realism proposed by Courbet in 1855. Courbet's vigorous figural representations, which radically opposed even the work of his competitors Ingres (1780–1867) and Delacroix, his palette-knife technique with its thick masses of paint, and his huge compositions exerted considerable influence. They were instrumental in encouraging Renoir to resist the temptation to imitate the detailed pictorial narratives of the history paintings that were standard fare at the Salon exhibitions.[30] Without Courbet's example, he would never have begun with such impressive large formats (cat. nos. 4, 7–10). Completely alien to him, on the other hand, was Courbet's speculation on the scandalous effects of certain aspects of content. Maintaining his distance from the painter-princes and artist-rebels of the Second Empire, Renoir personified instead the middle-class painter who remained skeptical of both pompous splendor and rebellious fervor. This posture enabled him to apply the matter-oriented realism of Courbet, with all its overheated effects, with greater detachment, to interpret the pathos of Courbet's landscapes more naturally and at the same time to moderate the disturbing qualities of the older artist's nude paintings. Following Monet's lead, Renoir eventually liberated Courbet's use of color from the dramatic tensions

décolletés or undressed altogether. But with the apostles Gleyre sought to paint this time— Gleyre and apostles, indeed!— there could be no triumph over his own painting" (Baudelaire 1977, p. 150).

24 Daulte 1971, No. 7.

25 "How often I copied the *Embarkation for Cythera*! And thus Watteau, Lancret and Boucher were the first painters with whom I gained greater familiarity. To be more precise, Boucher's *Diana Bathing* was the first painting that truly captured my fancy; I have been in love with it my whole life long, in the way one loves his very first love. I was told that one could not really love 'that,' because Boucher was 'only a decorator' . . . as if it were something to be ashamed of. Yet Boucher is one ᴄ painters who understood 'ᴇ body best. It is ᴀt people never want a person credit for what ᴜn do. Someone says to you, prefer Titian to Boucher!' My God, so do I. But after all, Boucher did paint some very pretty little women. You know, a painter who has a feeling for breasts and behinds cannot fail" (Vollard 1961, p. 17).

26 André 1919, p. 60.

27 "Moi je reste dans le rang," Renoir declared to the German art writer Meier-Graefe around 1900 (Meier-Graefe 1911, p. 23).

28 Baudelaire 1989, p. 153.

29 As early as 1845–1846, Baudelaire had propagated the concept of the "heroism of modern life": "No one listens for the wind that will blow tomorrow; yet we are surrounded, besieged by the heroism of modern life There are themes and colors enough for new epics. The painter, the true painter, will be the one who exposes the epic dimensions of contemporary life, the one who, with color or through drawing, will allow us to see and under-

stand how great we are and how poetic, in our neckties and patent-leather boots" (Baudelaire 1977, pp. 183f.).

For Baudelaire in 1859, Constantin Guys came to epitomize the "painter of modern life." Guys "has voluntarily performed a service that other artists chose to neglect and which a man of the world was best suited to carry out; he sought everywhere the transient, fleeting beauty of contemporary life, the characteristic feature of what we, with the reader's permission, have called modernity" (Baudelaire 1989, p. 258).

30 The 23-year-old painter had made his first appearance at a Salon exhibition in May and June of 1864 with the painting *La Esmeralda*. Renoir was admitted to the Salon in 1865 with a portrait of his friend Sisley's father (ill. p. 72) and a painting entitled *Soirée d'été*, which no longer exists.

of its light-and-shadow existence by developing a palette largely purified of intermediate tones.

Renoir dared to bridge the gap between Courbet's realism and Delacroix's intensity of color; he saw no conflict between an interest in exemplary works of art in museums and an openness to the diversity of atmospheric phenomena that nature revealed to the young artists. He wanted to relate the immediacy of vision to the various polar tensions—from classicist discipline of line and romanticist color fantasy to realist revolt—embodied in the work of Ingres, Delacroix and Courbet. However, when Gleyre closed his studio, leaving his students to fend for themselves, Renoir set out with little experience in working from real landscape motifs. The study of nature had been of no interest to his teacher, for whom the work of his contemporaries Diaz (1808–1876), Rousseau (1812–1867), Corot, Daubigny (1817–1878) and Millet (1814–1875) held no appeal whatsoever. These artists had devoted themselves for many years to the poetry of trees, paths, cabins and rock formations in southern Paris or the countryside around Barbizon, a village at the edge of the forest of Fontainebleau. Although they gradually achieved some success thanks to the efforts of their agents, the art dealer Jean-Marie-Fortuné Durand (1800–1865) and his son Paul (1831–1922), the art critic Baudelaire, otherwise so far-sighted, felt obliged to accuse them of having no imagination at all. What remained, in his view, was "the banality that one encounters particularly among those artists who feel closest to visible nature because of its unique character, artists like the landscape painters, who generally consider it a triumph when they succeed in extinguishing their own personality. For all their looking, they forget to feel and to think."[31]

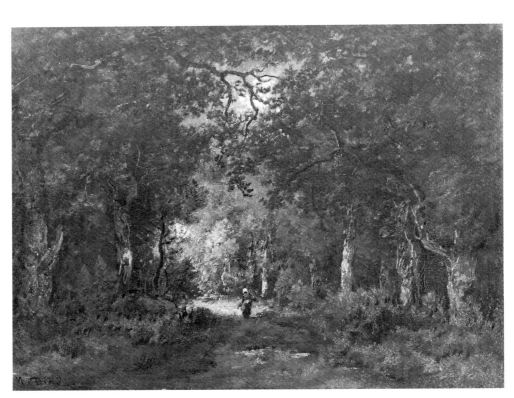

Narcisse Virgile Diaz de la Peña, *Forest Path*, 1865–1870, Musée d'Orsay, Paris

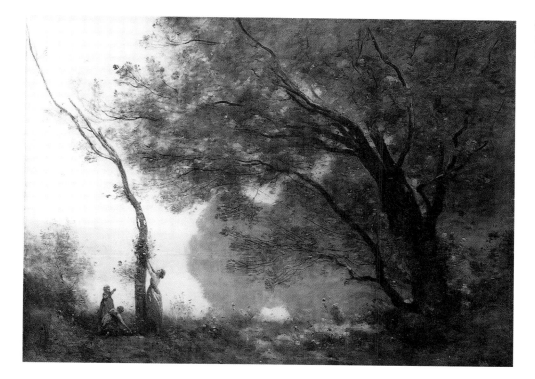

Camille Corot, *Memory of Mortfontaine*, ca. 1864, Musée du Louvre, Paris

Of Renoir's fellow-artists from Gleyre's studio, only Monet had acquired a more extensive grasp of open-air painting through his work with Boudin and Jongkind. It was Monet who took his friends to Chailly-en-Bière, a village near Barbizon, where they spent many hours together sketching the huge trees and rock formations of the Fontainebleau forest. The painter Jules Le Cœur (1832–1882) purchased a house in Marlotte in April 1865, and in the years before the outbreak of the Franco-Prussian War in 1870 the comrades often returned to the area to follow in the footsteps of the experienced landscape painter known as the "Master of Barbizon" (cat. no. 7): "I was impressed with Rousseau, and with Daubigny as well," Renoir later recalled. "I realized immediately that Corot was the great man who would endure. He ignored prevailing trends, just like Vermeer van Delft [1632–1675] Diaz was my great love. I understood him. If I were a painter, I thought to myself, I would want to paint like him, and perhaps I would even succeed. Besides, I enjoy forest landscapes in which there is a hint of water. Diaz's paintings often have the smell of mushrooms, of rotting leaves and moss. His paintings remind me of the ballads I once sang with my mother in the forests of Louveciennes and Marly."[32] A personal encounter between the two artists took place under rather dramatic, comical circumstances. While working in the forest of Fontainebleau, Renoir was ridiculed by a group of young Paris dandies because of his smock. Diaz—a man of impressive stature—happened to be passing by at the time and hurried to the aid of his young colleague, driving the tormentors away with his walking stick. Once the excitement had passed, Diaz took a careful look at the painting on Renoir's easel and suggested he try painting in lighter tones.[33]

31 Baudelaire 1989, p. 146. While Baudelaire's remarks on Millet in his review of the 1859 Salon were devastating, his appraisals of Diaz, Rousseau and Corot were more positive. He credits Diaz, at least, for whose eye "the perception of a shimmering miniature world had become habit," with "the joyousness of color, more glittering than rich," which he found reminiscent of "the cheerful colorpatterns of oriental fabrics." Although he admits that public opinion consistently attached the "greatest significance" to Rousseau and Corot "with regard to the singular quality of their landscape painting," he remained skeptical himself, despite his correct assessment of the two landscape painters as pioneers of the Impressionist cause (ibid., pp. 188, 172f., 189).

32 Renoir 1981, pp. 64f.

33 Vollard 1961, p. 21.

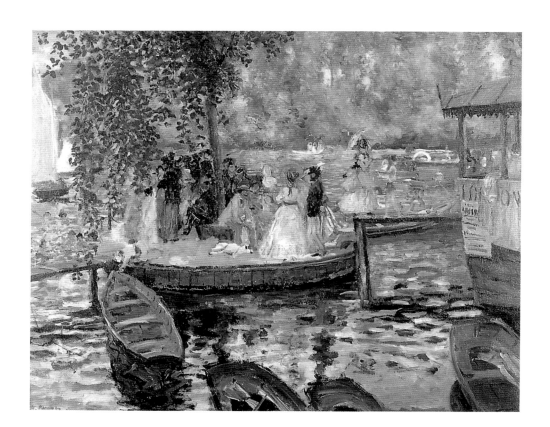

IV

What distinguished Monet, Sisley, Pissarro and Cézanne from their predecessors of the "Barbizon School" was their unqualified commitment to painting "sur la motif," i.e. in direct contact with the landscape.[34] Although Renoir later followed Corot's advice that he complete a painting begun outdoors in the studio, he, too, was initially an advocate of open-air painting, perhaps not least of all because he lacked a studio of his own. In a letter of July 3, 1865, bearing the inside address "Chez Sisley, avenue de Neuilly 31, Porte Maillot," he invited Bazille to take part in a sailboat trip down the Seine to Le Havre and to join him in sketching motifs from nature: "We want to watch the regattas in Le Havre. We plan to be out for about ten days; the costs will come to roughly fifty francs. I would be very pleased if you would come along. There is plenty of room on our boat. I'm going to take my paints, so that I can make sketches wherever a place catches my fancy. I think it's going to be delightful. Nothing can stop you from leaving a spot you find displeasing, and nothing can keep you from staying at a place you like."[35]

In addition to Renoir's frequent visits to locations in Marlotte in the Fountainebleau forest in 1866, ordinarily in the company of Sisley and Le Cœur (cat. no. 7), we also know of summer stays in the country in the following years—in Chantilly in July and August 1867, for example, or in Ville d'Avray in 1868. Renoir surely took advantage of these excursions to perfect his open-air painting. The most significant step in

34 Of Renoir's friends, it was primarily Cézanne who made frequent use of the term in his statements and letters.

35 François Daulte, *Frédéric Bazille et son temps*, Geneva 1952, p. 47.

that direction was his work with Monet from July to September 1869. In that year, Renoir spent the summer at his parents' home in Voisins-Louveciennes, a town to the west of Paris, where Sisley later lived with his family. Monet lived nearby in Saint-Michel, near Bougival. The two friends met daily to paint from nature. During these weeks they formed a close working relationship similar to the one Pissarro and Cézanne would develop somewhat later. Pissarro and Cézanne received fertile impulses from each other, and the relationship between Renoir and Monet was characterized by a similar reciprocity. Together, the two artists developed the mode of representation now rightly regarded as marking the birth of what is generally called Impressionism. The name La Grenouillère may be regarded as symbolic of their early efforts. On September 25, 1869, Monet wrote to Bazille telling him that he and Renoir had sketched there: "I have a dream, a painting of the baths at La Grenouillère; I did a few bad sketches for it—it is only a dream, of course. Renoir, who has just spent two months here, would also like to do such a painting."[36] La Grenouillère was a tavern with a bathing area located on an arm of the Seine near Croissy (cat. no. 16). For a few sous, people could take day trips by train from Paris to swim, row, or have picnics at the spot. As we learn in a novel by Maupassant (1850–1893), regular Sunday visitors to La Grenouillère included artist-bohemians and solid middle-class citizens, boatsmen and countless grisettes hoping to catch the eye of some wealthy man favorably disposed to their charms. It was the coquettes of Paris and their gallants who gave the locale its name—"the frog pond."[37] "It was a never-ending party, and what a confused conglomeration of people!" Renoir later recalled.[38]

36 Poulain 1932, pp. 161f.

37 Renoir 1981, pp. 181f.

38 Vollard 1961, p. 27.

Monet's dream took concrete form in a number of paintings in which he and Renoir focused upon the merry happenings along the Seine (ill. pp. 28 and 29), works that impressively manifest the fresh spring air of Impressionism in bloom. Nothing is staged in these scenes; coincidence defines the diction, while the changing light conveys the momentary character of events. One senses the fleeting quality of the moment in the very spontaneity of execution. To capture the effects of light and shadow on formal

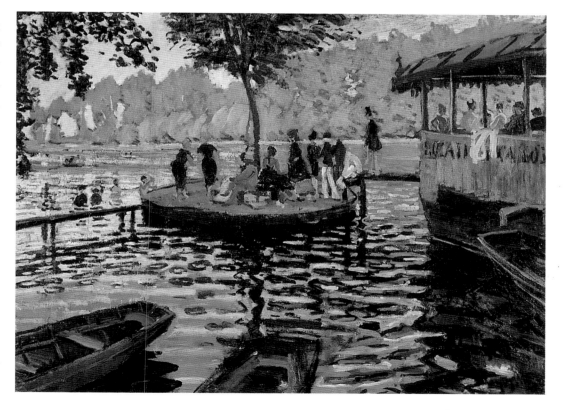

Claude Monet,
La Grenouillère, 1869,
The Metropolitan Museum
of Art, New York

structure, the two painters applied their colors in brushstrokes set apart at short intervals in patterns full of lightness. If color is to "take on vitality and freshness," Baudelaire had advised years before, "the individual strokes should not be allowed to run together; they will melt together naturally when viewed from a distance that is determined by the law of harmony governing their relationships to one another."[39]

Just how little these contemporary allegories of unencumbered *joie de vivre* had to do with the actual circumstances in which the two friends lived becomes evident in their letters. Monet, who lived with his wife Camille (1847–1879) and son Jean (1867–1914) in abject poverty, wrote to Bazille on August 9, 1869: "Renoir brings us bread from home to keep us from starving."[40] And Renoir himself reported to Bazille in Montpellier that he was "living with my parents, and spend most of my time with the Monets, who, by the way, are not doing well at all. They do not have enough to eat every day. Yet I am satisfied, for as far as painting is concerned, Monet is good company. I'm doing almost no work because I have only a few paints."[41]

Let us return, however, to the Paris studio the wealthy Bazille had rented at Rue Visconti 20 in early 1867. Following Sisley's marriage, Bazille gave the homeless Renoir and, for a brief period, Monet refuge there until year's end. In a letter to his parents, the host remarked: "I am putting up one of my friends, a former fellow student at Gleyre's, since he has no studio of his own at the moment. Renoir is his name, and he works very hard; he uses my models and even gives me money on occasion to help pay for them."[42] In a letter written to his mother somewhat later we read: "Since my last letter something new has happened on the rue Visconti. Monet has come out of the blue with a collection of magnificent canvases He will stay with me until the end of the month. Along with Renoir, I am giving shelter to two needy painters. It's a veritable infirmerie. This delights me. I have plenty of room, and they are both very gay."[43] Bazille and Renoir also shared rooms and a studio in 1868 after moving to the Rue La Condamine in January of that year. They remained there until the spring of 1870. Their new domicile at the foot of Montmartre was only five minutes' walking distance from the legendary Café Guerbois, Grande Rue des Batignolles 11, on what is now the Avenue de Clichy, where Manet had met regularly with his friends and admirers since 1867. In addition to Guys (1805–1892), these included Fantin-Latour (1836–1904), Degas, Pissarro and others, among them Renoir, Bazille, Sisley and Monet. Other regular guests at the café were Zola, who promoted Manet in particular in his writings for the press, the art critics Astruc (1833–1907) and Duranty (1833–1880), the music-lover Edmond Maître (1840–1898) and the photographer and pioneer balloonist Nadar (1820–1910). "There was nothing more interesting," Monet recalled later, "than these battles of words. They sharpened our minds, filling us with an enthusiasm that lasted for weeks, until an idea finally

39 Baudelaire 1989, p. 147.

40 Poulain 1932, p. 157.

41 Ibid., pp. 155f.

42 Ibid., p. 101.

43 *Frédéric Bazille and Early Impressionism,* The Art Institute of Chicago, 1978, pp. 173, 203.

reached its finished form. We left the café with strengthened resolve, our thoughts clearer and our moods buoyant."[44]

At the same time—and yet in different ways—both Fantin-Latour and Bazille created monuments to this circle of friends, each of them assigning a key role to Renoir. The monumental group portrait painted by Fantin-Latour in 1869 for the 1870 Salon, a work entitled *Un atelier aux Batignolles* (ill. p. 32), shows Manet in the center, sitting at an easel. Seated at his side is Astruc, whose portrait he is painting. Arranged around them from left to right are the German painter Otto Scholderer (1834–1902), Renoir, Zola, Maître and the elegant, stately Bazille, behind whom Monet is almost hidden at the edge of the painting. Only Renoir is depicted without pose, lost in contemplation of Manet and his painting. Though he appears in the background, his importance is heightened by the fact that Fantin-Latour has placed him in front of a gold frame, giving him the character of a portrait subject. Thus Renoir alone is represented at two different levels of meaning: as an observer present in the studio and as a figure painted in the studio. Although Fantin-Latour's homage to Manet presents a more freely arranged grouping of figures than his somewhat smaller *Hommage à Delacroix* of five years earlier (ill. p. 32), the two paintings share a significant feature: the picture-within-a-picture motif, a device that has always played an important role in art. In the earlier composition, the symmetrically arranged group of figures—Baudelaire, Manet, Duranty, Whistler (1834–1903) and Fantin-Latour himself—is shown gathered before the portrait of Delacroix after the death of their esteemed friend in August 1863. In the later painting, on the other hand, it is the likeness of Renoir that is emphasized by the gold frame and positioned directly behind Manet. It is possible that Fantin-Latour, a long-time friend of Renoir, regarded him as the legitimate successor to the artist honored in the earlier painting. In a letter to the English graphic artist Edwards (1823–1879) dated June 15, 1871, Fantin identified the persons portrayed, referring to Renoir as a painter about whom there would one day be much to say.[45]

In comparison, Bazille's studio scene is a much less sophisticated work. In his *L'atelier de la rue La Condamine* (ill. p. 33), likewise painted in 1869–1870, the dark colors of Fantin-Latour's painting have given way to a lighter palette. Almost the same group of artists is gathered here in a light, airy interior. Maître is seated at a piano to the right. Bazille himself—sketched by Manet in the center of the painting—is shown holding a palette, identifying him as the author of the painting on the easel. Manet and behind him Astruc or Monet examine the painting, while Renoir appears to have engaged Sisley, who is seated on a table, in discussion from his position on the stairs. The most striking difference evident in this painting is the scale of the figures, which—now much smaller—are literally driven to the walls by the figure paintings in the room. Renoir's gold-framed composition, featuring a seated female figure and a nude seen from the rear, occupies the place of honor next to the large studio window.[46] All the other paintings

44 Rewald 1965, p. 125.

45 Ehrlich White 1984, p. 30.

46 Only a fragment of the painting has survived (Daulte 1971, No. 25). The fragment shows the upper portion of the figure on the left, probably cut out of its original pictorial context by Renoir himself and later signed and dated personally (?). Originally part of a private collection, the fragment was kept under lock and key at the Pushkin Museum in Moscow after the war.

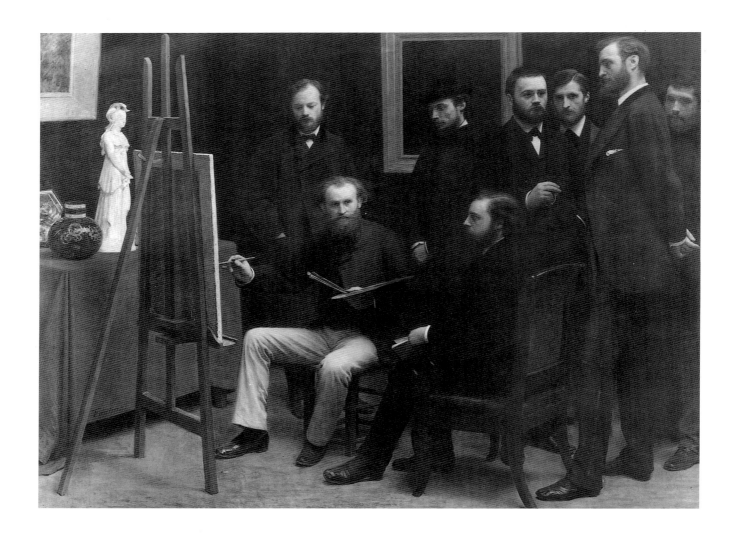

Henri Fantin-Latour,
Studio in Batignolles, 1870,
Musée d'Orsay, Paris

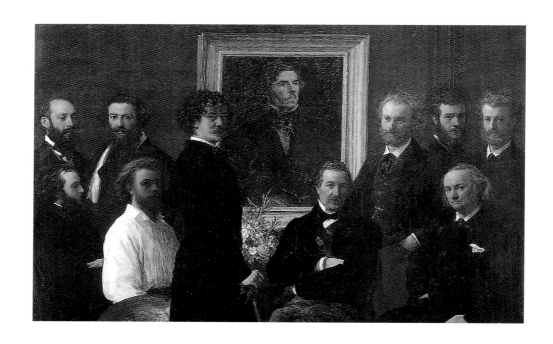

Henri Fantin-Latour,
Homage to Delacroix, 1864,
Musée d'Orsay, Paris

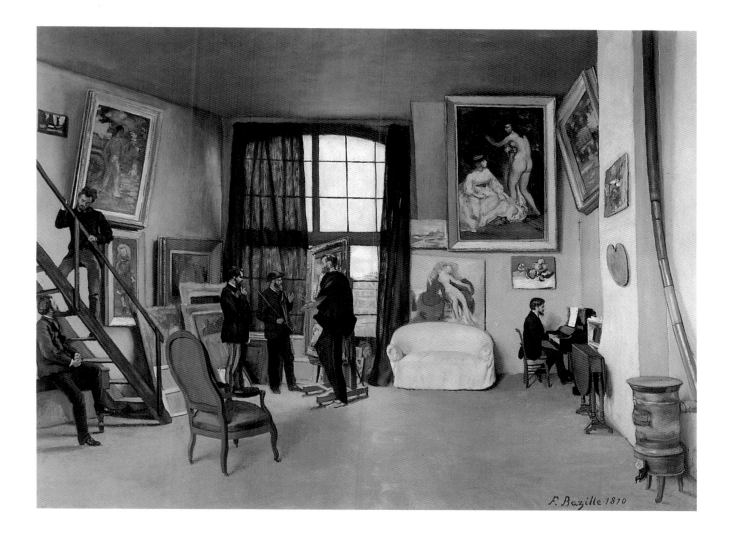

shown are works of Bazille's, with the exception of a small still life by Monet hung on the wall above Maître, the piano player. With this composition, in which all the other works depicted are subordinated to Renoir's painting, Bazille evidently meant to express the admiration he felt for his studio comrade as the inventor of the large-scale figural composition.

The group of friends was abruptly torn apart by the outbreak of the Franco-Prussian War on July 19, 1870. Monet and Pissarro fled to London to avoid conscription. Cézanne went into hiding in L'Estaque. Renoir was drafted into military service as a horseman in the 10th Cavalry Regiment in southwestern France, an assignment that kept him far from the battlefront. Like Manet and Degas, Bazille volunteered for duty in a Zouave regiment. With his death on November 28, 1870, in the battle of Beaune-la-Rolande, Renoir lost one of his closest friends, and painting a promising talent.

Frédéric Bazille,
*Studio in the Rue
La Condamine*, 1870,
Musée d'Orsay, Paris

V

In the aftermath of the dramatic events of the war and the post-war period—the abdication of Napoleon III and the establishment of the Third Republic, the capitulation of Paris in late January 1871, the proclamation of the Paris Commune and its eventual suppression—Renoir's life appears to have returned rather quickly to normal. Returning to Paris in April 1871, he spent the following months, as he had done before, in Louveciennes, Marly and Marlotte in the company of Sisley and Jules Le Cœur. Portrait commissions and first purchases in 1872 and 1873 (cat. no. 8) by the art dealer Paul Durand-Ruel and Théodore Duret (1838–1927), a cognac producer who also engaged in journalism, enabled him to rent an attic flat with a studio in the Rue Saint-Georges 35 in Montmartre. This was to remain his primary domicile for the next ten years. Durand-Ruel, to whom Renoir had been introduced by Monet in the spring of 1872, had met Monet and Pissarro in London during the war and decided to expand his activities on behalf of Courbet and the "Barbizon School" to include the younger generation as well. He was the first to buy works from those artists who were soon afterward decried by the art public as "Impressionists," devoted to the "cult of ugliness." As his agent, Durand-Ruel was one of the most important people in Renoir's life, and despite occasional economic difficulties the artist remained loyal to him throughout his life (cat. no. 102).

The budding Impressionists now began to question the picturesque exoticisms of the Salon painters in earnest by confronting them with immediate sense perception. They opposed the everyday lives of their fellow human beings to the appeal of the extraordinary in history and mythology or in allegorical and religious scenes from the past. The everyday life of Impressionism was to be found primarily on the boulevards of the city, in excursions to the banks of the Seine or in cafés, theaters and the village-style amusement locales of Montmartre. In Renoir, Monet, Pissarro and Cézanne, the *grand-bourgeois* urbanity of Manet or Degas was confronted by artists whose origins lay in quite different social circumstances, more readily identifiable as lower middle-class. These younger painters showed only limited willingness to respond to the substantive innovations introduced by the two great Parisian matadors. Instead, they relied entirely on the vitality of a radically modified palette and on new approaches to color.

By the time Renoir joined Monet in their venture into open-air painting, Courbet's heavy, earthy coloration was already a thing of the past. Although the constantly changing light in outdoor settings had once posed a difficult challenge for him, Renoir had learned to accept colors as they came and as he perceived them through his senses. Drawing upon a color spectrum of increasing purity, he focused his attention in the ensuing years on the way in which light reflections change the appearance of objects, dissolving outlines and causing seemingly dark shadows to emerge from colors. Discovering the aspect of the fleeting moment in atmospheric phenomena, the painter devel-

oped a mode of representation for a contemporary life in constant flux, a life which—analyzed by many from Baudelaire and Zola to Daumier and Guys—was unfolding at that time in Paris and its environs.

Between 1871 and 1873, Renoir painted a series of landscape paintings, figural compositions and portraits in which the richness of his inventive imagination is magnificently displayed. The dissolution of forms with light imbued his landscapes with a coloration that outshone everything that had come before (cat. nos. 15, 16, 19–22). After Monet moved with his family to Argenteuil, a rural suburb on the banks of the Seine north of Paris, he and Renoir spent the summer months from 1872 to 1875 standing at their easels, often focusing upon the same picturesque riverside or garden views. Their working methods were so similar that the results of their efforts are often difficult to distinguish from one another. Nevertheless, it is clear that Renoir's landscapes are more intimate. In contrast to Monet's breathy expansiveness, Renoir's scenes are bathed in a more transient atmosphere of light, air and sunlight. Their color substance is more palpable, more aromatic. While Monet set richly contrasting accents and relentlessly pursued the dissolution of form, Renoir's freer gaze was devoted to the sunlit nature of his noonday scenes. For both artists, who remained lifetime friends, color was the elixir of life. A beneficiary of this development was Manet, who joined Renoir and Monet in Argenteuil in 1874 and ultimately converted permanently to open-air painting (ill. p. 124).

From then on, Renoir consistently developed the vital driving force of color as his own personal specialty, deriving the power of his images from its abundant wealth. His keen insight into the essence of color tones and the laws that governed them yielded a specific intensity of being that lent significance to both the bohemian scenes of suburban Paris and the landscapes outside the gates of the city, immersed in shimmering light. This same insight also enabled the painter to avoid digressing into genre-style representation or losing himself in the fashionable details of furnishings. The interplay of color tones held in suspended balance diminishes even the banality of the worldly facades of some of his society ladies, turning their poses of decorum and the imposing outer shells of their costumes into unparalleled painterly accomplishments.

Although Renoir did not dwell upon the fleeting *en passant* of the figures seen hurrying by in his paintings, the application of paint in short, pregnant strokes emphasizes the transitory aspect so essential to pictorial statement in Impressionist art. The rhythm of the brushwork accelerated into a staccato of rapidly applied groups of elongated points. A densely woven fabric of quick brushstrokes conveyed the spontaneous suggestion of objective form. The painter achieved harmony between the web of light and shadow areas, derived from the coexistence of opaque colors in a kind of all-over structure, and transparent layers of color, a technique he had learned from his studies of Rubens' paintings.[47] The surface reflections of light thus intermingled with the inner glow of a color scheme that was refined in its every

47 "In my early days, I often used thick greens and yellows, because I thought I would obtain greater 'values' that way. Then I discovered in the Louvre that Rubens got much more out of a light, transparent color than I with my thick application. On another occasion I saw that Rubens rendered a silver tone with black. Naturally, I made use of these insights, but does that mean that Rubens influenced me?" (Vollard 1961, p. 68).

nuance. What Manet or Degas accomplished in terms of evocative illumination radiates in the paintings of Renoir—an artist who mistrusted the effects of artificial light and worked only in daylight, even in his studio—from the substance of his colors.

The month between April 15 and May 15, 1874, witnessed the noteworthy exhibition in the studio rooms of the photographer Nadar on the Boulevard des Capucines that was to give the Impressionists their name. Participants at the show—inconclusively entitled *Societé anonyme des artistes, peintres, sculpteurs, graveurs, etc.*—included Renoir, Monet, Sisley, Pissarro, Cézanne, Degas and Berthe Morisot (1841–1894), along with numerous lesser-known artists. Although both were invited, Manet and Fantin-Latour declined to take part. Renoir, who presented six paintings and a pastel (cat. no. 21), was entrusted with the task of hanging all the pieces, while his brother Edmond assumed responsibility for the catalogue, covering the entire collection of 165 works. The defamatory designation applied to the members of this loosely organized group of artists—now an accepted stylistic definition—first appeared in a devastating review published in the journal *Le Charivari* on April 25, 1874, a piece maliciously entitled "The Impressionists' Exhibition." As Renoir recalled, "the name 'Impressionists' suddenly occurred to visitors viewing one of the exhibited paintings, a work that was quite well suited to evoke laughter or outbursts of scorn; it was an atmospheric morning scene by Claude Monet entitled *Impression*."[48] The disdainful epithet was soon firmly entrenched in the public mind and within the artists' group itself, whose only program consisted in not having one, or rather in placing personal perception above any program. By the time it closed, the exhibition had attracted only 3,500 visitors, far fewer than had been anticipated. By way of contrast, the Salon exhibition presented at the same time drew nearly 400,000 people, according to Zola's estimates.

Renoir took an active part in three of the eight Impressionist exhibitions presented between 1874 and 1886. The second exhibition opened in early April 1876 at the Galerie Durand-Ruel. He exhibited 15 paintings, including 12 portraits, presumably hoping to attract commissions (cat. no. 27). Although international press coverage included reporting by a number of prominent writers—Zola wrote on the Impressionists for St. Petersburg, Henry James (1843–1916) for the *New York Tribune*, Strindberg (1849–1912) for a Swedish newspaper and Mallarmé (1842–1898) for a London monthly[49] in late September—the show attracted even fewer visitors than its predecessor. On April 3, 1876, *Le Figaro* published the most violent attack on the group. The reviewer singled out a nude by Renoir (ill. p. 37) for particular contempt: "Try to explain to M. Renoir that a woman's torso is not a pile of decomposing meat with green and purplish spots that suggest the condition of a rotting cadaver You might just as well spend your time trying to convince a patient of Dr. Blanche [a Paris psychiatrist] who believes himself to be the Pope that he lives in Batignolles, and not in the Vatican."[50]

48 Ibid., p. 40.

49 Ehrlich White 1984, p. 58.

50 Perruchot 1964, p. 115.

The painter made one last attempt the following year, presenting 21 paintings at the third exhibition. Failing once again to attract positive attention, he resolved to end his participation at the Impressionist shows and submit to the judgment of the Salon jurors again, as he had done sporadically since 1864. Although he had originally been one of the driving forces behind the Impressionist exhibitions and the organizer of two public auctions featuring both his own works (cat. nos. 19, 20) and those of his fellow Impressionists in March 1875 and May 1877, Renoir eventually came to agree with Manet, who sought success exclusively within the context of the Salon, primarily out of fear that his hard-earned reputation might be damaged as a result of association with the Impressionists. Renoir's Impressionist friends took his decision as an affront, and the group voted on a ban that would prohibit him from exhibiting either at their shows or in the Salon. In a letter to Durand-Ruel written in March 1881, Renoir attempted to justify his position: "There are

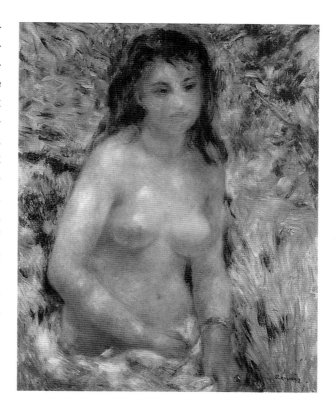

Renoir, *Female Nude in the Sunlight*, 1875–1876, Musée d'Orsay, Paris

scarcely 15 devotees of art in Paris capable of recognizing a painter who is not represented at the Salon. But at least 80,000 are willing to purchase any piece of canvas painted by an artist who exhibits at the Salon If I could be accused of neglecting my art or making sacrifices against my better judgment for the sake of some blind ambition, then I could understand these critics My submission to the Salon was made for business reasons only. It is the same as with certain medicines: even if they don't help, at least they do no harm."[51]

The letter-writer undoubtedly saw better chances to attract the interest of potential clients as a participant in the official Salon exhibitions than he could have expected from further involvement in the activities of the Impressionists. Even Zola had supported this view in 1880, for he, too, regarded the Salon as the only exhibition setting capable of helping young artists achieve a breakthrough: "I am for independence in any case, and in every way, yet I admit that M. Renoir's behavior struck me as completely reasonable. One must be aware of the excellent opportunities the official Salon offers young artists to make a name for themselves; given circumstances as they are here, that is the only place in which they can achieve truly great success. Of course it is important to maintain independence in one's work . . . but afterwards one has to do battle in the light of day, under the conditions most likely to favor victory. It is simply a matter of opportunism, as the politicians of our day are so fond of saying."[52]

Renoir celebrated his greatest Salon success from May to June of 1879 with his large group portrait of Marguerite Charpentier (1848–1904), her three-year-old son Paul and her six-year-old daughter

51 Venturi 1939, I, p. 115.

52 F.W.J. Hemmings and Robert J. Niess (eds.), *Emile Zola. Salons*, Geneva/Paris 1959, p. 239.

53 Pissarro 1980, p. 133.

54 Cézanne 1962, p. 168.

55 Ehrlich White 1984, p. 87.

56 Daulte 1971, Nos. 226, 178.

57 Ibid., Nos. 218, 219. "Painting decorations had always been an unparalleled pleasure for me, beginning with the works of my youth, which I painted on the walls of a café. Unfortunately, there was little space at Madame Charpentier's. The rooms were decorated in the style of the time with Japanese curiosities. Therefore, Madame Charpentier left me only two high, narrow walls in the stairway. I painted two figures, a man and woman, as a companion piece" (Vollard 1961, p. 58).
The two wall decorations, confiscated by Soviet occupation troops from the Gerstenberg collection in Berlin, are now in the Hermitage in St. Petersburg.

58 Renoir referred to himself in this way in a letter of November 30, 1878 (Florisoone 1938, p. 35).

59 Renoir recalled that "Madame Charpentier's salon was a gathering place for everything Paris had to offer in the way of celebrities from the world of politics, literature and art. Among her most frequent guests were Alphonse Daudet, Zola, Spuller, the two Coquelins, Flaubert and Edmond de Goncourt. I saw Cézanne there, too, on a single occasion; he had come with Zola. But the place had too much high-society flair for him Maupassant had reached the pinnacle of his fame, and his steadily growing production filled Goncourt and even Zola with horror. Conversation between the two always began with 'Ah, this Maupassant, this great talent! But who is to call his attention to the dangers of overproduction?' . . . Madame Charpentier was not content just to invite artists into her home. She interested her husband in the idea of publishing a journal under the title La

Georgette in the Japanese boudoir of their house at Rue de Grenelle 11 (ill. p. 39). "Renoir has had great success at the Salon," wrote Pissarro to Meunier on May 27, 1879. "I think he has made his breakthrough. And all the better for that! Poverty is so hard."[53] And Cézanne wrote to the collector Victor Chocquet (1821–1891), a mutual friend, commenting that he was very happy to have learned of Renoir's success.[54] Yet the positive response of the public and the press was hardly attributable solely to the "lively and smiling grace" and the "enchantment of color" that the art critic and later minister of art Jules Castagnary (1830–1888) recognized in Renoir's painting.[55] An equally important factor was the social standing of Madame Charpentier herself, who suffered through no less than 40 sittings between September 1878 and the completion of the painting in mid-October of the same year.

Georges Charpentier (1846–1905), who had assumed control of his father's publishing firm in 1871, had met Renoir at La Grenouillère before the war. The two men met again at the auction organized by Renoir in 1875, where Charpentier was among the few purchasers. The publisher's commissions for portraits of his wife and daughter Georgette—the paintings were exhibited at the 1877 Impressionist exhibition[56]—and the decoration of his staircase with two frescoes[57] eventually led to the growth of a close friendship. As the Charpentiers' "family painter,"[58] Renoir was a regular guest at Madame Charpentier's frequent soirées. These events were attended by a highly stimulating circle of intellectuals, liberal politicians, aristocrats, composers, actors and writers—among them such prominent figures as Flaubert (1821–1880), Zola, Daudet (1840–1897), Maupassant and later Gambetta (1838–1882), Clémenceau (1841–1929), Saint-Saëns (1835–1921), Massenet (1842–1912) and Chabrier (1841–1894).[59] It was a salon after Marcel Proust's (1871–1922) own heart, who expressed his thoughts on the matter at the end of his novel *A la recherche du temps perdu*: "The artist may paint anything in the world that he chooses, but when beauty is awakened within him, the model for that elegance in which he will find themes of beauty will be provided for him by people a little richer than he is himself, in whose house he will find what is not normally to be seen in the studio of an unrecognised man of genius selling his canvases for fifty francs: a drawing room with chairs and sofas covered in old brocades, an abundance of lamps, beautiful flowers, beautiful fruit, beautiful dresses—people in a relatively modest position Will not posterity, when it looks at our time, find the poetry of an elegant home and beautifully dressed women in the drawing room of the publisher Charpentier as painted by Renoir, rather than in the portraits of the Princesse de Sagan or the Comtesse de La Rochefoucauld by Pierre-Auguste Cot [1837–1883] or Chaplin [1825–1891]? The artists who have given us the most splendid visions of elegance have gathered the materials for them among people who were rarely the leaders of fashion of their age, for the leaders of fashion rarely commission pictures from the unknown bearer of a new type of beauty which they are unable to distinguish in his canvases."[60]

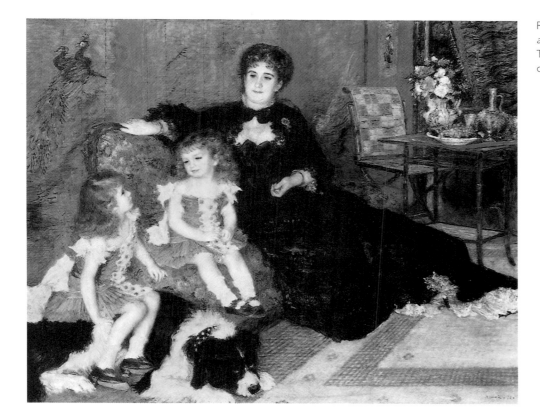

Renoir, *Madame Charpentier and her Children*, 1878, The Metropolitan Museum of Art, New York

On July 4, 1880, Cézanne mentioned to Zola that "Renoir is said to have received several good commissions for portraits."[61] Nor was Pissarro mistaken in assuming that the Charpentiers would promote Renoir's advancement;[62] for it was primarily their recommendation that brought him commissions from new clients who admired his portraits, in addition to those proffered by previous collectors such as Théodore Duret (cat. no. 8), the pastry chef Eugène Meunier (1846–1906), Stanislas Henri Rouart (1833–1912, cat. no. 9), a friend of Degas, the customs inspector Chocquet (cat. no. 26), Count Doria (1824–1896, cat. no. 31), the industrialist Jean Dollfus (1823–1911, cat. no. 27), Paul Gallimard (1850–1929), director of the Théâtre des Variétés, and Renoir's friends Charles Deudon (1832–1914) and Charles Ephrussi (1845–1905). Among these new clients were the banker Louis Cahen d'Anvers (1836–1922, cat. nos. 63, 64), Armand Grimprel (1838–1910) and most notably the embassy secretary Paul Antoine Bérard (1833–1905). Bérard invited Renoir, who spent some time on the coast of Normandy during the summer of 1879, to visit him at Wargemont, his nearby palace. The artist returned often to Wargemont in the following years to paint his hosts, their four children and a number of landscapes and still lifes (cat. nos. 70, 54–57).

By the end of the 1870s, the painter had reached the zenith of his creative powers. As a gifted colorist for whom no challenge appeared too great, he had achieved mastery of monumental figural compositions, become a portraitist in great demand and had painted landscapes and still lifes that are surely among the most beautiful ever created

Vie Moderne, which would advance the cause of Impressionism. We on the staff were to be paid from the surplus income; in other words, we never received a single franc!" (Vollard 1961, p. 56; see Renoir 1981, pp. 123ff.).

60 Marcel Proust, *In Search of Lost Time*, vol. VI: *Time Regained*, trans. Andreas Mayor and Terence Kilmartin, New York 1993, p. 45

61 Cézanne 1962, p. 180.

62 Pissarro 1980, p. 110.

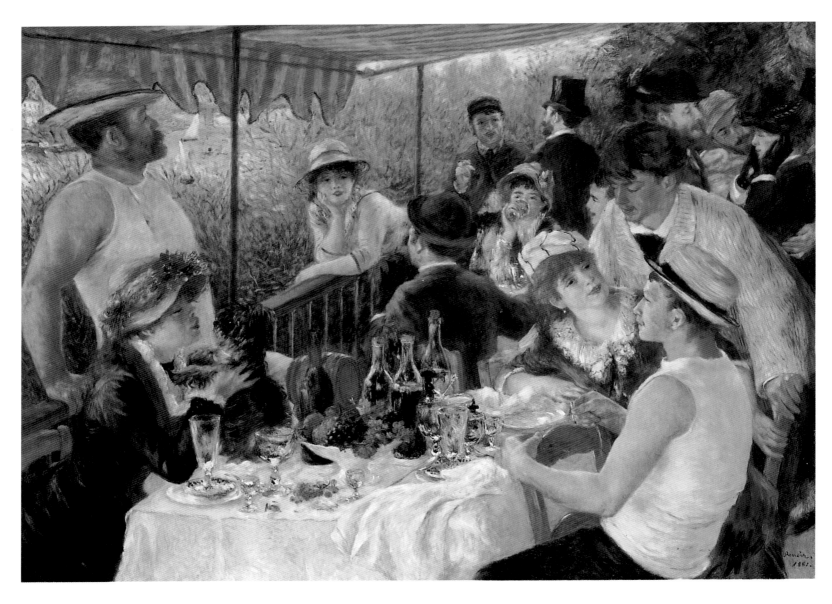

Renoir, *The Rowers' Breakfast*,
1881, The Phillips Collection,
Washington

under the signet of Impressionist art. Thus he was ideally prepared to realize the group portrait *Le déjeuner des canotiers* (ill. p. 40), a work that was to signify both a farewell and a new beginning. The painting was done at the guest house of Père Fournaise on an island in the Seine near Chatou. Renoir wrote about his plans in a letter to Bérard written in August or September of 1880: "I am in Chatou and hope to see you in Paris on October 1 I am now working on a painting of rowers. I have been waiting impatiently to realize the idea for a long time. I am slowly growing old, and did not want to postpone this little celebration, the costs of which I would not be able to pay later on. It is expensive enough as it is. I do not know yet whether I will be able to complete it, but I told Deudon about my troubles, and he agreed with me that even if the enormous costs prevented me from finishing my painting, it would still be a step forward. From time to time one has to attempt things that are beyond one's powers."[63]

Parisian bohemian life is represented here one last time in a painting saturated with sunlight. On a verandah on the second floor of the guest house in view of the Seine, the proprietor Alphonse Fournaise stands to the left, while Renoir's artist-friend Caillebotte (1848–1894) is seated on a chair facing backwards beside the actress Ellen Andrée (1857-c. 1915); another woman, possibly the actress Jeanne Samary (1857–1890), appears in the background to the right. Whereas traditional table scenes depict festivities of weighty import, Renoir's commemorative scene with wine and fruits is the glorification of an unrepeatable impression, a backward glance at a time of untroubled youth and friendship. At the same time, however, despite its undeniably Impressionist intensity of color, it points toward the future, announcing a new stability of form. The painting also introduces Aline Charigot (1859–1915), who as Renoir's wife would later give the artist's life an entirely new direction (cat. nos. 58, 76–78). Aline appears at the left as the almost childlike figure holding a small dog. "Renoir met my mother during a period of personal crisis," wrote Jean Renoir: "'I had no idea what to do. I was drowning!' After ten years of struggle and a number of inconsistent attempts, his doubts about Impressionism were growing ever stronger. Aline Charigot took a simpler view of things. With her healthy country common sense, she recognized that Renoir was meant to paint, just as a grapevine is meant to bear grapes."[64]

63 Maurice Bérard (ed.), "Lettres de Renoir à Paul Bérard (1879–1891)" in *La Revue de Paris*, December 1968, p. 3.

64 Renoir 1981, p. 195.

VI

In May of 1878, Théodore Duret offered a vehement defense of the Impressionist painters in his brochure entitled *Les peintres impressionistes*, naming Monet, Pissarro, Berthe Morisot and Renoir as the key figures in the Impressionist movement. By that time, however, it had already become clear to Renoir, at least in terms of his role as a "figure painter," that his ties to those artists were now few and that they would henceforth go their separate ways. In retrospect, he qualified his position within the group, which had never been a homogeneous one, in no uncertain terms: "I painted with light colors because it was necessary to paint in light colors. That was not the consequence of any theory but simply a necessity that presented itself. Everyone recognized it subconsciously; I wasn't alone. I painted with light colors, but that did not make me a revolutionary."[65]

Impressionist euphoria gave way to sobering realization in the early 1880s. After more than a decade, Impressionism, which derived its power from the single moment, was threatening to become a permanent institution. Its model of transitory existence had grown stale. The themes of modern life had been played out; contemporaries sought ways to transcend their time. Impressionist techniques of color application and the dissolution of form had lost much of their persuasive power. The Impressionists' exclusive concern with openness and sketchiness in the composition had nearly exhausted its potential. Ultimately, the artist-community revealed itself to be no longer viable. The comrades went their separate ways. Sisley had retreated to Saint Mammès near Moret in 1882, Monet moved to Giverny in 1883, Pissarro settled in Eragny in 1884 and Cézanne was spending increasing amounts of time in Aix-en-Provence. As for Renoir, the moments of joy, those succinct poetic images as heralds of happiness, had outlived their usefulness. The experience of the reality of past moments was no longer enough for him. Nor was he willing any longer to systematically apply the principles that had helped him and Monet achieve their breakthrough many years before, and which Monet—who had pursued them with the greatest consistency—would eventually overcome, using them as weapons in their own defeat. Renoir later confessed to the art dealer Ambroise Vollard (1868–1939) that he had taken Impressionism to an extreme, only to arrive at the realization that he could neither paint nor draw.[66] What remained to him in that situation was to flee from himself, from the beautiful fixation on the spontaneity of personal style and lightness of coloration that had become all too seductive. The horizons that promised to provide impulses for a new beginning were to be found in Algeria, Rome, Naples and L'Estaque in the south of France.

Having developed a well-situated circle of acquaintances since 1879, Renoir could count on a measure of security from portrait commissions. Beginning in January 1881, he received more or less regular payments from Durand-Ruel for groups of paintings entrusted to him on commission; Durand-Ruel was the first art dealer to engage the artist

65 Ibid., p. 69.

66 Vollard 1961, p. 71.

in a binding relationship with his gallery by paying him monthly advances. Thus Renoir could afford to travel to North Africa in the footsteps of Delacroix and to Italy in search of the old masters in 1881 and 1882. "I suddenly became a traveler," he wrote in a letter to Marguerite Charpentier during his journey to Italy from late October 1881 to January 1882. "I have contracted the fever of desire to see the paintings of Raphael [1483–1520]. And so I have begun to devour my Italy." With a touch of irony, the tourist with a thirst for learning added: "Now I can say without hesitation, 'Yes, Sir, I have seen the Raphaels; I have seen the beauties of Venice, etc. [cat. no. 66]. I have turned north, and I shall travel to the tip of the boot's toe as long as I am here, and when I have done all that I shall stumble back, exhausted, to have breakfast with you. I hope that you will receive me in spite of my ingratitude. A man who has seen the Raphaels!'"[67]

Renoir also provided Durand-Ruel with an updated account of his progress in a letter dated November 21, 1881: "I saw Raphael's paintings in Rome. They are very beautiful. I should have gotten to know them long ago. They radiate knowledge and wisdom. Unlike me, he did not strive for the impossible. But they are wonderful. Nevertheless, I prefer Ingres when it comes to painting on canvas. The frescoes are magnificent, however, in both scale and simplicity." Dissatisfied with his own work, the great admirer of Delacroix, who had taken in the landscape of North Africa through the latter's eyes a short while before and in the same breath professed his admiration for the Raphael of the Farnesina and the Vatican loggias, remarked in the same letter: "Unfortunately, I am still searching. I am not satisfied, and I am continuously wiping the page clean. I hope this mania comes to an end soon I am behaving like a schoolchild. The white page must be written in an immaculate hand, and look—a spot! I'm already forty years old, and I am still spotting my pages."[68]

The traveler experienced his greatest revelation in the "Pompeiian paintings in the museum of Naples. I was driven to exhaustion by the exquisite Michelangelos [1475–1564] and Berninis [1598–1680]. Too much drapery, too many folds, too many muscles! I love painting that has something of the eternal . . . but unspoken; an eternity of the everyday, captured on the nearest street corner; the maid stops cleaning her pots for a moment and suddenly becomes Juno on Mount Olympus! . . . Italian streets are filled to overflowing with heathen gods and biblical figures. Every mother nursing her child is like a Raphael Madonna! And you can tell they weren't trying to turn out a masterpiece. Merchants or courtesans had their houses painted. The painter did his best to put some joy into a bare wall—and that is all! No genius! No agonies of soul!"[69]

Still, the Frenchman was homesick for Paris: "I feel somewhat lost when I am away from Montmartre . . . ," he admitted to Deudon, the collector. "I long for my familiar surroundings and still find the ugliest of Parisian women more attractive than the most beautiful woman in Italy."[70]

67 Florisoone 1938, p. 36.

68 Venturi 1939, I, pp. 116f.

69 Renoir 1981, pp. 204f.

70 Schneider 1945, p. 97.

On his return journey from Palermo and Naples, Renoir stopped in Marseille and L'Estaque in 1882. From there he wrote to Durand-Ruel on January 23, mentioning that he had met Cézanne and made plans to work with him.[71] In his letter to Madame Charpentier, written in early February, we read: "Conditions for work are so good here that I find it impossible to return to Paris. I have constant sun, and I can scrape my canvas clean and start over as often as I wish. That is the only way to learn, and in Paris one is forced to get along on so little. I did many studies in the museum in Naples. The paintings of Pompeii are extremely interesting from every point of view. So I shall stay in the sun, not to do portraits in the full sunlight but to warm myself and make many observations. I think I will have gained the greatness and simplicity of the old masters. Raphael, who never worked in the open air, studied the sunlight, for his frescoes are full of it. And thus through much observation in the outdoors, I have finally arrived at the point where I see only the great harmonies, without having to concern myself with the small details that extinguish the sun rather than igniting it. I hope therefore when I return to Paris to do something that would represent the product of all of these general studies, and from which you might benefit as well. As you are probably thinking, I could do myself harm in the process, but I'm sure I have done what is necessary to avoid that. It is human nature to deceive oneself. I trust you will excuse me. P.S. I hope to return by the end of the month at the latest."[72] Yet Renoir was unable to return as soon as he had hoped; in L'Estaque he contracted a severe case of pneumonia and was forced to stay longer than he had planned. Cézanne and his aging mother cared for him lovingly during his convalescence.[73]

His travels in Italy and his long stay in the company of Cézanne, who had been the first to recognize the symptoms of crisis in the Impressionist mode of vision and was at work on its disillusionment, contributed significantly to Renoir's heightened appreciation for the old masters. He began to give his images more definition, to allow the moment more time and to imbue his transitory impressions with a more lasting character. Without denying the achievements of Impressionism, he set himself the goal of establishing stricter guidelines for his compositions. An inclination towards the corporeal was to be given its due once again in the modulation of color (cat. nos. 67, 68, 70, 73–76). Renoir and Cézanne, the two outsiders so different from each other, discovered a certain affinity in the distance that now separated them from the somewhat time-worn Impressionism, a movement that had estranged them from the painting traditions upon which they now refocused their attention. Nevertheless, Renoir's delicately intoned landscape melodies, perceived through all the senses, continued to differ from the balanced symphonic compositions of the master of Aix. Cézanne achieved clarity through color, while Renoir used color to evoke the opposite effect. In Cézanne's view, working "sur le motif" represented a constant challenge to create a pictorial image; Renoir, on the other hand, saw it as an inexhaustible source of chromatic inspira-

71 Venturi 1939, I, p. 118; see Cézanne 1962, p. 194 and Vollard 1961, p. 65.

72 Florisoone 1938, p. 36.

73 The artist's son commented in detail about the friendship between Cézanne and Renoir: "Cézanne and Renoir loved each other dearly, but they had never made overt demonstrations of friendship. They barely even shook hands when they met. They addressed one another in the formal style. They could sit together for hours without speaking a word, completely content to enjoy each other's company The friendship between the two men lasted a lifetime. It even carried over to their children. Cézanne's son Paul was more than a friend to me; I always looked upon him as a brother. He died after the Germans took Paris" (Renoir 1981, pp. 325, 103).

tion. Although the two artists often painted the same motifs in L'Estaque or the countryside around Aix-en-Provence, Renoir's open, animated landscapes, in which their creator's impulsiveness was consistently given free rein, were worlds apart from Cézanne's self-contained, unpopulated scenes, whose strict regularity contributed to the development of an image of Provence that persists to the present day.

Renoir's intense interest in the Pompeiian wall decorations and in Raphael, Ingres and the ideas of Cézanne went hand in hand with a reexamination and rejection of his own past. Its target was a state of ease that threatened to give way to rigid routine. What followed were years of crisis, during which Renoir subjected himself to a degree of discipline naturally opposed to his lively temperament and innate pleasure in painting. Despite his great admiration for Rubens, for the *Dixhuitième* and for Delacroix, Renoir—particularly in his role as a portraitist—never lost sight of the importance of Ingres' example. It was Ingres' clearly drawn and thoroughly structured pictorial images from which he drew his greatest inspiration during the 1880s. Apparently he now felt the need for the same distance that Ingres, and later Degas, had established between themselves and their models in precisely delineated constellations. Renoir, who had previously employed the play of light or the random quality of pictorial detail to emphasize the transience of visual perceptions, now adopted a measured approach to form derived from an emphasis upon aspects of drawing and a plasticity achieved primarily through the use of light colors (cat. no. 71). In order to place vision upon a stable foundation once again, the relationships between bodies, lines and colors were carefully thought through, while the profiles of body outlines were rendered with greater clarity. Renoir's brushwork became smoother; his paint was applied in thinner layers and with greater attention to area; his colors took on a less opulent, more austere quality.

As time passed, Renoir grew increasingly critical of open-air painting. As early as 1883, he noted that studio work suited him better at his advanced age.[74] He later commented to Vollard: "The diversity of light is much greater outdoors than in the studio, where it is always the same; but outdoors you are completely taken in by the light; you have no time to concern yourself with composition; aside from that, you have no eye for what you're doing outdoors What is more, the painter working outside is, as I said, only looking for an effect; he ceases to compose and soon succumbs to monotony I had the good fortune to meet Corot personally; I told him how hard it is for me to work outdoors. 'Yes,' he answered, 'because you never know exactly what you've done when you're outdoors. You must always reexamine things in the studio.' Yet Corot painted nature more realistically than any 'Impressionist' ever managed to do! . . . So let us stop talking about the 'discoveries' of the Impressionists; the old masters were surely aware of these things as well, and if they put them to one side, then it was because all of the great artists have managed without effect. By simplifying nature, they made it all the greater."[75]

74 Ehrlich White 1984, p. 133.

75 Vollard 1961, pp. 71ff.

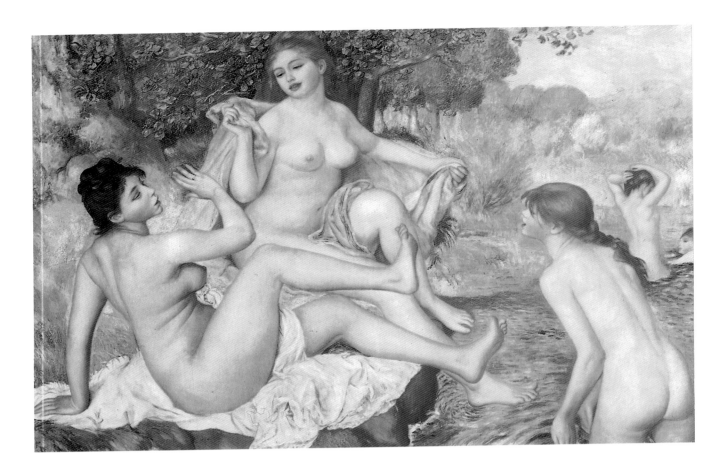

Renoir, *The Large Bathers*,
1887, Museum of Art,
Philadelphia

François Girardon,
Nymphs Bathing, 1668–1670,
fountain relief, Allée des
Marmousets, Versailles

VII

During the last decades of their lives, Renoir, Monet, Cézanne and Degas, aloof from the political and social problems of their times and untroubled by developments in technology and art, had created solitary refuges in which they sought to perfect themselves. Degas pursued this course in the isolated darkness of his Paris studio, Cézanne in the mountain setting of the Montagne Sainte Victoire, Monet among the splendid flowers in his garden in Giverny and Renoir in the lap of his family. Although unable to match the late style of his friends, which was to exert considerable influence in the future, he eventually did find the peace and inner contentment that enabled him to create a late œuvre in which his emphatic desire for harmony united a highly sensual concept of happiness with the full vigor and vitality of overflowing color.

The groundwork had been laid in the improvement in the market in early 1890 and his marriage to Aline Charigot on April 14 of the same year. Things continued to change for the better, permitting Renoir to present his situation in a favorable light in a letter to Bérard: "Painting would go wonderfully if I could work, but this dark weather makes it necessary to start all over the next day whatever you've done the day before I'm in demand again on the market and I worked a lot in the spring; if nothing happens to disturb my work, it will go like clockwork."[86] A letter to Durand-Ruel written from Tamaris-sur-Mer on March 5, 1891 has a similarly optimistic ring: "...I am working, I've got wonderful weather now, but I truly hope it holds, for everything is in motion. But nothing, with the exception of two studies, is finished. I put a lot of effort into progressing far enough so that I don't have to experiment. For four days now [?], I have been all of fifty years old, and it's a bit late to be searching at this age. Well, I do what I can; that is all I can tell you."[87]

The years of not always satisfactory compromise between improvisation and decoration were over. New impulses replaced Renoir's skeptical restraint. Even in old age, the now corpulent Renoir refused to abandon his affection for all that has grace and dignity in nature. Indeed, his work of the 1890s is characterized by even greater splendor. The artist sought to achieve harmony between the revitalized richness of his images and the boundless wealth of color. Dispensing with outlines, he once again shaped bodies with colors alone, and the proportional relationships of the masses on the canvas were their exclusive domain. Contours modeled with the finest of brushstrokes literally rounded out the volumes, creating full-bodied forms that often seemed on the verge of bursting at the seams.

The final breakthrough came in the years following 1892. In April 1883, Durand-Ruel had presented an extensive Renoir exhibition featuring 70 paintings (cat. no. 63). In May 1892 he organized a retrospective show with 110 paintings, including nearly all of the artist's major early works, an œuvre which clearly affirmed the triumph of Renoir's painting (cat. no. 78).[88] Shortly before, the French government had—

86 Ehrlich White 1984, p. 189.

87 Venturi 1939, I, p. 144.

88 Maurice Joyant, a confidant of Toulouse-Lautrec, appears also to have expressed interest in a Renoir exhibition. Pissarro mentions this in a letter dated December 14, 1891: "Joyant told me today that he would be coming to Eragny on Tuesday. In the course of our conversation he said . . . that he wanted to organize a comprehensive exhibition of Renoir, whose light he thinks Durand has hidden under a bushel, whereas he wanted to let it shine far and wide. Joyant asked me to say nothing about this to anyone. That will be a fine surprise for Durand!" (Pissarro 1953, p. 228).

strict, linear development of forms. His son Jean confirms the change in his living circumstances as well as in his art, which now, in a much more personal vein, focused almost exclusively upon family, children and women: "My mother gave my father a great deal: peace of soul, children whom he could paint and a reason not to go out in the evenings.' She made it possible for me to think. She had a talent for maintaining the routine around me that I needed in order to solve my problems.' . . . The birth of my brother Pierre was an earth-shaking event in Renoir's life (cat. nos. 77, 78). A dimple in the thigh of the newborn babe was enough to overshadow all the theories propounded in the 'Nouveau Athènes' [a Paris café and gathering place for artists in the late 1870s]. In response to this external stimulus he painted his son in a storm of enthusiasm and, always true to himself, transposed the tender, velvet skin of the scarcely shaped flesh in response to this external stimulus. And as he did so, Renoir began to rebuild his own inner world."[83]

It would take years, however, to make the new structure truly sound and to gain recognition on broad scale. On April 14, 1887, Pissarro reported to his son Lucien (1863–1944) that Renoir had allegedly destroyed everything he had painted during the preceding summer. On October 1, 1888, he wrote the following remarks to Lucien: "I had a long talk with Renoir. He confessed that everyone—Durand as well as the old collectors—were criticizing him and were unhappy with his attempts to find a way out of his romantic period. I got the impression that what we thought about his exhibition was very important to him. I told him that for us, the quest for simplicity was the goal for which every intelligent artist should strive, and that even if great mistakes were made, it was more intelligent and worthier of an artist [to pursue that goal] than to continue to follow in the footsteps of the romanticists. He has had no portrait commissions for some time!"[84] Full of doubts about his previous work, Renoir had written the following words as early as July 10, 1888, to the critic Claude Roger-Marx, who was involved in preparations for a presentation of 19th-century French painting at the 1889 World's Fair in Paris: "If you see M. Chocquet, I would greatly appreciate it if you would listen to nothing he says about me. I shall explain quite simply, as soon as I have the pleasure of meeting with you, why I think that everything I have done is bad and why it would be extremely embarrassing for me to have it exhibited."[85]

83 Renoir 1981, pp. 208f, 221.

84 Pissarro 1953, pp. 115, 147.

85 Roger-Marx 1937, p. 68.

want to move forward; but now he is interested in nothing but line. The figures separate from one another without any consideration of color values, and thus everything remains incomprehensible. Since Renoir has no talent for drawing and no longer commands the beautiful, instinctively felt tones of earlier years, there is no sense of relationship in his work."[79] In view of the negative responses of most critics to the product of many years of work in the studio and the accusation that he had destroyed what it had taken him so long to achieve, Renoir recognized that the project had failed. He was forced to admit that he had hardly succeeded in presenting viable alternatives for the exhausted state of Impressionism: "Having finally completed the *Bathers* after three years, the painting I regard as my most important work, I sent it to Georges Petit [1835–1900] for an exhibition. And the critics tore me apart mercilessly! This time they agreed, Huysmans [1848–1907] in particular, that I was a lost soul; some even accused me of laziness. And God knows how hard I worked!"[80]

As the decade of the 1880s progressed, Renoir's economic situation worsened. After his success in 1879, the hopes he had placed in the Salon exhibitions had come to nothing. His submissions of the following years were hung in unfavorable locations and hardly noticed at all. Collectors made no purchases of any kind for some time. Duret, Dollfus, Chocquet, Rivière (1855–1943), Meunier, Ephrussi and Deudon had bought nothing for years, and between 1880 and 1885 Hoschedé (1838–1890), Armand Grimpel, Louis Cahen d'Anvers and even Renoir's friends Charpentier, Caillebotte and Bérard ceased purchasing his works.[81] Durand-Ruel was similarly skeptical of Renoir's attempts to find a new orientation (cat. no. 78). In order to ensure that he would receive some money from Durand-Ruel, at least, the painter felt compelled to accommodate the art dealer's own ideas to an increasing extent. In a letter to Durand-Ruel written in the fall of 1885 from Essoyes, where he was staying with Aline Charigot and his son Pierre (1885–1952), born on March 23 of that year, he wrote: "I think you will be satisfied this time. I have taken up my old soft, light approach to painting once again and shall continue to practice it [cat. nos. 73–75] Nothing new will come of it, but it is a sequel to the paintings of the 18th century. I am not referring to the best of them. I simply wish to explain a little about my new and last painting style (like Fragonard's, though not as good) I do not presume to compare myself, please believe me, to an 18th-century master. But I must explain to you the direction my work is taking. Those who seem to have nothing to do with nature know more about it than we do."[82]

The birth of his son Pierre in 1885 represented a significant turning point in Renoir's life. Previously single and independent, he was now responsible for supporting a family. His financial troubles grew all the more worrisome. In an effort to come to grips with problems of life unconventional for him and to attract the interest of a new clientele for his works, the painter placed increasing emphasis on convention in the

79 Pissarro 1953, p. 119.

80 Vollard 1961, pp. 74f.

81 Ehrlich White 1984, p. 145.

82 Venturi 1939, I, pp. 131f.

The quest for new approaches to form and content led Renoir, Cézanne and Degas to comparable results. Having achieved a measure of distance from the principles of pure Impressionism, all three artists focused a great deal of attention on the nude during the 1880s, a motif they handled in a variety of ways in the motif of *Bathers* (cat. nos. 71–73). As a group, they de-emphasized the concrete character of Impressionist pictorial statements associated with specific times of the day, seasons or recognizable locations in favor of figure paintings devoid of reference to concrete reality, time or place, integrating the figures into neutral landscapes or—in Degas' case—anonymous interiors. If Renoir did not entirely succeed in imbuing his nudes with universality in accordance with classical models, it was because of his excessive concentration upon the vitality and vivaciousness he saw in the bodies and pretty faces of his Parisian models. No solution would be found for the resulting discrepancy, which was less of a problem for Cézanne and Degas, until Picasso offered a radical response in his *Demoiselles d'Avignon*, the epoch-making work that pushed content to the point of absurdity through the disintegration of form.

Around the middle of the decade, Renoir—mindful of the impossibility of perpetuating Impressionism as a style or developing it into a method as Neo-Impressionism—attempted a tentative summary of his experience in large-scale figure painting in the work *Grandes baigneuses* (ill. p. 46). The importance he attributed to this painting—an intricate figural composition based on a relief by Girardon (1628–1715, ill. p. 46)—is evident in the fact that he spent years completing it. His objective in undertaking the work was to achieve in a large canvas painting what he had been unable to accomplish as the author of monumental frescoes. Conceived in the studio and carefully composed from individual studies, Renoir's *Baigneuses* sacrifices spontaneity to the stringency of formal structure (cat. no. 71). While the loss may seem regrettable, we should take into account Renoir's desire—enter-tained by Cézanne and Degas as well—to reinvest the human image with a quality of the eternal, to remove it from the mass and to do full justice to its natural stature.

Renoir's *Grandes baigneuses* was presented to the Paris public at the *6e exposition internationale* sponsored by the Galerie Georges Petit in May 1887. Response to the work was equivocal. The hopeful artist wrote to Durand-Ruel on May 12: "'The exhibition at the Petit Gallery has opened and is not doing badly, people say.' . . . I think I have come a step forward in terms of public recognition, a small step, but at least that In short, the public seems to have developed a taste [for my work]. I may be wrong, but I am hearing that from all sides. But why now and not the other times?"[76] Even Monet had nothing but praise: "Renoir's *Baigneuses* is a magnificent creation, a work that will not be understood by everyone but certainly by many."[77] Of the younger artists, van Gogh (1853–1890) admired the "'clear, pure lines" of the paint-ing.[78] Pissarro, however, expressed a very different opinion on May 14, 1887: "'I think I understand what he is trying to do. It is very good to

76 Venturi 1939, I, p. 138.

77 Ibid., pp. 325f.

78 Rewald 1965, p. 324.

thanks to the intervention of Stéphane Mallarmé—purchased its first "Renoir" for the Musée du Luxembourg for 4,000 francs.[89] After the death of Gustave Caillebotte in the spring of 1894, the painter was actively involved as the executor of Caillebotte's will in organizing the bequest of his friend's singular collection of Impressionist paintings to the state. Already at the age of 28, Caillebotte, a wealthy bachelor who achieved success as both a boatbuilder and a painter, had written his will in November of 1876, bequeathing his entire collection to the state with the proviso that the paintings would one day be displayed in the Louvre. Appointed executor of the estate, Renoir now assumed the thankless task of persuading the government authorities to accept the unwelcome gift. After years of negotiating with the reluctant officials of the Musées Nationaux, he succeeded in having 38 of the total of 67 paintings and drawings, among them six of his own works, placed in the Musée du Luxembourg in February 1897. The current international reputation of the Musée d'Orsay is due in part to those museum officials. On February 18, 1897, almost thirty years after the birth of the Impressionist movement, Pissarro remarked: "Did I mention in my letter that the side wing of the Luxembourg Museum has been opened? It appears that a crowd of howling people gathered in front of the Impressionists (the Caillebotte bequest). By the way, it is a small, ugly, poorly lighted room with disgusting frames; the paintings are as poorly displayed as can be." On March 10, he added: "We should be satisfied with the quality of the paintings in the Caillebotte collection in the Luxembourg: Renoir's *Bal au Moulin de la Galette* is there, a masterpiece [ill. p. 158] I haven't had time to go there, but Degas told me about it. He thinks the collection is very good, although incomplete, and that Renoir's painting is wonderful. I'm sending you a few newspapers. *L'Eclair* has an interview with Gérôme [1824–1904]; the institute has lodged a protest with the Ministry of Culture. He speaks about Renoir and says that he [Renoir] cannot be mistaken for Renouard, who can draw and has talent! That beats everything! Gérôme is torn apart in the response of the *Temps*. The idiot has made a laughingstock of himself and the institute. It shouldn't bother us. All in all, they bash their heads together and we are on the right track."[90]

Relatively high prices were paid at the auctions of the collection of Théodore Duret on March 19, 1894, and of Count Armand Doria and the customs inspector Chocquet in May and July of 1899. Victor Chocquet had first appeared on the scene at the infamous Impressionist auction initiated by Renoir at the Hôtel Drouot in Paris in March 1875, where 20 Renoir paintings, along with other works, brought in the modest sum of 2,150 francs (cat. no. 21). In the following years Chocquet, a fervent admirer of Delacroix, assembled the most significant collection of the contemporary art of his time in the course of barely two decades. Chocquet was particularly

89 Ehrlich White 1984, p. 195.

90 Pissarro 1953, pp. 359ff.

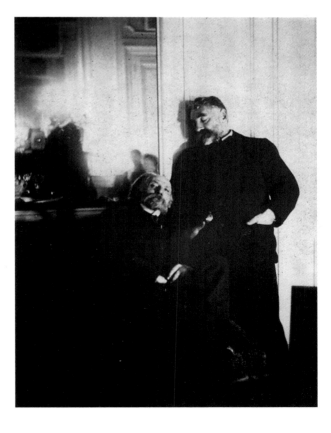

Renoir and Stéphane Mallarmé, photographed by Edgar Degas, 1895

attracted to Renoir, to whom he thankfully referred as "the miracle of my life," concurring with the latter in his esteem for the masters of the 18th century and for Delacroix and Cézanne. Their work was a major focus of the collector's passion. Chocquet possessed 35 paintings by Cezanne alone, along with 14 by Renoir, all from the period before 1880 (cat. no. 26). The breathtaking rise in prices during the 1890s is illustrated by the example of the portrait of Madame Charpentier and her children (ill. p. 39). The artist had received the respectable sum of 1,000 francs for the picture in 1878. At the Charpentier auction on April 11, 1907, the hammer fell at 84,000 francs, a bid that ensured the painting a prominent home in New York's Metropolitan Museum. At the time, this was the highest price ever paid for a painting by an Impressionist. Durand-Ruel's years of struggle to gain a foothold in America had finally been crowned with success, unleashing a veritable tidal wave of enthusiasm for Impressionism.

The joy of success was diminished, however, by the severe attacks of rheumatism that had plagued Renoir since 1898. He found himself forced to flee the unpleasant climate of Paris for increasing periods of time, journeying to the south—to Essoyes, his wife's home in the Champagne, to Aix-le-Bains, Grasse, Cannes or the Provence—to regain a measure of health. In the fall of 1908, Renoir moved with his family to Cagnes in the vicinity of Nice. There at Les Collettes, the country house he had designed himself, he spent most of his time until his death in 1919. The last two decades of his life were marked by the growing severity of his illness, which confined him to a wheelchair from 1910 on. His son's notes indicate that his eyesight, at least, did not abandon him: "His body became more rigid day by day. His crippled hands could no longer grasp anything. It has been said that we bound his brush to his hand. That is not quite true. Actually, his skin had grown so sensitive that it was rubbed raw by the handle of the brush. In order to avoid this unpleasant consequence, he would have someone place a piece of soft linen in his palm. His deformed fingers actually clamped fast around the brush rather than holding it. But to his last breath, his arm remained as firm as that of a young man, and his eyes were astonishingly sharp. I can still see him placing a small, white dot on the canvas, no larger than the head of a pin. This dot was to represent a reflection in his model's eye. Without a moment's hesitation, the brush shot out like a bullet from the rifle of a skilled marksman and hit its target. He never rested his arm anywhere, nor did he use a ruler to lay out proportions."[91]

Renoir retained his gallows humor in spite of his infirmity. In a letter to Georges Rivière of January 1903 he wrote: "I'm writing to you so that you don't send your doctor. I know myself. I wouldn't do anything he told me to do. People with characters like mine who contract illnesses keep them. Unless they disappear again on their own, angry because they aren't being treated."[92] In a letter to Durand-Ruel dated September 4, 1904, he added laconically: "What bothers me most at the

91 Renoir 1981, p. 404.

92 Graber 1943, p. 174.

Renoir at home, Boulevard de
Clichy, Paris, 1912

moment is that I can't sit for long, because of my thinness: 97 pounds. That is not fat. My bones press through the skin, and after a while I can't stand to sit any longer. But I still have a good appetite. Let us hope that it will help me put on some weight."[93]

When Durand-Ruel, himself 81 years of age, visited the painter in Cagnes in December 1912, he reported from Les Collettes that "Renoir is in the same sad condition, but still has, as always, astonishing will-power. He can neither walk nor get up from his armchair. He has to be carried everywhere by two people. Such torment! Yet he is always cheerful and happy when he can paint. He has already done several different things, and yesterday he painted an entire nude half-figure he had begun in the morning. It lacks a great deal of work, but it is wonderful!"[94]

Though increasingly restricted by his illness, Renoir did not permit even the slightest trace of his suffering or the despair it caused him to

93 Venturi 1939, I, p. 182.

94 Ibid., p. 107.

appear in his art. In its radiant youthfulness, it was his declaration of war upon the discontent brought on by the infirmities of age. Like no other painter after him besides Picasso, he resisted the loss of his creative powers by painting bodies full of vitality and sensuality (cat. nos. 85–88, 101). "His life was a long martyrdom," remarked Matisse. "He suffered for twenty years from the worst kind of rheumatism; the joints in his fingers were all immense, calloused, horribly distorted [And he still did] all his best work! . . . as his body dwindled, the soul in him seemed to grow stronger continually and express itself with more radiant ease."[95]

Secure in the comfort of his family, the aging painter distanced himself from the life of the big city and devoted himself to his faith in a timeless, transfigured existence in accord with the models of antiquity, the Venetians and Rubens. The greater the agony of his debilitating pain, the more unshakable his belief in the indestructible harmony of nature seemed to become. And while his crippled hands slowly turned to useless gout-ridden clumps, his eye focused all the more sharply on the splendid intensity of color. His completely stiffened fingers, barely able to hold a brush, swept with ever-increasing lightness across the canvas, bringing forth a finely woven fabric of color structures in delicate transparent tones. A light that spreads a sense of warmth and comfort radiates in bold, glowing contrasts. The surplus of a palette tending increasingly towards red is often balanced by a deep blue that reveals the immeasurable expanse of the southern skies. In all conceivable gradations of color volume—from a supple rosé to a more robust chord composed of red and reddish-yellow or a vigorous orange—color breaks the ties that bind it to objects now consolidated into corporeal masses and, heeding only its own laws, forms a shimmering, all-encompassing pattern. Depiction and depicted image, motif and the process of painting melt once again into a continuum of color (cat. nos. 99–101).

In all its problematic aspects, however, the act of painting itself is revealed as the artist's solitary monologue in his passionate attempt to come to grips with the object. Yet Renoir did not always resist the temptation to project the more congenial aspects of his natural disposition onto an art that occasionally left room for a rather ingratiating kind of charm. Faced with the temptations of the market and constant anxiety over his ability to support his family, now grown larger with the birth of his sons Jean and Claude (cat. nos. 93, 97) in 1894 and 1901, he feared that a loss of creative power would make it impossible for him to sustain the success he had achieved. Under the influence of these pressures, he did occasional "odd jobs" that certainly did little to bolster his reputation.[96] They were executed without appreciable structure, in submission to the decorative suppleness of the broad brushstrokes, as rather sugary odes to the beauty of the landscape or of fair womanhood. Perhaps the growing recognition Renoir now enjoyed both in France and abroad was so seductive that he found it impossible to entirely resist a certain dulling effect upon his art.

95 *Henri Matisse. The Early Years in Nice 1916–1930*, National Gallery of Art, Washington, 1986, p. 19.

96 These "odd jobs" were mentioned in a letter of April 25, 1901, addressed to Durand-Ruel. With regard to the auction of the collection of Abbé Gaugain on May 6: "I was too weak to resist the temptation to be untrue to you in favor of the Abbé on several occasions, although what I gave him you would have rejected and regarded as horrid, which it is, by the way. But if I were to sell only good things I would die of starvation, and then I also thought that he was going to keep these monstrosities for a while. He begged me for four years to give him a scene from the South. It was an order I refused to fill for a long time. Finally, I put together a *Palace of the Popes* [Avignon], and that is all. But I now have my fill of these art lovers and shall surely not allow myself to be 'softened-up' again" (Venturi 1939, I, pp. 166f.).

In response to a question posed by the American artist and critic Walter Pach (1883–1938), who published an article on Renoir in *Scribner's Magazine* in May 1912 with the assistance of Gertrude Stein (1874–1946), the painter had talked about his approach to his work: "I position my subject as I wish to have it. Then I begin, painting like a child. I want a red to resound like the clanging of a bell. If I do not succeed at first, then I take more red and other colors as well, until I've got it. But I am none the wiser. I have neither rules nor methods. Anyone can examine my material or watch me while I paint—he will soon see that I have no secrets. I observe a nude body; I see countless tiny spots of color. I have to find the ones that bring the flesh to life on my canvas and give it vibrancy. Nowadays, people want to have everything explained. But if a painting could be explained, it wouldn't be a work of art. Do you want me to tell you what I think are the two qualities that characterize true art? It must be indescribable and inimitable The work of art must captivate the viewer, wrapping itself around him and carrying him away. The artist expresses his passion in it; it is the current he sends out and with which he draws the viewer into his passion."[97]

Julius Meier-Graefe (1867–1935) published the first biography of Renoir in 1911, a work still regarded as foundational. Three years later, Meier-Graefe, a committed advocate of modern French art in Germany, made one last visit to Renoir in his Paris studio on the Boulevard Rochechouart 38bis.[98] His visit came only a day after the assassination of the Austrian crown prince in Sarajevo and thus at one of those moments in which the present shifts noticeably into the past. He found his host sunk down into his wheelchair. The haggard figure, his senses still keen, reminded Meier-Graefe of Titian's (1489–1576) portrait of Pope Paul III (1468–1549) as an old man in the company of his relatives, a painting exhibited in the museum in Naples. Asked what he thought about the assassination and its political impact, the aging artist answered briefly, his terse response lacking conviction. He was surely aware that the war that now seemed imminent would put an end to the carefree world in which he lived. Four long years later, as the last hopes lay in ruins, the severely ill Renoir, his strength rapidly waning, undertook a last journey to Paris only a few months before his death. On this occasion, his most fervent wish was to be taken in his wheelchair through the galleries of the Louvre, which were later restored after the war. He wanted to see, one last time, the masterpieces of Titian, Veronese (1528–1588) and Rubens, his lifetime companions.[99] His remarks in this context express the modesty of wisdom: "In truth, we are no longer capable of doing anything; we are totally helpless. When we look at the works of the old masters, we realize that we really have no reason to be conceited. And what wonderful artisans those people were! They were masters of their craft! And therein lies the secret! Painting is not for daydreamers. It is above all a craft, and a good craftsman must work at it. But everything has been turned upside down. Painters actually regard themselves as extraordinary beings; they

97 Pach 1958, p. 19.

98 Meier-Graefe 1929, p. 424.

99 Renoir 1981, p. 412.

delude themselves into thinking that they can change the face of the world by using blue instead of black. As for me, I have always resisted the role of the revolutionary; I have always believed, and still believe today, that I am only continuing what others before me have done much better than I."[100]

Pierre-Auguste Renoir died on December 3, 1919 in Cagnes. Upon hearing the news of his death several weeks later, Claude Monet, his oldest friend, wrote: "The poor soul has left us. It is a great loss for me, and my pain is deep"[101]

Marcel Proust conceived the following epilogue for his *À la recherche du temps perdu*: "There was a time when people recognised things quite easily when it was Fromentin [1820–1876] who had painted them, and could not recognise them at all when it was Renoir. People of taste tell us nowadays that Renoir is a great eighteenth-century painter. But in so saying they forget the element of Time, and that it took a great deal of time, even at the height of the nineteenth century, for Renoir to be hailed as a great artist. To succeed thus in gaining recognition, the original painter or the original writer proceeds on the lines of the oculist. The course of treatment they give us by their painting or by their prose is not always pleasant. When it is at an end the practitioner says to us: 'Now look!' And, lo and behold, the world . . . appears to us entirely different from the old world, but perfectly clear. Women pass in the street, different from those we formerly saw, because they are Renoirs, those Renoirs we persistently refused to see as women. The carriages, too, are Renoirs, and the water, and the sky; we feel tempted to go for a walk in the forest which is identical with the one which when we first saw it looked like anything in the world except a forest, like for instance a tapestry of innumerable hues but lacking precisely the hues peculiar to forests. Such is the new and perishable universe which has just been created. It will last until the next geological catastrophe is precipitated by a new painter or writer of original talent."[102]

100 André 1919, pp. 13f.; see also Vollard 1961, pp. 97f.

101 Venturi 1939, I, p. 455.

102 Marcel Proust, *In Search of Lost Time*, vol. III: *The Guermantes Way*, trans. C. K. Scott Moncrieff and Terence Kilmartin, New York 1993, pp. 445–446.

1 Portrait of Renoir's Mother 1860–1861
Portrait de la mère de Renoir

Oil on canvas
45 × 38 cm
Private collection
Daulte 1971, No. 1

Renoir, who openly professed his devotion to all that is "endearing and lovely"[1] and who specialized in the depiction of youth, began his career by painting the portrait of a careworn elderly woman upon whom the years of toil had clearly left their mark. It is the portrait of his mother, a painting undertaken by Renoir at the age of barely 20. Having completed the expressive head and face, he left the remainder of the work unfinished, although he kept it for the rest of his life. His heirs eventually sold the painting to Coco Chanel. That she, of all people, who shaped the ideal image of French womanhood for decades, found Renoir's youthful painting of an aging woman so fascinating is one of the many puzzles associated with this work.

In 1860, following his apprenticeship as a porcelain painter and a series of odd jobs as a decorative artist, Renoir resolved to acquire an academic education in art. In January of that year he was granted permission to copy paintings in the Musée du Louvre (cat. no. 3). In this, the first of his surviving works, however, there is no trace of the smooth precision of porcelain painting. Rather, the rough clarity of the portrait bespeaks the budding artist's desire to make his way without catering to the beautifying tastes of the time—in other words, to orient himself to Corbet's revolutionary realism. Without the latter, neither the emphatic starkness of the son's view of his mother nor the rough, vigorous brushwork would have been conceivable.

Only the alert, shining eyes suggest the actual age of the subject, who, although she appears much older to modern viewers, was only 53 at the time. For this reason the figure in the painting was once believed to have been the artist's grandmother, though the latter had died already in 1857. Renoir's mother, Marguerite Merlet (1807–1896), a seamstress from Saintes, had married the tailor Léonard Renoir of Limoges in 1828.

Pierre-Auguste Renoir was the sixth of seven children, two of whom died in infancy. The portrait was probably painted in the family's apartment at Rue d'Argenteuil 23, where the entire extended family resided until his parents moved to Voisins-Louveciennes in 1868. Madame Renoir remained there, living with her daughter Elisa Leray and her son Victor until her death.

1 André 1919, p. 30.

Provenance
The Renoir family, Cagnes and Paris; Coco Chanel, Paris

References
André 1931, No. 1, Ill. 1; Drucker 1944, Ill. 1; Daulte 1971, No. 1, ill., p. 418; Fezzi 1972, p. 89, No. 1, ill.; Daulte 1973, p. 14; ill.; Monneret 1990, p. 27, Ill. 8.

Exhibitions
Portraits contemporains, Galerie Drouin, Paris, 1941; *La vie familiale*, Galerie Charpentier, Paris, 1944, No. 113; Marseille 1963.

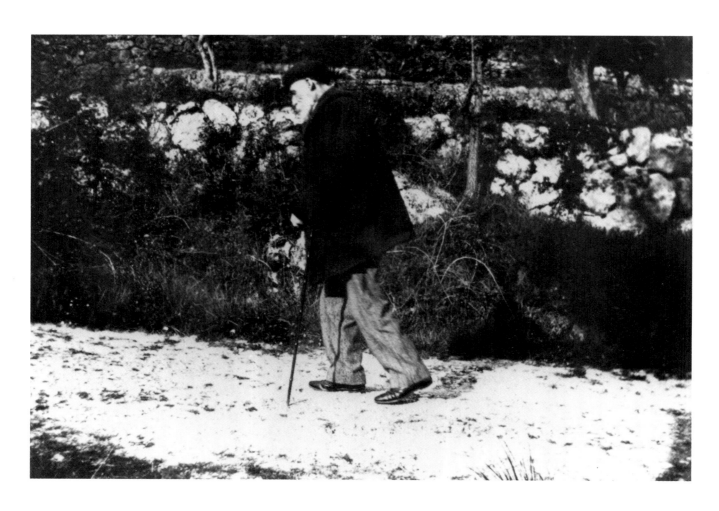

Renoir in Le Cannet,
1901–1902

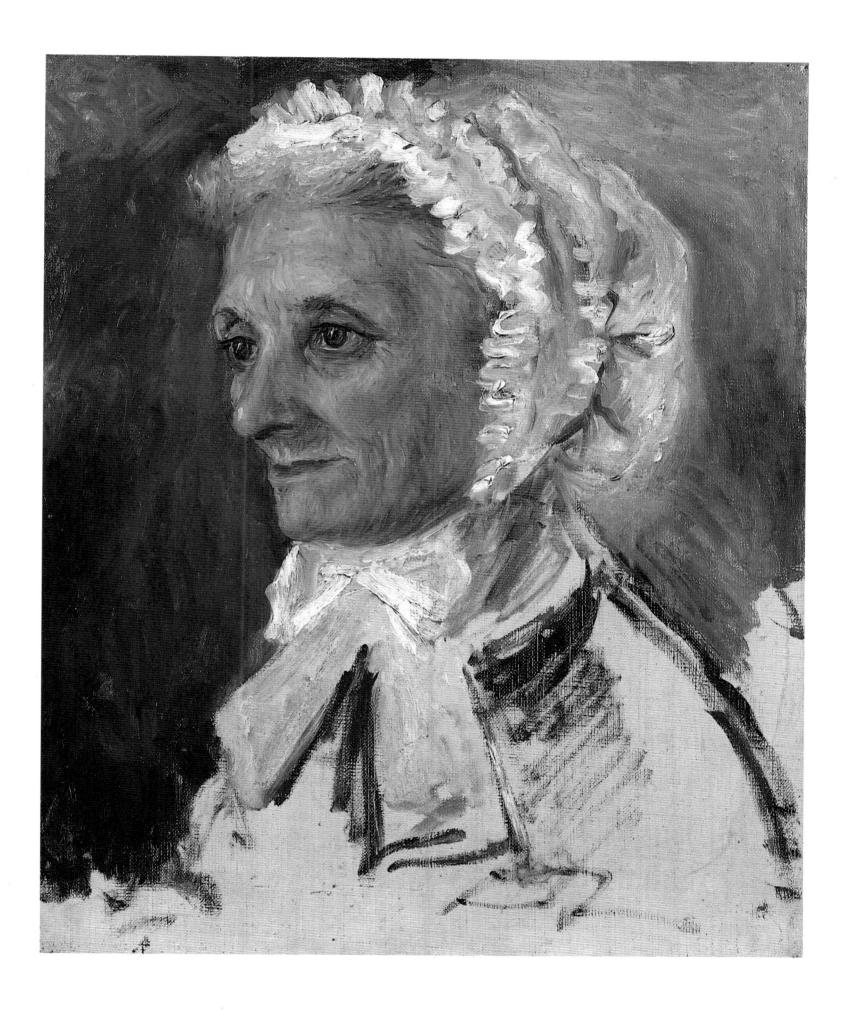

2 Gathering around a Boat 1862
Réunion autour d'un bateau

Oil on canvas
50.8 × 61 cm
Signed and dated, lower
right: A. Renoir 1862.
Maxwell Cummings,
Montreal, Canada

This summertime beach scene is one of the first paintings in which we recognize Renoir's progress towards maturity as an independent artist. The effective combination of seascape and genre scene clearly shows the artist's signature and date. Although still somewhat hesitantly, elements of content and style begin to emerge here in anticipation of the Impressionist tendencies that were to revolutionize 19th-century art only a few years later.

The painting shows a large group of young people, accompanied by several children and a dog, wading in the water or promenading along the sandy beach. A number of figures dressed in modest bathing suits or gathered-up dresses and skirts play merrily among the waves. A sailboat flying the tricolor French flag has come to shore to allow female passengers to disembark. The lowered sails reveal the view of a rapidly painted, cloud-filled sky which, together with the blue sea, provides the backdrop for the light-hearted activities.

Renoir made it clear that his intention was to capture a contemporary scene featuring fashionably dressed, youthful figures from his own generation, enjoying themselves in the sun, wind and water—an image that has little in common with the more sought-after history paintings of the time with their religious, mythological, allegorical or historical iconography. Whether and under what circumstances he experienced such a scene, preserved it in his memory and painted it from sketches in his studio cannot be determined. The significance of the result for him and his fellow artists in 1862, however, becomes apparent when we review the events of that year, a chronology influenced by the dictates of a strictly regimented course of academic studies. As in the two previous years, the student's application for permission to copy in the Louvre was approved on January 21, 1862 (cat. no. 3). Only a few weeks later, Renoir was admitted to the Ecole Impériale et Spéciale des Beaux-Arts. On April 18 he took an examination in perspective drawing, passing the test by correctly rendering several temple steps and the shaft of a Doric column. On August 16, the student Renoir was examined once again, this time being required to demonstrate his compositional skills in the treatment of a biblical theme.[1]

This dogmatic course of training was supplemented by instruction in the studio of Charles Gleyre, whose students worked from plaster casts and live models for a fee of ten francs per month. Gleyre, however, also encouraged his students to sketch outside the studio.[2] Enrolled as Gleyre's pupil since 1861, Renoir became acquainted with three new students in the fall of 1862: Frédéric Bazille of Montpellier, born in the same year as Renoir, the 22-year-old Claude Monet, a native of Le Havre, and Alfred Sisley, age 23, who had completed a commercial apprenticeship in London (cat. no. 5). The four young men soon

1 London–Paris–Boston
1985–1986, p. 295.

2 See *Charles Gleyre et la
Suisse romande*, Musée
historique, Lausanne 1994.

Renoir, *Calla and Hothouse Plants*, 1864, Sammlung Oskar Reinhart, Winterthur

4 Spring Flowers in a Hothouse 1864
Fleurs de printemps dans la serre

Oil on canvas
130 × 98.4 cm
Signed, lower right:
A. Renoir
Hamburger Kunsthalle
(Inv. no. 5027), Hamburg

Very early in his career, Renoir found ways to distinguish his work from the elegant products of the still-life specialists represented at the Salon, but also from the bravura of Manet and the tasteful, Dutch-inspired style of Fantin-Latour. Here, the sober eye of the realist has created a floral piece whose apparently random composition is particularly striking. At age 23, Renoir, who had debuted as a painter of histories at the 1864 Salon exhibition (cat. no. 5), found the inspiration for this masterful rendering of nature in the corner of a hothouse, where a variety of flowers in pots stood alongside a wooden crate full of young plants. In a left-to-right progression of smaller to larger flowers, the nearly life-sized objects are presented in a scarcely definable environment. A mullioned window emerges only as a vague shadow from the background. In contrast to the light-flooded ambiance of a hothouse, the background of the painting is rendered in dark, thinly-applied tones. Against it, the single tall calla, a solitary color accent, stands out as strikingly as the more expansive, delicate blue lilac, the alpine violets and hyacinths, the daisies and the tulips.

The common spring flowers in their simple containers counteract the monumentality suggested by the unusual size of this painting, a work once in the possession of Max Liebermann in Berlin. The artist deliberately avoided the kind of contrived arrangement that had become so popular during the Second Empire in favor of an unpretentious composition in which his own hand is not initially evident. Renoir captures a refreshing immediacy and a sense of natural objectivity in the sketchlike design and his unconventional choice of detail. In contrast, the decorative character of Monet's still lifes of the same period seems quite traditional.[1] A more elaborately detailed version of this everyday motif, also dated 1864, is found in the Oskar Reinhart collection in Winterthur, Switzerland (ill. p. 68).

1 Wildenstein 1974, No. 20.

Provenance

Auction, Hôtel Drouot, Paris, May 29, 1900, No. 17 (?); Max Liebermann, Berlin; Mrs. Kurt Riezler, née Liebermann, New York; Marianne Feilchenfeldt, Zurich; acquired in 1958.

References

Meier-Graefe 1929, p. 16; Dietrich Roskamp, "Erwerbungen der Gemäldegalerie im Jahre 1958," in *Jahrbuch der Hamburger Kunstsammlungen*, 4, 1959, pp. 149f.; Fezzi 1972, p. 89, No. 8A, ill.; Champa 1973, pp. 37, 41, ill. 13; Karl-Heinz and Annegret Janda, "Max Liebermann als Kunstsammler," in *Forschungen und Berichte der Staatlichen Museen zu Berlin*, 15, 1973, p. 144, No. 122; Keller 1987, pp. 18ff., ill. 12; Werner Hofmann, *Hamburger Kunsthalle*, Munich 1989, p. 99, ill. 202; Bade 1989, pp. 46f., ill.

Exhibitions

New York 1941, No. 2; Vevey 1956, No. 1, ill. ill.: *Verkannte Kunst*, Recklinghausen, Kunsthalle, 1957, No. 149; Munich 1958, No. 1; London–Paris–Boston 1985–1986, No. 3, ill., p. 199; Paris–New York 1994–1995, No. 168, p. 179.

Peter Paul Rubens,
*Hélène Fourment and her
Children*, ca. 1636,
Musée du Louvre, Paris

As an old man, Renoir alluded to his lifelong admiration for Rubens in remarks made to the art dealer Vollard. In connection with a visit to the Pinakothek in Munich in the summer of 1910, he stated with reference to the Rubens collection there: "By the way, we needn't be envious of anyone as far as Rubens is concerned, since we have *Hélène Fourment and her Children* in the Louvre. The skirt in that painting is white but full of dirt because of the stupid varnish. But it is one of a kind nevertheless. That's what I call painting! One can put everything imaginable and unimaginable on beautiful colors. Rubens— oh, he was a generous painter!"[3]

3 Vollard 1961, p. 81.

Provenance
Dr. Fritz Nathan, Zurich.

References
Bünemann 1959, p. 123; K. E. Maison, *Themes and Variations. Five Centuries of Master Copies and Interpretations*, London 1960, ill. 215; Daulte 1971, No. 8, ill.; Daulte 1973, p. 74, ill.; Callen 1978, p. 11; Ehrlich White 1984, pp. 13f., ill.; London–Paris–Boston 1985–1986, p. 264.

Exhibitions
Munich 1958, No. 3.

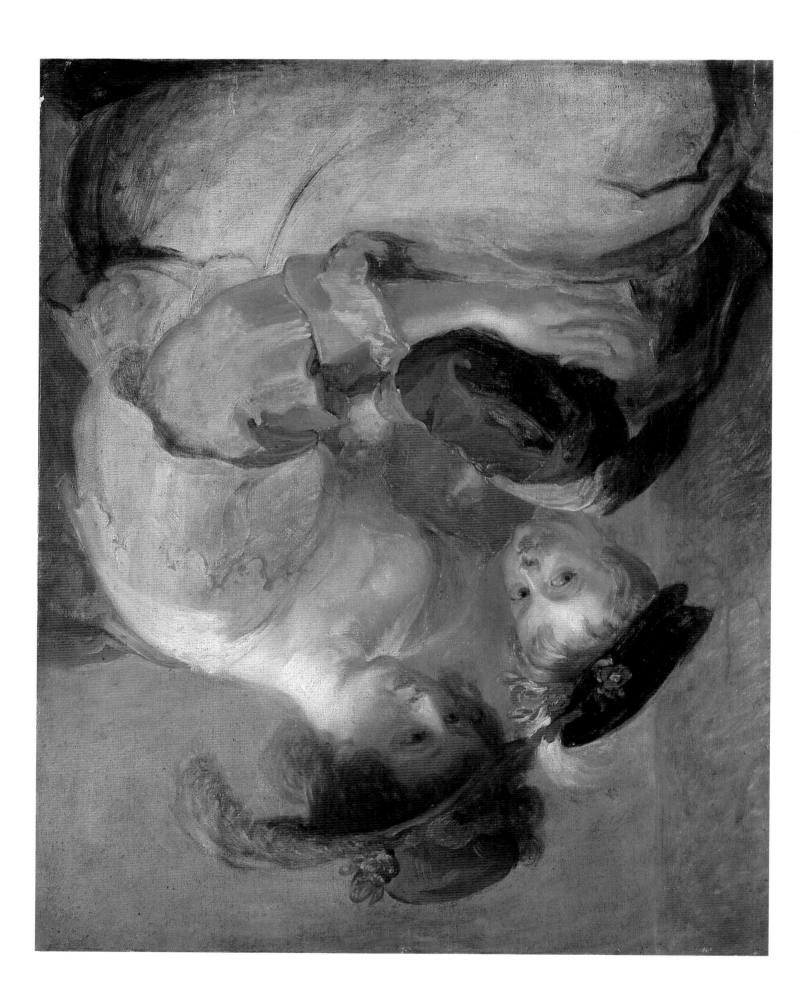

became friends and followed their mentor's advice to begin working on landscape motifs as well. Monet had already gained experience with open-air painting in Le Havre under the guidance of Eugène Boudin and the Dutch artist Johan Barthold Jongkind.

With his beach scene under a sky that could easily have been painted by Jongkind, Renoir far surpassed the early efforts of his fellow students. Indeed, he went far beyond anything he might have learned from Boudin or from Jongkind, a resident of Paris since 1860 whom Manet later referred to as the father of the modern landscape.

Provenance
Ambroise Vollard, Paris; Durand-Ruel, Paris; Alex Reid & Lefevre, London.

References
Vollard 1918, I, p. 8, No. 30, ill.; Ehrlich White 1984, pp. 16, 18, ill.; Monneret 1990, pp. 28f, ill.

Exhibitions
Chicago 1973, No. 1, ill.; New York 1974, No. 1, ill.

3 Copy after Rubens ca. 1863
Copie d'après Rubens

Oil on canvas
73 × 59.5 cm
Private collection
Daulte 1971, No. 8

Every year from 1860 to 1864, Renoir applied for permission to copy paintings in the Louvre.[1] Trained under the strict academic regimen of the Ecole des Beaux-Arts and in Charles Gleyre's studio, the young art student discovered in the works of Rubens a joyously sensual kind of painting whose vibrant coloration and openness accorded closely with his own interests. Two copies of paintings by the Flemish artist have survived: a theatrical mythological scene from the Medici cycle[2] and this detail from a portrait of Hélène Fourment and her children Claire and François, painted by Rubens in 1636 (ill. p. 66).

A remarkable feature of this copy is the manner in which Renoir adapted the model to suit his own interests by focusing attention on the intimate relationship between the mother and her son, born in 1633—a theme, by the way, that would continue to occupy him in later years as well (cat. nos. 77, 78). In order to achieve a "gallery tone" in keeping with the prevailing tastes of the time, he coated his copy of Rubens' portrait of his second wife with a thick, distorting layer of varnish, which was not removed until 1952.

1 London–Paris–Boston 1985-1986, p. 294.

2 Daulte 1971, No. 7.

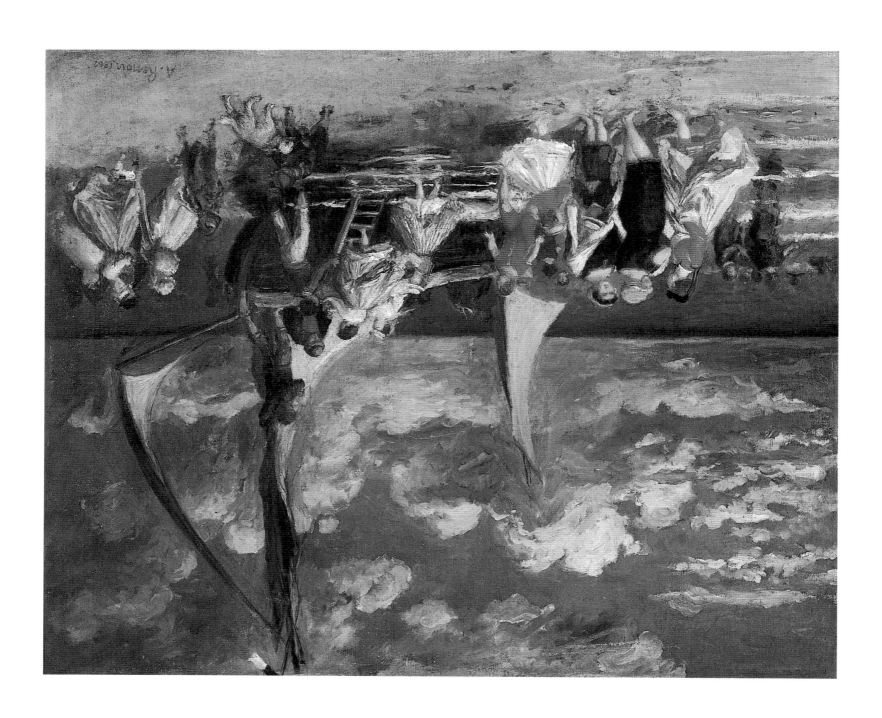

5 Portrait of the Painter Alfred Sisley 1864
Portrait du peintre Alfred Sisley

Oil on canvas
82 × 66 cm
Stiftung Sammlung
E. G. Bührle, Zurich
Daulte 1971, No. 37

Any artist who entertained hopes of earning a living as a painter in Paris during the latter half of the 19th century found it helpful to establish a reputation as a portraitist. Even Baudelaire remarked that people in general were passionately in love with their own images and tended to heap unqualified admiration upon the artists they selected to paint them.[1] Not least of all for this reason did the annual Salon exhibitions of current art, which attracted visitors by the hundreds of thousands and played a key role in ensuring an artist's success or failure, feature countless portraits. In 1868, Zola complained that the tide of portraits was rising year after year and threatened to flood the Salon, adding that paintings were purchased only by those who wished to have themselves immortalized in a portrait.[2] Ultimately, the versatile Salon virtuosos outlived their usefulness as portraitists, having achieved a virtually unsurpassable level of technical perfection and now finding themselves in competition with the new medium of photography.

For the budding portraitist, the path to success lay in the emulation of either Ingres or Franz Xaver Winterhalter, the industrious society painter of the Second Empire. Winterhalter's portraiture presented itself demonstratively to the outside world, making use of suitable props to underscore the social status of his clients. From the outset, however, Renoir adopted an approach to portraiture marked by a maximum of true-to-life objectivity in the style of Ingres, attempting at the same time to incorporate elements of his own subjective view. For this reason, one has the impression that Renoir painted primarily pictures of friends, people close to him whom he knew and trusted.

We do not know why this portrait of Alfred Sisley (1839–1899), one of Renoir's first major works, was neither signed nor dated by the artist. Although he was accustomed to adding dates and signatures, he presumably refrained from doing so in this case because the painting was intended for one of his closest friends, a man intimately familiar with his previous work. Clues with respect to the chronological placement of the work may be derived from a portrait of William Sisley, the painter's father, a work of identical format and very similar detail which bears the date 1864 (ill. p. 72).[3] It was shown at the Salon in 1865. Having introduced himself as a history painter to the Paris public and the jurors of the Salon the previous year with the painting *La Esmeralda*,[4] Renoir wanted to make himself known as a portraitist in 1865. His decision to abandon history painting in favor of portraiture was a fundamental one. Barely 23 years old, he had recognized at an early age that his real talent lay in the field of portrait painting. The two likenesses of the Sisley father and son masterfully demonstrate how right he was.

1 Baudelaire 1989, p. 184.

2 Jean-Pierre Leduc-Adine (ed.), Emile Zola, *Ecrits sur l'art*, Paris 1991, p. 192.

3 London–Paris–Boston 1985–1986, p. 189.

4 "My painting shows an 'Esmeralda' dancing around a fire with her goat. After the Salon I had no idea what to do with this huge piece, and so I destroyed my work. To a certain extent, that was also prompted by my anger over the bitumen color that had not yet completely disappeared from my palette" (Vollard 1961, p. 21).

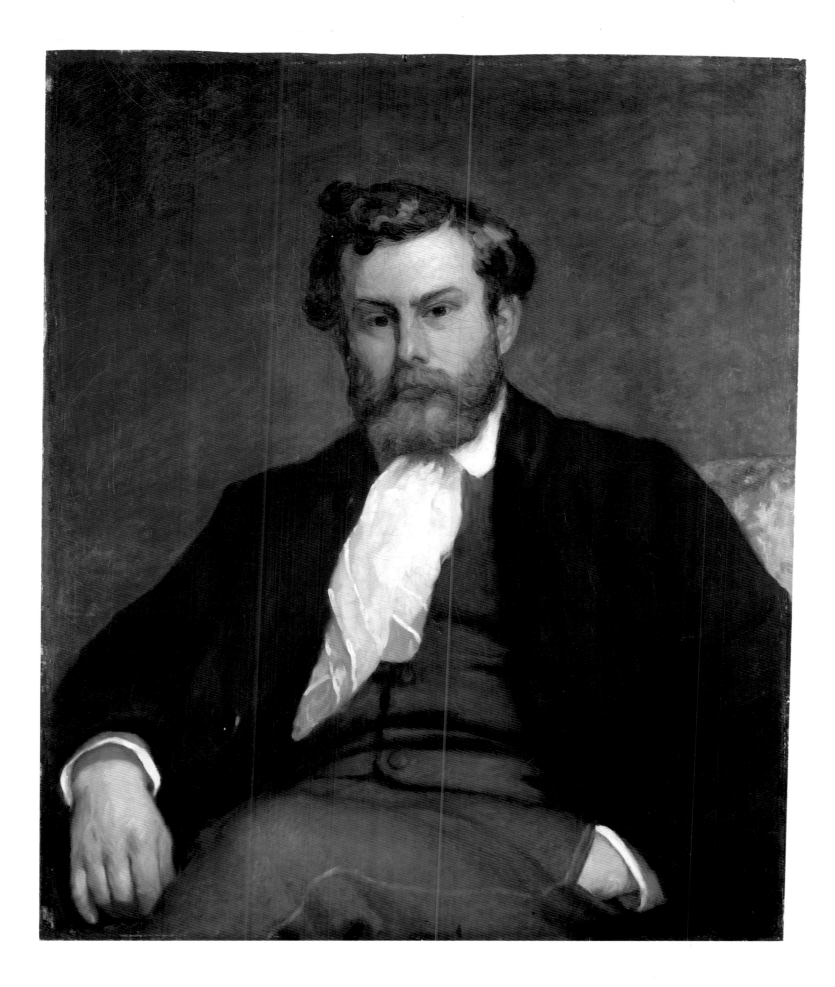

5 Four other portraits of Sisley were to follow by 1876. Daulte 1971, Nos. 20, 34, 117, 193.

6 Renoir took the latter approach in his genre-style group portrait of the friends entitled *Le cabaret de la mère Antony.* Daulte 1971, No. 20.

The son of English parents, Alfred Sisley was born in Paris, where his father and grandfather had established themselves as merchants. Following a business apprenticeship in London, he returned to Paris in 1862, determined, with the support of his understanding parents, to become an artist. Enrolled as a student at the Ecole des Beaux-Arts since 1862, he became acquainted with Renoir, Monet and Bazille at Charles Gleyre's studio in October of the same year.

Until 1871, the year his parents lost their fortune in the aftermath of the Franco-Prussian War, Sisley was able to provide support for Renoir, whose own resources were meager, by obtaining portrait commissions for him. Thus it is no surprise that Renoir's first portrait of his friend[5] presents him in his role as a bourgeois patron rather than as a fellow painter and member of a rebellious community of artist-bohemians.[6] Dressed impeccably as a gentleman (who retained his English citizenship though he lived in France), Sisley—who looks more settled here than the typical 25-year-old—could easily be taken for a man who had already climbed the first rungs of the ladder to success as a businessman or a banker. With legs crossed and his hand in the pocket of his trousers, he has made himself comfortable on a seat of some kind, its vivid floral upholstery visible in a detail on the right. His earnest gaze is fixed upon the viewer. The painterly rendering of the head suggests the influence of Courbet, while the composition of the painting, in keeping with the classical dictates of the golden section, and the nobly restrained coloration are more reminiscent of earlier works by Ingres or Fantin-Latour, whom Renoir had first met in 1862. Renoir's color scheme relies heavily upon cool gray tones alongside the blue-streaked white of the shirt and neckerchief and the dominant black of the jacket.

Renoir, *William Sisley*, 1864, Musée d'Orsay, Paris

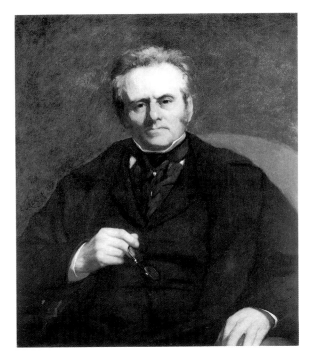

Provenance
Alfred Sisley, Paris and Moret-sur-Loing; Jeanne Sisley, Paris; Henri Lapauze, Paris; Charles Pomaret, Paris; Paul Brame and César de Hauke, Paris; Emil Georg Bührle, Zurich; acquired in 1955.

References
Meier-Graefe 1911, p. 19, ill.; Meier-Graefe 1912, p. 15, ill.; Duret 1924, p. 72; Coquiot 1925, p. 224; Meier-Graefe 1929, pp. 23, 26, Ill. 10; Roger-Marx 1937, Ill. 15; Florisoone 1937, p. 33, ill.; Drucker 1944, p. 193; Jedlicka 1947, Ill. 7; Chamson 1949, Ill. 7; Schneider 1957, p. 31, ill.; Robida 1958, Ill. XXI; Cooper 1959, p. 168; Daulte 1971, No. 37, ill., p. 419; Fezzi 1972, p. 90, No. 24, ill.; Reidemeister 1973, pp. 160f.; London–Paris–Boston 1985–1986, p. 189; Keller 1987, pp. 32, 34, Ill. 25.

Exhibitions
Paris 1907, No. 1; Paris 1907/1908, No. 106; St. Petersburg 1912, No. 539; *Alfred Sisley*, Georges Petit, Paris, 1917, No. A; Paris 1917, No. 51; Paris 1933, No. 5; Paris 1937, No. 392; Paris 1938, No. 10; *Alfred Sisley*, Kunstmuseum, Berne 1958, No. 99, ill. frontispiece; Zurich 1958, No. 166, Ill. 48; Berlin 1958, No. 9; Munich 1958/1959, No. 129; Edinburgh–London 1961, No. 47; Washington–Montreal–Yokohama–London 1990–1991, No. 49, ill.

6 Portrait of Marie-Zélie Laporte 1864
Portrait de Marie-Zélie Laporte

Marie-Zèlie Laporte (1847–1922) was the sister of Emile Henri Laporte, who like Renoir was born in 1841 and died in 1919. The two friends had attended a drawing course together at the Ecole gratuite de dessin et d'arts décoratifs in the Rue des Petits-Carreaux, joined Charles Gleyre's studio together and together passed the qualifying examination for admission to the Ecole Impérial et Spéciale des Beaux-Arts in April of 1862. The penniless Renoir was a frequent guest of Laporte's parents, who lived at the Place Dauphine. Presumably it was there that he painted his friend's portrait[1] and that of his sister.[2] Aside from the Sisley portraits (cat. no. 5), these two paintings were the first commissions arranged for him by fellow students.

According to family legend, Renoir had asked for the hand of 17-year-old Marie-Zélie in marriage, but was rejected because her parents hoped to find a more suitable match for their daughter.[3] This may explain the sober composition of the half-length portrait, its subdued coloration and the transformation of the original decolleté—still visible to the naked eye—into a modest dress closed at the throat and adorned with a black velvet ribbon. The few weaknesses of the portrait—the posture of the arms and the somewhat awkward additions of black lace to the sleeves,[4] for example—are offset by the finely painted head and the beautiful, full face.

Oil on canvas
61 x 50.5 cm
Musée Municipal de l'Evêché (Inv. no. P. 436), Limoges
Daulte 1971, No. 10

1 Daulte 1971, No. 9. See Vollard 1961, pp. 19f.

2 Véronique Notin, "Le portrait de Marie-Zélie Laporte," in *Bulletin de la société archéologique et historique du Limousin*, t. CXX, April 1992, pp. 202ff.

3 Mademoiselle Laporte married Gustave Peignot on January 11, 1865.

4 Undulating lines applied in a similarly amateurish fashion are also found on the dress of *Romaine Lacaux*, a portrait dated 1864 (Daulte 1971, No. 12).

Provenance
Marie-Zélie Peignot, née Laporte, Paris; M. Payet, Saint-Cloud; acquired in 1991.

References
J. Tuleu, *Souvenirs de famille*, Paris 1915, p. 34, ill.; Graber 1943, p. 25; Perruchot 1964, p. 28; Daulte 1971, No. 10, ill., p. 414; Monneret 1990, p. 6; François Daulte, "Un portrait de Renoir entre au musée municipal," in *L'Oeil*, 437, December 1991, p. 92; Véronique Notin, "Le portrait de Marie-Zélie Laporte, une œuvre de Renoir au Musée Municipal de l'Evêché de Limoges," in *Bulletin de la société archéologique et historique du Limousin*, t. CXX, April 1992, pp. 202ff., Ill. 1.

Exhibitions
Paris 1938, No. 39; Tokyo–Kyoto 1979, No. 2, ill.; Brisbane–Melbourne–Sidney 1994–1995, No. 2, ill.

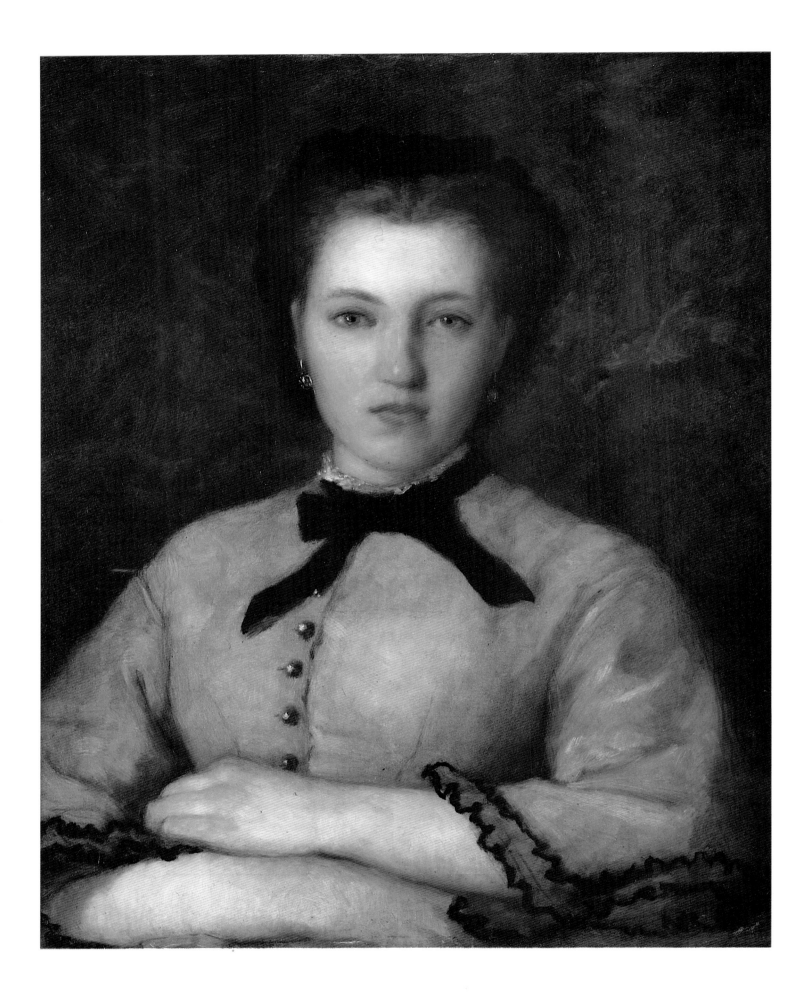

The Painter Jules Le Cœur with his Dogs in Fontainebleau Forest 1866
Le peintre Jules Le Cœur et ses chiens dans la forêt de Fontainebleau

Nine years older than Renoir, Jules Le Cœur (1832–1882), the son of wealthy parents and an architect who abandoned his profession to become a painter after the death of his wife in 1863, was one of Renoir's closest friends and supporters in these early years (cat. nos. 11, 14). The two had probably been introduced by Sisley (cat. no. 5) in 1864. From April 1865 on, Renoir was a frequent guest at Le Cœur's home in Bourron-Marlotte on the southern edge of the Fontainebleau forest.[1] It was there that he met Lise Tréhot, the 17-year-old sister of Clémence Tréhot, his host's common-law wife (cat. nos. 8–10).[2]

From a letter written by Le Cœur, we learn that Renoir, Sisley and he strolled through the Fontainebleau forest in February 1866 in search of suitable motifs.[3] Just such a walk through the forest in the summer or fall of the same year may have inspired this forest landscape with figures. The large size of the painting suggests that it was probably not executed in front of the motif, but painted from sketches in Le Cœur's studio in Marlotte. It then remained in Le Cœur's possession for some time.

In no other painting did Renoir follow Courbet's example so closely. The coloration, tonal values and patterns of light breaking through the thick vegetation are clearly reminiscent of Courbet's realistic approach to landscape. Pissarro, Cézanne and even Renoir, moreover, shared Courbet's preference for the application of paint with the palette knife. Renoir had Courbet's forest landscapes with hunters in mind when he conceived this painting and asked his friend to pose for him with his right foot resting on a fallen tree trunk. A smaller detail from the same landscape, but without the figure,[4] supports the presumption that the artist later added the figure to the final version at his friend's request or as a token of gratitude to Le Cœur.

Although the relationship between the figure and the natural surroundings has a somewhat staged appearance, this painting is Renoir's first great landscape composition. It is an homage both to the forest environment where he had discovered nature in all its diversity and to Le Cœur, who supported him so generously.

In a letter written by Jules Le Cœur's sister Marie, we read that when Renoir submitted two other landscapes painted near Marlotte to the Salon jury in 1866, he met with little success, despite the favorable votes of the jurors Corot and Daubigny: "Poor Renoir has been rejected. Just imagine—he had painted two pictures: a landscape with two figures—everyone says that they are good, that they have deficiencies but strength as well—and the other one he painted near Marlotte in a mat-

Oil on canvas
106 × 80 cm
Signed and dated, lower right: A. Renoir 1866
Museu de Arte de São Paulo
Assis Chateaubriand, São Paulo
Daulte 1971, No. 27

1 "Marlotte consisted of a few farms arranged loosely around the intersection of the roads from Fontainebleau and Montigny to Bourron. Renoir and his companions often painted here. Their appreciation of the poetry of reality grew stronger in Marlotte, to the extent that it could be any stronger, and so did their determination to paint only from nature. At that time, however, none of them had crossed the threshold to Impressionism. Many memories, traditions still stood between them and nature . . . Renoir and his friends had only recently discovered that the world in its everyday garb is a never-ending fairy tale. 'Give me an apple tree in a suburban garden; that is quite enough! I have no need for Niagara Falls!' Nevertheless, my father admitted that they were as deeply affected by the theatrical aspects of the forest as their contemporaries Behind the gratuitous effect of the sunlight falling through the leaves they discovered the real essence of light." Renoir 1981, pp. 112ff.

2 Cooper 1959, pp. 163ff.,
322ff.

3 Munich 1989, p. 98.

4 Fezzi 1972, pp. 89f., No. 10,
ill.

5 Venturi 1939, I, p. 30.

ter of two weeks Since no one could tell him whether he had been accepted or rejected, he went there on Friday and waited at the exhibition exit for some of the jurors to come out, and when he saw Messrs. Corot and Daubigny (two well-known landscape painters) he asked them whether the paintings of Renoir, a friend of his, had been accepted. Daubigny then recalled the work and described Renoir's painting, saying, 'We're very sorry for your friend, but his painting was rejected. We did all we could to prevent it; we begged ten times over to have the painting reconsidered, but we could not get it accepted; what should we have done? Only six of us voted against all of the others in favor of the painting. Tell your friend that he mustn't be discouraged. There are great qualities in his paintings; he should draw up a petition and request an exhibition of rejected paintings.' Thus in his misfortune he at least had the comfort of encouragement from two artists whose talent he admired."[5]

Provenance
Jules Le Cœur, Paris; Paul Cassirer, Berlin; M. Kuthe, Berlin; Auction *Kuthe*, Berlin, December 2, 1911, No. 47; Georg Hirth, Munich; Auction, Düsseldorf, November 12, 1932, No. 142; Knoedler, New York; Francisco de Assis Chateaubriand, São Paulo; acquired in 1958.

References
Vollard 1918, I, p. 123, No. 488, ill.; Vollard 1919, p. 32; Vollard 1924, p. 25; Duret 1924, p. 23; Meier-Graefe 1929, pp. 17, 22, 38; Graber 1943, p. 30; Rouart 1954, p. 22; Cooper 1959, pp. 163, 325, 328; Bünemann 1959, pp. 35f., ill.; Vollard 1961, p. 24; Perruchot 1964, p. 46; Daulte 1971, No. 27, ill., p. 415; Fezzi 1972, pp. 89f, No. 11, ill.; Champa 1973, pp. 40f., 44, Ill. 57; Wheldon 1975, pp. 18f., 21, Ill. 8; Gauthier 1977, p. 17; Callen 1978, pp. 7, 40f., ill.; Ehrlich White 1984, p. 21, ill.; Rouart 1985, pp. 10, 14, ill.; Monneret 1990, pp. 148, 156, No. 5, ill.; Distel 1990, p. 11.

Exhibitions
Berlin 1925, No. 45; *Sammlungen eines rheinischen Kunstfreundes*, Kunstverein, Düsseldorf, 1932; *Old Masters of Modern Art*, the Memorial Art Gallery, Rochester, 1944; *Exhibition of Impressionism*, Proctor Institute, Utica, 1947, No. 8; London–Paris–Boston, 1985–1986, No. 4, ill., pp. 11, 179; Munich 1989, pp. 96ff., ill.; *The Rise of Landscape Painting in France. Corot to Monet*, Currier Gallery of Art, Manchester–IBM Gallery, New York–Museum of Art, Dallas–High Museum of Art, Atlanta, 1991–1992 (cat. ed. Kermit S. Champa), No. 101; Paris–New York 1994–1995, No. 171, Ill. 90, p. 70.

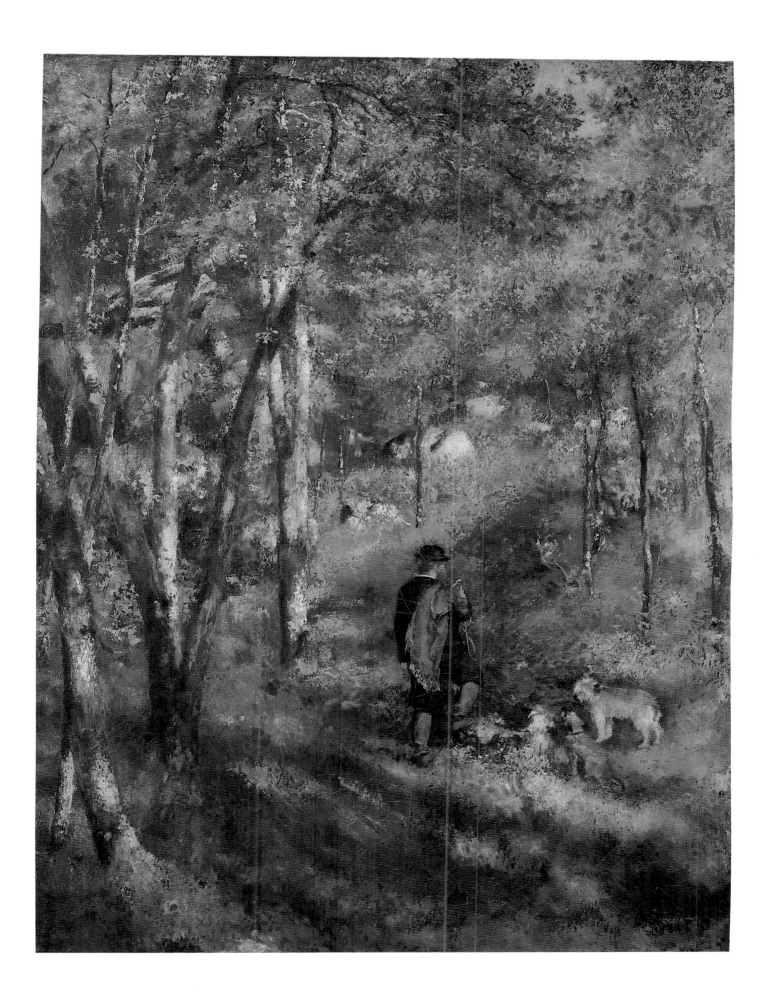

8 In the Summer, Study 1868
En été, étude

Oil on canvas
85 × 59 cm
Signed and dated, lower
left: Renoir.
Staatliche Museen zu
Berlin, Nationalgalerie
(Inv. No. A I 1014), Berlin
Daulte 1971, No. 33

Although the title of the painting and the placement of the model in front of a leafy background flecked with light suggest an experiment in open-air painting, the overall effect is that of a studio composition. The young woman's deliberately natural pose, the carelessly draped clothing and the long, tumbling locks of hair are in keeping with studio conventions in vogue since Courbet's time and which had also been appropriated by photography. The diffuse light establishes no link between the figure and its surroundings. The leaves, rendered in schematic brushstrokes, are no more than a stylized, ornamental screen. The back of the chair and a balustrade whose function is unclear separate the figure even more clearly from the artificial natural background.

Despite these limitations, the artist achieved a degree of realism which, within a confined space, expresses the physical presence of the subject in a particularly compelling manner. The young woman's facial expression and fixed gaze suggest the strain of hours of posing. The loosely falling hair, bound by a red ribbon, the slightly inclined head, the sloping shoulders, the position of the arms and hands and the decorative striped pattern of the skirt—its red complementing the green in the upper half of the painting—all contribute to the impression of an exhausted body literally pulled downward by hours of sitting.

Renoir's model was Lise Tréhot (1848–1922), daughter of the postmaster of Ecquevilly. Renoir had a close relationship with her from 1866 to 1871. Jules Le Cœur, who lived with Lise's older sister Clémence, had introduced them in late 1865 or early 1866 (cat. no. 7). The relationship came to an end when Lise married the architect Georges Brière de l'Isle in April 1872.[1] Renoir is believed to have immortalized her in 25 paintings, as a contemporary figure or a mythological adaptation, as a nude or an odalisque, in the open air or indoors (cat. nos. 9, 10).[2]

Although the artist's first full-figure portrait of Lise with a parasol was well received at the 1868 Salon exhibition,[3] this painting, submitted under the title *En été, étude* in 1869, attracted little positive attention, despite his deliberate effort to conform to convention and appeal to the jury's voyeuristic inclinations. Presumably for the same reason, the painting was one of the first to find a buyer. In the spring of 1873, a paint dealer in the Rue La Bruyère sold it to the cognac producer and art critic Théodore Duret for 400 francs. Duret later remarked that he had been captivated by the young girl's charm and the quality of the painting itself.[4]

Thanks to the commitment of Hugo von Tschudi, director of the Nationalgalerie in Berlin, to modern French art in the face of stubborn resistance on the part of the German emperor, the painting was admitted to the collection of the Nationalgalerie along with another work by

1 Cooper 1959, pp. 163ff., 322ff.

2 Daulte 1971, Nos. 15, 16, 21–25, 29–35, 45, 48, 51, 54, 57–60, 65, 83, 88.

3 Ibid., No. 29.

4 Duret 1924, p. 14.

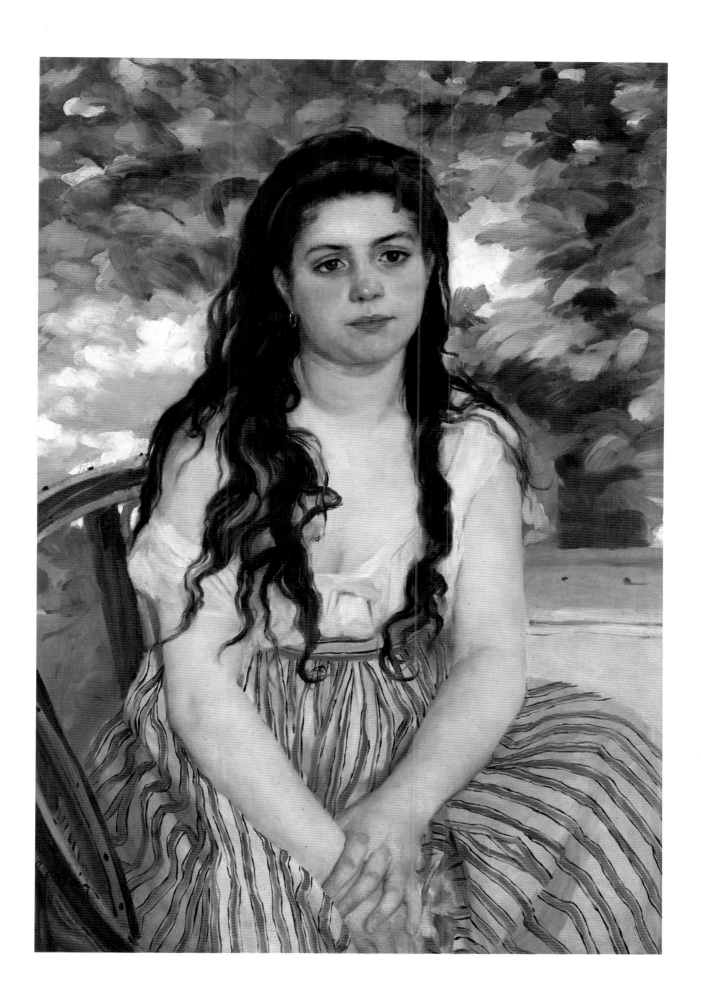

Renoir in the fall of 1906.[5] Tschudi had acquired Renoir's *Children's Afternoon in Wargemont* (cat. no. 70) in 1905. Aside from a double portrait purchased by the French government in 1892 for the Musée du Luxembourg, these were the first paintings by Renoir to find their place in a museum setting. Museums in Frankfurt am Main and Bremen followed Berlin's example only a few years later (cat. no. 59).

5 Paul 1993, pp. 195, 370, No. 78.

Provenance
Théodore Duret, Paris; Félix-François Depeaux, Rouen; Auction *Depeaux*, Georges Petit, Paris, May 31 and June 1, 1906, No. 40; Durand-Ruel and Bernheim-Jeune, Paris; Paul Rosenberg, Paris; Paul Cassirer, Berlin; acquired in 1906 by Hugo von Tschudi through a donation by Mathilde Kappel.

References
Duret 1906, p. 283; Meier-Graefe 1911, pp. 10, 34, 62; Meier-Graefe 1912, pp. 6, 30ff.; Duret 1924, p. 14, Ill. 3, pp. 23, 33, 78; Coquiot 1925, p. 177; Meier-Graefe 1929, pp. 22, 50; Barnes-de Mazia 1935, pp. 48, 113, 229, 380f., 443, No. 11, ill.; Venturi 1939, I, p. 31; Graber 1943, pp. 35, 42, 183, ill. pp. 36–37; Drucker 1944, p. 30, Ill. 10, pp. 182, 193, 220; Chamson 1949, Ill. 4; Cooper 1959, p. 168, Ill. 11; Bünemann 1959, pp. 32f., ill.; Perruchot 1964, pp. 59, 86; Rewald 1965, Ill. 73; Daulte 1971, No. 33, ill. p. 419; Fezzi 1972, p. 91, No. 31, ill.; Daulte 1973, p. 16, ill. p. 20; Champa 1973, pp. 40, 53ff, Ill. 74; Wheldon 1975, pp. 27, 30, 33, Ill. 15; Callen 1978, p. 33, Ill. 11; Ehrlich White 1984, pp. 30, 33, ill. p. 45, p. 96; Keller 1987, p. 24, Ill. 17, p. 31; Monneret 1990, pp. 10, 32f., ill.; Distel 1990, p. 59; Paul 1993, pp. 195, 370f., No. 78, ill.; Brisbane–Melbourne–Sidney 1994–1995, pp. 45f., ill., p. 48.

Exhibitions
Salon de 1869, Palais de l'Industrie, Paris, 1869, No. 2021; *Centennale de l'art français*, Grand Palais, Paris, 1900, No. 555 (?); *Impressionnistes et romantiques français dans les musées allemands*, Musée de l'Orangerie, Paris, 1951, No. 74, ill.; London–Paris–Boston 1985–1986, No. 8, ill., pp. 20. 23, 25, 31, 180, 190, 193, 199; Paris–New York 1994–1995, No. 174, Ill. 246, pp. 141, 201, 457.

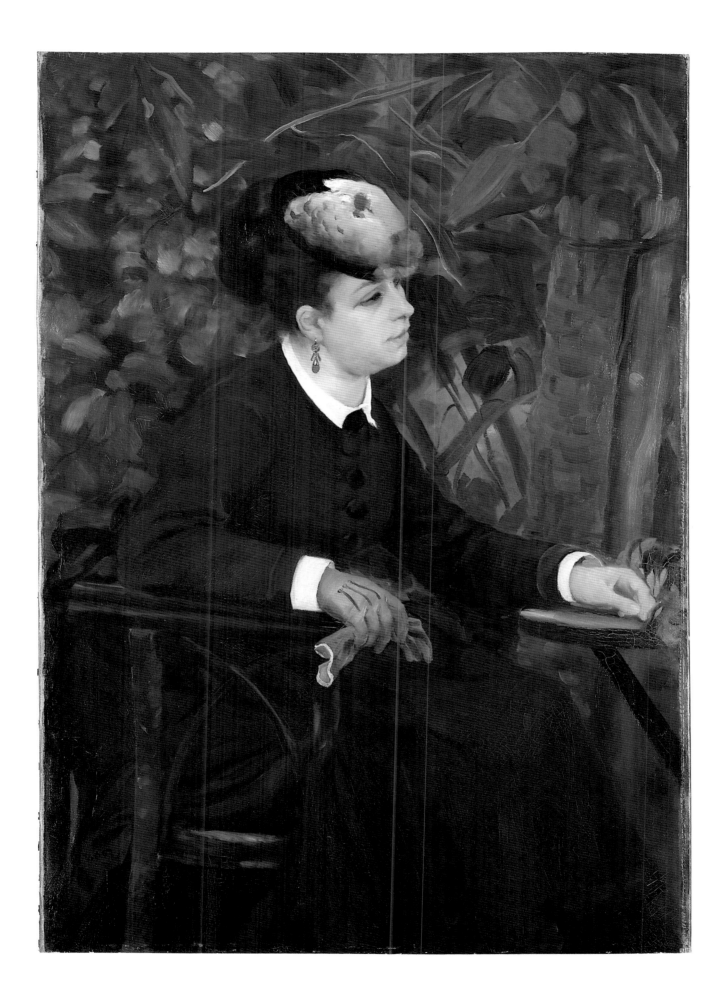

9 Lady with a Gull Hat 1868–1869
La femme à la mouette

Oil on canvas
106 × 73 cm
Signed and dated, lower
left: Renoir.
Öffentliche Kunstsammlung,
Basle, Kunstmuseum
Daulte 1971, No. 83

In this portrait of Lise Tréhot, the intimate character of the preceding painting (cat. no. 8) is given an official air. What Renoir had explored in the "study" was rendered in a more dignified form here. Working from the same basic elements—the figure posed on a chair against an artificial background of leaves—the artist now gave the representation a new orientation in the fashionable clothing, the more stately posture and the larger format of the work. The somewhat disheveled-looking, girlish artist's favorite was transformed into a well-situated upper-middle-class woman in her Sunday attire. With an air of self-assurance, she wears a high-necked, dark-blue dress, mustard-yellow gloves and a small hat decorated with bluish-gray gull feathers perched low on her forehead. Leaning slightly forward with bent arms supported, Lise Tréhot sits at ease at a small table.

The composition, with the subject posed in front of a background of artificial nature, might easily have been arranged by a photographer of the day were it not for the impressively large size of the painting, the generous coloration and the highly expressive head which, devoid of beautifying embellishments and facing toward the right, appears to be gazing at a companion we cannot see. Many people, from the German art expert and author Julius Meier-Graefe, who made a name for himself as one of the first interpreters of French Impressionism and gave this painting its title, to François Daulte, have dated the work to the year 1872, by which time Henri Rouart had already acquired it from Renoir. The renowned collector, a friend of Degas, was one of the first purchasers of Renoir's work from outside the circle of friends who commissioned occasional pieces (cat. nos. 5–7, 11, 13). Aside from the fact that Renoir's approach to portraiture had taken on unmistakable Impressionist characteristics by 1872 (cat. nos. 17, 18) and that his relationship with Lise had already ended early that year, there is also stylistic evidence—such as the obvious adaptation of Courbet's realistic view—to support the contention that this painting was indeed completed between the two portraits of Lise that precede and follow it here (cat. nos. 8, 10).[1]

1 See also the portraits painted between 1867 and 1871 (Daulte 1971, Nos. 29, 30, 48 and 65) as well as the scene featuring Alfred Sisley and Lise Tréhot (ibid., No. 34).

Provenance
Henri Rouart, Paris; Auction Rouart, Manzi-Joyant, Paris, December 9–11, 1912, No. 270; Thea Sternheim, Berlin; Auction Sternheim, Amsterdam, February 11, 1919, No. 13; Alfred Cassier, Berlin; private collection, Switzerland; on long-term loan to the Kunstmuseum Basle since 1936; acquired in 1988.

References
Kunst und Künstler, XXVII, 1928/1929, p. 69, ill.; Meier-Graefe 1929, p. 58, Ill. 32; Chamson 1949, Ill. 11, Cooper 1959, p. 167; Daulte 1971, No. 83, ill. p. 419; Fezzi 1972, p. 93, No. 81, ill.; Paris–New York, 1994–1995, pp. 200f., Ill. 248.

Exhibitions
Basle 1943; London–Paris–Boston 1985–1986, No. 10, ill.

10 Bather with a Pinscher 1870
La baigneuse au griffon

The painting, a life-sized celebration of beauty, is an early example in the series of female nudes that Renoir was to paint with great fervor beginning in the 1880s (cat. nos. 49, 71–73, 85–88, 101). Having failed to attract positive attention at the 1869 Salon exhibition (cat. no. 8), he staged his appearance the following year accordingly, self-confidently presenting this huge vertical painting to the public together with a contrasting companion piece, the differently colored, horizontal picture entitled *Une femme d'Alger*, at the Palais de l'Industrie in 1870. Featuring the same model, Lise Tréhot (cat. nos. 8, 9), the two paintings were intended to illustrate and draw public attention to the range of his painterly potential. His aim was to contrast the standing nude with the reclining odalisque, the interior scene with a supposedly outdoor scene and, not least of all, his admiration for Courbet with his appreciation for the art of Delacroix. Indeed, the realistic nude painting is highly reminiscent of Courbet, while the iconography and coloration of the odalisque refers to Delacroix's *Femmes d'Alger* of 1834. Apparently Renoir had no reservations about presenting his favorite model, who by then had become his mistress, to the public in the form of a highly individualized nude or a lascivious Parisian woman in oriental costume—in other words, as an object of desire in both cases.

Oil on canvas
184 × 115 cm
Signed and dated, lower right: A. Renoir. 70.
Museu de Arte de
São Paulo
Assis Chateaubriand,
São Paulo
Daulte 1971, No. 54

Renoir, *A Woman of Algiers*, 1870, National Gallery of Art, Washington

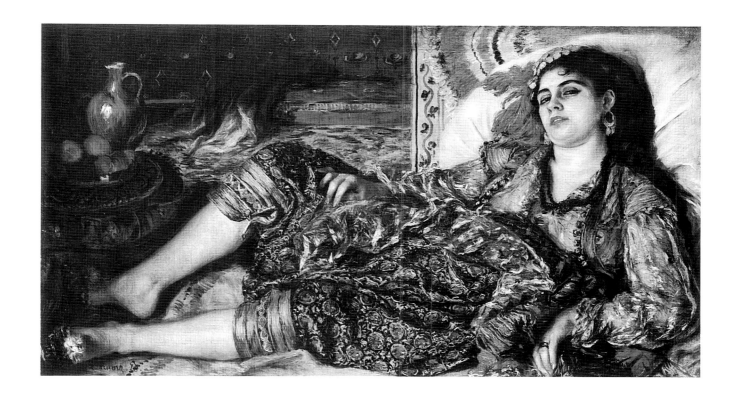

1 Manet himself may even have had Renoir's Salon painting in mind when he juxtaposed the upright, seated figure in the foreground of his family scene of 1870—a painting presumably done in the open air—with her reclining counterpart in the background (ill. p. 86).

2 London–Paris–Boston 1985–1986, pp. 193f.

3 Daulte 1971, No. 65.

4 Venturi 1939, I, p. 202.

The title of the painting, exhibited at the 1870 Salon exhibition as number 2405, identifies the nude as a *Baigneuse*. Yet the term says little about the posed scene at a willowy waterside, a subject that alludes to the presence of nature but was executed in the studio rather than in the open air. Renoir's difficulty in achieving harmony between his suburban Venus (a reverse imitation of the ancient Aphrodite of Knidos), the pompous arrangement of her discarded clothes, the figure in the background and the landscape behind is evident. The relationship between the two women remains a particularly elusive problem. Is the half-sitting, half-reclining figure, captivated by the view of the upright nude, to be understood as a darkly-clothed metaphor for transience and the opposing poles of youth and age? Was it conceived as the image of a brokeress in the commercial market of love, acting in the background, or merely as a horizontal counterweight to the vertical orientation of the composition? It might also have been added to the pictorial context as a reference, calling to mind in its pensive attitude Courbet's shocking *Demoiselles des bords de la Seine*. Nor can we rule out the possibility that Renoir wished to establish a link between his modern nude and Manet's *Olympia* (ill. p. 92), the provocative image *par excellence* that had caused such an uproar at the 1865 Salon exhibition.[1] In any case, the erotic character of the scene with the lap dog lying on the discarded undergarments and the hand held over the pelvic region—which serves rather to reveal than to conceal—struck the caricaturist de Bertall as sufficient material for parody (ill. p. 86). In his cartoon, all that remains of the mysterious eroticism of Renoir's painting and its ambiguous interplay of light and dark is an unwashed nude, her horrified female observer and the pinscher, transformed into a bothersome, barking mutt. It is worth noting that the reviewers of the Salon exhibition criticized the dirty yellow of the nude's skin, which they denounced not least of all as a caricature of the Venus de Medici.[2]

Asked by the art dealer Durand-Ruel in 1912 whether he would recommend purchasing the early piece from the Dutch collector Hoogendijk, Renoir advised against doing so in a letter of March 23, 1912: "The messenger who is bringing this letter to you

Gustave Courbet, *Girls on the Banks of the Seine*, 1857, Musée du Petit Palais, Paris

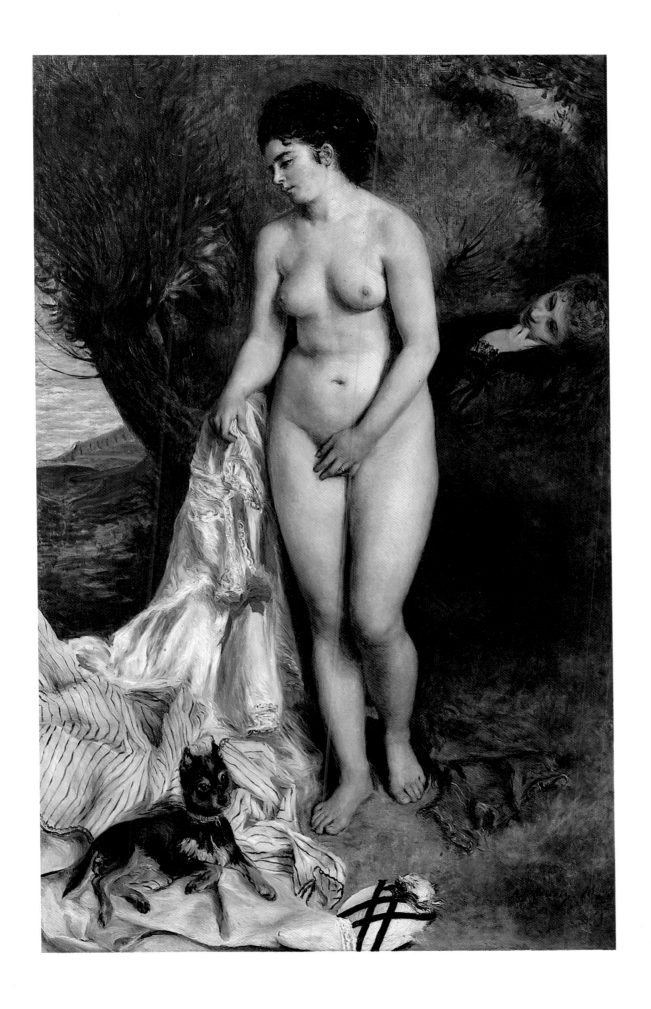

has just shown me photographs of the two paintings. The woman with parrot[3] must have been painted about the same time as the nude woman, no later than '71, as far as I can determine by looking at the model who posed for both paintings. Neither of the paintings, by the way, particularly the woman with the bird, is of any value whatsoever. I would advise you not to let yourself be talked into purchasing these monstrous daubs of paint."[4]

Provenance
Cornelis Hoogendijk, The Hague; Auction *Hoogendijk*, Fredrik Muller & Co., Amsterdam, May 22, 1912, No. 56; Bernheim-Jeune, Paris; Auguste Pellerin, Paris; Paul Cassirer, Berlin; Alfred Cassirer, Berlin; Kunstmuseum Basle (deposit); Wildenstein, New York; Francisco de Assis Chateaubriand, São Paulo; acquired in 1954.

References
Duret 1906, p. 285; Mirbeau 1913, p. 17, ill.; C. Glaser, "Eröffnungsausstellung des Kunstsalons Paul Cassirer," in *Die Kunst*, January 1913, p. 179, ill.; Duret 1922, pp. 98, 101, ill.; Régnier 1923, Ill. I; Duret 1924, p. 34; Coquiot 1925, p. 224; Meier-Graefe 1929, p. 38; Barnes-de Mazia 1935, pp. 48, 50, 56, 82, 177, 200, 233, 443, No. 16, ill.; Venturi 1939, I, p. 31; Graber 1943, pp. 11, 39f., ill. pp. 52–53, p. 210; Drucker 1944, pp. 17, 29, 74, 111, Ill. 13, pp. 182f., 194, 220; Jedlicka 1947, Ill. 8; Chamson 1949, Ill. 8; Gaunt 1952, p. 4, Ill. 5; Rouart 1954, p. 22; Cooper 1959, p. 168; Gimpel 1963, p. 165; Perruchot 1964, pp. 65f.; Rewald 1965, Ill. 81; Ehrlich White 1969, p. 334, Ill. I; Daulte 1971, p. 26, No. 54, ill.; Fezzi 1972, Ills. V, VI, pp. 91f., No. 50, ill.; Champa 1973, p. 40, Ill. 89; Wheldon 1975, p. 23, Ill. 11, p. 29; Gauthier 1977, p. 21; Callen 1978, pp. 36f., Ill. 15; Gaunt-Adler 1982, p. 8, No. 7, ill.; Ehrlich White 1984, pp. 33, 37, ill. p. 255; Rouart 1985, p. 12, ill. p. 14; Shimada 1985, p. 73, ill.; Keller 1987, p. 44, Ill. 33, p. 47; Nagoya–Hiroshima–Nara 1988–1989, p. 2, ill. p. 22, ill.; Bade 1989, pp. 64f., ill.; Monneret 1990, pp. 8f., 148, No. 20, ill.; Brisbane–Melbourne–Sidney 1994–1995, p. 58, ill.

Exhibitions
Salon de 1870, Palais de l'Industrie, Paris, 1870, No. 2405; Paris 1913, No. 4, ill.; Paris 1931, No. 64; Paris 1933, No. 7, Ill. VI; Brussels 1935, No. 65; London 1954, No. 50; *Meisterwerke des Museums São Paulo*, Kunstmuseum, Düsseldorf, 1954, No. 65, Ill. 36; London–Paris–Boston 1985–1986, No. 15, ill., pp. 31, 180, 232; Munich 1989, pp. 101ff., ill.; Paris–New York 1994–1995, No. 180, Ill. 151, pp. 109, 113.

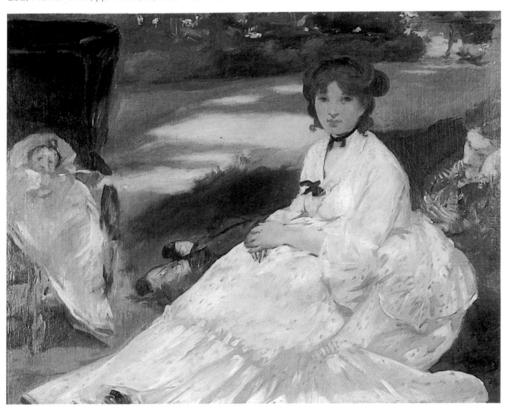

Edouard Manet, *In the Garden*, 1870, Shelburne Museum, Shelburne

11 Portrait of Marie Le Cœur 1870
Portrait de Marie Le Cœur

The wealthy Jules Le Cœur was Renoir's first important client since 1866 (cat nos. 7, 14). No less than 16 portraits of him[1] and other members of his family have been identified.[2]

Marie Le Cœur (1858–1937), portrayed here at the age of 12, was the daughter of Jules Le Cœur's brother Charles, a respected Paris architect who was also a friend of Renoir.[3] After many years, the artist's close ties with the family were severed abruptly in the summer of 1874. Renoir was staying as a guest of the architect and his family at their summer house in Fontenay-aux-Roses, which they had acquired in 1873. The 33-year-old painter fell in love with Marie, only 16 at the time, and communicated his feelings to her in a letter. Jules discovered the letter and informed Charles. Renoir's behavior was taken as an affront to a family of high standing, and all ties of friendship were broken forever.[4]

Oil on canvas
41 × 33 cm
Musée d'Art Moderne
et Contemporain
(Inv. no. 55.974.0.689),
Strasbourg
Daulte 1971, No. 52

Provenance
Hector Brame, Paris; acquired in 1922.

References
Hans Haug, *Le Musée des Beaux-Arts de Strasbourg*, Strasbourg 1926, p. 61, ill.; *Le Musée des Beaux-Arts de Strasbourg. La peinture française*, Strasbourg 1955, p. 17, No. 638; Cooper 1959, pp. 323, 327, Ill. 28; Daulte 1971, No. 52, ill. p. 415; Fezzi 1972, p. 91, No. 44, ill.; Monneret 1990, p. 148, No. 19, ill. p. 156.

Exhibitions
Les origines de l'art contemporain. La peinture française de Manet à Bonnard, Maison d'art alsacienne, Strasbourg, 1947, p. 6, No. 24; *Kunstschätze aus den Strassburger Museen*, Kunsthalle, Basle, 1947, No. 197; Troyes 1969, No. 4, Ill. X; *Renoir. Les Collettes*, Cagnes-sur-Mer, 1969/1979, No. 14; *Le portrait dans les musées de Strasbourg: à qui ressemblons-nous?*, Ancienne Douane, Strasbourg, 1988, p. 243, ill.; *Les Modernes 1870–1950: En préfiguration du Musée d'Art Moderne et Contemporain*, Ancienne Douane, Strasbourg, 1992, No. 8.

1 Daulte 1971, Nos. 20, 27.

2 Ibid., Nos. 18, 26, 39, 41–43, 52, 63, 64, 67, 90, 94, 99, 100.

3 Charles Le Cœur was instrumental in securing a commission for Renoir to paint two rococo-style ceiling frescoes in the newly erected palace of Prince Georges Bibesco in Paris in March 1868 (Cooper 1959, p. 326).

4 Ibid., p. 328.

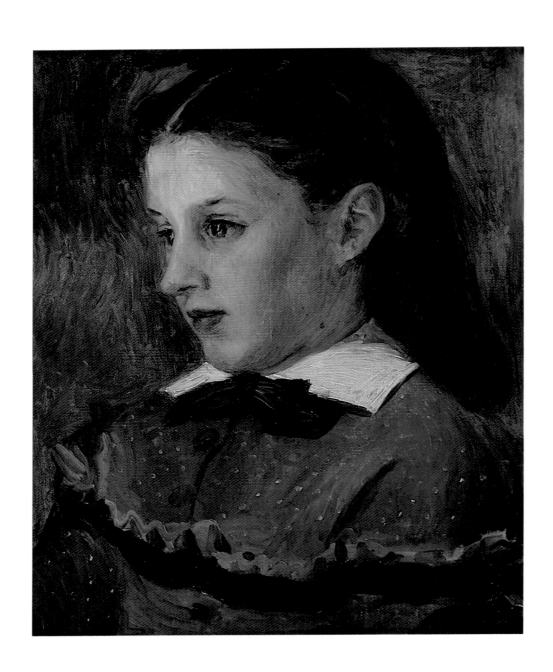

12 Still Life with Bouquet and Fan 1871
Nature morte au bouquet et à l'éventail

The still life was the most economical genre for a painter to produce, since neither expensive models nor time-consuming journeys to landscape sites were required. Yet only a few isolated still lifes—flower and fruit pieces—appear in Renoir's early work (cat. no. 4). This *Still Life with Bouquet and Fan* is above all an expression of Renoir's admiration for Manet, as the objects selected clearly suggest.[1] This is most evident in the central motif, hung on the ochre-brown wall with a light-red ribbon. The black frame, its left side cut off by the edge of the painting, and the passe-partout underscore the light-dark contrasts of an etching by Manet entitled *Les petits cavaliers* (ill. p. 90), a piece done in 1861–1862 as an adaptation from a group portrait in the Louvre then attributed to Velázquez. The etching was exhibited at the Salon des Refusés in 1863, at the great Manet exhibition of 1867 and at the official Salon in 1869.[2]

Manet's famous portrait of Zola (ill p. 92) also contains a number of elements to which Renoir's still life makes reference. These include the picture-within-a-picture motif, consisting of an engraving by Nanteuil based on Velázquez' painting *Los Borrachos*, placed loosely in a frame behind a reproduction of Manet's *Olympia* (ill. p. 92). Other corresponding features are the books stacked on the table and allusions to the fondness for things Japanese that had become widespread among artists and intellectuals since 1860, evidenced in the Renoir painting by the Japanese vase and the oval Japanese fan decorated with floral ornaments (cat. nos. 13, 17).[3] Manet's precedent also determined the provenance of the bouquet of red and yellow roses with delicate-purple lilacs wrapped in white paper. Manet had incorporated a bouquet with similar accents into his *Olympia* of 1863. Renoir's citation of this motif is an indirect tribute to the painterly qualities of the elder artist's scandalous painting.

Oil on canvas
73.3 × 58.9 cm
Signed and dated, lower right: A. Renoir. 71.
The Museum of Fine Arts (Robert Lee Blaffer Memorial Collection, gift of Mrs. Sarah Campbell Blaffer,
Inv. no. ACC:57–1),
Houston

1 S. Lane Faison, "Renoir's Hommage à Manet," in *Intuition und Kunstwissenschaft, Festschrift für Hanns Swarzenski*, Berlin 1973, pp. 571ff.

2 Paris–New York 1983, pp. 120f. The rather reserved relationship between Renoir and the older Manet was described by the art writer Meier-Graefe with the double-edged comment, "Manet was Spanish [i.e. Greek] to him" (Meier-Graefe 1929, p. 32).

3 Asked later in life about this "Japanomania," however, Renoir distanced himself from it: "The Japanese engravings are surely interesting, as long as they remain Japanese engravings— provided, in other words, they stay in Japan; for a people must not appropriate things that do not belong to its own race, as that would involve the risk of making foolish mistakes I once expressed thanks to a critic because he had written that I simply belonged to the French school. 'I am happy,' I said to him, 'to belong to the French school, not because I hold it in greater esteem than the others but because I, as a Frenchman, belong to my own country'" (Vollard 1961, pp. 41f.).

Provenance
Ambroise Vollard, Paris; Gaston Bernheim de Villiers, Paris; Durand-Ruel, Paris and New York; Robert Lee Blaffer, Houston; Sarah Campbell Blaffer, Houston; presented as a gift in 1957.

References
Vollard 1918, I, p. 122, No. 487, ill.; Barnes-de Mazia 1935, pp. 50f, 444, No. 21; S. Lane Faison, "Renoir's Hommage à Manet" in *Intuition und Kunstwissenschaft, Festschrift for Hanns Swarzenski*, Berlin 1973, pp. 571ff.; Callen 1978, pp. 46f, Ill. 23; Ehrlich White 1984, pp. 39ff., ill.; Shimada 1985, Ill. 14; Monneret 1990, p. 149, No. 11, ill.

Exhibitions
Paris 1920, No. 22; New York 1933, No. 23; Los Angeles–San Francisco 1955, No. 8, ill; New York 1958, No. 2, ill.; Chicago 1973, No. 9, ill; Tokyo–Kyoto 1979, No. 7, ill.; London–Paris–Boston 1985–1986, No. 18, ill. p. 218; Nagoya–Hiroshima–Nara 1988–1989, No. 3, ill.; Brisbane–Melbourne–Sidney 1994–1995, No. 3, ill.

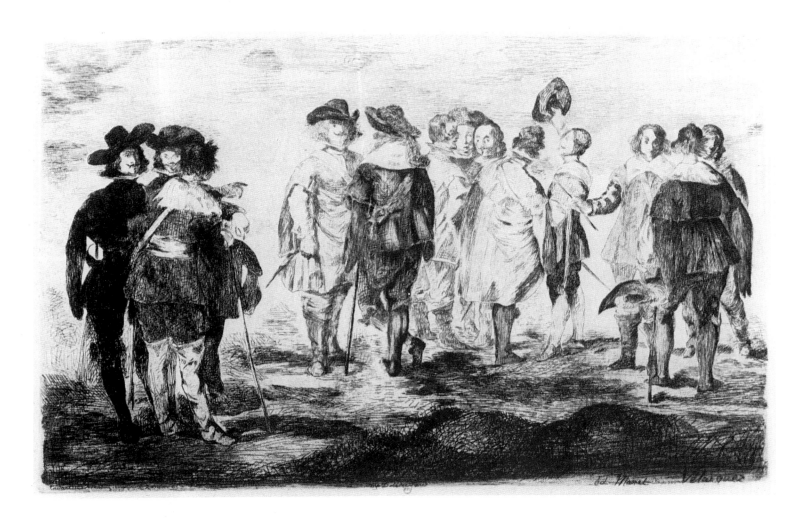

Edouard Manet, *The Little
Cavaliers*, 1861–1862, etching,
Bibliothèque Nationale, Paris

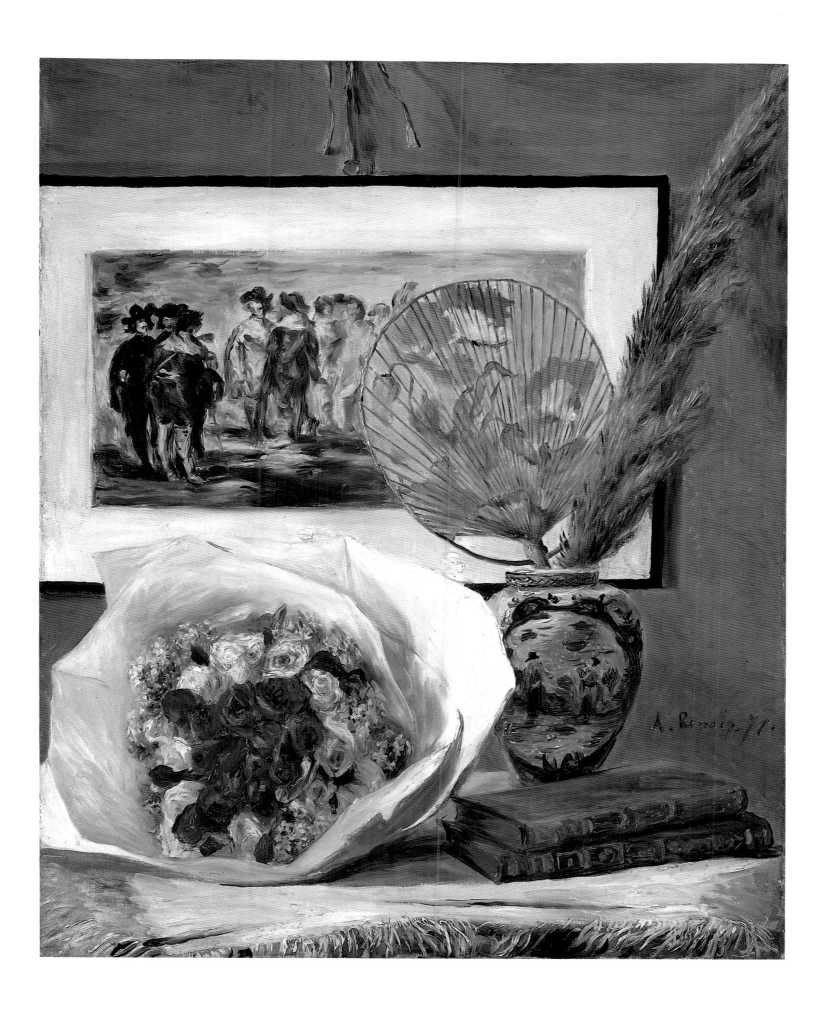

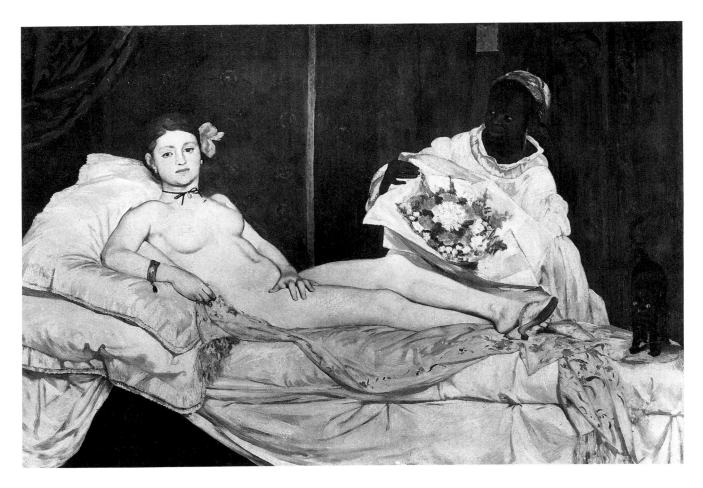

Edouard Manet, *Olympia*, 1863,
Musée d'Orsay, Paris

Edouard Manet,
Portrait of Emile Zola, 186
Musée d'Orsay, Paris

13 Portrait of Rapha 1870–1871
Portrait de Rapha

Large-scale portraits of elegant Parisian women enjoyed great popularity at the Salon exhibitions of the 1860s. They catered ideally to the desire for self-representation of a clientele grown wealthy during the Second Empire. Well-known Salon stars from Winterhalter to Carolus-Duran thus satisfied the desire of well-situated female customers to remain *en vogue* (ill. p. 94).

When the two friends Renoir and Monet first attempted to establish a foothold at the Salon, they did so in full awareness of prevailing public tastes, appropriately submitting sophisticated portraits. Since neither of them could rely upon wealthy patrons, Monet debuted as a figure painter at the 1866 Salon with a life-sized portrait of Camille Doncieux,[1] the woman he later married, while Renoir presented his mistress Lise Tréhot with a parasol in front of a natural background at the 1868 exhibtion.[2] Although their strategy proved successful—the submissions of both young artists were well received in press reviews authored by such critics as Castagnary, Zola, Astruc and Bürger-Thoré—several years passed before Renoir once again attempted a similarly complex subject in his *Portrait of Rapha*, a work he completed in April 1871.

For this painting, Renoir chose an interior scene—as Monet had done in his 1868 portrait of Madame Gaudibert (ill. p. 94)—in order to create a setting commensurate with his richly costumed figure.[3] The figure itself is brightly illuminated by sunlight from the left. Turned towards a window and somewhat away from the pictorial axis, the slim female form, narrowing toward the upper edge of the painting, stands in front of a birdcage, apparently lost in thought. She holds a Japanese fan in both hands (ill. p. 107, cat. nos. 12, 17). The artist combined the expansive costume fashionable at the time, the natural flowers on the floor with their artificial echo in the drapery and wallpaper and the anecdotal motif of the birdcage into a complex interplay of light and shadow. In addition, the impression arises that the arrangement of the robe and the diamond pattern on the wallpaper serve above all to draw attention to the woman's head in the bright sunlight at the top of the painting. The opulence of the interior decoration heightens the effect of the subject's calm, composed attitude and her inward gaze. Without alluding to the often sentimental didactic intent often associated with the depiction of caged creatures in popular, genre-style scenes since the 18th century, Renoir created one of his most magnificent portraits in this painting.

Rapha was the lady friend of Edmond Maître, a native of Bordeaux who held an administrative post in Paris and was an enthusiastic afficionado of the arts, especially music. A friend of Baudelaire and Verlaine, Maître was also close to Renoir and Bazille, who immortalized him as the piano player in his studio scene (ill. p. 33). Renoir stayed at

Oil on canvas
130 × 83 cm
Signed and dated, lower right: A. Renoir. avril. 71.
Private collection, Switzerland
Daulte 1971, No. 66

1 Wildenstein 1974, No. 65.

2 Daulte 1971, No. 29.

3 See the portrait of Lise Tréhot, *La femme à la perruche*, ibid., No. 65.

4 See the portraits of Rapha, ibid., Nos. 46, 50, 68.

Maître's apartment at Rue Taranne 5 for several weeks in the early summer of 1870. It was probably there that he began working on the portrait of Rapha, although he did not complete it until after his discharge from military service in April 1871.[4]

Provenance
Edmond Maître, Paris; Durand-Ruel, Paris; M. Poznansky, Paris; Auguste Pellerin, Paris; Mme. René Lecomte, Paris; Louis de Chaisemartin, Neuilly sur Seine.

References
Duret 1906, p. 292, ill.; Meier-Graefe 1912, p. 34, ill.; Karl Scheffler, "Die Maler 1870 bis 1914," in *Kunst und Künstler*, 1914/1915, p. 209, ill.; Duret 1924, p. 52; Coquiot 1925, p. 224; Meier-Graefe 1929, p. 45, Ill. 27; Florisoone 1937, Ill. 94; Roger-Marx 1937, p. 27, ill.; Terrasse 1941, Ill. 5; Drucker 1944, pp. 33, 194f., Ill. 16; Rouart 1954, p. 26; Cooper 1959, pp. 163, 168; Perruchot 1964, p. 74; Daulte 1971, No. 66, ill. p. 416; Fezzi 1972, p. 92, No. 60, ill.; François Daulte, "Une grande amitié, Edmond Maître et Frédéric Bazille," in *L'Oeil*, April 1978, p. 40; Rouart 1985, pp. 21f., ill.; Monneret 1990, p. 149, No. 5, ill.

Exhibitions
Kunstausstellung der Zweiten Berliner Secession, Berlin 1900, No. 244; *Ausstellung französischer Kunst*, Kunsthalle, Basle, 1906, No. 517; London–Paris–Boston 1985–1986, No. 19, ill.

Claude Monet, *Portrait of Madame Louis Joachim Gaudibert*, 1868, Musée d'Orsay, Paris

Emile Auguste Carolus-Duran, *The Lady with the Glove*, 1869, Musée d'Orsay, Paris

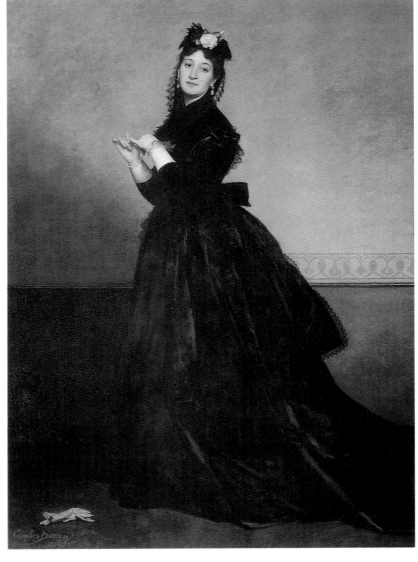

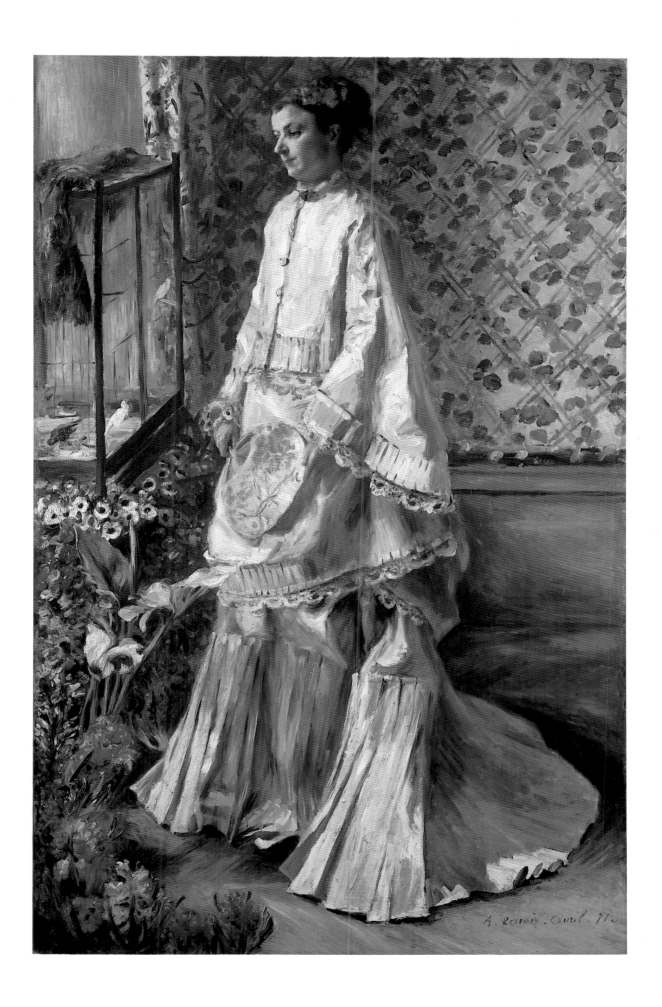

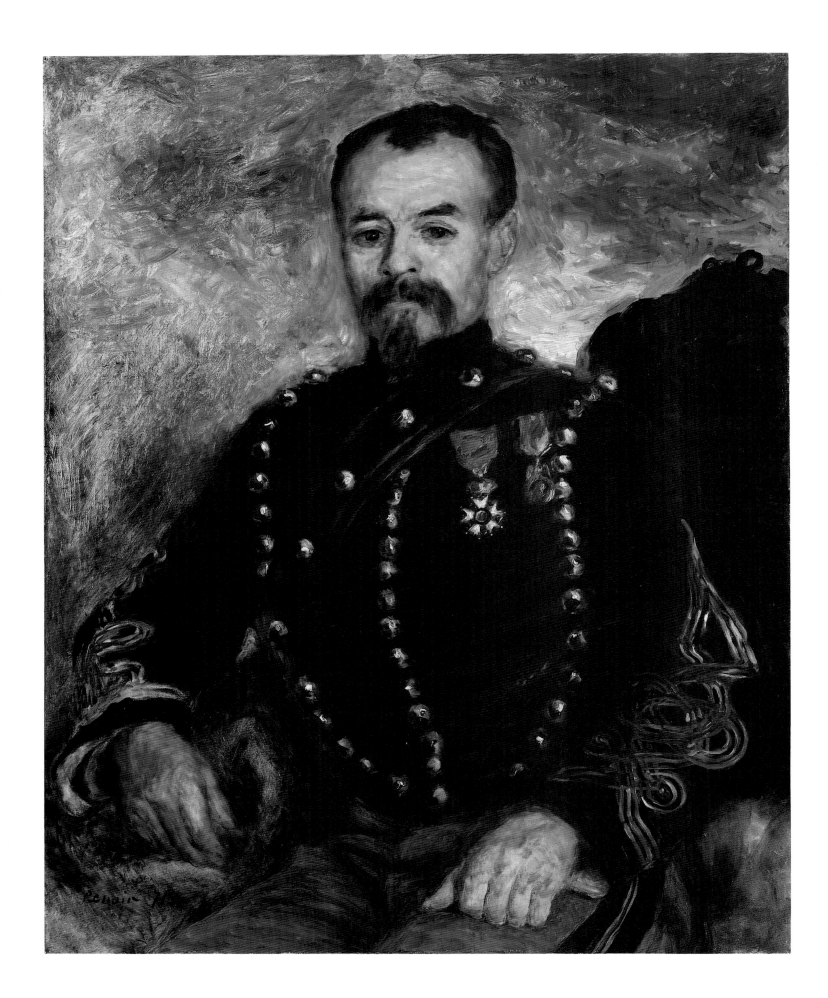

14 Portrait of Captain Darras 1871
Portrait du capitaine d'infanterie Darras

Through the intercession of Jules Le Cœur and his brother Charles (cat. nos. 7, 11), who continued to assist Renoir after the end of the Franco-Prussian war, the artist met Captain Paul-Edouard-Alfred Darras (1834–1903), a native of Dijon, and his wife Henriette in the fall of 1871. The officer, a veteran of the Mexican campaign whose successes would eventually advance him to the post of division commander by 1895, commissioned Renoir to paint him and his wife in a matching pair of portraits. The income from the commission enabled Renoir to rent his first studio in the Rue des Petits Champs.[1]

Only a very few of his portraits contain such unmistakable references to the profession of his subject (cat. no. 29).[2] With a certain air of pride, Darras, in his mid-thirties at the time, presented himself in a silver-embroidered black uniform jacket with red trousers, with the decorations awarded him for his outstanding accomplishment displayed on his chest. Clearly he had survived the transition from the Second Empire to the Third Republic without a scratch. In contrast to the more conventional portraits of his wife,[3] the image of the officer is marked by a much freer pictorial form. Among the most striking features are the energetic brushstrokes in the background, which Renoir used to convey a specific kind of energy.

Oil on canvas
81 × 65 cm
Signed and dated, lower left: Renoir 71.
Gemäldegalerie Neue Meister (Inv. no. 2608), Staatliche Kunstsammlungen, Dresden
Daulte 1971, No. 70

1 Ehrlich White 1984, p. 40.

2 Daulte 1971, Nos. 28, 38, 131, 132, 252, 297.

3 Ibid., Nos. 69, 93, 94.

Provenance
M. Bernier, Paris; Durand-Ruel, Paris; Bernheim-Jeune, Paris; Josef Stransky, New York; acquired in 1926.

References
Meier-Graefe 1929, p. 43, Ill. 29; *Die Staatliche Gemäldegalerie zu Dresden. Katalog der Modernen Galerie*, Dresden 1930, No. 2608, Ill. 23; Barnes-de Mazia 1935, pp. 50f., 80, 443, No. 19; Florisoone 1937, pp. 15, 40, ill.; Venturi 1939, I, p. 32; Graber 1943, p. 41; Drucker 1944, p. 183; Gaunt 1952, p. 5, Ill. 11; Rouart 1954, p. 25; Fosca 1961, p. 33, ill.; Perruchot 1964, p. 78; *Dresdener Galerie. Neue Meister*, Leipzig 1964, No. 69; Daulte 1971, No. 70, ill., pp. 411f.; Fezzi 1972, p. 92, No. 65, ill.; Callen 1978, p. 45; Ehrlich White 1984, p. 40, ill.; Rouart 1985, p. 20; Monneret 1990, pp. 10, 149, No. 10, ill. p. 156; Distel 1990, p. 18.

Exhibitions
Internationale Kunstausstellung, Dresden, 1926, p. 145, ill.; Paris 1933, No. 8, Ill. VII.

15 In the Park at Saint-Cloud 1871
Dans le parc de Saint-Cloud

Oil on canvas
50 × 61
Private collection

Renoir's close friend and biographer Georges Rivière (cat. nos. 28, 46) was the first owner of this park landscape, a scene animated by the inclusion of leisurely strollers and an outdoor café. He later bequeathed the painting to his daughter Hélène, the wife of Renoir's nephew Edmond. In Rivière's first book on Renoir, a foundational work published in 1921, the painting is reproduced in color under the title *Dans le parc de Saint-Cloud* and dated to the year 1866. Although the painting was still executed on a dark ground, Rivière's dating is undoubtedly too early, as the artist's view of the landscape is quite different from that of the landscape composition *Jules Le Cœur with his Dogs in Fontainebleau Forest* (cat. no. 7), a work dated to 1866. The latter painting, a realistic view of the forest interior, reveals the unmistakable influence of Courbet and the artists of the Barbizon school. This park landscape, on the other hand, illuminated by awkwardly gesticulating patches of sunlight and rendered in predominantly silvery blues, grays and greens, is the first genuine product of the attempts undertaken in La Grenouillère in 1869 (ill. p. 28) to capture the mood of a moment with a light, sketchlike style of painting and an entirely new palette of luminous colors, approaching new themes in an open-air setting. After the war, Renoir resumed these experiments in the summer of 1871, accomplishing the first step towards pure Impressionism in landscapes like this and the following one (cat. no. 16).

The painter spent some time in La Celle-Saint-Cloud near Bougival during the month of August 1871.[1] From there he took advantage of the opportunity to visit both the nearby park in Saint-Cloud and La Grenouillère, the outdoor amusement area on the Seine island near Croissy (cat. no. 16), motifs he recorded in typical Impressionist fashion in paintings executed in direct contact with the outdoor scenes.

1 See Renoir's letter to Théodore Duret (Florisoone 1938, p. 39).

Provenance
Georges Rivière, Paris; Edmond and Hélène Renoir, née Rivière, Virolay; Auction, Christie's, New York, May 12, 1993, No. 5.

References
Rivière 1921, ill. pp. 8–9; Coquiot 1925, pp. 147, 223; C. Künstler, *Renoir, peintre fou de couleurs*, Paris 1941, p. 8, Ill. 2; Daulte 1973, p. 75, ill.; Champa 1973, pp. 47, 57, Ill. 63; Auction catalogue, *Impressionist and Modern Paintings, Drawings and Sculpture (Part I)*, Christie's, New York, May 12, 1993, No. 5, ill.

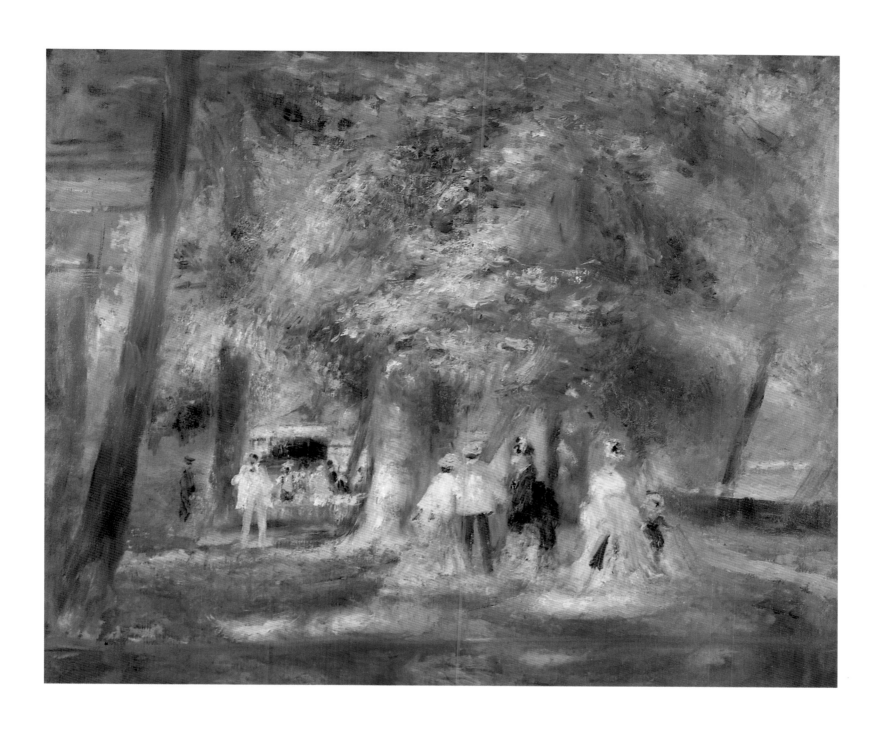

16 La Grenouillère 1871–1872
La Grenouillère

Oil on canvas
49.5 × 57 cm
Signed, lower right:
Renoir.
Private collection, U.S.A.,
courtesy of the Artemis
Group

During the summer months of 1869, Renoir and Monet spent a great deal of time together near Bougival on the banks of the Seine painting different views of La Grenouillère, an outdoor amusement area with a restaurant, bathing area and boat rental on the Ile de la Loge (ills. pp. 28, 29).[1] Operated by Monsieur Seurin, La Grenouillère was a popular spot for excursions. The journey by train from the Gare Saint-Lazare in Paris to Chatou and from there by boat to the amusement area took barely an hour. During the 1860s, the island was a gathering point for Parisian high society and the *demimonde*, for bohemians and the fashionable rich alike. La Grenouillère was frequented by celebrated Salon painters such as Gérôme, Vibert or Frémiet and by younger talents whose promising careers as painters, journalists, writers or idlers still lay ahead of them. The double meaning of the name La Grenouillère, which denoted both a bathing area and a frog pond, was explained by Jean Renoir in his memoirs: "The name Grenouillère, or 'frog pond,' had nothing to do with the countless amphibians that inhabited the meadows in the area but referred to frogs of quite a different kind. 'Frogs' was the term people used for women who were not overly fastidious about virtue. They were not actually prostitutes, but belonged rather to that category of unattached young girl that typified Parisian morality. They changed lovers frequently, took whatever struck them as desirable at any given time and would swap a mansion on the Champs-Elysées for an attic room in Batignolles without batting an eye."[2]

Writing in the journal *L'Evènement illustré* of June 20, 1868, Raoul de Presles described La Grenouillère as a Trouville on the banks of the Seine, a place invaded by hordes of raucous Parisians who left the city to spend their summers in Croissy, Chatou or Bougival. The article also mentions an old houseboat anchored permanently at the riverside, a vessel with a barracks-like, green-and-white painted superstructure and a narrow wooden balcony that served as a restaurant and source of refreshments of all kinds. The reader is told that a boatbuilder's workshop was located to the left of the houseboat and the changing cabins for bathers to its right. Boats, the author noted, could be seen tied all around the island.[3]

There is no doubt that the sketches done by Renoir and Monet on the Ile de la Loge in 1869 represent genuine "incunabula" of Impressionist painting (ills. pp. 28, 29). As preliminary studies for works planned for presentation at the Salon exhibition of 1870—plans which, to be sure, bore no fruit (cat. no. 10)—they were not intended for public view. Since these works were spared the trial of exposure to broad public scrutiny, they were free to serve as radical programmatic experiments in the painting technique, immediacy of perception and light

1 London–Paris–Boston
1985–1986, pp. 191f.

2 Renoir 1981, pp. 181f.

3 London–Paris–Boston
1985–1986, p. 191.

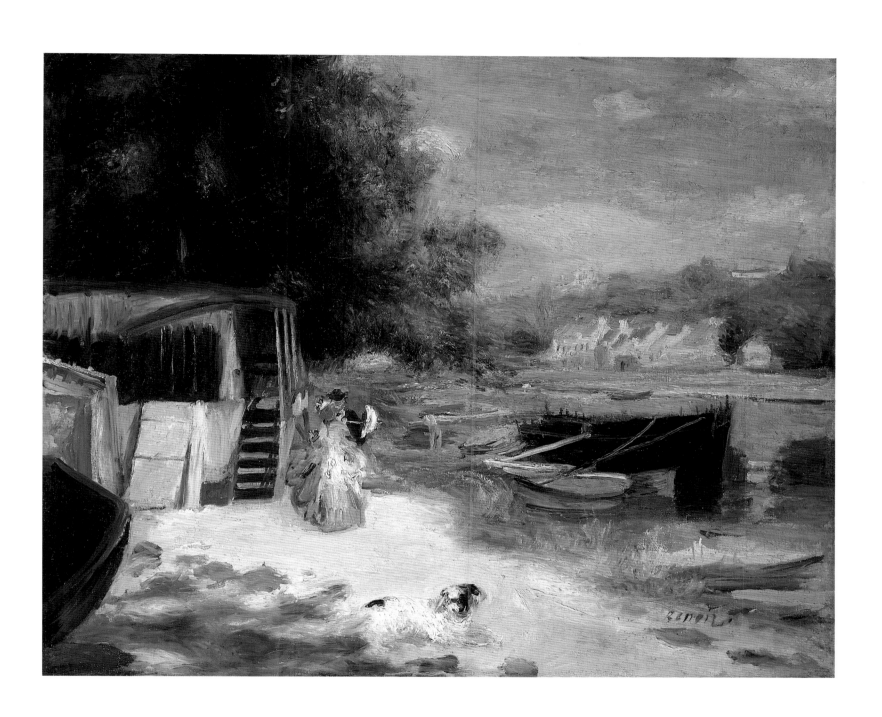

Ferdinand Heilbuth,
La Grenouillère, 1870,
private collection

effects that would so profoundly alter traditional modes of vision as Impressionism in the years to come.

A view of the Seine by Ferdinand Heilbuth, also entitled *La Grenouillère*, conveys a sense of the appearance a motif of this kind needed to assume in order to be accepted by the general public. Heilbuth's painting was exhibited with success at the Salon of 1870. Renoir is likely to have had Heilbuth's creation in mind when he turned his attention once more to La Grenouillère and its surroundings in this riverside landscape, painted after the war in the summer of 1871. A comparison of the two paintings makes clear, of course, how difficult it must have been for young painters to oppose the perfectionism of the established Salon art. Compared to Heilbuth's expansive composition, influenced by both Corot and the Dutch landscape painters of the 17th century, compared to his masterful tone-in-tone painting and the intricate detail of his illustrative elements, Renoir's painting must have appeared technically amateurish and banal in its choice of subject. What could he offer in lieu of the picturesque harmony of Heilbuth's landscape, the pathos of his river and his giant trees, the

sheer elegance of his figures preparing for a boat ride? Nothing more —and nothing less—than a modern, subjectively colored view of reality.

While Heilbuth compiled his well-tempered assortment of figures from fashion journals and the history of art, Renoir gave his Cytherean isle, seen directly beneath the open sky, an entirely prosaic look. A couple has wandered away from the crowd to be alone—offstage, so to speak—at the boatbuilder's workshop and dry-dock. In place of Heilbuth's group of elegant figures, Renoir has positioned a dog in the very center of the foreground on a sandy stretch of riverbank bounded by blue streaks of water. The path leads to the rear entrance of the restaurant described above. The superstructure of the houseboat is rendered in black, gray and salmon-pink. The dark hull of a boat, cut off by the edge of the painting, protrudes into the scene from the left. Small boats and a heavy freight barge crowd the water along the banks. The outskirts of the town of Rueil and the vaguely suggested shape of the Château Malmaison in the hills above can be seen on the opposite side of the river.[4] Renoir chose the quieter, less attractive rear view of the popular site as his motif. While his earlier Grenouillère paintings (ill. p. 28) show the influence of stimuli derived from his work with Monet, here he has clearly adopted the more intimate approach that would characterize his painting in subsequent years. He has rid his palette of all unnecessary elements; his brushwork is light and open. Warmed by the sunlight, his coloration is in complete harmony with his swiftly moving brush, which shapes the outlines of forms in their own colors.

4 See the detailed commentary by Alexandra R. Murphy in *Auction Catalogue*, Christie's, New York, November 9, 1994, pp. 46f.

Provenance
Durand-Ruel, Paris; Carlo Z. Thomsen, Hamburg; Fine Arts Associates, New York; Ralph and Mary Booth, Detroit; William Booth Vogel, Milwaukee; Auction, Christie's, New York, November 9, 1994, No. 13.

References
Meier-Graefe 1911, p. 63, ill.; Meier-Graefe 1912, pp. 58f., ill.; Meier-Graefe 1929, p. 62, Ill. 38; Barnes-de Mazia 1935, pp. 50, 53f., 97, 121, 200, 235, 445, No. 31, ill.; Florisoone 1937, p. 117, ill. p. 167; Drucker 1944, p. 183; Fosca 1961, Ill. 5; J. Isaacson, *The Early Painting of Claude Monet*, Berkeley 1967, p. 326, ill.; Fezzi 1972, pp. 93f., No. 95, ill.; Callen 1978, p. 11; Ronald Pickvance, *La Grenouillère. Aspects of Monet*, New York 1984, p. 46, No. 17, ill; London–Paris–Boston 1985–1986, p. 192, ill.; Auction catalogue *Impressionist and Modern Paintings, Drawings and Sculpture (Part I)*, Christie's, New York, November 9, 1994, No. 13, ill.; Paris–New York 1994–1995, p. 456, Ill. 425.

Exhibitions
New York 1950, No. 8, ill.; *Hidden Treasures: Wisconsin Collects Paintings and Sculptures*, Art Museum, Milwaukee, 1987, No. 38, ill.

17 Madame Claude Monet Reading 1872
Madame Claude Monet lisant

Oil on canvas
61.2 × 50.3 cm
Signed, lower left:
A. Renoir.
Sterling and Francine Clark
Art Institute
(Inv. no. 612 RSC 1933),
Williamstown,
Massachusetts
Daulte 1971, No. 73

1 Daulte 1971, Nos. 85, 87.

2 Ibid., Nos. 77, 78, 98.

3 Baudelaire had already
pointed out that the ideal of
beauty that prevailed in any given
era was influenced primarily by
fashion (cat. no. 42): "Fashion
must therefore be seen as the
striving for the ideal that outlasts
in the human mind all of the
coarseness, baseness and filth
that natural life deposits there, as
a sublime deformation of nature
or rather a ceaseless series of
attempts to reshape nature. Thus
it has been said, and understand-
ably so (without disclosing the
reason for it), that all fashions are
appealing—relatively speaking,
that is—each as a more or less
successful renewed effort to
achieve beauty, each as an
approach towards an ideal which
the unsatisfied human spirit is
driven to pursue by a constant
tickling urge" (Baudelaire 1989,
p. 249).

4 Renoir's blue achieves the
very dominance here that
prompted the art critic Joris Karl
Huysmans eight years later to
accuse the Impressionists not
only of having little talent, paint-
ing awkwardly and using screech-
ing colors but also of succumbing
to an "addiction to blue" (Rewald
1965, p. 252).

Claude Monet's was apparently a family of readers. Renoir painted his friend, a man he had first met in Gleyre's studio in October 1862 and with whom he retained close ties throughout his life, in the act of reading in two of his first major portraits in 1872.[1] He also observed Monet's wife Camille (1847–1879) reading a book in this preciously decorated portrait, whose dimensions match those of the previously mentioned portraits of her husband. Three more paintings of Camille reading would follow in 1872–1873 (cat. no. 18).[2]

Camille Léonie Doncieux married Monet in the summer of 1870, having served as his model since 1865. Thus she had had sufficient practice by the time she posed, completely relaxed, for this portrait by her husband's friend. Renoir was enthralled by the natural charm of the 25-year-old Camille and the down-to-earth atmosphere of her personal surroundings. Even in a painting focused upon decoration and furnish-ings such as this one, in which the complete litany of conventional devices was used to stage the motif as effectively as possible, the inti-mate character of this "painting for a friend" outweighs its functional quality as a representative image.

Without adopting the precise detail and tendency toward affecta-tion of the Salon portraitists, Renoir was here able to pursue his already pronounced interest in the material quality and fashionable details of the satin, silk-tuft or velvet clothing he consistently painted with painstaking care (cat. no. 13). This interest was quite natural for a painter whose father and brother Léonard-Victor were tailors, whose mother was a seamstress and whose brother-in-law Charles Leray earned his living as a fashion illustrator. Sisley's father, the subject of a portrait painted by Renoir in 1864 (ill. p. 72), also traded in silk fabrics and artificial flowers.[3]

In this painting, Camille Monet is shown stretched out full length upon a sofa. In keeping with prevailing taste, the upholstery is deco-rated with a floral pattern and heron motifs. One of the sofa cushions serves Camille as a footrest. The angle of view provides a virtually fron-tal presentation of the figure, while the perspective from below con-tracts the depth of field in the room. Despite the impression of a fleet-ing encounter between the painter and his nonchalant model, every element of the composition is developed with great care and subtlety. The arrangement of the cushions, for example, serves solely to empha-size the head and face of the woman deeply immersed in her reading. The pyramid-shaped configuration of the dress in luxuriously orna-mented blue[4] and the isolated white accents distributed in a diagonal pattern extending from the foot to the pages of the book and ending in the neckerchief contribute to the fascinating hierarchy of colors and forms.

Claude Monet, *Camille Monet Embroidering*, 1875,
The Barnes Foundation, Merion

Next to nothing of this quality remains, however, in Monet's 1875 portrait of his appreciably older-looking wife, wearing the very same dress and embroidering in a room filled with potted plants (ill p. 106).

The Japanese fans hung obliquely on the blue wall as exotic *aperçus*, which also appear as decorative commonplaces in portraits by Whistler (ill. p. 107) or Tissot and somewhat later in Manet's work, were Renoir's tribute to the "Japanomania" that had become widespread among painters and literary figures in Paris since mid-century (cat. nos. 12, 13). They may have been part of the furnishings in Monet's apartment. Similar objects appear on the wall in Monet's 1876 portrait of his wife as a Japanese woman wearing a kimono (ill. p. 107).

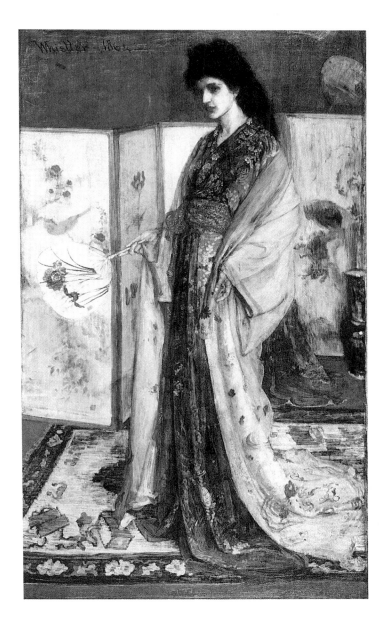

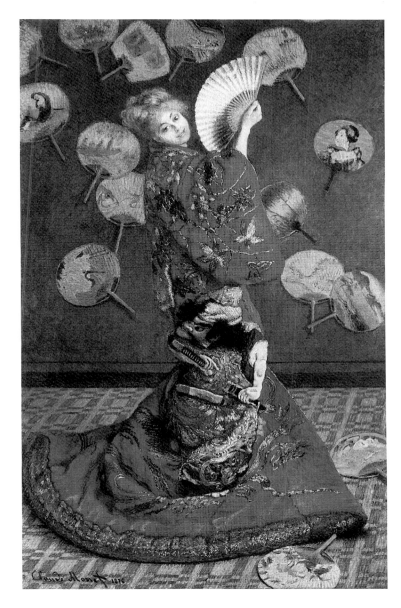

James McNeill Whistler,
*Princess from the Lands
of Porcelain*, 1864,
Freer Gallery of Art, Washington

Claude Monet, *Camille Monet in
a Japanese Costume*, 1876,
Museum of Fine Arts, Boston

Provenance
Durand-Ruel, Paris and New York; Robert Sterling Clark, New York; acquired in 1933.

References
Meier-Graefe 1929, p. 57, Ill. 35; Graber 1943, p. 41; Elaine de Kooning, "Renoir, as if by Magic," in *Art News*, 55, 6, October 1956, p. 44, ill.; Fosca 1961, p. 64; Daulte 1971, No. 73, ill. p. 412; Fezzi 1972, p. 93, No. 83, ill.; Wheldon 1975, pp. 53, 57, Ill. 39; Callen 1978, pp. 58f., ill.; Shimada 1985, Ill. 39; Monneret 1990, p. 149, No. 18, ill.; Steven Kern, *List of Paintings in the Sterling and Francine Clark Art Institute*, Williamstown 1992, p. 90, ill.

Exhibitions
Salon d'Automne, Grand Palais, Paris, 1904, No. 20; London 1905, No. 250; Paris 1912, No. 13; *French Paintings of the Nineteenth Century*, Sterling and Francine Clark Art Institute, Williamstown, 1963, No. 122, ill.; New York 1969, No. 7, ill.; *"A la Mode." Women's Fashions in French Art, 1850–1900*, Sterling and Francine Clark Art Institute, Williamstown, 1982, No. 16, ill.

18 Portrait of Madame Claude Monet 1872
Portrait de Madame Claude Monet

Oil on canvas
36.5 × 32.5 cm
The Lefevre Gallery,
London
Daulte 1971, No. 77

Camille Monet is portrayed here gazing downward and wearing the robe also featured in the preceding portrait (cat. no. 17). One may reasonably conclude that she is reading, as this head-and-shoulder study is closely related to the full-figure portrait in which she is seen reading *Figaro* in a chaise-longue in Argenteuil.

Born of a moment, this spontaneously outlined study is an early example of the application of Impressionist achievements to portraiture. The wall and the gown are rendered in the same delicate blue, providing a thinly sketched ground for the complementary coloration of the facial features, the skin and the pattern on the front of the robe. The prominent red of the lips stands out between the dark, abundant hair and the suggestion of a collar in brilliant white. Without the experience gained in painting directly from landscape motifs, it would hardly have been possible to use color to liberate the portrait, confined for the most part to interior spaces, from its apodictic poses.

Renoir, *Camille Monet Reading Le Figaro*, 1872,
Calouste Gulbenkian
Foundation, Lisbon

Provenance
Georges Renand, Paris; Lord F. Churchill, London; Mrs. Huttleston Rogers, London; Arturo Peralta Ramos, Taos, New Mexico.

References
John Rewald, "La peinture française du XIXᵉ siècle en Angleterre," in *L'Amour de l'Art*, 1938, p. 330; Daulte 1971, No. 77, ill. p. 412; Fezzi 1972, pp. 94f., No. 121, ill.; Daulte 1973, p. 23, ill.; Monneret 1990, p. 150, No. 10, ill.

Exhibitions
Los Angeles–San Francisco 1955, No. 15; New York 1958, No. 13, ill.; *Olympia's Progeny*, Wildenstein, New York, 1965, No. 87, ill.; New York 1969, No. 15, ill; *Inaugural Exhibitions: One Hundred Years of American and European Art*, Adelson Galleries, New York, 1990, No. 12, ill; *Important XIX & XX Century Paintings*, The Lefevre Gallery, London, 1993, No. 5, ill.

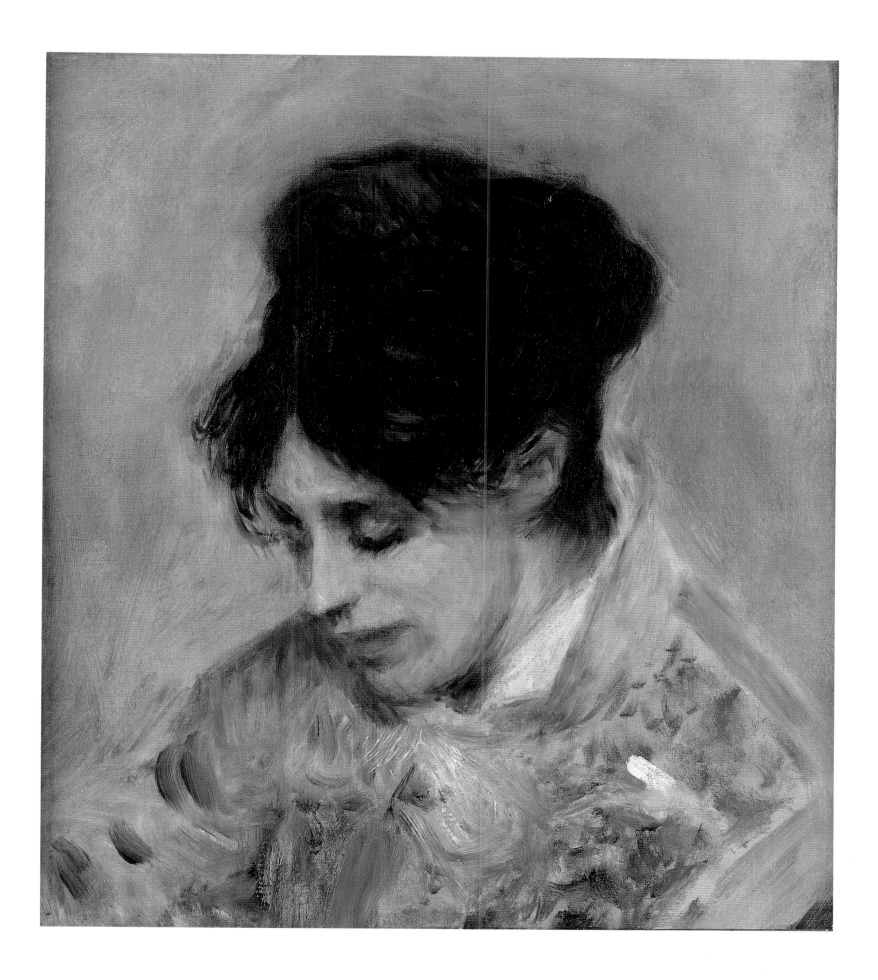

19 Strong Wind. The Gust of Wind ca. 1872
Grand vent. Le coup de vent

Oil on canvas
52 × 82.5 cm
Signed, lower right:
A. Renoir.
Lent by the Syndics of the
Fitzwilliam Museum
(Inv. no. 2403), Cambridge

By the early 1870s, Renoir had gained full command of his gifts as a painter, as is convincingly demonstrated in this and other summer landscapes (cat. nos. 20–22). The elongated horizontal format presents a hillside landscape in the Ile de France with bushes and trees under massive formations of light and dark clouds. The vegetation, exposed to violently gusting wind, is captured in swift brushstrokes. The quickly blended painterly action is played out between complementary contrasts. An airy sky-blue opposes the yellow of the fields, while the various greens of the trees and bushes are augmented by isolated patches of reddish-brown. The impasto colors are applied more thinly in the sky areas, where the light-colored ground shines through.

In all likelihood, this is the painting auctioned as number 36 under the title *Grand vent* at the legendary Impressionist auction organized by Renoir and held on March 24, 1875 (cat. no. 21). It was sold for the modest price of 55 francs to the Swiss painter Auguste de Molins, a participant in the Impressionist exhibition of 1874.[1] Although at Durand-Ruel's advice the event was held at the Hôtel Drouot, the state-sanctioned Paris auction house, and managed in a professional manner by Charles Pillet, the auction of 73 paintings by Renoir, Monet, Sisley and Berthe Morisot was a fiasco. The works offered for sale—among them 20 paintings by Renoir—caused such an uproar among the visitors that the police were forced to intervene.[2] Paintings by Berthe Morisot sold for an average of 250 francs, those of Monet and Sisley for 233 and 122 francs, respectively. Renoir recorded the poorest results with an average sale price of slightly more than 100 francs. In fact, he and Durand-Ruel felt compelled to enter the bidding themselves in order to push the total sales figure to 2,251 francs.

1 Bodelsen 1968, p. 335.

2 Rewald 1965, p. 209; Bodelsen 1968, pp. 333ff.

Provenance
Auction *Monet–Morisot–Renoir–Sisley*, Hôtel Drouot, Paris, March 24, 1875, No. 36 (?); Auguste de Molins, Paris (?); Durand-Ruel, Paris; Alphonse Kann, Saint-German-en-Laye; L. H. Lefevre & Son, London; F. Hindley Smith, Cambridge; presented as gift in 1939.

References
James Laver, *French Painting and the Nineteenth Century*, London 1937, Ill. 87; Carl Winter, *The Fitzwilliam Museum*, Cambridge 1958, p. 403, Ill. 103; Bodelsen 1968, p. 335; Fezzi 1972, p. 106, No. 395, ill.; Callen 1978, pp. 14, 50f., ill.; Keller 1987, pp. 38, 40, Ill. 29; Bade 1989, pp. 72f., ill.; Monneret 1990, pp. 12, 149, No. 15, ill.

Exhibitions
London 1905, No. 276; Zurich 1917, No. 165; *The Impressionist School and some Great French Painters of the Nineteenth Century*, L. H. Lefevre & Son, London, 1923, No. 19; *Landscape in French Art*, Royal Academy, London, 1949–1950, Ill. 62; *Treasures of Cambridge*, Goldsmith's Hall, London, 1959, No. 51; *Impressionism*, Royal Academy, London, 1974, No. 94, ill.; London–Paris–Boston 1985–1986, No. 25, ill. p. 215.

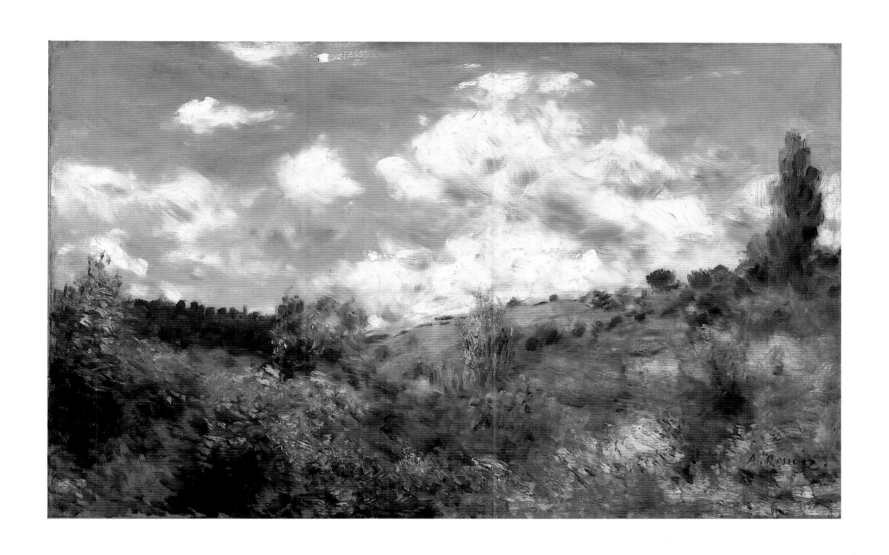

20 After the Storm ca. 1872
Après la tempête

Oil on canvas
45 × 55 cm
Signed, lower right:
A. Renoir
Private collection,
courtesy of Galerie
Nathan, Zurich

1 Still employed by Courbet and
adopted by Renoir in his early
years, the old masters' technique
of building color values upon a
dark canvas ground was first
abandoned by Manet, who opted
for canvases with light grounds.
Renoir and Monet later followed
his example in order to give their
painting a lighter timbre.

Closely resembling the stormy landscape described previously (cat. no. 19), this landscape scene featuring three towering trees and a house in the distance is an early example of Renoir's open-air painting. The moods evoked in the two scenes of a storm-whipped countryside under patchy canopies of gray and white clouds are likewise comparable. Also virtually identical are the colors, the energetic brushwork and the artist's technique of applying dry paint over more fluidly painted layers. Even the signatures have the same form. An unusual feature of both paintings is the complete absence of human figures, which, however, would only have detracted from the real subject of the paintings: the representation of elementary natural forces.

In 1872–1873, Renoir responded to Monet's expansive views with a series of relatively compact landscapes (cat. nos. 19–22). In many cases, his horizons extend beyond the middle of the painting, thus achieving the classical effect of a ground structure receding stepwise. The initially conventional color scheme gradually gives way to radiant lightness. Deep, dark grounds cause widely scattered, rapidly applied, sparkling patches of light to vibrate with motion. An earthy rust-brown approximating the brick-red of the house roof marks a path among the widely differentiated greens of the bushes and shrubbery. Spots of light-colored canvas are visible primarily near the horizon.[1]

Provenance
Ida Bienert, Dresden; Dr. Fritz Nathan and Dr. Peter Nathan, Zurich

References
Will Grohmann, *Die Sammlung Ida Bienert, Dresden*, Postdam 1933, No. 3, ill.; Fezzi 1972, p. 95, No. 144, ill.

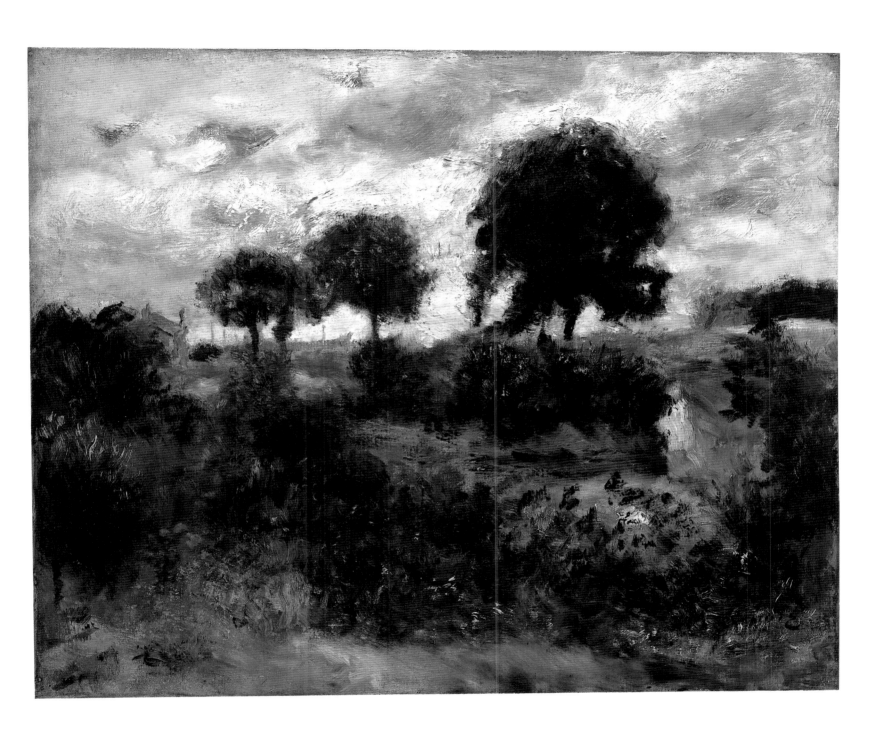

21 The Harvesters 1873
Les moissonneurs

Oil on canvas
60 × 74 cm
Signed and dated,
lower left: Renoir. 73.
Private collection,
Switzerland

This landscape detail showing fields of grain, farmers at harvest time and two women passing by under a hazy blue sky is one of Renoir's "Impressionist" paintings. The dividing line between earth and sky, from which a house and several trees rise upward, bisects the painting somewhat above the horizontal midline (cat. nos. 20, 22). A path leading into the depth of the picture serves as a vertical counterweight. Without reverting to the constrained allegorical diction of Millet, Renoir's farmers simply provide necessary accents here and there within the expansive field of a landscape bathed in sunlight. Baudelaire had subjected Millet's industrious, productive farmers to scathing criticism already in 1859, calling them "pedants who think too highly of themselves," who "exhibit a kind of sinister, inexorable stupidity" and "lay claim, in their monotonous ugliness . . . to a philosophical, melancholy, Raphaelite significance."[1] Renoir "detested" Millet's "sentimental landscapes," whose figural extras reminded him of actors in farmers' costumes.[2]

Renoir dissolved the genre-like activity of his human figures in color. In keeping with Impressionist iconography and its bourgeois glorification of urban and rural life without regard for industrial and social realities, neither the farmers' work nor the difficulties and burdens of their lives is a thematic concern. Even the results of their efforts, the sheaves laid in rows along the path, are not the products of strenuous activity depicted in a naturalistic manner, but rather wonderfully sketched chromatic allusions composed of dark blue layers of shadow covered with white and yellow applied with a dry brush. Renoir's sole concern was to evoke in painted form the oppressive midday heat that set the air flickering, combining a broad range of fresh yellows and transparent blue with rapidly added daubs of green to create an image of summer itself.

The painting's "Impressionist past" is also significant. It was painted in the summer of 1873, a period in which Renoir spent many hours working with Monet near Argenteuil (cat. no. 22). From April 15 to May 15, 1874, it was one of the finest pieces shown at the first joint exhibition of the *Société anonyme des artistes, peintres, sculpteurs, graveurs, etc.,* held in the studio of the photographer Nadar at Boulevard des Capucines 35. In the catalogue compiled for the occasion, the landscape is listed as Number 144 under the title *Moissonneurs.* This undertaking, organized for the most part by Renoir and his brother Edmond and featuring the work of 30 artists including Monet, Morisot, Degas, Pissarro, Cézanne and Sisley, went down in history as the first Impressionist exhibition. In Louis Leroy's infamous review of the "Exposition des impressionnistes" for the April 25 issue of the satirical journal *Le Charivari,* the author singled out Renoir's *Moissonneurs* for

1 Baudelaire 1989, p. 188.

2 Renoir 1981, p. 64.

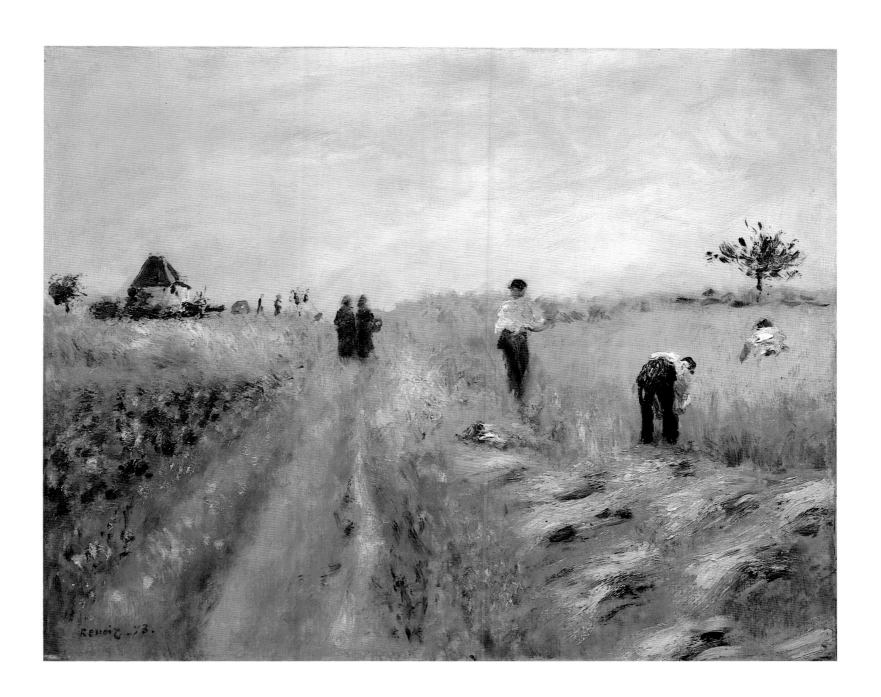

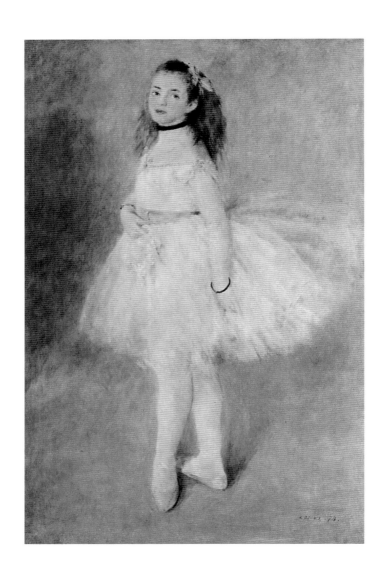

Renoir, *The Dancer*, 1874,
National Gallery of Art,
Washington

particular ridicule. In a fictitious dialogue, he commented sarcastically
on the painting as a prime example of Impressionist presumption: "Oh,
I was in for a strenuous day when I set out in the company of the land-
scape painter Joseph Vincent . . . to visit the first exhibition on the
Boulevard des Capucines. The impetuous soul had gone there, suspect-
ing nothing. He expected to find . . . both good and bad painting, as
always, but not such transgressions against aesthetic manners, against
the great masters and against form In the very first room Vincent
received a shock as he stood in front of Renoir's *Dancer*. 'What a pity,'
he said, 'that the painter, who has a certain feeling for color, cannot
draw any better. The legs of his dancer are as woolly as her net skirt'
. . . . 'What idiots are those who paint for hours on the detail of a hand;
they know nothing about impressionist art, and Manet would soon ban-
ish them from his kingdom.' 'So Renoir is on the right track,' I
remarked, 'for there is not a single superfluous detail in his *Harvest*. I
would even say that his figures . . . are still too thoroughly executed.'
'But M. Vincent! . . . Look at these three patches of color that are meant
to represent a person standing in the grain field.' 'Two of them are
unnecessary. One would have sufficed!' I stole a glance at Bertin's stu-

dent. His face had turned a deep red. Disaster was in the air. It was left to Monet to administer the final blow."[3] The influential critic Ernest Chesneau, who had spoken out for Monet, dismissed *The Harvesters* as a "fruitless experiment" in an article for the *Paris-Journal* of May 7. Only in the May 1 issue of *L'Artiste* did the otherwise polemical Marc de Montifaud write of the quality of Renoir's submissions, which he found confirmed not least of all in *The Harvesters*.[4]

As sales of works exhibited at the show left a great deal to be desired, Renoir fixed his sights on an auction project to be carried out the following year on March 24, 1875, under the title *Tableaux et aquarelles par Claude Monet, Berthe Morisot, A. Renoir, A. Sisley* at the Hôtel Drouot, the official Paris auction house (cat. no. 19). Twenty of Renoir's own works were offered, and it is assumed that the landscape found a purchaser, since a *Paysage d'été* measuring 60 x 73 cm was listed in the catalogue under number 47. According to the auction record, it was sold to Gabriel Thomas of Paris for 105 francs.[5] Despite the very low prices paid for the auctioned works, the artist did indeed benefit from the venture. The publisher Georges Charpentier entered his life as the purchaser of three paintings, Monet's brother Léon bought two more and the customs inspector Victor Chocquet commissioned Renoir to paint his wife's portrait (cat. no. 26).

3 Rewald 1965, pp. 195, 197.

4 Washington–Montreal–Yokohama–London 1990–1991, No. 50.

5 Bodelsen 1968, p. 336.

Provenance
Auction *Monet–Morisot–Renoir–Sisley*, Hôtel Drouot, Paris, March 24, 1875, No. 47 (?); Gabriel Thomas, Paris (?); Mme Carmona, Paris; Auction, Hôtel Drouot, Paris, March 30, 1938, No. 27; Dr. Fritz Nathan, Zurich; Emil Georg Bührle, Zurich; acquired in 1951.

References
Venturi 1939, II, p. 256; Graber 1943, p. 46; Rouart 1954, p. 34; Douglas Cooper, *Great Private Collections*, New York 1963, p. 220; Rewald 1965, p. 197; Bodelsen 1968, p. 336; Fezzi 1972, pp. 93f., No. 100, ill.; *Centenaire de l'impressionnisme*, Galeries Nationales du Grand Palais, Paris 1974, pp. 250ff., 260, 266, 269; Wheldon 1975, p. 58; Gauthier 1977, p. 34; Callen 1978, p. 50. Ehrlich White 1984, p. 50; Schneider 1985, p. 56; London–Paris–Boston 1985–1986, pp. 197, 202; Washington–San Francisco 1986, p. 122; Wadley 1987, Ill. 25; Monneret 1990, pp. 11, 149, No. 24, ill. (reversed).

Exhibitions
Société anonyme des artistes, peintres, sculpteurs, graveurs, etc., 35 Boulevard des Capucines, Paris, 1874, No. 144; Zurich 1958, No. 167, Ill. XII; Berlin 1958, No. 26; Munich 1958/1959, No. 130; Edinburgh–London 1961, No. 48; Lucerne 1963, No. 21; Washington–Montreal–Yokohama–London 1990–1991, No. 50, ill.

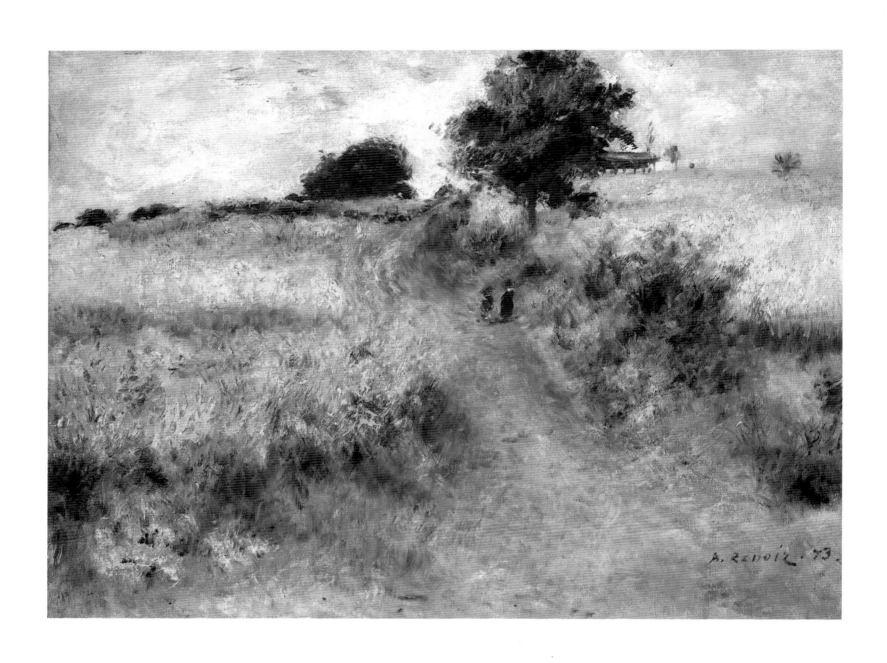

22 The Watering Trough 1873
L'abreuvoir

Immersed in light, the composition displays the full luminous power of Renoir's palette. The scene is "populated" by two figures on the right. More than mere figural extras, they are integrated into their natural surroundings, if only as casual strollers. They walk along a path lined with bushes and fields of grain which divides the gently rising hillside landscape near the center of the painting. Treetops and a watering trough for animals rise above the horizon line, establishing balance between the upper and lower halves of the picture.

The painter here impressively demonstrates his ability to exploit even a reductive approach to achieve a rich diversity of color and expand the breadth of his potential. Indeed, this painting is based almost exclusively upon the green hues that stand for nature *per se*. The interplay of alternating areas of thinly applied pigments and thick layers of paint reveals a splendidly diverse sequence of green tones, ranging from a dark cobalt or cinnabar green to the green of luxuriant mosses to a very light green, found only as a delicate hint in the shimmering ochre of the fields. Even the sun-bleached yellow of the stalks and ears of grain and the isolated patches of sky-blue among the gray clouds refer to the basic components of the color green.

Now an Impressionist through and through, Renoir, who spent the summer of 1873 painting with Monet in the open air in the countryside around Argenteuil, sought to capture impressions gained directly from nature (cat. no. 21). Decades later he would remark in an entirely pragmatic vein that the availability of pigments in tubes—that is, in a form convenient to transport and handle—was one of the essential preconditions for the development of open-air painting.[1]

Oil on canvas
47 x 61 cm
Signed and dated,
lower right: A. Renoir. 73.
Private collection,
courtesy of
Galerie Nathan, Zurich

1 "I, for example, am thoroughly convinced that it is better for a painter to grind his pigments himself, or to have an apprentice do it for him. But since there are no apprentices anymore, and because I would rather paint than grind pigments, I buy them from my old friend Mullard, the paint dealer in the Rue Pigalle, who grinds them for me So I make do with paints in tubes But I am rewarded for my passivity. These tube paints, which are so easy to transport, enable us to really paint from nature. Without them there would be no Cézanne, no Monet, no Sisley or Pissarro, nor would we have what the journalists call Impressionism" (Renoir 1981, p. 69).

Provenance
Georges Petit, Paris; Paul Cassirer, Amsterdam; Siegfried Kramarsky, New York; Rosenberg & Stibl, New York

References
Fezzi 1972, pp. 93f., No. 99, ill.; Wheldon 1975, pp. 56, 58, 63, Ill. 43; Nathaniel Harris, *A Treasury of Impressionism*, Hamlyn 1979, p. 151, ill.; Rouart 1985, p. 32, ill.; Denis Thomas, *The Age of the Impressionists*, London 1987, p. 94, ill.; Monneret 1990, p. 149, No. 23, ill.

Exhibitions
Chefs-d'œuvre des Collections Suisses de Manet à Picasso, Musée de l'Orangerie, Paris, 1967, No. 52, ill.; *Landschaft im Licht, Impressionistische Malerei in Europa und Nordamerika 1860–1910*, Wallraf-Richartz-Museum, Cologne—Kunsthaus, Zurich, 1990, No. 150, Ill. 60; London 1995, No. 54. ill.

23 The Little Theater Box 1873–1874
La petite loge

Oil on canvas
27 × 20.7 cm
Signed, upper right:
Renoir.
Stiftung Langmatt,
Sidney and Jenny Brown
(Inv. no. 179/GZ),
Baden, Switzerland
Daulte 1971, No. 91

Renoir used the motif of spectators in a theater box, a subject treated by Daumier and featured in many popular prints of the period, to develop a representative pictorial theme. None of his fellow artists, not even Manet or Degas, whose interests the motif would presumably have well suited, had previously concerned themselves with this form of seeing and being seen. Degas depicted such scenes in isolated works beginning in the late 1870s,[1] and Toulouse-Lautrec devoted considerable attention to the theme in his graphic art (ill. p. 122).[2] It first attracted the public eye in 1874, the year Renoir caused such an uproar among the critics with his painting *La loge* (ill. p. 122) at the first Impressionist exhibition in Nadar's studio. That work, a frontal view of a couple shown seated in a theater box, preceded this smaller and less elaborately executed painting (and another variation on the theme of the same size[3]) presenting a couple in profile.[4]

Characterized by a delicacy fully in keeping with its small format, the painting was dated by Daulte to the year 1873. He identified the two figures in the box as Monsieur and Madame Lainé. Edouard Lainé (1841–1888), to whom the second version of the painting mentioned above originally belonged, was an acquaintance of Degas. The two had met during the war in 1870 while serving in the national militia. Degas painted Lainé and two other comrades in March of 1871.[5] Yet there is no resemblance between the figure in the Degas portrait and the man in Renoir's *Theater Box* of 1873, and it is highly unlikely that the subject of the latter is Lainé.[6] Thus the identities of the woman in the elegant high-collared evening dress and her indispensable companion remain uncertain.

In the manner of a relief or a coin portrait, the two heads are juxtaposed, one forward and the other to the rear. The woman appears to be perusing a vaguely suggested program or libretto, while her companion's gaze is fixed on events taking place at a distance. The two figures, whose apparent size derives from the somewhat lowered perspective, are surrounded by the dark purple of the chair back and the theater box partition in the background, which is crowned by a sweeping curve of golden trimming. Renoir interspersed the black—a color that had fallen into disfavor among the Impressionists—of the man's coat with the pure white of the shirtfront, while the white elements of the dress are accentuated by the black ribbon around the woman's neck. Following Manet's example, he also made frequent use of black as a localized color of great brilliance, although he did not ignore the Impressionists' dictate that black should not be used to darken shadows.

For Renoir, the seating areas for the audience in the stalls and boxes—along with the people who frequented them—were much more

1 Lemoisne 1946, II, III, Nos. 434, 476, 577, 580, 584, 737, 828.

2 Götz Adriani, *Toulouse-Lautrec. Das gesamte graphische Werk*, Cologne 1986, Nos. 8, 66, 69, 129, 194, 196, 202, 204, 212, 214, 314.

3 Daulte 1971, No. 92.

4 Quite similar in detail, these two paintings were followed in 1876 by *La première sortie* (ibid., No. 182). The subject appears to have fascinated female artists in particular, including Mary Cassatt, Berthe Morisot and Eva Gonzales. This characteristic view of the loge is absent in Renoir's later scenes of the theater and its visitors (ibid., Nos 329, 350, 630).

5 Lemoisne 1946, II, No. 287.

6 London–Paris–Boston 1985–1986, p. 204.

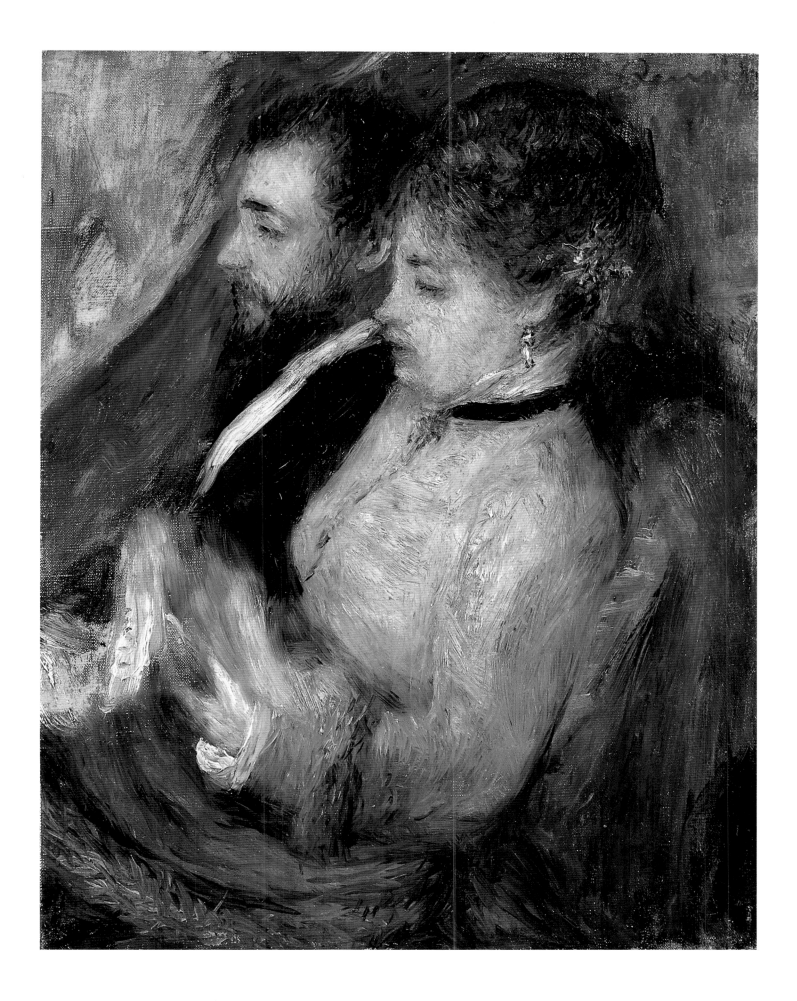

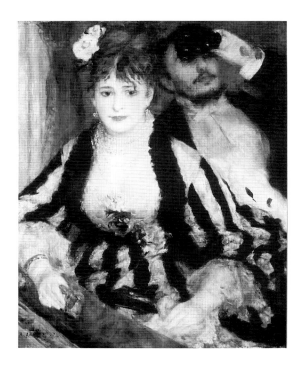

Renoir, *The Theater Box*, 1874,
Courtauld Institute Galleries,
London

Henri de Toulouse-Lautrec,
Divan Japonais, 1892–1893,
lithograph, private collection

important aspects of the theater than the stage itself. "'I think that the drama is played out in the audience as well. The audience is just as important as the actors!'" he once explained to his son Jean. "He told me that the theater stalls in Italy of the 18th century were comprised exclusively of boxes. People looked upon the theater as a social gathering place, and they wanted to see not only the play but the other people as well. The theater box, often preceded by a tiny boudoir, was but an extension of the salon 'What annoys me about the modern theater is its solemnity. You'd think you were attending mass. If I want to go to mass, I will go to church!' I must admit that, as a stage and screen writer, I do not completely share my father's enthusiasm for people in the audience who talk during a performance We go to the theater to watch a plot unfold or to observe the development of characters— things in which my father wasn't the least bit interested. He went to the theater in much the same way as other people take Sunday walks, to enjoy the fresh air, the flowers and especially the other people strolling about. He had the gift of being able to take in ten different impressions at once and concentrate on only one of them."[7]

7 Renoir 1981, pp. 164f.

Provenance
Ambroise Vollard, Paris (?); Georges Viau, Paris; Auction *Viau*, Durand-Ruel, Paris, March 21–22, 1907, No. 74; Eugène Blot, Paris; Galerie Neupert, Zurich; Sidney W. Brown and Jenny Brown-Sulzer, Baden; acquired in 1916.

References
A. Basler, *Pierre-Auguste Renoir*, Paris 1928, Ill. 19; Daulte 1971, No. 91, ill. p. 414; Fezzi 1972, p. 94, No. 112, ill.; Deuchler 1990, pp. 174f., ill.

Exhibitions
Paris 1900, No. 44.

24 Madame Claude Monet and her Son Jean in the Garden at Argenteuil 1874
Madame Claude Monet avec son fils Jean dans le jardin à Argenteuil

After participating in the legendary first "Impressionist Exhibition" in April and May of 1874—a show in which the more successful Manet had prudently declined to participate—Renoir spent the summer months as a guest of the Monets in Argenteuil as he had done in previous years. Monet and his family occupied a house with a garden at Rue Pierre Guienne 2. A 15-minute train ride from Paris, the suburban town on the Seine, at that time still an idyllic location, lay across the river from Gennevilliers where Manet spent his summers. Thus it was to be expected that Renoir and Monet would meet with their neighbor from the opposite bank, providing Manet with an opportunity to discover his younger colleagues' practice of open-air painting.

Manet's painting of Monet with his wife Camille (cat. nos. 17, 18) and their son Jean-Armand-Claude in the garden at Argenteuil (ill. p. 124), as well as Renoir's adaptation of Manet's approach in this modified version, represents a milestone in the history of art. Renoir's comment to Ambroise Vollard about the occasion some time later bears a trace of self-irony: "I arrived at Monet's home just as Manet was beginning to paint his subject. You can surely imagine that I would not fail to take advantage of the opportunity offered by the presence of these models. After I left, Manet said to Claude Monet, 'You're a friend of Renoir's. You should persuade him to forget painting! Can't you see how little talent he has for it?'"[1] Even the aging Monet, the proud owner of this unaffected family scene, remembered the occasion: "This marvelous painting of Renoir's, which I am fortunate to own, is a portrait of my first wife. It was done in our garden in Argenteuil. Thrilled by the colors and the light, Manet started painting a picture outdoors with people beneath the trees. Renoir arrived at the scene while he was working. He, too, was captivated by the atmosphere of the moment. He asked me to give him a palette, a brush and a canvas so that he could paint at Manet's side. Manet watched him out of the corner of his eye, wandering over to him from time to time to cast a glance at the canvas. Then he made a face, walked quietly over to me and whispered in my ear: 'The boy has no talent! You're his friend—tell him to give up painting! . . . ' Wasn't that an amusing thing for Manet to say?"[2]

Renoir set up his easel in front of Manet's in order to narrow the field of view. Manet's larger horizontal format included the figure of Monet gardening at the left. Renoir concentrated on the representation of the mother and her son. His close-up view focuses much more immediately on the pyramidal arrangement of the two figures than Manet's secularized Holy Family in the garden of paradise. The energy

Oil on canvas
50.4 × 68 cm
National Gallery of Art
(Alisa Mellon Bruce
Collection,
Inv. no. 1970.17.60),
Washington, D. C.
Daulte 1971, No. 104

1 Vollard 1961, p. 43.

2 Marc Elder, *Chez Claude Monet à Giverny*, Paris 1924, p. 70.

123

of the thinly applied brushstrokes visible in the mother's dress and the suit worn by the reclining boy—her first-born child, only seven years old at the time—is attributable to Manet's influence. Despite the rather pensive, distant attitude of Madame Monet, who died of consumption five years later after years of severe deprivation, this painting is Renoir's homage to the joys of his hosts' life in the country. This scene, now regarded as the epitome of Impressionist *joie de vivre*, shows summer guests, dressed in the high-buttoned style of city-dwellers, relaxing and enjoying themselves beneath a tree on the grassy green of a garden lawn. The rooster on the right was presumably perceived only as a color accent, effectively complemented by the edge of a flowerbed in the upper left-hand corner. The only relief from the noonday heat is provided by the red, white and blue fan, a prop Camille also holds in the later work *La japonaise* (ill. p. 107). The hat, however, was probably borrowed from Madame Manet, as she is seen wearing it in several other paintings by her husband.[3] Intended as a gift to his friend Monet, the painting was left unsigned and undated (cat. no. 5).[4]

3 Paris–New York 1983, p. 363

4 Monet also owned the Renoir portraits identified in Daulte 1971 as Nos. 28, 47, 78, 85, 86, and 130 as well as the *Baigneuse*, ibid., No. 396.

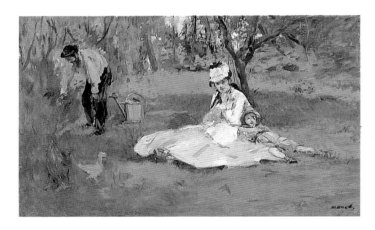

Edouard Manet,
The Monet Family in their Garden, 1874,
The Metropolitan Museum of Art, New York

Provenance
Claude Monet, Giverny; Michel Monet, Giverny; Edward Molyneux, Paris; Alisa Mellon Bruce, New York; presented as a gift in 1970.

References
Mirbeau 1913, p. 2, ill.; Vollard 1919, pp. 52, 67; Vollard 1924, pp. 58f.; Meier-Graefe 1929, p. 32; Graber 1943, p. 48; ill. pp. 67–68, p. 156; Vollard 1961, p. 43; Gimpel 1963, p. 155; Rewald 1965, Ill. 113; Daulte 1971, No. 104, ill. p. 412; Fezzi 1972, pp. 94f., No. 123, ill.; Gaunt-Adler 1982, No. 17, ill.; Ehrlich White 1984, pp. 51, 55, ill.; Keller 1987, pp. 48, 50, Ill. 37; Bade 1989, pp. 74f., ill.; Monneret 1990, pp. 11, 52, ill. p. 156.

Exhibitions
Paris 1913, No. 6; Paris 1933, No. 30; *French Paintings from the Molyneux Collection*, The Museum of Modern Art, New York, 1952, pp. 8, 12, ill; *French Paintings of the Nineteenth Century from the Collection of Mrs. Mellon Bruce*, The California Palace of the Legion of Honor, San Francisco, 1961, No. 53, ill; *Impressionist Treasures from Private Collections in New York*, Knoedler, New York, 1966, No. 31, ill.; *French Paintings from the Collections of Mr. and Mrs. Paul Mellon and Mrs. Mellon-Bruce*, The National Gallery of Art, Washington, 1966, No. 99, ill.; London–Paris–Boston 1985–1986, No. 30, ill., pp. 196, 253; *Französische Impressionisten und ihre Wegbereiter aus der National Gallery of Art, Washington und dem Cincinnati Art Museum*, Neue Pinakothek, Munich, 1990, No. 48, ill.

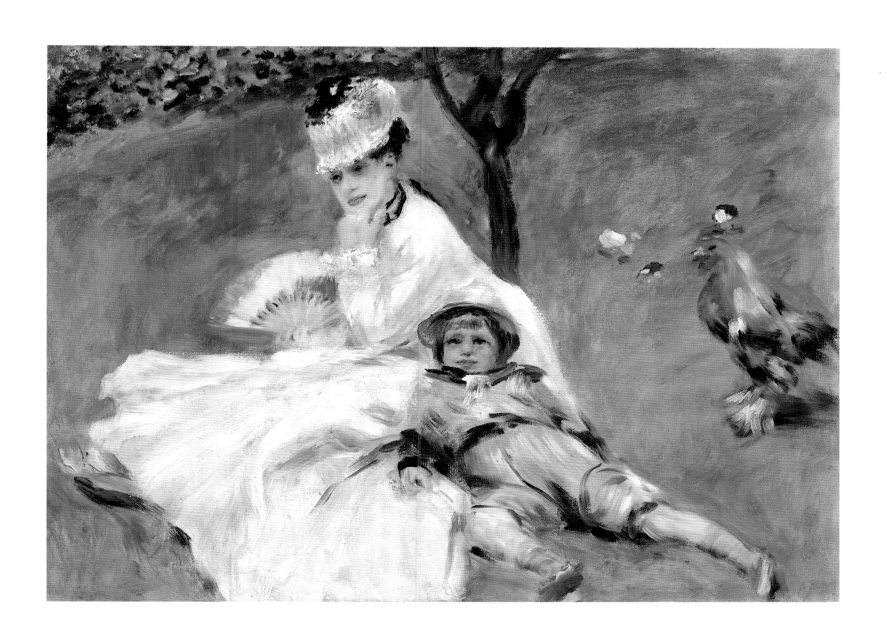

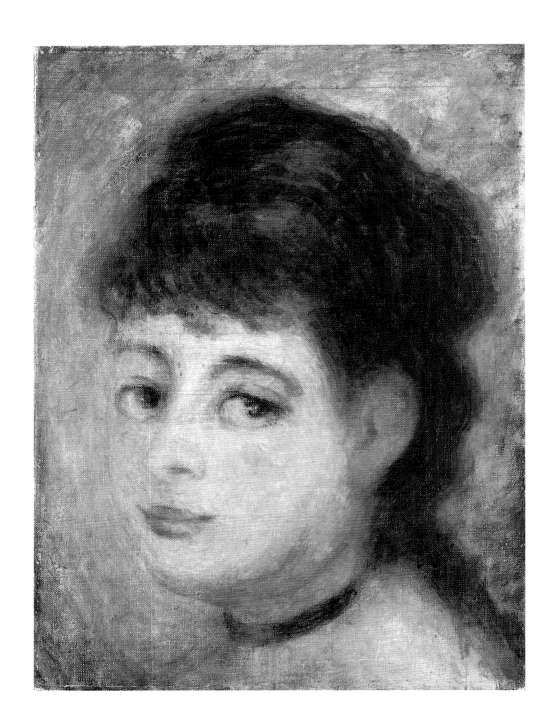

25 Portrait of a Young Woman.
The Parisian ca. 1875
Portrait de jeune femme.
La Parisienne

Despite the unmistakably individual features, the beautiful young woman with the large almond eyes has never been identified. She is one of the countless dark-haired beauties who filled the streets of Montmartre. Renoir used her as a model in an attempt to apply his Impressionist approach to color, developed in landscape painting, to the genre of portraiture and thus to intensify its expressive power.

Provenance
Heinrich Thannhauser, Munich; Dr. Arthur Hahnloser and Hedy Hahnloser-Bühler, Winterthur; Professor Hans R. Hahnloser, Berne.

References
Meier-Graefe 1929, p. 69, Ill. 50; Daulte 1971, No. 135, ill.; Fezzi 1972, pp. 96f., No. 169, ill.; Monneret 1990, p. 150, No. 25, ill.

Exhibitions
Winterthur 1935, No. 4; *Sammlung Dr. Arthur Hahnloser*, Kunstverein, Winterthur, 1937, No. 107; *Die Hauptwerke der Sammlung Hahnloser*, Kunstmuseum, Lucerne, 1940, No. 91, Ill. 4.

Oil on canvas
33 × 24 cm
Signed, lower left:
Renoir.
Private collection,
Switzerland
Daulte 1971, No. 135

26 Portrait of Madame Chocquet in White
1875
Portrait de Madame Chocquet en blanc

Renoir probably met the collector Victor Chocquet on March 23 or 24, 1875, at the auction of 73 Impressionist paintings organized by the artist at the Hôtel Drouot in Paris, an event that was accompanied by public protest (cat. nos. 19, 21). The incensed crowd turned the auction into a scene of unprecedented tumult, forcing the auctioneer to call in the police to restore order. Renoir's paintings drew the lowest bids among the works offered for sale. Yet he later confessed to Vollard that the auction had "nonetheless brought about a fortunate turns of events: I met Monsieur Chocquet, a government official who had succeeded in acquiring a remarkable collection despite his modest resources. Back then, and much later as well, one did not need to be rich in order to collect paintings; all it took was a little taste. Monsieur Chocquet had

Oil on canvas
75 × 60 cm
Signed and dated,
center right: Renoir. 75.
Staatsgalerie
(Inv. no. 2564),
Stuttgart
Daulte 1971, No. 142

happened to come to the Hôtel Drouot during our exhibition. He recognized in my paintings a certain small resemblance to Delacroix, his idol. That very same evening he wrote me a letter in which he paid all manner of compliments to my painting and asked if I would paint Madame Chocquet. I accepted his offer without hesitation. If you have ever seen the portrait, Vollard, then you have probably also noticed the copy of a Delacroix in the upper portion of the painting. This Delacroix was part of Chocquet's collection. It was at his own request that I incorporated the Delacroix into my painting: 'I wish to have you together,' he said, 'you and Delacroix!'"[1]

By the time of this remarkable encounter, through which he became Renoir's friend and devoted patron, the customs inspector Chocquet had already amassed a highly respectable collection with purchases made initially from his own modest income and later from funds inherited by his wife.[2] In addition to French art of the 18th century, he had also acquired works by Courbet, Corot, Daumier and Diaz. For Jean Renoir, "Father Chocquet" was a good friend of Renoir during his years in the Rue Saint-Georges: "Renoir called him 'the greatest French collector since the days of the kings, perhaps the greatest in the world since the Popes!' . . . Monsieur Chocquet was a customs inspector. His salary was meager. Even as a youth he saved on meals and clothing in order to be able to purchase objects of art, especially from 18th-century France. He lived in an attic flat and went about in rags, but owned clocks by Boulle Soon, people began to develop an interest in Chocquet in Paris. Renoir attributed this popularity to the rising prices for Watteau's work. Chocquet possessed a number of paintings by the master. He had paid a few hundred francs for them, when no one wanted them. People spoke of his dressers, his mirrors and chandeliers from the age of Louis XV and Louis XVI He took advantage of this curiosity, exhibiting his Renoirs and Cézannes ostentatiously in genuine Louis-Quinze frames. Even though he thought that Louis-Quatorze was more suited to Cézanne, since it brought out the depth better."[3]

Chocquet's special favorite was Delacroix, whom he had asked to paint his wife Augustine Marie Caroline, née Buisson (1837–1899) in 1862. But Delacroix had refused, explaining that he "had abandoned portrait painting entirely because of a certain hypersensitivity of the eyes."[4] Evidently, the collector recognized a worthy successor in Renoir 13 years later and wished to entrust him with the task. Renoir seized the chance immediately and did his very best to satisfy his client. Chocquet wished to have his wife, a woman of 38 whom he had married in 1857, portrayed as an understanding supporter of his passionate collecting activity. Thus the painter opened a view to her left through an open doorway, revealing gold-framed paintings and a rococo-style table, placing the elaborately framed segment of a painting by Delacroix on the wall to the right.[5] In this way, he gave striking expression to the collectors' special interest and the ambience of their dwelling at Rue de Rivoli 204.

1 Vollard 1961, p. 51.

2 Rivière 1921, pp. 37ff.

3 Renoir 1981, pp. 168f.

4 Rewald 1965, p. 63.

5 This study for the decoration of the cupola of the Palais Bourbon shows *King Numa and his Wife Egeria*.

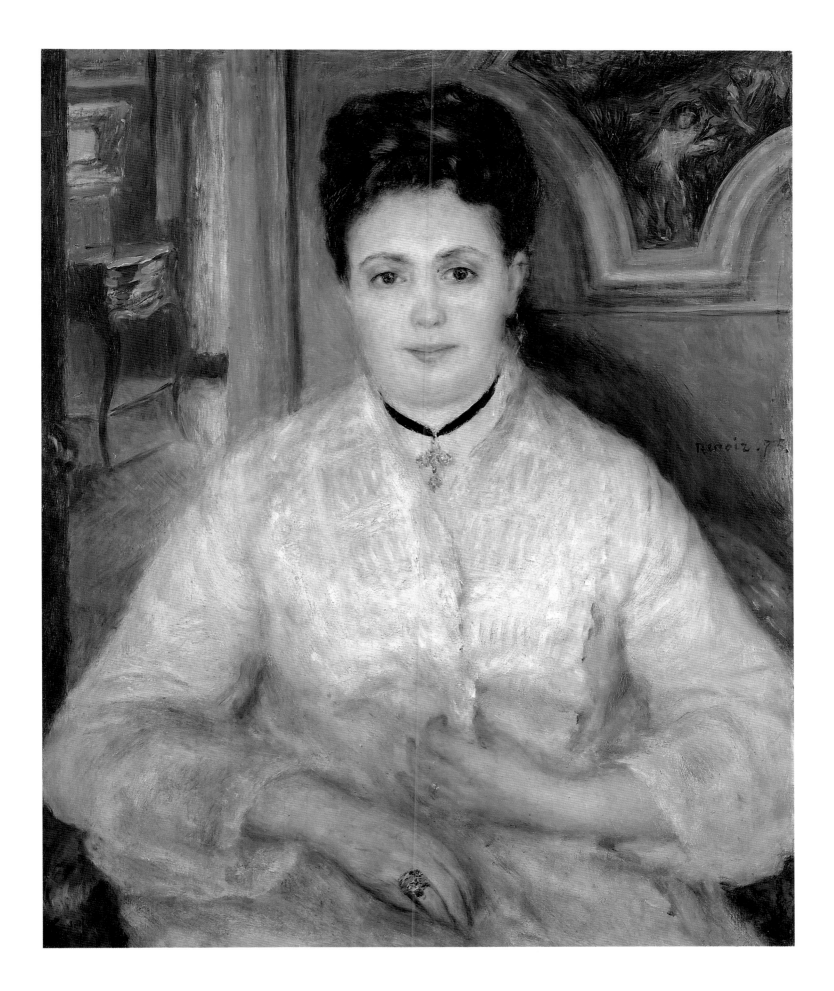

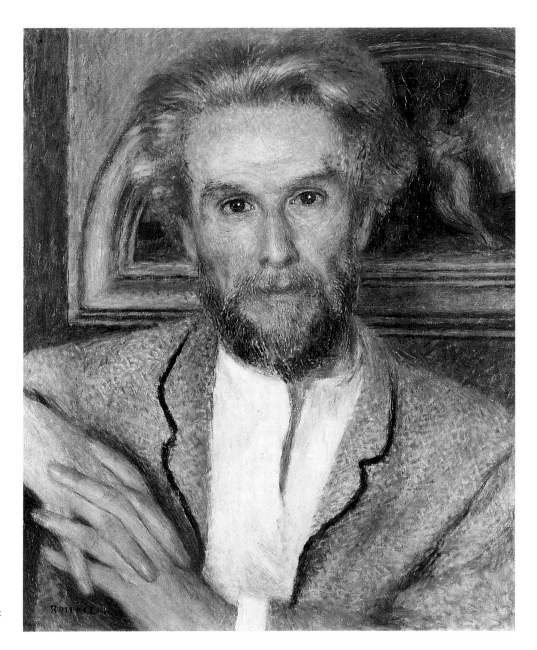

Renoir, *Portrait of Victor Chocquet*, ca. 1875, Fogg Art Museum, Harvard University Art Museums, Cambridge, MA

6 White, incidentally, is the color most apt to be associated with Renoir—in much the same way that Manet restored black to the status of a color on the basis of insights gained from the art of Velázquez and Goya. Both as a localized color and an accentuating light pigment at the vertices of primary colors, white had been a significant element in his palette since his days as a porcelain painter.

Not only does this background information help explain the content of the painting, it is also significant for an understanding of the use of color and form. The view into another room lends the portrait an added dimension of depth, while the warm golden yellow of the picture frame counterbalances the rather cool white of the figure, rendered in light brushstrokes in a full frontal view.[6] The white dress streaked with blue finds its polar opposite in the dark hair, eyes and ribbon around Madame Chocquet's throat as well as in the shadows on the olive-tinted wall and in the section of a door panel bordering the composition on the left.

Monsieur and Madame Chocquet were surely impressed with the efforts of their portraitist. The very next year they ordered two more portraits of Madame Chocquet showing her at the window of their

apartment with a view of the Tuilleries as well as two smaller bust portraits of Victor Chocquet (ill. p. 130).[7] Chocquet himself was prompted by his encounter with Renoir to expand his collecting activities to include the work of other young artists whose work was in disrepute, including Manet, Monet, Sisley, Pissarro and others. Moreover, it was Renoir who pointed out to Chocquet that Cézanne was the most important of the widely rejected Impressionists, an opinion the customs inspector readily adopted as his own. Over the years he acquired 35 paintings by Cézanne, an artist who shared his profound devotion to Delacroix.[8] After Madame Chocquet's death, the collection was auctioned at the Galerie Georges Petit on July 1–4, 1899. Of the 14 Renoirs Chocquet had acquired, however, only ten paintings, a pastel and a drawing were listed in the auction catalogue. Neither this portrait of Madame Chocquet nor the two likenesses of her husband are mentioned.

7 Daulte 1971, Nos. 173 (the painting formerly held at the Kunsthalle Bremen has been kept under lock and key at the Pushkin Museum in Moscow since the end of the Second World War), 174–176.

8 John Rewald, "Chocquet et Cézanne," in *Gazette des Beaux-Arts*, LXXIV, 111, July–August 1969, pp. 33ff.

Provenance
Victor Chocquet, Paris; Durand-Ruel, Paris; Georges Bernheim, Paris; Georges Viau, Paris; Trygve Sagen, Oslo; Walther Halvorsen, Oslo; Ragnar Moltzau, Oslo; acquired in 1959.

References
Duret 1906, p. 289; Vollard 1919, pp. 75ff.; Vollard 1924, p. 67; Meier-Graefe 1929, pp. 86, 88, Ill. 61; P. Jamot, "L'Art français en Norvège," in *La Renaissance de l'Art français*, February 1929, p. 71, ill.; Barnes-de Mazia 1935, pp. 51, 64, 446, No. 42; J. Joets, "Les Impressionistes et Chocquet," in *L'Amour de l'Art*, 1935, p. 123, ill.; J. This, *Renoir*, Oslo 1940, p. 23; Graber 1943, p. 50; Drucker 1944, p. 184; Rouart 1954, p. 37; Vollard 1961, p. 51; Perruchot 1964, pp. 103, 105; Rewald 1965, Ill. 120; Peter Beye and Kurt Löcher, *Katalog der Staatsgalerie Stuttgart, Neue Meister*, Stuttgart 1968, pp. 148f., Ill. 26; John Rewald, "Chocquet et Cézanne," in *Gazette des Beaux-Arts*, LXXIV, 111, July–August 1969, p. 39, Ill. 2; Daulte 1971, No. 142, ill. p. 411; Fezzi 1972, pp. 96f., No. 176, ill.; Daulte 1973, pp. 26, 29, ill.; Wheldon 1975, pp. 67, 69, Ill. 49; Callen 1978, pp. 14, 58, ill.; Gaunt-Adler 1982, p. 15, Ill. 21; Christian von Holst, *Katalog Staatsgalerie Stuttgart, Malerei und Plastik des 19. Jahrhunderts*, Stuttgart 1982, pp. 118f., ill.; Ehrlich White 1984, p. 60, ill.; Rouart 1985, pp. 36f., ill.; Shimada 1985, Ill. 41; London–Paris–Boston 1985–1986, p. 27; Melissa McQuillan, *Porträtmalerei der französischen Impressionisten*, Rosenheim 1986, pp. 16f., ill.; Keller 1987, p. 58, Ill. 43; Monneret 1990, pp. 11, 151, No. 3, ill; Distel 1990, p. 132, ill.

Exhibitions
Exposition d'art français contemporain, Château des Rohan, Strasbourg, 1907, No. 226; *Renoir*, Galerie Leicester, London, 1926, No. 8, ill.; Paris 1933, No. 22; *Exposition d'art français*, Svensk–Franska Konstgalleriet, Stockholm, 1935, No. 12; New York 1937, No. 9, ill.; *Sammlung Moltzau*, Kunsthaus, Zurich, 1957, No. 81, ill.; *Neuere Französische Malerei aus der Staatsgalerie Stuttgart*, Kunsthalle, Karlsruhe, 1961–1962, pp. 29f., Ill. 1.

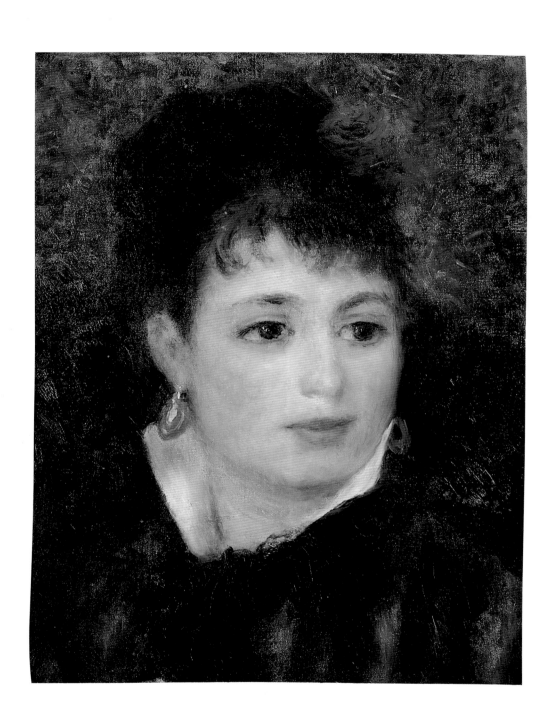

27 Woman with a Rose 1875–1876
Femme à la rose

This finely nuanced portrait of a young woman, turned to the right with a dark red rose in her hair, once belonged to the Jean Dollfus collection. A native of Alsace, the industrialist Dollfus was an early admirer of Renoir, whose affinities to Delacroix he especially appreciated (cat. no. 26). In 1875, he commissioned the painter to copy Delacroix's *La noce juive* in the Louvre for a fee of 500 francs.[1] While selecting his submissions to the second Impressionist exhibition in April 1876, a show in which he was represented with 15 works including 12 portraits, Renoir asked Dollfus to lend him both his portraits of Monet and the *Femme à la rose*. Six works by Renoir remained in the collector's possession until the latter's death in 1911; they fetched gratifyingly high prices at the Dollfus auction conducted by Georges Petit on March 2, 1912.[2] The tiny second version of *La loge* was purchased for 31,200 francs, while *Femme à la rose*, No. 58 in the auction, went for an impressive 10,550 francs.[3]

It is hard to imagine a less complicated composition than this portrait of a woman with her smooth, regular facial features and her head turned discreetly away from the central axis of the painting. Renoir was particularly adept at imbuing the bust portrait with life, a form that had been employed almost excessively since the early Renaissance. The painterly qualities of the portrait as well as its Jewish provenance earned it the dubious honor of confiscation by the German occupation forces in France during the Second World War for the collection of Hermann Göring.

Oil on canvas
35.5 × 27 cm
Signed at right, above shoulder: Renoir.
Fondation Rau
(Inv. no. GR 1.682)
Daulte 1971, No. 167

1 Daulte 1971, No. 139.

2 Ibid., Nos. 87, 115, 132, 139, 167, 214.

3 In this connection it should be noted that the Berlin art dealer Paul Cassirer acquired the monumental painting *Allée cavalière au bois de Boulogne* (now in the possession of the Kunsthalle in Hamburg) for 95,000 francs at the Rouart auction held in December of the same year (ibid., No. 94).

Provenance
Jean Dollfus, Paris; Auction *Dollfus*, Georges Petit, Paris, March 2, 1912, No. 58; M. Stettiner, Paris; Paul Rosenberg, Paris; confiscated by German occupation troops by order of Hermann Göring in 1941; private collection, Paris; Auction, Christie's, London, July 3, 1973, No. 17.

References
Venturi 1939, II, p. 258; Daulte 1971, No. 167, ill.; Fezzi 1972, p. 100, No. 253, ill.; Bernard Dunston, *Painting Methods of the Impressionists*, New York 1983, p. 57, ill.; Distel 1990, p. 152.

Exhibitions
2e exposition des Impressionnistes, Rue le Peletier, Paris, 1876, No. 217; *Les chefs-d'œuvre des collections privées françaises retrouvés en Allemagne*, Musée de l'Orangerie, Paris, 1946, No. 44; London 1995, No. 59, ill.

28 The Conversation, Rivière and Margot. At the Fireside 1875
La conversation, Rivière et Margot. Au coin de la cheminée

Oil on canvas
61.5 x 50.6 cm
Signed, lower right:
Renoir
Staatsgalerie
(Inv. no. 2537),
Stuttgart
Daulte 1971, No. 137

Although the artist's painting style makes it almost impossible to identify the two figures in this picture, their names are known from a corresponding photograph.[1] The young man leaning against the fireplace is Georges Rivière (1855–1943), a 20-year-old friend of Renoir. Depicted for the first time in this painting,[2] Rivière made a name for himself as an art critic and later as a ministry official. He published his memories of the artist and his friends in 1921.

Jean Renoir referred to him as one of his father's closest friends during the years between 1874 and 1890: "His work at the Ministry of Finance left him sufficient spare time, which he devoted entirely to my father. He later became a department head, then cabinet chief; he married and had children. These manifold duties took him far away from the Montmartre of his youth."[3]

One of the pioneer advocates of Impressionist ideas, Georges Rivière had been part of the circle of Renoir's closest friends since 1874, a group that met regularly in the artist's studio on the top floor of the building at Rue Saint-Georges 35.[4] Hoping to attract public attention to the Impressionist movement above and beyond the two exhibitions held in 1874 and 1876, Rivière, 14 years younger than Renoir, followed the artist's advice to publish a journal with explanatory texts in defense of the movement. The weekly appeared in five issues written primarily by Rivière and Renoir under the title *L'Impressionniste journal d'art* from April 6 to April 28, 1877.[5]

Seated on the right in the painting is Marguerite Legrand, a model known as "Margot" (cat. nos. 39, 47, 48), whom Rivière described in the following words: "Margot had dull, chestnut-colored hair with little body, light eyebrows, and her reddened lids had no lashes. The somewhat thick nose seemed to sit between the bulging cheeks as if positioned between two pillows, and the sensitive mouth with its heavy, blood-red lips occasionally formed an arrogant smile Margot was loud. In a word, she represented the typical suburban rabble. Yet somehow, thanks to his gifts, Renoir created figures that made her look pretty, indeed quite respectable."[6]

Margot was also a frequent visitor to Renoir's studio in the years from 1875 to 1878. Her own domicile was nearby, at Rue Lafayette 47. She contracted smallpox in January of 1879, and the artist asked the physicians Dr. Gachet—a friend of Cézanne and later van Gogh's medical advisor—and the collector Dr. de Bellio to look after her. Yet their efforts were in vain, and she died on February 25, 1879.[7]

1 Vollard 1918, I, p. 6, No. 24.

2 Renoir's portraits of Rivière were painted during the years 1876 to 1880. Daulte 1971, Nos. 188, 198, 207–209, 238, 259, 346.

3 Renoir 1981, pp. 159f. Rivière's two daughters, Hélène and Renée, married Renoir's nephew Edmond Renoir and Cézanne's son Paul. Ibid., p. 325.

4 Rivière 1921, pp. 3, 61ff.

5 Ibid., pp. 154ff.

6 Ibid., p. 66.

7 Ehrlich White 1984, pp. 89ff.

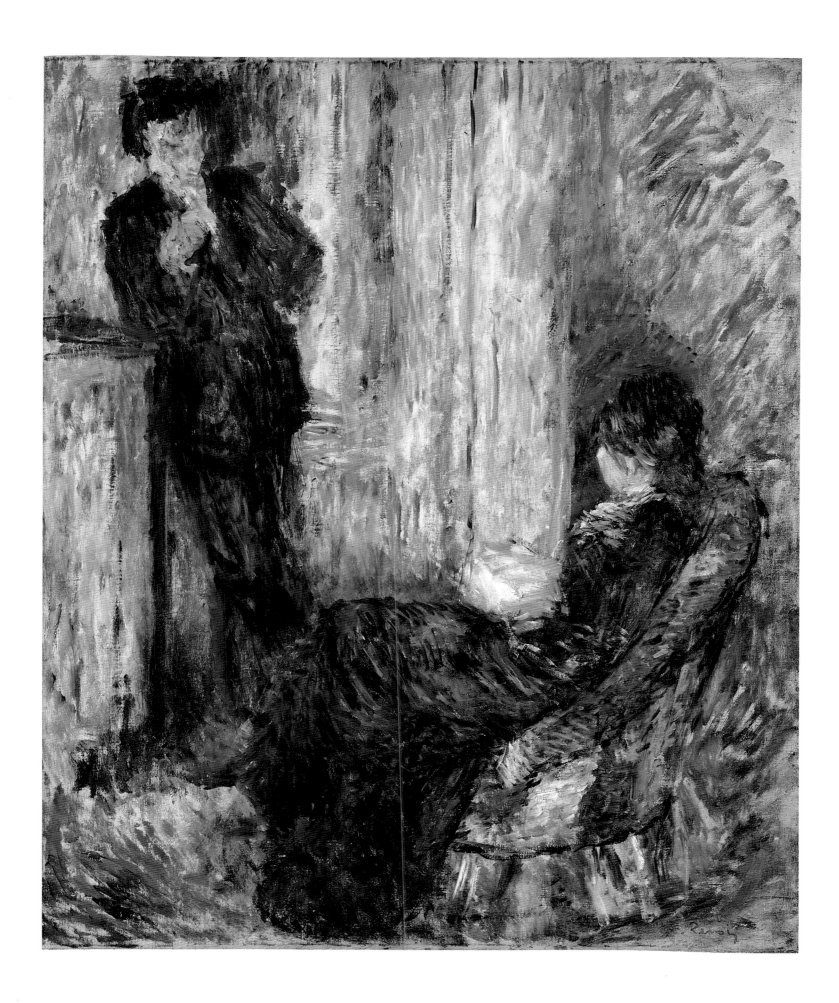

Presumably painted in Renoir's rooms on the Rue Saint-Georges, *The Conversation* is his first true interior scene. It was followed by a number of smaller interiors sketched in much the same manner in which, characteristically, either Rivière or Margot played leading roles (cat. nos. 46–48).[8] It is also Renoir's most painstaking attempt to take the insights regarding the dissolution of color gained through open-air painting and apply them to an interior setting. Although the result is not without merit, it was to remain the only work of its kind with respect to scale and consistency of execution.

The staccato of brushstrokes applied to the light ground of the canvas is most densely concentrated in the deep blue of the two figures. A translucent curtain of delicate blue combines with the warm yellow hues of a wall—merely suggested in cross-hatching—to illuminate the room from the depths of the painting. Margot is seated on a patterned stuffed chair that was part of the studio furniture. The back of the chair appears to mold itself around her body in a supple curve. Holding an open book in her lap, she directs her gaze towards the man standing at the fireplace. His prominent features are strikingly irregular and angular in comparison to hers. The subtly developed interactions and oppositions between the two people engaged in conversation, expressed in the juxtaposition of man and woman, of standing and seated figures and of bodies viewed frontally and in profile, are the real subject of this painting. Yet Renoir established an easy balance between this substantive aspect and what he wished to express as a painter in his use of brush and paints.

8 Daulte 1971, Nos. 188, 238.

Provenance
Ambroise Vollard, Paris; private collection, England; Kurt Meissner, Zurich; acquired in 1959.

References
Vollard 1918, I, p. 6, No. 24, ill; Vollard 1919, ill. pp. 54–55; Peter Beye and Kurt Löcher, *Katalog der Staatsgalerie Stuttgart. Neue Meister*, Stuttgart 1968, p. 149, Ill. 25; Daulte 1971, No. 137, ill. pp. 415, 418; Fezzi 1972, pp. 96f., No. 170, ill.; Christian von Holst, *Katalog Staatsgalerie Stuttgart. Malerei und Plastik des 19. Jahrhunderts*, Stuttgart 1982, pp. 119f., ill.

Exhibitions
New York 1950, No. 16; *Neuere Französische Malerei aus der Staatsgalerie Stuttgart*, Kunsthalle, Karlsruhe, 1961–1962, p. 30, Ill. 2.

29 The Page. Madame Henriot Dressed as a Man ca. 1875
Le Page. Madame Henriot en travesti

At the first Impressionist exhibition in 1874, Renoir showed his painting *Parisienne* (ill. p. 139), a typified image of a fashion-conscious Parisian woman in the person of the actress Henriette Henriot, who performed at the Théâtre de l'Odéon from 1863 to 1868. This full-figure portrait of identical dimensions features her in an entirely different role. Whereas the earlier painting portrayed the society lady dressed for an evening on the town, her sartorial splendor worthy of illustration in the popular fashion journals of the time, the subject here is an actress in the costume of a page, shown in the familiar setting of her theatrical profession. Strangely, Renoir seldom gave much thought to the ambiences associated with a protagonist's activities, functions, or professional involvement. Strictly speaking, in the period from 1860 to 1890 he did so only in the two portraits of his friends Bazille and Monet in the act of painting, in two paintings with circus settings and in several later rural scenes.[1] His willingness to depict aspects of the surroundings and professional milieu of his subject may reflect the wishes of Henriette herself, a well-known actress. With a degree of ironic distance, he even grants her some of the honorific attributes of pose and dress that had been restricted primarily to rulers since the introduction of the life-sized, courtly single portrait by Titian or Clouet.

Henriette Henriot occupied a special position among the numerous models engaged by Renoir for five francs per sitting. Next to Lise Tréhot in his early years (cat. nos. 8–10), Marguerite Legrand (cat. nos. 28, 47, 48) and Nini Lopez during the 1870s, and after 1880 Aline Charigot, who later became his wife (cat. nos. 58, 76–78), the actress was his most frequent model between 1874 and 1876 (cat. no. 30). With the exception of Lise Tréhot, moreover, none of the women mentioned was featured so exclusively in large-scale portraits.[2] By portraying Henriette Henriot, who had introduced him to the theater milieu, in her role as an actress on stage (a stage which nonetheless was never to became a theme in his work), Renoir established the distance necessary to satisfy her desire for conventional self-representation, i.e. in a style that conformed to long-standing pictorial traditions. The portrait's satirical overtones may have been the reason why the large canvas long remained in the possession of a junk dealer in the Rue de Rennes, who offered it for 80 francs, before it was finally acquired for the collection of the Prince de Wagram.[3]

Oil on canvas
161.3 x 104.8 cm
Signed, lower right:
Renoir.
Columbus Museum of Art
(Howald Fund),
Columbus, Ohio
Daulte 1971, No. 123

1 Daulte 1971, Nos. 28, 38, 131, 292, 297, 466, 467, 498, 499.

2 Ibid., Nos. 102, 109, 124, 127, 186.

3 "The portrait of a lady dressed as a page, today one of the pearls of the Prince de Wagram collection, stood for some time on the street in front of a junk dealer's shop in the Rue de Rennes. The merchant had written the price in chalk on the canvas: 80 francs" (Meier-Graefe 1911, p. 58).

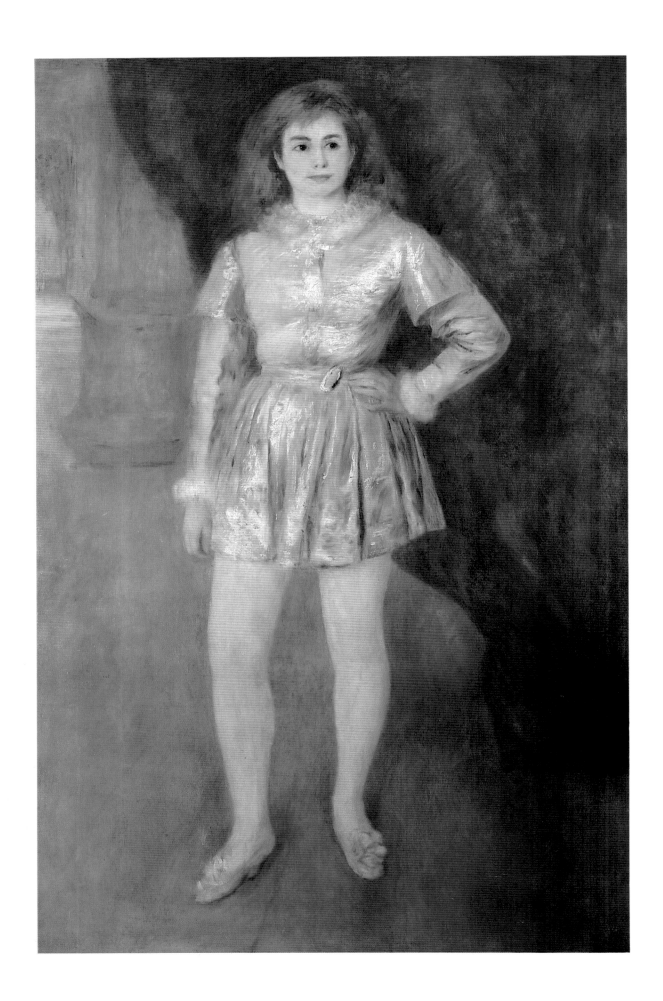

Provenance
Alexander Berthier, Prince de Wagram, Paris; Dr. Georges de Bellio, Paris; Knoedler, New York; Stephen C. Clark, New York.

References
Meier-Graefe 1911, p. 58; Vollard 1918, I, p. 93, No. 371, ill.; André 1919, Ill. 9; Besson 1929, Ill. 7; Barnes-de Mazia 1935, pp. 392, 447, No. 55; Graber 1943, p. 41; Drucker 1944, pp. 47, 184; Gaunt 1952, Ill. 27; Daulte 1971, No. 123, ill. p. 414; Fezzi 1972, p. 96, No. 159, ill.; London–Paris–Boston 1985–1986, p. 26; Monneret 1990, p. 150, No. 23, ill. p. 156; Distel 1990, p. 120.

Exhibitions
The Classical Period of Renoir, Knoedler, New York, 1929, No. 1, ill.; Paris 1933, No. 27, Ill. XIX; New York 1937, No. 10, ill.; Los Angeles–San Francisco 1955, No. 17, ill.; New York 1969, No. 16, ill.; Nagoya–Hiroshima–Nara 1988–1989, No. 8, ill.

Renoir, *La Parisienne*, 1874,
The National Museum of Wales,
Cardiff

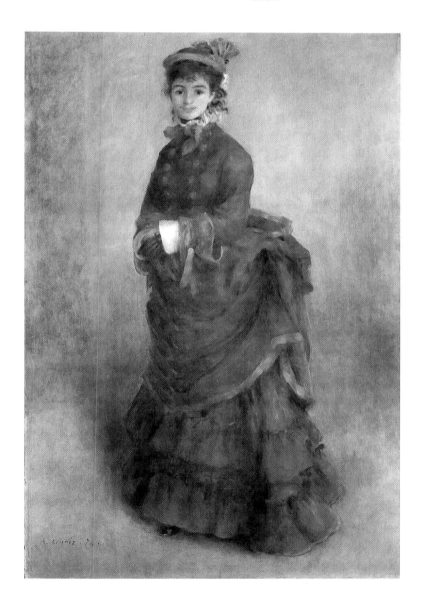

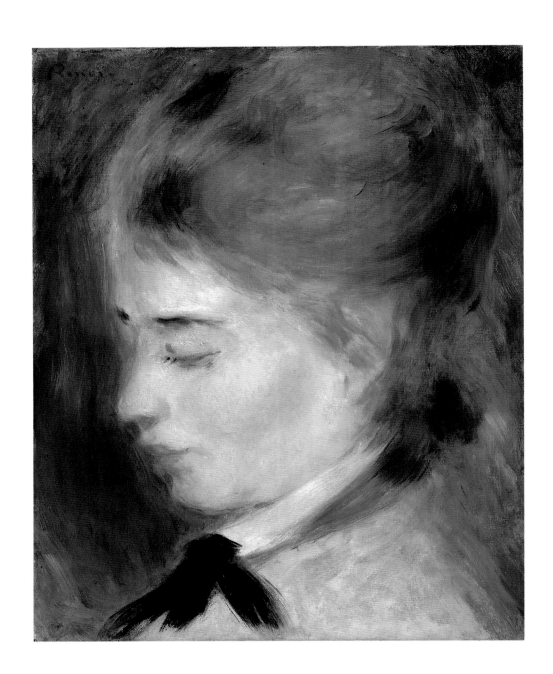

30 Portrait of Henriette Henriot ca. 1875
Portrait de Henriette Henriot

Alongside the larger, more imposing portraits done at Mademoiselle Henriot's request (cat. no. 29), Renoir also painted the actress in two small profile studies.[1] The restrained beauty of this version evokes the unmistakable individuality of the subject solely through the sublimated reflections of the color. The painting thus represents a superb résumé of Renoir's painterly skill.

Provenance
Georges Viau, Paris; Auction, Hôtel Drouot, June 17, 1927, No. 143; Hugo Perls, Berlin; Paul Cassirer, Berlin and Amsterdam; private collection, Germany

References
Daulte 1971, No. 184, ill.; Fezzi 1972, p. 99, No. 231, ill.

Oil on canvas
24 x 19.2 cm
Signed, upper left:
Renoir.
On loan from the Ernst von Siemens-Kunstfonds to the Bayerische Staats-gemäldesammlungen, Munich
Daulte 1971, No. 184

1 Daulte 1971, No. 183.

31 The Grand Boulevards 1875
Les grands Boulevards

Renoir is known to have painted only a very few scenes of Paris. This fact is somewhat surprising, especially since the first painting he ever sold was just such a view of the city: the *Pont des arts* of 1867, purchased by the art dealer Durand-Ruel for 200 francs on March 16, 1872.[1] Apparently motivated by this success, he produced a painting of the *Pont-Neuf* in the same year, a motif also depicted by Monet.[2] Similar views of Paris streets and squares from elevated perspectives would become a familiar part of Monet's, and later Pissarro's, œuvre. In Renoir's work, however, they appear only infrequently, despite his close identification with the city (cat. no. 83).

While Renoir's brightly illuminated earlier panoramas focused on the old Paris, *Les grands Boulevards*, surely his most famous Paris scene, shows the modern metropolis as it had developed by 1870. Although he often looked back with longing at the medieval compact-ness of the Paris of his childhood,[3] this Impressionist "snapshot" was a gesture of tribute to the boulevard as an urban bulwark. Haussmann's splendid, broad, tree-lined avenues encircling and cutting through the French capital still define the city's character today. They were the most important achievement of Napoléon III's urbanistic policy, and Renoir's images of them are probably the most "Parisian" ever created

Oil on canvas
52.1 x 63.5 cm
Signed and dated, lower right:
Renoir. 75.
Philadelphia Museum of Art (The Henry P. McIlhenny Collection in memory of Francis P. McIlhenny,
Inv. no. 1986-26-29), Philadelphia

1 The painting was eventually acquired by the Norton Simon Foundation of Pasadena.

2 Renoir's painting is now on view at the National Gallery of Art, Washington., D. C.

3 See. p. 23.

Claude Monet, *Boulevard des Capucines*, 1873, The William Rockhill Nelson Gallery of Art – Atkins Museum of Fine Arts, Kansas City

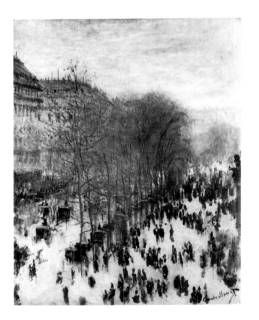

by an Impressionist artist. Unlike his friends, he concentrated primarily on the details of the bustling boulevard traffic: the horse-drawn carriages, the passers-by and shops, the advertising column to the left, the gas lights and candelabras. From the swiftly passing coach to the mother walking along the street with her children, from the elegant boulevard strollers to the white-hooded nun—everything is in motion. The captivating perspective takes in the street itself as well as the building façades and trees in a fleeting *en passant* animated by light and shadow. Renoir's color scheme makes little distinction between people, vegetation or the multi-storied buildings with their extended awnings. The whole is a panorama of quickly assimilated impressions. And although the details are rendered with considerable precision, they are flooded with a typically Parisian sunlight whose delicate haze absorbs excessively brilliant color effects. In this painting, Renoir employed this quality of light as an Impressionist stylistic means for the first time. Standing in the shadows himself, he nonetheless looked out onto the sunny side of modern urban life, leaving its darker aspects for Toulouse-Lautrec to explore somewhat later.

Provenance
Comte Armand Doria, Paris; Auction *Doria*, Georges Petit, Paris, May 4–5, 1899; Bernheim-Jeune, Paris; Oscar Schmitz, Dresden; private collection, New York; Henry P. McIlhenny, Philadelphia.

References
Meier-Graefe 1911, pp. 64, 79, ill.; Vollard 1918, I, p. 88, No. 352, ill.; Vollard 1924, ill. pp. 48–49; Coquiot 1925, p. 225; Meier-Graefe 1929, p. 91, Ill. 60; Drucker 1944, p. 184, Ill. 23; Rouart 1954, pp. 29f., ill.; Schneider 1957, p. 29, ill.; Bünemann 1959, pp. 53f., ill.; Fezzi 1972, pp. 97f., No. 185, ill., Ill. XXIII; Daulte 1973, p. 77, ill.; Rouart 1985, p. 25, ill.; Shimada 1985, Ill. 48; Robert L. Herbert, *Impressionist Art, Leisure and Parisian Society*, New Haven/London 1988, p. 16, ill.; *Paintings from Europe and the Americas in the Philadelphia Museum of Art*, Philadelphia 1994, p. 152, ill.; auction catalogue, *Impressionist and Modern Art (Part I)*, Sotheby's, New York, November 8, 1995, at No. 28, ill.

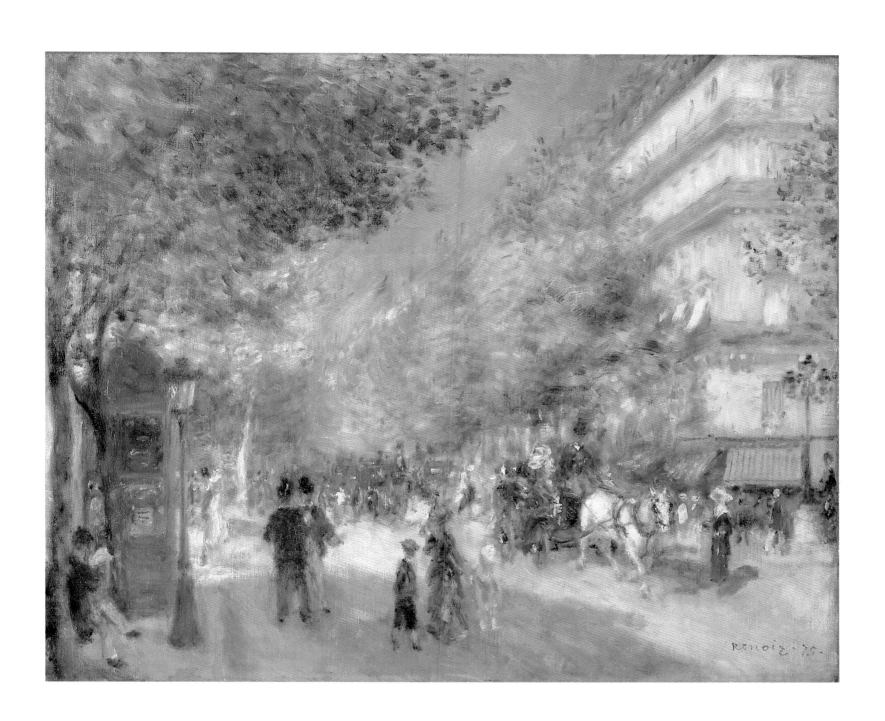

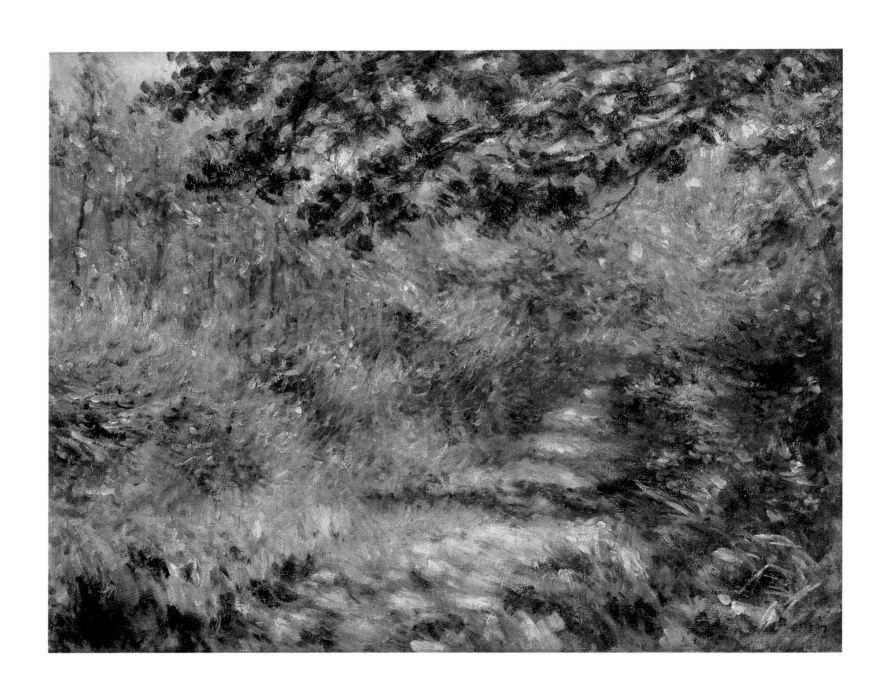

32 Forest Path ca. 1875
L'allée sous bois

Cézanne is known to have painted similar solitary "forest interiors" in the late 1880s.[1] Scenes of this kind make use of paths leading into depth to reveal the structuring effects of light falling through a dense pattern of leaves and branches. Renoir approached this subject years before Cézanne in a much more definitive manner.[2] The oblique orientation of the path, the emphasis on horizontal levels and the complex of branches entering the picture from above prevent Renoir's pictorial space from developing with equal abruptness into depth. The effects of light and shadow are integrated harmoniously into the close-knit matrix of color particles, from which the shimmering atmosphere of the natural phenomenon emerges (cat. no. 82).

Although in a less obvious way than Cézanne, Renoir also subjected the rhythm of his color fabric to a system of order based on fundamental contrasts. The painting derives its Impressionist character from the contrasts between warm and cool hues and from the horizontal layers of shadow on the path, branching off at right angles to the rising vertical lines of the tree trunks on the left. The contrasts between the patches of color, oscillating between sunlight and the green of the leaves, are incorporated into a pictorial space structured in terms of clearly legible planes.

Oil on canvas
49.5 x 62.8 cm
Signed, lower right:
Renoir.
Private collection

1 Venturi 1936, Nos. 626–628, 649.

2 Three similar paintings featuring forest paths are listed in the Christie's auction catalogue of November 28, 1988, p. 27.

Paul Cézanne, *Avenue in the Park at Chantilly Castle*, 1888, Berggruen Collection, National Gallery, London

Provenance
Arthure Tooth & Sons, London; private collection, London; Auction, Christie's, London, November 28, 1988, No. 9.

References
The Burlington Magazine, 718, CV, January 1963, pp. 39, 41, Ill. 50; auction catalogue, *Impressionist and Modern Paintings and Sculpture*, Christie's, London, November 28, 1988, No. 9, ill.

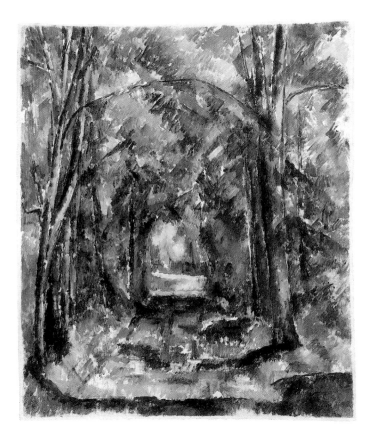

33 The Bridge at Chatou 1875
Le pont de Chatou

Oil on canvas
51 x 65.2 cm
Signed, lower right:
Renoir
Sterling and Francine
Clark Art Institute
(Inv. no. 591 RSC 1925),
Williamstown,
Massachusetts

The painting of bridge structures was actually Monet's specialty. In the years between 1870 and 1878 alone, he completed more than 30 such views of bridges on the Thames and in Holland, but above all in Paris and its environs. The street and railroad bridges across the Seine near Argenteuil were his two most favored motifs during the years 1873–1874. The only surviving painting from Chatou is a view of the railroad bridge, dated 1875.[1] In that year, Renoir spent the summer months with Monet in Argenteuil, where he painted portraits of his friend, and in Chatou, where he completed a portrait of Alphonse Fournaise, proprietor of the restaurant on the Ile de Chatou.[2] Monet's fascination with bridges may well have prompted his friend to approach the subject himself.

Renoir's *Bridge at Chatou* blends man-made structures with elements of nature, adeptly using the water's reflection to create a single, colorful organism. The wide viaduct and the houses on the high banks of the river have slowed the flow of the stream; towering above the river, they calm it. The Romantic view of water as an untamed, boundless, threatening element has no place here. Instead, the gently flowing brushstrokes applied in a finely woven fabric of color harmonies evoke the image of the perpetual stream which humanity may harness and use as it sees fit.

A painting by Renoir entitled *Le pont de Chatou* was sold at the Hoschedé auction of June 6, 1878, for 42 francs to the collector Dr. Georges de Bellio, a Romanian homeopathic physician who practiced in Paris and had become a friend of the artist.[3] The painting in question was presumably the one now held in the Williamstown collection. The work was originally purchased from Renoir by the department store owner Ernst Hoschedé, a close friend of Monet. Dubious business dealings drove Hoschedé's company into bankruptcy in 1878, and he was forced to auction off his entire collection of paintings by artists such as Manet, Monet, Sisley, Pissarro, Morisot and Renoir at the Hôtel Drouot.

1 Wildenstein 1974, No. 367.

2 Daulte 1971, Nos. 132, 158.

3 Bodelsen 1968, p. 340.

Provenance
Ernst Hoschedé, Paris (?); Auction *Hoschedé*, Hôtel Drouot, Paris, June 5–6, 1878, No. 74 (?); Dr. Georges de Bellio, Paris; Georges Hoentschel, Paris; Knoedler, New York; Robert Sterling Clark, New York; acquired in 1925.

References
Meier-Graefe 1911, p. 58; Bodelsen 1968, p. 340; Remus Niculescu, *Georges de Bellio. L'ami des Impressionnistes*, Florence 1970, No. 2; Fezzi 1972, p. 96, No. 150, ill.; Claude Vacant, *Routes et ponts en Yvelines du XVIIe au XIXe siècle*, Paris 1988, ill. pp. 152–153; Distel 1990, pp. 119f.; Steven Kern, *List of Paintings in the Sterling and Francine Clark Art Institute*, Williamstown 1992, p. 89, ill.

Exhibitions
French Paintings of the Nineteenth Century, Sterling and Francine Clark Art Institute, Williamstown, 1963, No. 108, ill.; Chicago 1973, No. 18, ill.

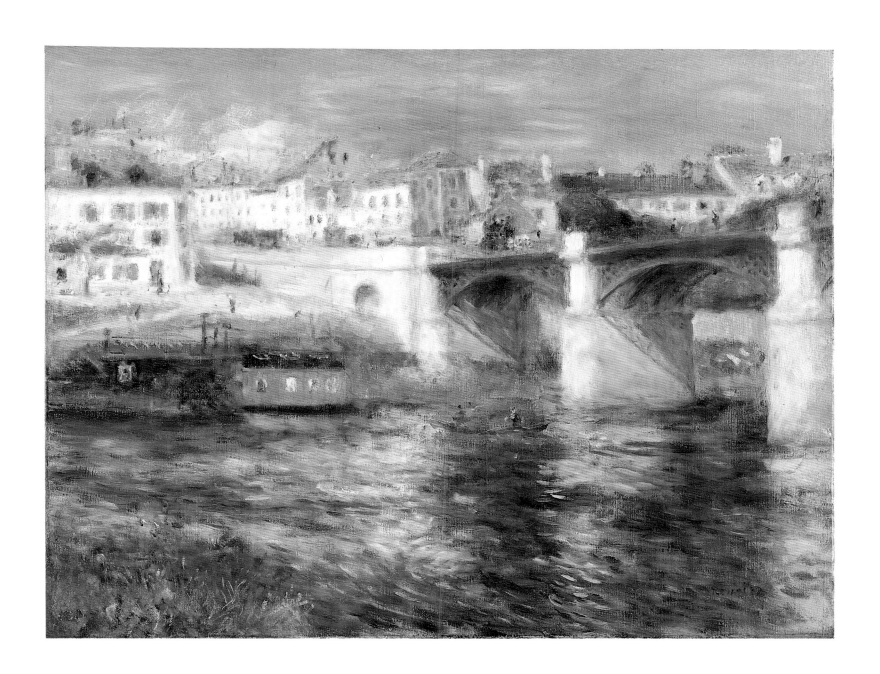

34 The Seine near Argenteuil ca. 1875
La Seine à Argenteuil

Oil on canvas
54 x 65 cm
Signed, lower right:
Renoir.
Erwin Bernheim,
Switzerland

This Seine landscape from the countryside near Argenteuil is a feast of vibrant colors. Immersed in the dancelike movements of the light, the colors reflect reality in an unreal way, their patterns relating only fleetingly to objective forms. Grasses and shrubs, houses and pulsing waves become visible above all as aromatic daubs and strokes of color. A whirring web of thin branches and leaves spreads a diaphanous veil over much of the painting's surface. Through the luscious green of the trees, accented with yellow and white, we see into the deep blue of the river and the lighter blue of the sky above it.

Almost unbelievably, despite the seeming heterogeneity of the strokes and points of color thrown together in a wild confusion of gesticulating patches, they nonetheless form a homogeneous whole in which every nuance contributes to the impression of sparkling light. Without employing the picturesque motifs of bridges, sailboats, spectators on the banks or rowers on the water that made the Seine landscape around Argenteuil so appealing to Renoir and Monet during the 1870s (cat. no. 52), the artist created a subtle composition of radiance and vigor from the simple image of the riverbank itself. Here, the Impressionist objective of capturing a moment beneath a sunny, open sky is articulated in an airy, shimmering vista of color.

Provenance
Ernest Daudet, Paris; Jacques Blot, Paris; private collection, Zurich.

References
Meier-Graefe 1911, p. 63, ill.; auction catalogue *Impressionist and Modern Paintings, Watercolours and Sculpture (Part I)*, Christie's, London, June 26, 1995, No. 16, ill.

Exhibitions
Paris 1969, No. 7.

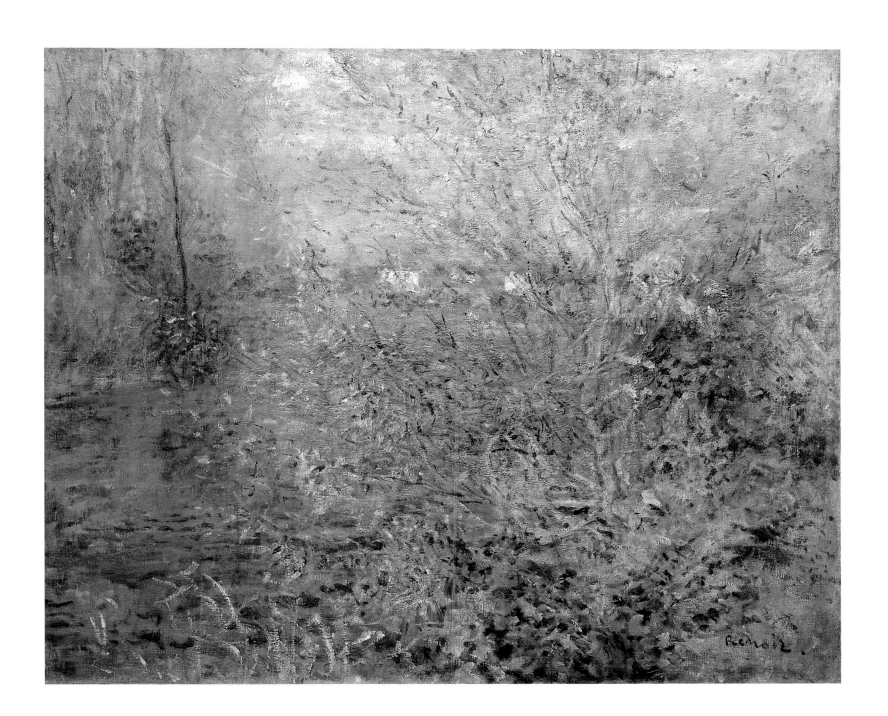

35 Woman with a Parasol in a Garden 1875
Femme avec parasol dans un jardin

Oil on canvas
54.5 × 65 cm
Signed, lower left:
Renoir.
Fundación Colección
Thyssen-Bornemisza
(Inv. no 1974, 43), Madrid

During the summer months of 1872 to 1874, Renoir often visited Claude Monet in Argenteuil (cat. nos. 17, 18, 21, 22, 24). He returned to the house and its handsome garden again in 1875 to paint his friend's portrait.[1] Monet had already painted several garden scenes with figures holding parasols, temporarily abandoning his expansive landscapes in favor of images of flowers and leaves that filled the entire canvas.[2] Prompted by Monet's example and his own experience as the new occupant of a studio with an overgrown garden on the Rue Cortot in Montmartre since the spring of 1875, Renoir also began to paint garden motifs. In paintings such as this and the following one (cat. no. 36), he far surpassed Monet's domesticated views of well-ordered gardens with paths and flower beds. With myriad points of color and brushstrokes moving in every conceivable direction, he dissolved objective forms, melting and intermingling colors in the shimmering flux of sunlight to a degree never before achieved within the context of Impressionist aesthetics. There could hardly be a more convincing demonstration of painting as painting.

Renoir needed no more than a field of flowers bordered by shrubs and trees, a meadow in which two figures leave traces of their presence, to make his pigments the true medium of expression in this painting. Clearly organized into discrete planes and surface areas, the splendor of the garden scene bathed in midday sunlight is structured according to very subtle criteria. A carpet-like pattern of grasses and flower petals extends upward at a slant in the foreground. Flanked by areas of shadow, it pulls the viewer's gaze into the depth of the picture, where the woman with the parasol appears to look on as her companion picks flowers. The dark dress and the light-colored parasol held by the female figure positioned in the vertical axis of the painting define the extreme color positions. In this context, the persons themselves serve only as a distant contextual impulse for the realization of a rich, complex ensemble of color which speaks to all the senses. Here, the Impressionist fulfills his dream of joyful harmony with a nature prepared for the city-dweller and discovered in passing.

1 Daulte 1971, No. 132.

2 Wildenstein 1974, Nos. 382–386.

Provenance
Durand-Ruel, Paris and New York; Sam Salz, New York; Mrs. Byron C. Foy, New York; Paul Rosenberg, New York; The Lefevre Gallery, London; Auction, Christie's, London, July 1, 1974, No. 14; Thyssen-Bornemisza Collection, Lugano.

References
Fezzi 1972, pp. 97f, No. 199, ill.; Gaunt-Adler 1982, No. 13, ill.; Wadley 1987, p. 70, Ill. 22.

Exhibitions
New York 1958, No. 7, ill.; *French Landscapes*, Marlborough Fine Arts, London, 1961, No. 34; *European Masters*, Marlborough Fine Arts, London, 1970, No. 55; *America and Europe. A Century of Modern Mas-*

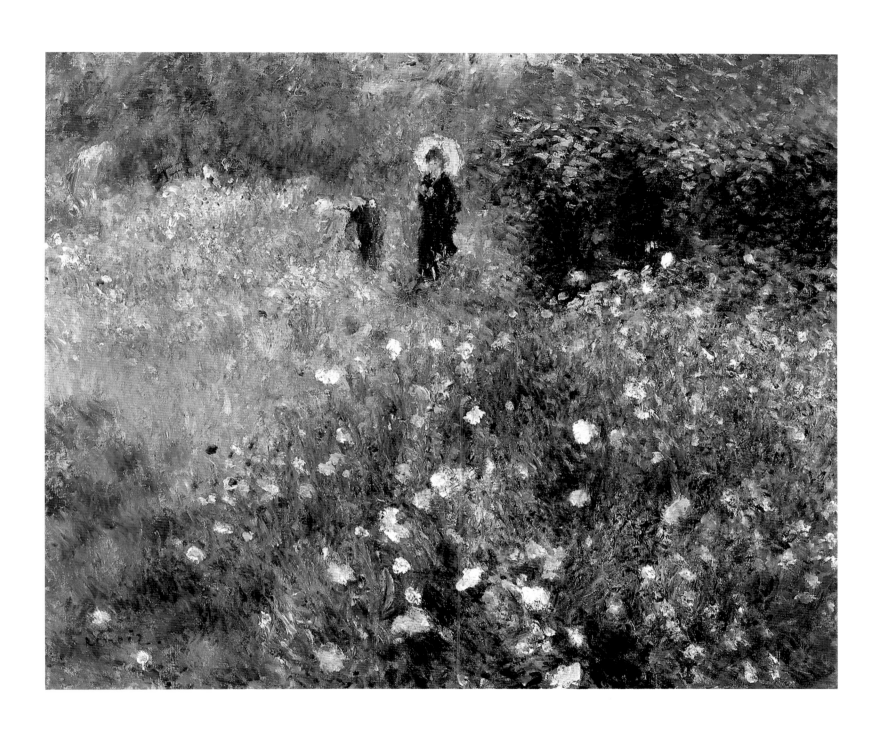

ters from the Thyssen-Bornemisza Collection, Art Gallery of Western Australia, Perth–Art Gallery of South Australia, Adelaide–Queensland Art Gallery, Brisbane–National Gallery of Victoria, Melbourne–Art Gallery of New South Wales, Sydney–National Art Gallery, Wellington, New Zealand–City Art Gallery, Auckland–Robert McDougall Art Gallery, Christchurch, 1979–1980, No. 1, ill.; Modern Masters from the Thyssen-Bornemisza Collection, The National Museum of Modern Art, Tokyo–Prefectural Museum, Kumamoto–Royal Academy of Arts, London–Germanisches Nationalmuseum, Nuremberg–Städtische Kunsthalle, Düsseldorf–Palazzo Pitti, Florence–Musée d'art moderne de la ville de Paris–Biblioteca Nacional Salas Pablo Ruiz Picasso, Madrid–Palacio de la Virreina, Barcelona, 1984–1986, No. 4, ill.; Nagoya–Hiroshima–Nara 1988–1989, No. 5, ill.; Impressionism and Postimpressionism. The Thyssen-Bornemisza Collection, Villa Favorita, Lugano, 1990, No. 20, ill.; Brisbane–Melbourne–Sidney 1994–1995, No. 8. ill.

36 Picking Flowers 1875
La cueillette des fleurs

Oil on canvas
54.3 x 65.2 cm
Signed, lower right:
A. Renoir
National Gallery of Art
(Alisa Mellon Bruce
Collection,
Inv. no. 1970.17.61),
Washington, D. C.

Although within the small circle of Impressionists who devoted themselves primarily to landscape—Pissarro, Monet and Sisley—Renoir stands out as a portraitist and figure painter, his landscapes, usually enriched with "figural" additions (for exceptions see cat. nos. 19, 20, 32, 34, 65, 75, 82, 99), occupy a prominent place in his œuvre. More versatile than the artists named above, he was without question their equal as a landscape painter during the 1870s.

This garden scene was presumably completed at the same time as the preceding work (cat. no. 35). It shows what appears to be the same couple, now viewed from a somewhat closer vantage point, in the midst of their richly colored natural surroundings. Partially concealed by flowers and grasses and positioned in the foreground of a fabric of radiant, golden sunlight, the silhouettes provide a soothing counterweight to the profligate abundance of their natural ambience. Areas of shadow immersed in colorful light provide a backdrop for a dense field of flowers in which radiant points of white, red, yellow and blue shine forth against the luscious green of the leaves and grasses. The nearest and the most distant points are set in balance in a diagonal constellation which extends from the blue and white sky to the blossoms in the right foreground. Such garden scenes reveal Renoir as the Impressionist *par excellence*.

Provenance
Durand-Ruel, Paris and New York; Sam Salz, New York; Howard Young, New York; Mrs. L. L. Coburn, Chicago; The Art Institute, Chicago; Carrol Carstairs, New York; Alisa Mellon Bruce, New York; presented as a gift in 1970.

References
Meier-Graefe 1929, pp. 99, 114, Ill. 94; Barnes-de Mazia 1935, pp. 68, 100, 257, 398, 450, No. 85, ill.; Fezzi 1972, p. 108, No. 439, ill.

Exhibitions
Exhibition of the Mrs. L. L. Coburn Collection Modern Paintings and Watercolors, The Art Institute, Chicago, 1932, No. 32; *A Century of Progress*, The Art Institute, Chicago, 1933, No. 349; *French Paintings from the Collection of Mr. and Mrs. Paul Mellon and Mrs. Mellon Bruce*, National Gallery of Art, Washington, 1966, No. 102, ill.

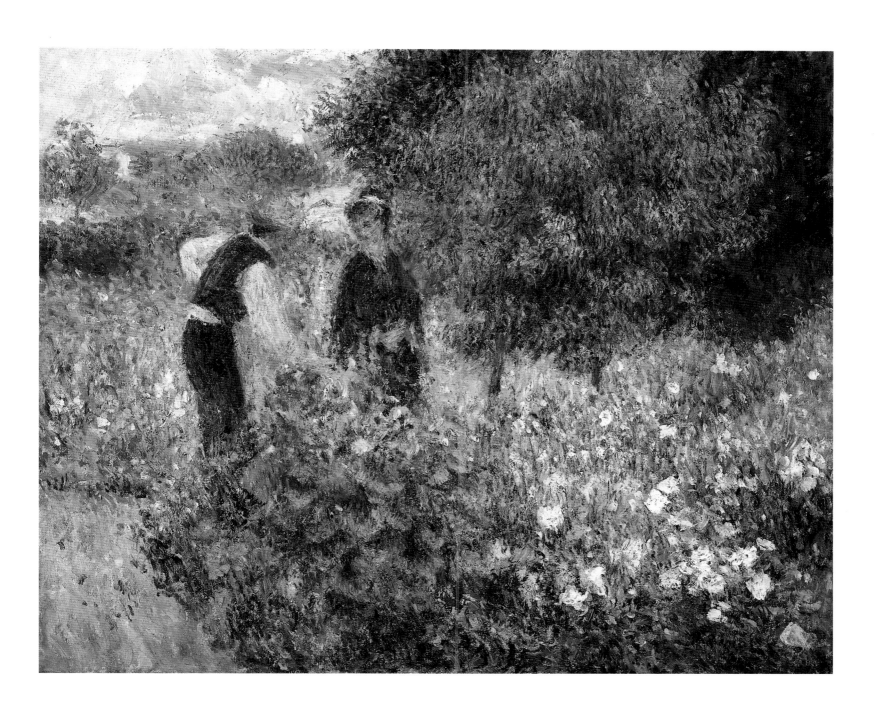

37 Young Woman with a Veil 1875–1877
Jeune femme à la voilette

Oil on canvas
61 × 51 cm
Signed, lower right:
Renoir.
Musée d'Orsay
(Legs de M et Mme
Raymond Koechlin, 1931,
Inv. no. RF 3668), Paris
Daulte 1971, No. 151

1 Pissarro, who maintained ties to the Neo-Impressionists at the time, wrote to his son Lucien on September 20, 1887, describing a gathering involving Renoir and his family at the tavern of Eugène Murer (Meunier): "Grand discussions about Pointillism! Murer said to me: 'But you know very well that the point is impossible!' Renoir added: 'You have abandoned the point again, and now you refuse to admit that you were mistaken.' I was quite upset and accused Murer of regarding me as a cheat. To Renoir I responded, 'I have not fallen to such a level of idiocy, my dear man. You, Murer, have no idea what you are talking about, and you, Renoir, rely upon coincidence. At least I know what I am doing!' The young men responded with scorn: Seurat had discovered nothing at all, and I, they said, considered such a man a genius. You can surely imagine how I lit into them. I had thought that they were in touch—if only so little—with our movement—but nothing, they understand not a word of it" (Pissarro 1953, p. 135).

This profile view of a woman wearing a black hat and veil is one of the most unusual and inventive accomplishments of Impressionist art. The individual physiognomy one might expect to find in a portrait is hidden from view in this painting. The young woman, though seen from close proximity, is nonetheless quite distant; she is identified, yet nameless, present and absent at the same time. The painting's open texture reveals nothing of her facial expression. In a manner atypical of Renoir, the picture holds the viewer at arm's length, concealing more than it reveals. Her attention directed inward, the woman is turned away from the viewer; yet she remains so palpably present—in the act of passing by, as it were—that we can easily imagine the fine features of her face and the nervous agitation of her delicate form. Only Degas was capable of probing so deeply into a subject by creating such distance.

The painting's special aura derives from the intelligence of its disciplined concentration upon formal order and the frugal use of color harmonies. The dialogue of light and dark generates a quiet interplay of lines and tonal values. The light-colored hands and the vanishing profile of the face represent the equivalent of light against the neutral background. The face is covered by the gossamer mesh of a veil dotted with black spots, highlighting the pale, delicate skin "à la mouche" while at the same forming the basic elements of a pointillist approach to painting well in advance of Pointillism itself. Here, Seurat's precisely structured system is anticipated in the geometry of the contrasting lines and fields of the plaid by an artist who years later would feel nothing but contempt for the lifeless methodology of his Pointillist colleague.[1]

Provenance
M. Orville, Paris; Durand-Ruel, Paris; Raymond Koechlin, Paris, presented as a gift to the Musée du Louvre in 1931.

References
M. Guérin, "Le Legs Raymond Koechlin," in *Bulletin des Musées de France*, May 1932, pp. 83f.; Barnes-de Mazia 1935, pp. 68, 255, 398, 449, No. 77, ill.; Florisoone 1937, p. 41, ill.; Drucker 1944, p. 185; Schneider 1957, p. 16, ill.; Daulte 1971, No. 151, ill.; Fezzi 1972, Ill. XXVIII, p.98, No. 207, ill.; Gauthier 1977, p. 14, ill.; Keller 1987, p. 60, Ill. 45, p. 63; R. Rosenblum, *Les Peintures du Musée d'Orsay*, Paris 1989, p. 294; Monneret 1990, p. 151, No. 5, ill.

Exhibitions
Cent ans de peinture française, Rue de la Ville l'Evêque, Paris, 1922, No. 131; *Rétrospective d'art français*, Rijksmuseum, Amsterdam, 1926, No. 95; *Exposition du legs Koechlin*, Musée d'Orangerie, Paris, 1932; Paris 1933, No. 390; Brussels 1935, No. 63; Paris 1938, No. 12; *Correspondances. Französische Malerei aus dem Musée d'Orsay*, Städtische Galerie im Städelschen Kunstinstitut, Frankfurt am Main, 1990, p. 26, ill.

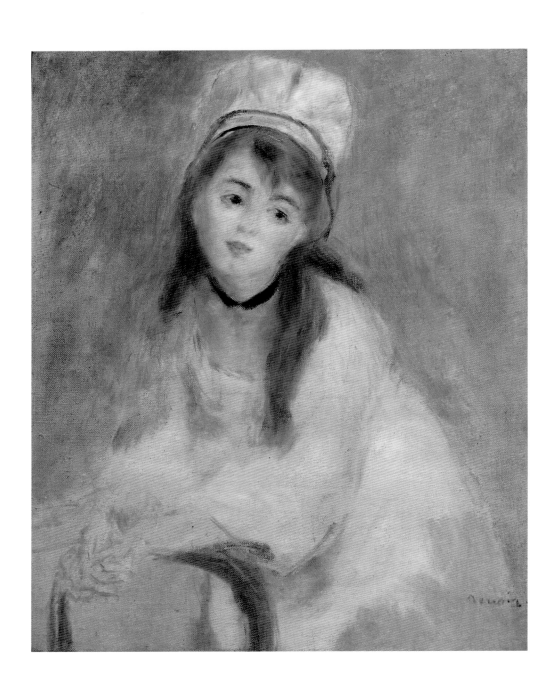

38 Portrait of a Young Woman.
Symphony in White ca. 1876
Portrait de jeune femme.
Symphonie en blanc

Renoir was able to characterize human physiognomies without excessive attention to psychological aspects. During the 1870s in particular, he frequently replaced the ponderous portrait poses of past years with new visual approaches that tended to focus upon random qualities. In so doing he gave his portraits a sense of immediacy which, despite the splendor of his colors and his flattering brushwork, counteracted any hint of artificial beautification. Even in the case of this young woman shown leaning against the back of a chair, the most important goal underlying the dialogue of trust between the artist and his model was to achieve the effect of an attitude assumed without deliberate intent.

In his brochure *Les peintres impressionnistes* of May 1878, the art critic Duret pointed out that Renoir, whom he identified alongside Monet, Pissarro and Berthe Morisot as the real trustee of the Impressionist movement, excelled as a portraitist and that no other painter had ever interpreted women in such an alluring manner: "What distinguishes Renoir most of all is his portraiture. He describes not only external features but also incorporates the facial expression, character and inner condition of his model. I do not think that any other painter has ever represented women in a more seductive way. Renoir's swift, light style gives them grace, suppleness and a quality of devotion; he makes their skin shimmer and gives their cheeks and lips a sheen of luminous red. Renoir's women are enchantresses One will find a beloved mistress in such paintings. But what a mistress! Always delightful, cheerful, smiling, she needs neither clothing nor hats and does very well without jewels—the truly ideal woman!"[1]

Oil on canvas
30 x 26 cm
Signed, lower right:
Renoir.
Collection Isabelle Hahn,
U.S.A.
Daulte 1971, No. 171

1 Duret 1922, pp. 27f.

Provenance
M. Soubies, Paris; Auction *Soubies*, Hôtel Drouot, Paris, June 14, 1928, No. 80; M. Guiraud, Paris; Edouard Esmond, Paris; Diane Esmond, Paris.

References
Bulletin de la vie artistique, January 1, 1924, p. 2, ill.; Daulte 1971, No. 171, ill.; Fezzi 1972, pp. 98f., No. 213, ill.

Exhibitions
Paris 1933, No. 20b; *Chefs-d'œuvre des collections parisiennes*, Musée Jacquemart-André, Paris, 1962, No. 69.

39 Dance at the Moulin de la Galette.
Study 1875–1876
Le bal du Moulin de la Galette. Esquisse

Oil on canvas
65 × 85 cm
Signed, lower left:
A. Renoir
Ordrupgaard,
Copenhagen
Daulte 1971, No. 207

In April 1875, Renoir rented two attic rooms and a converted ground-floor stable as a studio at Rue Cortot 12 in Montmartre for 100 francs per month. Behind the house was a large, overgrown garden. Located nearby, at the end of the Rue Pepic, was the Moulin de la Galette, parts of which have survived to this day. The cheap outdoor tavern and ball-room, situated on the grounds of an old 18th-century windmill of the kind that lent Montmartre its characteristic silhouette in the years before it, too, felt the impact of urban development, was operated by the Debrays, father and son. The mill was still used occasionally to pulverize iris bulbs for a Paris perfume manufacturer. A large room with an elevated gallery was built of green-painted boards. A ten-man band played for dances on a specially constructed stage —eight hours a day—on Sundays and holidays. The dance hall opened up behind the stage onto a courtyard shaded by acacias and furnished with long tables and benches. The gravel-paved ground was hard and even enough to permit dancing. Only the male visitors paid for their pleasure: five sous for admission and four sous for each dance. In his memoirs, Rivière described Le Moulin as a Sunday gathering place for clerks from the quarter, artists and students as well as working families from Montmartre: "Parents and small children sat at the tables, eating cake,

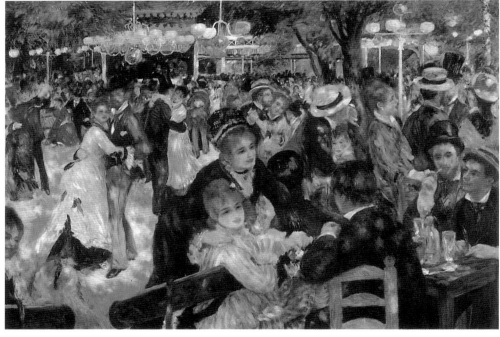

Renoir, *Dance at the Moulin de la Galette*, 1876, Musée d'Orsay, Paris

drinking wine or beer, while the young girls danced until dinner time The young men and women who appeared at the dances were always the same; they knew each other to one degree or another Renoir, Lamy, Goeneutte and I were among the most frequent visitors to the Moulin de la Galette Renoir found models there, women he tended to prefer because they ordinarily did not pose as models for painters in their studios . . . flower sellers, seamstresses or hatmakers "[1]

1 Rivière 1921, pp. 121ff.

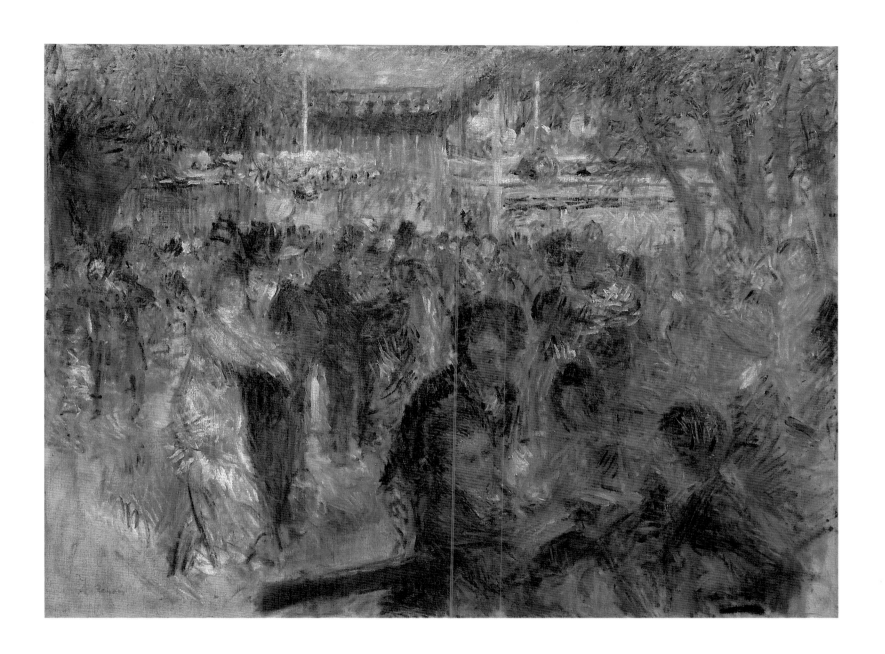

Edouard Manet, *Music in the Tuileries*, 1862, The Trustees of the National Gallery, London

Henri de Toulouse-Lautrec, *Dance at the Moulin de la Galette*, 1889, The Art Institute, Chicago

2 "Franc-Lamy once discovered in my studio a sketch that I had done of the Moulin de la Galette from memory. 'You simply must finish this painting!' he said to me" (Vollard 1961, p. 49).

3 Daulte 1971, No. 208.

Barely established in his studio on the Butte Montmartre, the artist set about depicting the lusty goings-on beneath the open sky in a large-scale composition. According to Rivière, he wanted to portray the usual guests of the Moulin in his painting, dispensing with professional models. This oil sketch on canvas represents the first step toward what is probably his most famous figure scene (ill. p. 158). Whether it was indeed sketched from memory, as the artist recalled later,[2] or "on location," which seems more likely, is a matter of conjecture. Aside from its sketchlike quality and the resulting restriction to only a few suggestions of color, the study differs from the completed painting in that it presents a narrower frame of view. The figures appear larger, and the group shown at the right in the final version is missing here. Nor are the models, people from Renoir's circle of friends and acquaintances, identifiable as such. Only in the later painting do we recognize a model by the name of Estelle, dressed in a striped dress sitting towards the front, and sitting across from her the painters Franc Lamy, Norbert Goeneutte and Georges Rivière (cat. nos. 28, 46). Marguerite Legrand (cat. nos. 28, 47, 48) is seen at the left, dancing with the Cuban painter Pedro Vidal, while the figures of Henri Gervex, Lestringuez and the journalist Paul Lhote are distinguishable in the background.

Completed in September 1876, the large painting, of which a smaller replica done for Victor Chocquet also exists,[3] was shown at the third Impressionist exhibition in April 1877. Writing on the sixth of that month in the first issue of the journal *L'Impressionniste*, the publication initiated by Renoir, Rivière commented on the painting: "Noise, laughter, movement, sunshine in an atmosphere of youthfulness: that is Renoir's *Le bal*. It is essentially a work about Paris. These young girls are the very same ones we see every day and whose chatter fills the air of Paris at certain hours of the day It is a bit of history, a precious monument to Parisian life, painted with strict precision. No one before

him has ever considered putting a scene from everyday life on a canvas of this size Monsieur Renoir and his friends understand that history painting is not merely the more or less amusing illustration of stories from the past. They have found a new direction which others are sure to pursue as well. Let those who would paint historical pictures paint the history of their own age instead of stirring up the dust of past centuries"[4]

Manet had created a similarly epoch-making "monument to Parisian life" with his *La musique aux Tuileries* (ill. p. 160) of 1862. Although both paintings feature crowds of people, Manet's appreciably older figures represent the *grand bourgeois* society of the Second Empire, while Renoir's later piece shows the suburban *jeunesse dorée* in pursuit of its harmless amusements. Each artist painted scenes from his own milieu, doing justice to modern life in the sense intended by Baudelaire—a life whose extremes would one day destroy Toulouse-Lautrec.

Compared to his final version, Renoir's study shows greater freshness and originality as well as an impetus devoted entirely to the moment. No artist before him had ever sketched such a scene with greater spontaneity or rendered the whirling crowd of embracing dancers with such animation. Seldom had the fleeting quality of a moment been expressed so vividly. Toulouse-Lautrec, who sought refuge in the stifling air of the dance clubs and music halls of Paris, was the first of the later artists to make use of Renoir's technique in similar scenes, sketching quickly in strokes of paint that dried immediately on unsized canvas (ill. p. 160).

4 Venturi 1939, I, pp. 308f.

Provenance
Alexander Berthier, Prince de Wagram, Paris; Marczell de Nemès, Budapest; Auction *de Nemès*, Manzi–Joyant, Paris, June 18, 1913, No. 120; M. Levesque, Paris; Ambroise Vollard, Paris; Ch. Tetzen Lund, Copenhagen; Wilhelm Hansen, Copenhagen.

References
Meier-Graefe 1911, p. 60; Vollard 1918, I, p. 58, No. 229, ill.; J. This, *Renoir*, Oslo 1940; Drucker 1944, p. 47, ill.; H. Rostrup, *Franske Malerier i Ordrupgaardsamlingen*, Copenhagen 1958, No. 96; Daulte 1971, No. 207, ill., at No. 209; Fezzi 1972, p. 100, No. 247, ill.; Ehrlich White 1984, p. 66, ill.; London–Paris–Boston 1985–1986, p. 211; Wadley 1987, p. 148, Ill. 52; Monneret 1990, p. 71, ill.; Auction catalogue, Sotheby's, New York, May 17, 1990, ill.; Mikael Wivel, *Ordrupgaard. Selected Works*, Copenhagen 1993, No. 46, ill.

Exhibitions
Die Sammlung Marczell de Nemès, Kunstmuseum, Düsseldorf, 1912, No. 107; *Fransk Konst*, Nationalmuseum, Stockholm, 1917, No. 85; *Auguste Renoir*, Stockholm–Copenhagen–Nasjonalgalleriet, Oslo, 1921, No. 10; *Gauguin et les chefs-d'œuvre de l'Ordrupgaard de Copenhague*, Musée Marmottan, Paris, 1981, No. 27, ill.; *French Master-pieces from the Ordrupgaard Collection in Copenhagen*, Nihonbashi Takashimaja–Yokohama, Takashimaja–City Art Museum, Toyobashi–Kyoto Takashimaja, Kyoto, 1989–1990, No. 56, ill.

40 Portrait of the Countess Pourtalès 1877
Portrait de la Comtesse de Pourtalès

Oil on canvas
95 × 72
Signed and dated,
lower right: Renoir. 77.
Museu de Arte de
São Paulo
Assis Chateaubriand,
São Paulo
Daulte 1971, No. 256

1 Daulte 1971, No. 62.

2 Although she had once had her portraits done by Franz Xaver Wintherhalter, the countess' openness to new ideas is suggested by her acceptance of Renoir's rapid painting technique (despite her insistence on the conventions of the showpiece portrait), an approach otherwise little appreciated by the members of Paris high society, who generally preferred the more pompous Salon heroes.

Sophie-Mélanie Renouard de Bussière (1836–1914), daughter of an Alsatian industrialist, married the Paris banker Comte Edmond de Pourtalès at the age of 17. Daulte, who identified a painting dated 1870 as an early portrait of the countess,[1] suggested that she was the first woman of Paris high society to have her portrait painted by the unknown Auguste Renoir. The decision of the well-known Second-Empire beauty to award the commission to Renoir may have been encouraged by Auguste de Pourtalès, one of Renoir's fellow students at Gleyre's studio, as well as by the artist's more or less successful showings at the 1868 and 1870 Salons (cat. nos. 8, 10). It is also possible that Jean Dollfus (cat. no. 27), a collector of Impressionist art who was also a native of Alsace and well acquainted with the countess, made the arrangements that enabled Renoir to do this second portrait seven years later, along with a pastel version (cat. no. 41).

The elaborately decorated portrait makes generous use of the most regal of all color combinations—a deep red, a bluish-black and the pale white of the woman's skin. A curtain and a chest of drawers with appropriate knickknacks are merely suggested as dark, shadowy forms against the red background. The bluish-black of the hair and the robe with its dull silver ornamentation mediate between the restrained coloration of the depth and the paleness of the subject's complexion. Apparently untouched by the sun, her skin stands out in the foreground and is appropriately enhanced by the low-cut, sleeveless dress. The countess' somewhat tired-looking eyes and self-satisfied smile testify to the age of this woman in her early forties, whose social position in the Third Republic was no longer the one she had enjoyed at the court of Napoléon III. Her casual posture, leaning back against the chair, is framed in the center of the painting by the left arm laid across her waist and the corner of the chair-back at her right shoulder.[2]

Provenance
Comtesse Mélanie de Pourtalès, Paris; Galerie Barbazanges, Paris; Paul Cassirer, Berlin; M. Rothermund, Dresden; Karl Sachs, Breslau; private collection, Basle; Dr. Heer, Zurich; Francisco de Assis Chateaubriand, São Paulo; acquired in 1952.

References
E. Waldmann, "Notizen zur Franzosen-Ausstellung in Dresden," in *Kunst und Künstler*, XII, 1914, p. 390, ill.; *Kunst und Künstler*, XXI, January 1923, p. 137, ill.; Daulte 1971, No. 256, p. 417; Fezzi 1972, pp. 101f., No. 289, ill.

Exhibitions
St. Petersburg 1912, No. 533; Basle 1943, No. 137; London 1954, No. 51; Munich 1989, pp. 112ff., ill.

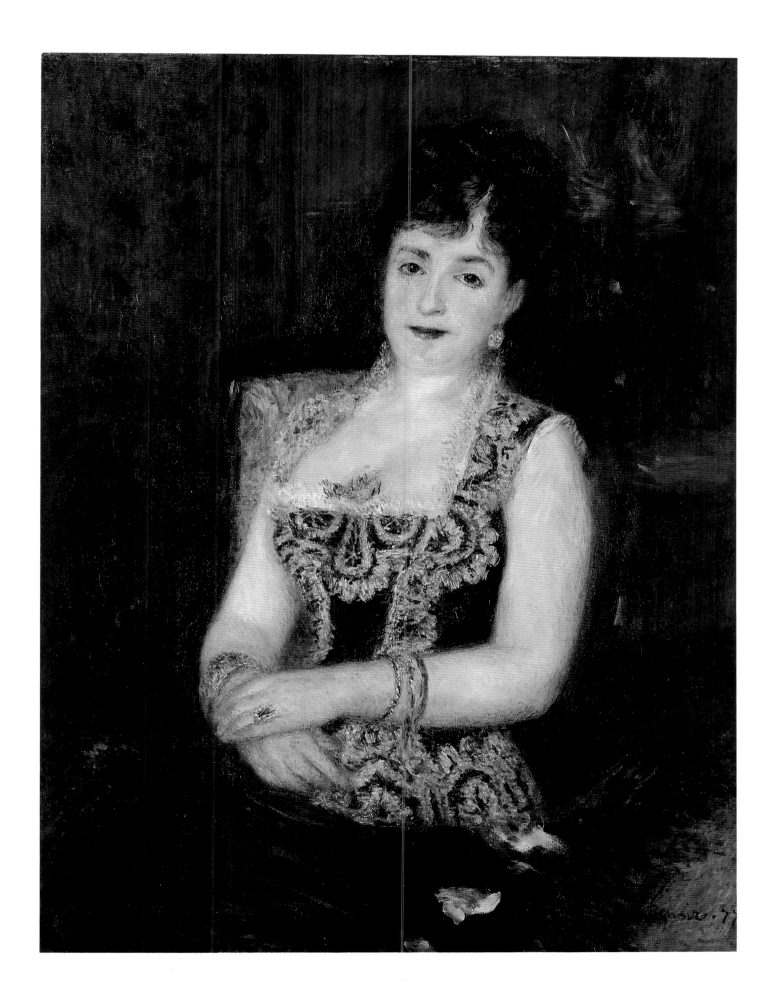

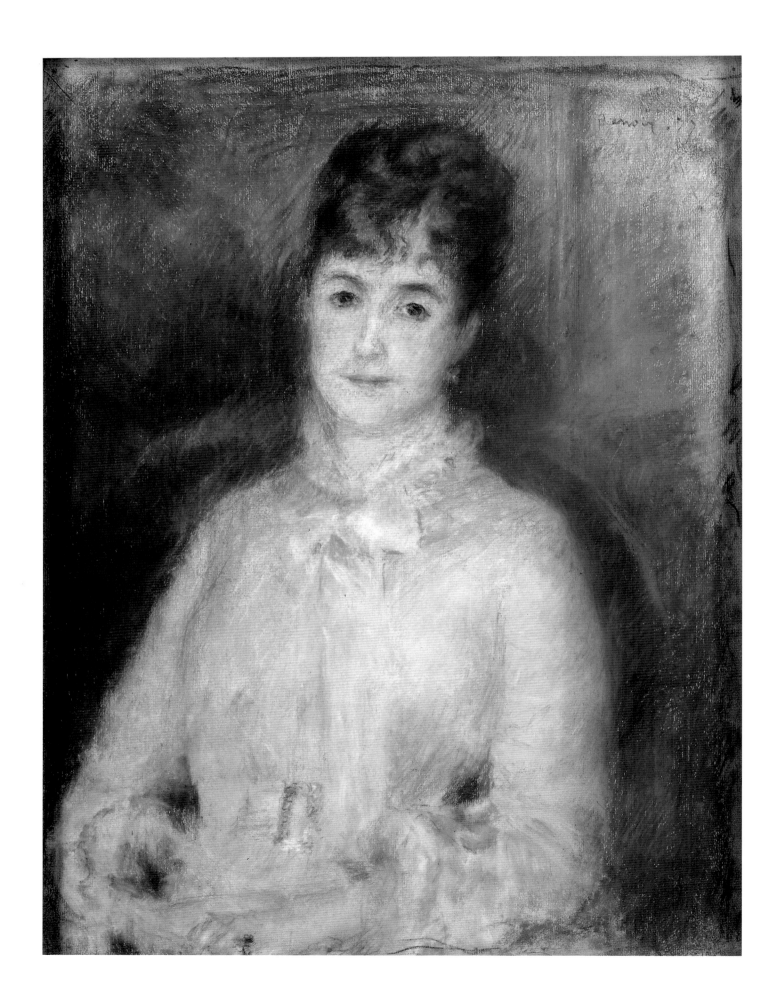

41 Portrait of the Countess Pourtalès 1877
Portrait de la Comtesse de Pourtalès

Compared to the imposing appearance of the painting (cat. no. 40), the pastel portrait of Countess Pourtalès, though done at the same time and showing her in a similar pose, is a more intimate treatment of the subject. The figure of the countess, her torso framed by the red back of an upholstered chair, is rendered in a gentler, more restrained approach. Seldom did Renoir achieve such a penetrating image of his subject from a psychological point of view. The countess' facial features—her somewhat melancholy eyes and the suggestion of a smile—may reflect the memory of bygone years, when the great beauty was a celebrated guest at the court of Napoléon III. The rouge that heightens the pale, translucent complexion is echoed in the ribbons of the fragrant-white dress with its accents of light blue and violet. To a certain extent, the countess' distinctive, noble air results from the deliberate adaptation of the traditions of the *Dixhuitième*, a period in which the art of pastel portraiture flourished in France (cat. nos. 42, 43).

Pastel on paper
60.5 x 50.5 cm
Signed and dated,
upper right: Renoir. 77
Private collection

Provenance
Claude Roger-Marx, Paris; Durand-Ruel, Paris; Otto Gerstenberg, Berlin

42 Young Woman with a Flowered Hat 1877–1879
Jeune femme au chapeau aux fleurs

Just as we continue to see the landscapes of the Provence through the eyes of Cézanne, we perceive the capricious charm of the Parisian woman through those of Renoir. Following the heroines, oriental beauties and peasant women of his classicist, romantic and realist predecessors, he created the prototype of urban proletarian femininity—the big-city flower barely out of childhood—that still populates Paris today. In so doing he fulfilled the expectations expressed by the brothers Goncourt in their artist-novel *Manette Salomon*, in which they called upon painters to take up the themes presented by the big city, to include "the indescribable beauty of the Parisian woman."[1]

In this picture of a young woman in red, wearing a hat adorned with flowers, Renoir achieved what Baudelaire had in mind when he linked the concepts of modernity and fashion (cat. no. 17). In his epoch-making article "The Painter of Modern Life", the poet wrote that the quest for modernity also involved "distilling from fashion the poetic qualities it contains in passing." Baudelaire spoke of the modern

Pastel on paper
46 x 41 cm
Signed, upper left:
Renoir
Private collection

1 Götz Adriani, *Edgar Degas. Pastelle, Ölskizzen, Zeichnungen*, Cologne 1984, p. 45.

artist's striving to "bring out the mysterious beauty embodied in the modes of dress of a given era, no matter how small and transient it might be," adding: "Modernity is the transient, the fleeting, the random—the one half of art, whose other half is the eternal and immutable. Every painter of the past has faced a modern age; the figures in most of the beautiful portraits that have survived from earlier periods wear the clothing of their times. They are in complete harmony, for their dress, their hairstyles, even their postures, gazes and smiles (every age has its own posture, its own gaze and its own smile) form a perfect, living whole. No one has the right to ignore or to put aside this fleeting, short-lived element that is subject to such frequent change."[2]

Baudelaire quite rightly denied contemporaries of any period the right to look with contempt upon the past from the vantage point of their modern cultures. If we accept the poet's definition of the two halves of art, then the modernity of Renoir's painting lies in its unqualified recognition of the ideal of beauty of an age, expressed in details of dress as much as in the modestly lowered eyelids and the coquettish suggestion of a smile. Accordingly, the other half would relate to the timeless existence—rescued from some "lost age"—of a woman of mature beauty, whose reserved expression and pale, painted complexion harmonize perfectly with the cinnabar and carmine red of her clothing.

Renoir could hardly have chosen a more appropriate medium for his model than the fine-toned pastels. Identified with the frivolity of the rococo and the courtly art of portraiture, pastel painting was initially frowned upon in 19th-century France as a technique typical of the *ancien régime*. Delacroix and the Goncourt brothers, who had initiated the campaign to rehabilitate the *Dixhuitième*, helped restore respectability to the pastel sticks made of powdery pigments pressed into a hard paste. Renoir's affinity for the art of the 18th century, which produced such masters of pastel painting as Maurice Quentin de la Tour, Jean-Baptiste Perroneau and Jean-Etienne Liotard, may have inspired him to add this medium, of which both Manet and Degas (after 1869) made liberal use, to his repertoire.[3] A born painter who found little appeal in the black-and-white of the drawing, Renoir employed pastels sporadically from the mid–1870s on,[4] later developing his technique of painting and drawing with pastel sticks to the highest level of perfection (cat. nos. 41, 43, 80). Degas' and Renoir's growing preference for pastels was based on economic considerations as well, as pastel works could be produced faster than oils and sold by Durand-Ruel at more affordable prices.

2 Baudelaire 1989, pp. 225ff.

3 Renoir especially admired Degas' pastels for their dry color effects, which reminded him of frescoes. "Just look at his pastels!" he said in response to a question posed by Vollard, "if you consider that he achieved the tone of the frescoes with a material that is so hard to handle!" (Ambroise Vollard, *Degas*, Berlin 1925, p. 58).

4 Renoir exhibited six oils and a pastel as early as 1874 at the first Impressionist exhibition.

Provenance
Justin K. Thannhauser, Berlin; Otto Gerstenberg, Berlin

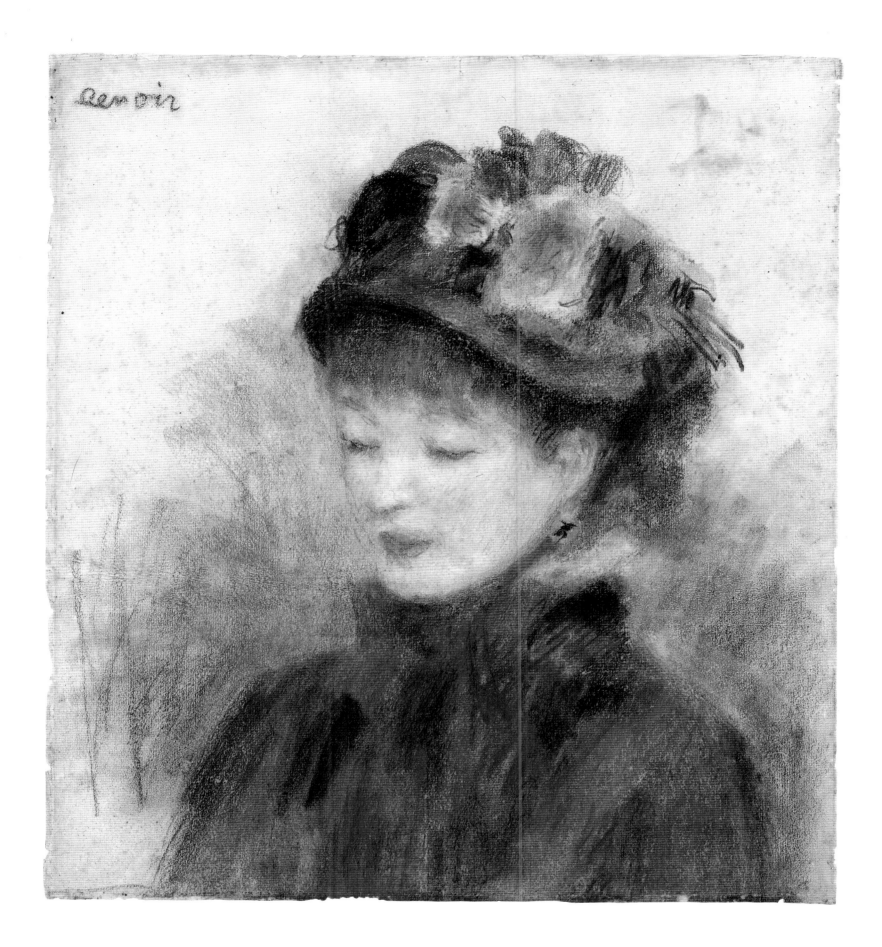

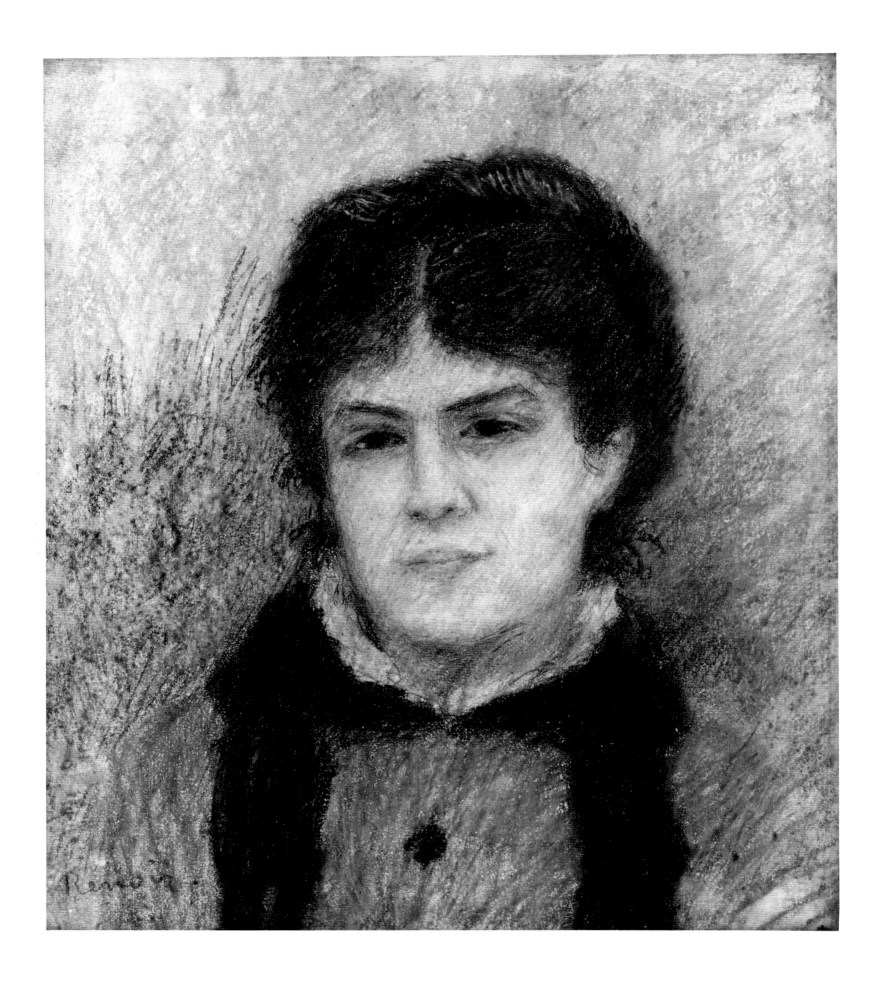

43 Portrait of Madame Bergerat 1878–1879
Portrait de Madame Bergerat

Unlike Degas, who at first employed the pastel technique only in land-scapes beginning in 1869, Renoir began to follow in the footsteps of the 18th-century French portraitists only a few years later, using pastel in his portraits as an ideal medium for rapid, economical production (cat. nos. 41, 42). In the spirit of Impressionism, however, he replaced the color-field textures of the rococo pastels with less compact, highly rhythmic strokes that appear more open and transparent.

The reserved coloration of this pastel portrait, unusual for a technique that ordinarily produces works of intense color, may represent the wishes of the client herself. The artist rendered her somewhat care-worn features with a color scheme intended to balance the cool, gray hues of the paper with the warmth of the dark chestnut-brown, yellow and light ochre. A matrix of oblique hatched lines applied in multiple parallel layers produce a largely unpolished surface. Opaque in and of themselves, the strokes of color were applied in such a way that the underlying layers and the paper ground remain visible, contributing to the overall effect.

The importance Renoir himself attributed to his pastels is suggested by the fact that one of his first exhibitions consisted primarily of pastel portraits. This show, one of a series of exhibitions sponsored by Edmond Renoir, took place on the premises of the Charpentier publishing house from June 19 to July 3, 1879. For the opening, Edmond wrote an informative article on his brother in the journal *La Vie Moderne*, No. 11 (a Charpentier publication for which Auguste Renoir served as art consultant).[1] Composing his text as a letter to the editor, Emile Bergerat, Edmond wrote: "Whenever he paints a person's portrait, he asks the model to assume a completely natural pose, to sit in just the way he or she always sits, to wear everyday clothing, all in order to ensure that nothing appears staged or artificial. And that is why his works have, aside from their aesthetic value, the magical charm of an accurate mirror of contemporary life. We see what he has depicted every day; he has recorded our lives in his works, which are surely among the most lively and harmonious of our time If we review my brother's art in its entirety, we recognize that he has never pursued a routine approach. No two pictures were done using the same technique, and yet each work is valid in its own right, was grasped correctly from the outset; and during the process of painting he sought not to achieve a lifelike representation of his subject, but only to capture the harmonies of nature as perfectly as possible.[2]

Pastel on paper
43 × 39 cm
Signed, lower left:
Renoir.
Private collection,
Switzerland

1 Rivière 1921, pp. 178ff.

2 Venturi 1939, II, p. 337.

44 Peonies 1878
Pivoines

Oil on canvas
59 x 49.5 cm
Signed, lower right:
Renoir.
Private collection

Introduced in Europe around mid-century, peonies first became popular in France and were the flower of fashion during the Second Empire. Even Manet was so taken with peonies that he planted many of them in his garden in Gennevilliers, devoting a number of flower paintings to the species in 1864 and 1865 (ill. p. 172).[1]

Renoir also developed a fondness for peonies (cat. no. 45) and developed the motif to perfection in this masterpiece. Indeed, the whole history of Impressionist painting is reflected in the contrasts between this work and Manet's soundly structured still lifes with peonies. Manet's dark backgrounds and local colors, closely related to the objects they represent, give way in Renoir's work to a splendid symphony of wide-ranging hues, reflected not only in the flowers but in their surroundings as well—here, the pot-bellied china vase and the surface upon which the scene is played out in an image full of lightness and movement. Manet's light-and-dark oppositions now radiate in a lighter, airier color scheme blossoming forth from the violet-blue areas of shadow and generating a series of increasingly bold contrasts between mauve and Verona green, violet-pink and lemon yellow.

It is interesting to note, however, the clarity with which even Renoir, the Impressionist, structured his compositions. Even in his early *Still Life with Bouquet and Fan* (cat. no. 12), a picture frame provides the objects with a kind of orthogonal support. In this work, a section of frame protruding into the painting from the upper right offers a horizontal contrast to the upright bouquet of peonies. It guarantees, in a sense, the stability of a precisely calculated pictorial construction which otherwise thrives upon the brilliance of its color relationships. The placement of the vase with its multicolored bouquet to the right of the vertical midline of the painting establishes balance with respect to the floral arrangement in the left foreground and the right angle of the yellow picture frame. As an Impressionist painter of still lifes who relied upon nature as well as the traditions inherited from the French baroque and rococo, Renoir gave his best in this painting, for seldom were his confrontations with *nature morte* characterized by such immediacy and spontaneous attention.

1 Rouart-Wildenstein 1975, Nos. 86–91.

Renoir, *Roses in a Vase*, ca. 1876, private collection

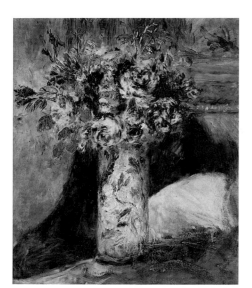

Provenance
Bernheim-Jeune, Paris; Hans Duensing, Boizenburg; Alice Scherrer von Guggenberger, Sorengo; Wildenstein, New York; B. E. Bensinger, Chicago; Auction, Christie's, London, April 15, 1975, No. 21; private collection, England; Auction, Christie's, London, June 26, 1995, No. 6.

References
Duret 1924, Ill. 27; Fezzi 1972, pp. 100f., No. 268, ill.; auction catalogue, *Impressionist and Modern Paintings, Watercolours and Sculpture (Part I)*, Christie's, London, June 26, 1995, No. 6, ill.

Exhibitions
New York 1969, No. 23, ill.; Chicago 1973, No. 23, ill.

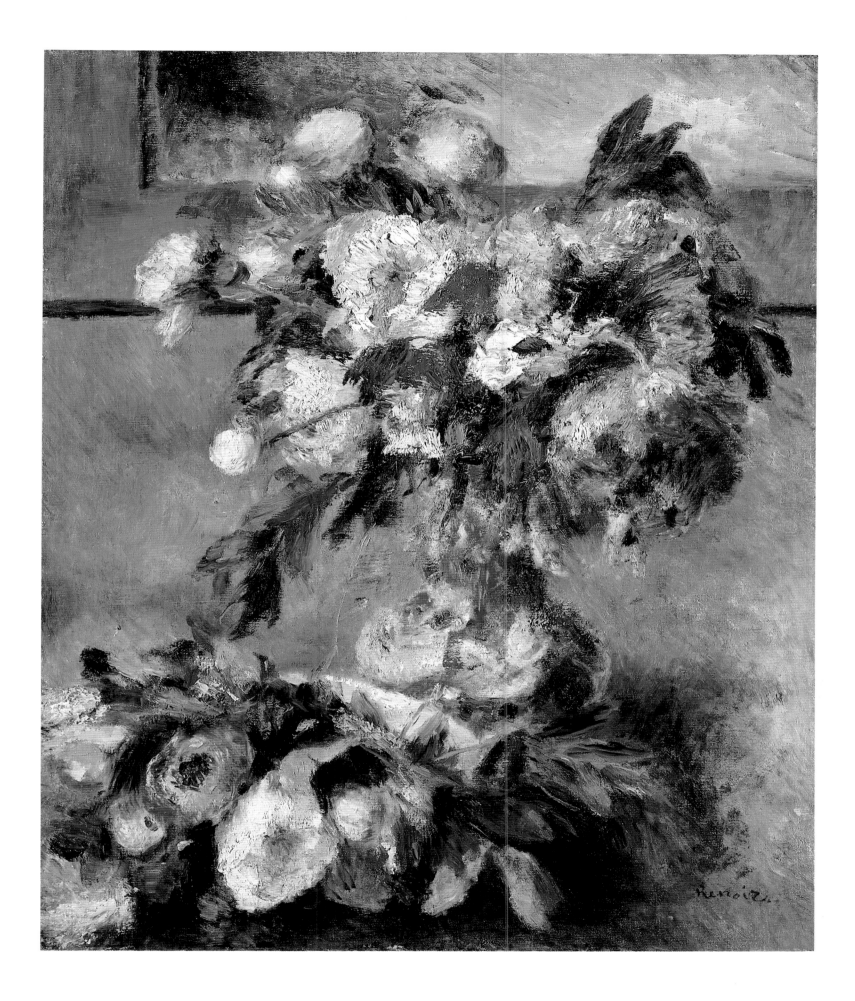

45 Peonies on a White Tablecloth 1878–1879
Pivoines sur une nappe blanche

Oil on canvas
29.3 x 42.3 cm
Signed, lower right:
Renoir.
Galerie Rosengart,
Lucerne

Renoir probably had Manet's series of peony still lifes from the years 1864–1865 in mind when he conceived this detail view of a single branch of peonies as a brightly colored accent against a light background (cat. no. 44). The depiction of cut flowers is probably not meant as a reference to the transient quality of life, for the carmine red blossoms that contrast so sharply with the green of the leaves evoke a thoroughly natural sensuality. Above all, however, the flowers were objects of pure painting—small-scale extracts of Renoir's great skill as a painter.

Provenance
Ambroise Vollard, Paris; Bernard Lorenceau, Paris; Gisèle Rueff-Béghin, Neuilly-sur-Seine.

References
Vollard 1918, II, p. 111, ill. (No. 1329); Michel Drucker, *Renoir*, Paris 1955, No. 73.

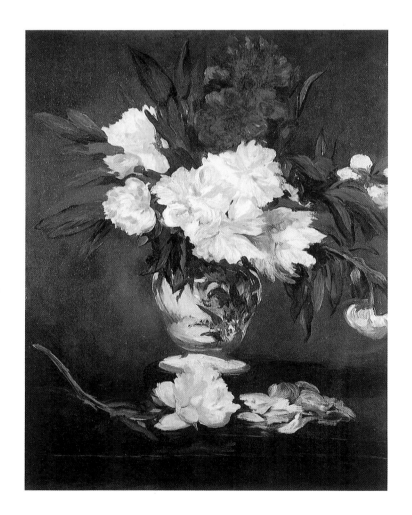

Edouard Manet,
Peonies in a Vase, 1864,
Musée d'Orsay, Paris

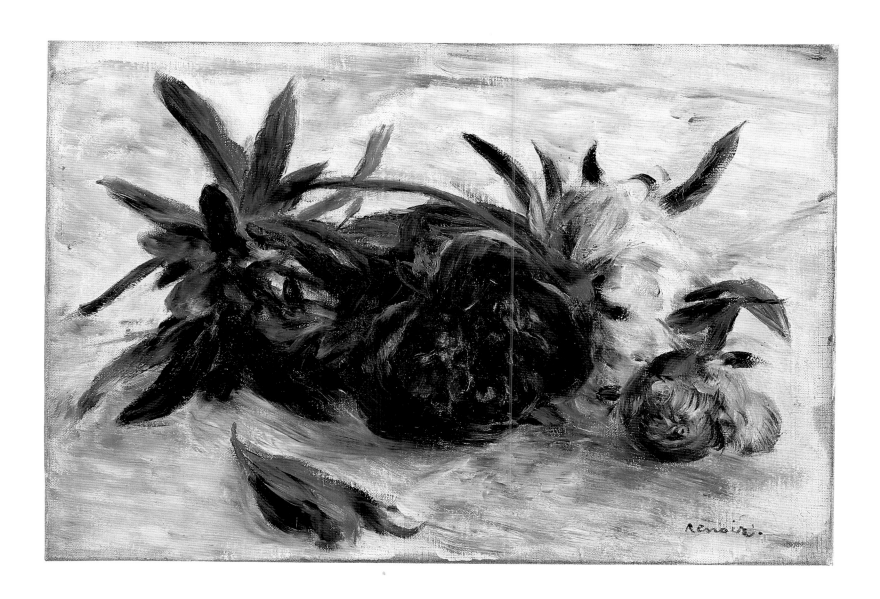

46 In a Café. Women Drinking 1877–1878
Au café. Les buveuses

Oil on canvas
39.5 x 34.5 cm
Signed, lower right:
A Renoir
Private collection
Daulte 1971, No. 239

1 Daulte 1971, Nos. 113, 181,
188, 238, 240, 322, 323, 325,
326.

Edgar Degas, *In a Café*,
1875–1876,
Musée d'Orsay, Paris

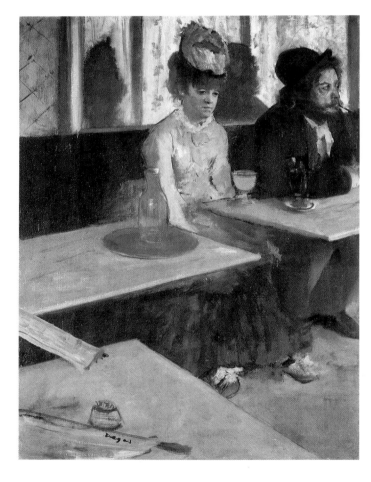

Between 1874 and 1880, Renoir conceived a series of scenes with multiple figures shown in somewhat disturbing views from above or below (cat. nos. 47, 48). These works, featuring everyday events and friends or models, interweave characteristics of genre painting with those of portraiture.[1] In these pieces, Renoir departed from the more personal milieu of his early work to enter the public sphere. As images of social situations, they reflect big-city activities in those establishments that had become the showplaces of modern life in 19th-century Paris: the cafés and theaters, the boulevards, the dance halls and bordellos, the fashion salons and studios.

During a period in which Renoir identified completely with the Impressionist movement, he had also come to realize that the Impressionists' devotion to the single moment was not entirely well suited to the portraitist's objective of achieving an authentic representation of physiognomic features. Intended for perpetuity and focused upon essential aspects, the portrait, influenced by the expectations of the client, remains aloof to the transient, temporary and chance concerns of modern life. Nor is it possible to establish fixed points of reference for specific effects of light in a given work. Thus other subjects, selected arbitrarily from the realm of everyday life, and fresh points of view were needed in order to capture aspects of urban life "en passant." It was Degas who developed the most radical solutions for this problem. His version of modernity was the most far-reaching in this regard. Degas' bizarre perspectives—views never before experienced in this way—his extremely fragmented figures, his intersections and abbreviations as well as the discontinuity of his approach to space inspired Renoir to develop a descriptive imagery of his own that reflected the ebb and flow of life. With precisely selected details of Paris reality, he sought to discover the true character of metropolitan civilization.

Renoir probably had Degas' absinthe-drinking woman at the Café de la Nouvelle Athènes in mind when he observed Georges Rivière (cat. no. 28)—who appears here on the periphery wearing a top hat—and the two well-dressed young ladies in their hats sitting at a café table. With respect to theme, at least, Degas' painting must have pointed the way for him—and shortly thereafter for Manet as well (ill. p. 176). Degas' work was exhibited in 1877 at the third Impressionist exhibition along with the pastel entitled *Femmes*

2 Lemoisne 1946, II, No. 419.

Edouard Manet, *In a Café*, 1878, Sammlung Oskar Reinhart, Winterthur

devant un café,[2] a piece singled out by Rivière in the first issue of *L'Impressionniste journal d'art*, a periodical published at Renoir's initiative. In contrast to Degas' café scenes, however, Renoir radically restricted the spatial parameters in this painting. The figures, perceived as if at random and thus only as fragmentary images from the perspective of the passer-by, remained—as always—much more important to him than specific spatial configurations or actions.

Provenance
Durand-Ruel, Paris; Bernheim-Jeune, Paris; M. Dubourg, Paris, Auction *Dubourg*, Hôtel Drouot, Paris, November 24, 1903, No. 15; Franz Goerg, Reims; Auction *Goerg*, Hôtel Drouot, Paris, May 30, 1910, No. 79; M. Oppenheimer, Paris; Otto Gerstenberg, Berlin.

References
Barnes-de Mazia 1935, pp. 71f., 186, 200, 253, 404f., 450, No. 81, ill.; Florisoone 1937, p. 92, ill.; Daulte 1971, No. 239, ill.; Fezzi 1972, p. 101, No. 280, ill.

47 The Conversation ca. 1878
La conversation

Oil on canvas
45 × 38 cm
Signed, upper left:
Renoir.
Nationalmuseum
(Inv. no. NM 2079),
Stockholm
Daulte 1971, No. 321

Aside from this painting, only two other interior and three street scenes exist in which the artist uses a diagonal structure composed of abruptly abbreviated figures in conversation with one another, each intersected by the edges of the picture.[1] Renoir presumably followed Degas' example in developing solutions of this kind. Although he did not share Degas' interest in the achievements of photography, it is entirely possible that the seemingly random choice of detail, much like a snapshot, does indeed relate to the impulsive perspective typical of many photographed scenes. There is no sense of illusionist perspective in the immediate confrontation of the female figure seen from the rear in the foreground and her conversation partner, presented in a frontal view towards the back of the picture.

According to Georges Rivière, the work was painted in 1879. The bearded young man with a pince-nez is Samuel Frédéric Cordey (1854–1911),[2] a friend of Renoir since 1875 and a member of the circle of artists who frequented the Café de la Nouvelle Athènes. His partner in conversation, her profile concealed, cannot be identified. In a companion piece of the same size showing the couple in a reverse configuration, however, the female figure is presented from the front.[3] Daulte has suggested that Renoir used Margot as a model in both paintings (cat. nos. 28, 39, 48). He, too, dated the painting to 1879, although his own research shows that Margot was taken seriously ill in January of that year and died soon afterward.

1 Daulte 1971, Nos. 113, 322, 323, 325, 326.

2 Rivière 1921, p. 23.

3 Daulte 1971, No. 322.

Provenance
Durand-Ruel, Paris; acquired in 1918.

References
Vollard 1918, I, p. 23, No. 91, ill.; Vollard 1919, ill. pp. 58–59; Rivière 1921, p. 23, ill.; R. Hoppe, "Renoir i National Museum," in *National Musearsbok*, Stockholm 1921, p. 84, Ill. 19; Meier-Graefe 1929, p. 126, Ill. 115; Chamson 1949, Ill. 25; Daulte 1971, No. 321, ill., pp. 411, 415; Fezzi 1972, pp. 103f., No. 334, ill.; Rouart 1985, p. 53, ill.; Monneret 1990, p. 152, No. 19, ill.; *Nationalmuseum Stockholm. Illustrerad Katalog över äldre utländkt maleri*, Stockholm 1990, p. 296, ill.

Exhibitions
Auguste Renoir, Stockholm–Copenhagen–Nasjonalgalleriet, Oslo, 1921, No. 17; *Fran Goya till Cézanne*, Museum, Malmö, 1966, No. 43, ill.

48 At the Milliner's Shop 1878
Chez la modiste

Oil on canvas
32.4 × 24.5 cm
Signed, lower left:
Renoir
Fogg Art Museum
(Bequest of Annie Swan
Coburn, Inv. no. 1934.31),
Harvard University Art
Museums, Cambridge,
Massachusetts
Daulte 1971, No. 274

In an unflattering description, Renoir's friend and biographer Georges Rivière characterized Marguerite Legrand, shown here in a milliner's shop, as a "suburban tramp" who had been elevated to a certain level of elegance and acceptability by Renoir's art (cat. nos. 28, 39, 47): "Few models tested Renoir's patience as much as Margot. She regularly failed to appear for sittings, even when she knew the painter was urgently expecting her. On such occasions he would go looking for her in the bars of Montmartre, finding her in most cases at a table with some young rascals seated in front of their glasses of wine. She would give in to the painter's insistent pleas and promise to return to the studio the next day, but she did not always keep her word. In 1881 she succumbed within only a few days to typhoid fever, and Renoir, overcome by sympathy as usual, had her buried at his own expense. I think that he even grieved for that cruel being who had caused him so much despair."[1] According to Daulte, she died on February 5, 1879, providing a *terminus ante quem* for this sketchlike interior scene.

1 Rivière 1921, pp. 66f.

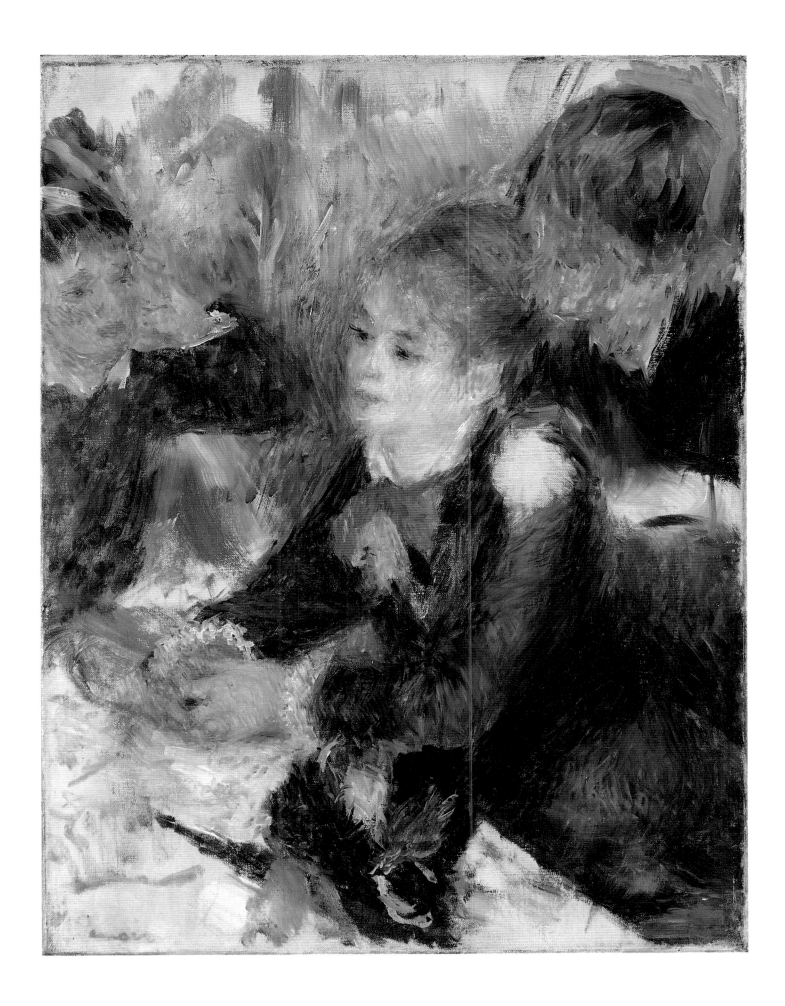

The three-figure scene takes place at a table positioned diagonally within the pictorial space. A feathered creation of the milliner is displayed on the table. The steep angle of view from above shortens the distances, causing the setting to assume a more planar than three-dimensional character. The apathy apparent in Margot's expression may be a sign of her illness. The figure behind her is probably the saleswoman; the customer whose form is cut off by the edge of the painting on the left is seen trying on a hat. As a delivery girl, she is dressed in the standard gray from which the grisettes derived their name, a designation that alludes to the cheap gray cloth produced in the textile mills of Castres.

Although Renoir assumed a certain pioneering role with this genre scene, a work he gave to his brother Edmond, he was content with a tentative view of the fashion salons of Paris, their clientele and their fashionable attributes. In the early 1880s, Degas, often accompanied by Mary Cassatt, followed in his footsteps with more extensive explorations of the milliners' salons. Degas' paintings imbue the arrangements of hats on display racks, in showcases or in the hands of customers with a life of their own, lending them a strange dominance over the generally concealed faces of their wearers.

Edgar Degas, *At the Fashion Salon*, 1882, Fundación Colección Thyssen-Bornemisza, Madrid

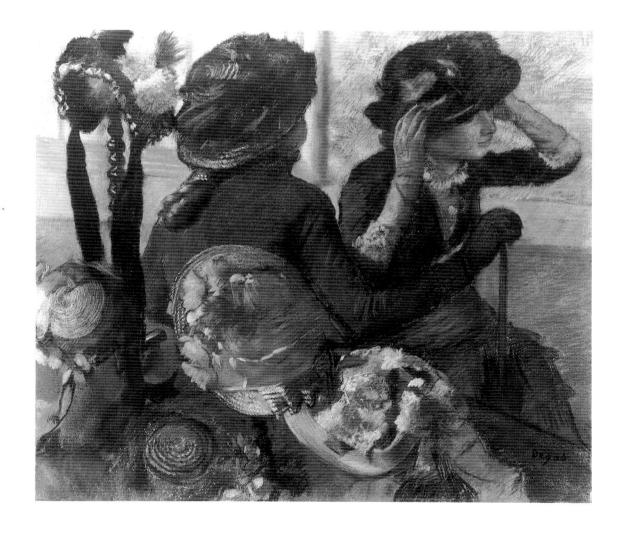

Renoir's interest in fashion took on more concrete form in the summer of 1879, when he presented Madame Charpentier (ill. p. 39) with Madame Bérard's suggestion of including the fashions of the week on the last page of *La Vie Moderne*, a journal published by her husband—a suggestion which, however, bore no fruit. Renoir indicated that he would "do detailed drawings following my return to Paris. In this way, you would have all of the readers on your side who are not particularly interested in the illustrations of Meissonier and his consorts. We could make an arrangement with milliners and seamstresses—one week for hats, the next for dresses, etc. I would visit them so that I could do the necessary drawings from different angles on site. Thus I offer you an idea. I submit it for your judgment."[2]

2 Florisoone 1938, p. 35.

Provenance
Edmond Renoir, Paris; Paul Rosenberg, Paris; Georges Bernheim, Paris; Howard Young, New York; Annie Swan Coburn, Chicago; presented as a gift in 1931.

References
Meier-Graefe 1929, p. 92, Ill. 75; Barnes-de Mazia 1935, pp. 68, 89, 249, 396, 448, No. 64, ill.; Drucker 1944, pp. 46, 57, 184, 197, Ill. 31; Daulte 1971, No. 274, ill. p. 415; Fezzi 1972, pp. 102f., No. 316, ill.; Rouart 1985, p. 49, ill.; Wadley 1987, p. 173, Ill. 59, p. 361; Monneret 1990, p. 156; Edgard Peters Bowron, *European Paintings before 1900 in the Fogg Art Museum*, Cambridge, Mass. 1990, p. 127, No. 380, ill.; Hollis Clayson, *Painted Love: Prostitution in French Art of the Impressionist Era*, New Haven and London 1991, pp. 121ff., ill.

Exhibitions
The Mrs. L. L. Coburn Collection of Modern Paintings and Watercolors, Art Institute, Chicago, 1932, No. 29, ill.; *Independent Painters of Nineteenth Century Paris*, Museum of Fine Arts, Boston, 1935, No. 44; New York 1937, No. 18, ill.; New York 1941, No. 24, ill.; San Francisco 1944, p. 22; New York 1950, No. 20, ill.; Los Angeles–San Francisco 1955, No. 18, ill.; New York 1969, No. 27, ill.; *The Crisis of Impressionism 1878–1882*, University of Michigan Museum of Art, Ann Arbor, 1979, No. 46; *Lasting Impressions. French and American Impressionism from New England Museums*, Museum of Fine Arts, Springfield, 1988, No. 21, ill.; Brisbane–Melbourne–Sydney 1994–1995, No. 12, ill., p. 18.

49 Small Blue Nude 1878–1879
Petit nu bleu

Renoir responded to the provocative indiscretions associated with nudity in such paintings as Goya's *Maya*, Courbet's *Baigneuse* or Manet's *Olympia* (ill. p. 92) with the ingenuousness of his own nudes. Having explored the theme early in his career in a number of life-sized figures shown standing, seated or reclining (cat. no. 10), he focused increasing attention on the representation of the female nude during the 1880s. His interest in the subject continued to grow as his career progressed (cat. nos. 71–73, 85–88, 101). Renoir deliberately avoided painting

Oil on canvas
46.4 x 38.2 cm
Signed, lower left:
Renoir.
Albright-Knox Art Gallery
(General Purchase Funds
1941, Inv. no. 41:2), Buffalo
Daulte 1971, No. 290

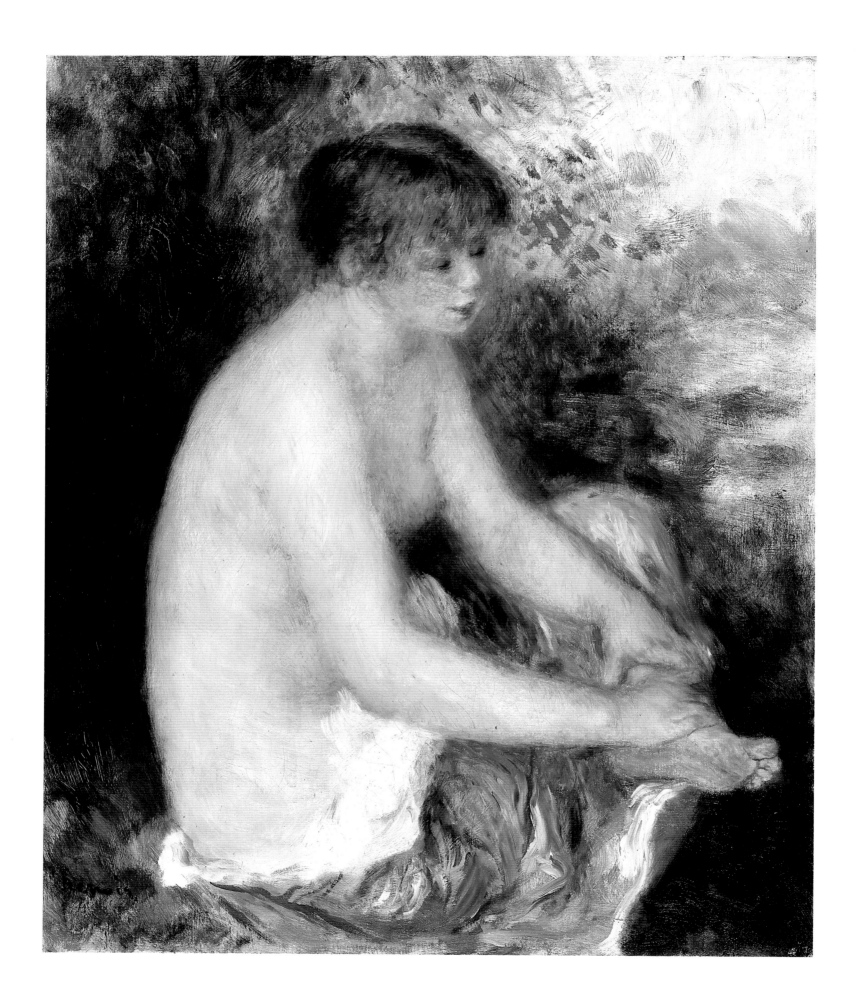

male nudes,[1] perhaps for fear of reducing the theme of natural beauty to the mere illustration of bathing scenes.

Cézanne had no such reservations as he set out to explore the subject of nudes—male and female—in the early 1880s (ill. p. 238). In completely different ways, yet at virtually the same time, the image of the nude bather came to embody for Cézanne as well as for Renoir and Degas the yearning for an enduring naturalness and unquestioned permanence, a problem for which Impressionism had found no empirical solution. While Cézanne ventured forth with his male and female bathers in search of an ideal correspondence between form and content, between nature and the human being, Degas made his discoveries in exclusively female nudes shown washing in vaguely defined interiors.[2]

Renoir opposed Cézanne's idealistic approach and Degas' more realistic one with symbolic figures of seemingly inexhaustible naturalness. In contrast to Cézanne's groups of figures, strictly separated by gender, and Degas' nude models observed in private moments in bathtubs or similar settings, with or without secondary figures, Renoir almost invariably isolated his female nudes (exceptions are cat. nos. 71, 73, 86), placing them amid natural surroundings in his studio paintings.

This seated nude, her legs wrapped in parts of a garment, serves as a medium for the most delicate of color nuances. The luminous skin of the woman's body is embedded in the shadowy color scheme of a vaguely suggested landscape, in which the rust-brown of the hair and the prominent blue and white of the garment are echoed in countless variations. No reference to the antique motif of the "thorn-puller"[3] is necessary to explain a pose repeatedly chosen by Renoir for his models (cat. no. 85).[4]

1 The single exception, a painting of a nude young man done in his early years, confirms the rule (Daulte 1971, No. 42).

2 Baudelaire described the nude as an expression of Parisian life: "Parisian life is rich in wonderful, poetic subjects. Wonderful things surround us and are as pervasive as the air; yet we do not see them. The nude, the naked figure that is so dear to artists, which contributes so much to their success, is as common and unavoidable in our life as it was among the ancients; in bed, in the bath, in the amphitheater" (Baudelaire 1977, p. 283).

3 Ehrlich White 1984, p. 95.

4 Daulte 1971, Nos. 178, 538.

Provenance
Mme Weiss, Paris; Durand-Ruel and Bernheim-Jeune, Paris; Jean Henri Laroche, Paris; Jacques Laroche, Paris; Paul Rosenberg, Paris and New York; acquired in 1941.

References
A. Basler, *P. A. Renoir*, Paris 1928, p. 47, ill.; Barnes-de Mazia 1935, No. 109, pp. 77ff.; Bünemann 1959, p. 11, ill.; Ehrlich White 1969, p. 344, Ill. 3; Daulte 1971, No. 290, ill.; Fezzi 1972, p. 105, No. 362, ill.; Daulte 1973, p. 39, ill.; Max-Pol Fouchet, *Les nus de Renoir*, Lausanne 1974, p. 118, ill.; Steven A. Nash, *Albright-Knox Art Gallery. Painting and Sculpture from Antiquity to 1942*, New York 1979, pp. 244f., ill.; Ehrlich White 1984, pp. 95, 99, ill.; Rouart 1985, p. 63, ill.; Eunice Lipton, *Looking into Degas. Uneasy Images of Women and Modern Life*, Los Angeles 1986, p. 184, ill.; Monneret 1990, p. 153, No. 7, ill., p. 156.

Exhibitions
Paris 1927, No. 9, ill.; Paris 1933, No. 60; New York 1941, No. 32, ill.; San Francisco 1944, No. 24; *The Nude in Art*, Wadsworth Atheneum, Hartford, 1946, No. 48; *Masterpieces by Delacroix and Renoir*, Paul Rosenberg, New York, 1948, No. 16, ill.; New York 1950, No. 28; New York 1958, No. 26, ill.; *One Hundred Years of Impressionism. A Tribute to Paul Durand-Ruel*, Wildenstein, New York, 1970, No. 40, ill.; New York 1974, No. 20, ill.; Nagoya–Hiroshima–Nara 1988–1989, No. 16, ill.; *On Classic Ground. Picasso, Léger, de Chirico and the New Classicism 1910–1930*, Tate Gallery, London, 1990, p. 226.

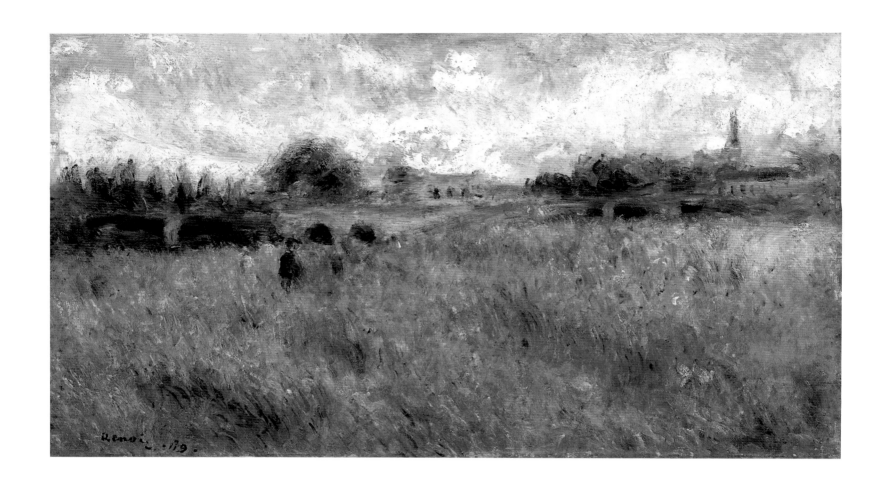

50 Seine Landscape near Rueil 1879
Paysage au bord de la Seine à Rueil

Oil on wood
37 × 66 cm
Signed and dated,
lower left:
Renoir. 79.
Private collection,
Switzerland,
courtesy of Salis & Vertes,
Munich–Salzburg

An orange-yellow and a restrained, hazy blue once again provide the complementary contrast from which Renoir develops an atmospheric pictorial cosmos of light and air. Enriched in a variety of ways, these two colors pervade the full breadth of a composition illuminated by vigorous brushstrokes and patches of color as if by the rays of the sun. The river, accompanied along its course by trees, houses and a distant church spire, leaves behind a trace of deep blue heightened with yellow. The narrow horizontal format is ideally suited to the features of the landscape along the bend in the Seine near the town of Rueil. The

human figures, standing out as spots of color amid the waves of grain, mediate between proximity and distance.

Provenance
Paul Renoir, Paris; Auction, Sotheby's, London, December 5, 1973, No. 21; Galerie Ferrero, Geneva.

References
Auction catalogue, *Impressionist and Modern Paintings and Sculpture*, Sotheby's, London, December 5, 1973, No. 21, ill.

51 At the Riverside 1878–1880
Au bord de l'eau

Although several of the seascapes painted by Renoir during the same period are characterized by greater restraint in technique and coloration (cat. nos. 54, 55), *At the Riverside* bears witness to his essential qualities as a painter in the tradition of 18th-century French art, Corot and the Impressionist landscape. The work derives its power from the myriad interrelationships of strong colors in a composition showing a rowboat and a rower on the radiant blue of a river near a tree-lined riverbank.

Employing a dynamic painting style, Renoir develops a striking pattern of color which, though applied with undeniable spontaneity, reveals a precisely conceived structure. Thus the blue of the river is enhanced by the rays of sunlight reflected on the leaves and the water's surface, while the red of the boat's hull is complemented by the luscious green of the trees. In full accord with the spirit of Impressionism, Renoir once again achieves a harmonious symphony of objects and color rhythms in a setting from which he often drew inspiration: the banks of flowing waters, where forms refract into a brilliant kaleidoscope of color (cat. nos. 16, 33, 34, 52, 53, 66).

Oil on canvas
54.6 × 65.7 cm
Signed, lower right:
Renoir.
Private collection, U.S.A.

Provenance
Ambroise Vollard, Paris; Durand-Ruel, Paris and New York; Frank C. Osborn, New York; Philadelphia Museum of Art.

References
Vollard 1918, II, p. 83, ill. (No. 1134); Fezzi 1972, pp. 112f., No. 550, ill.; Daulte 1973, p. 79, ill.; Monneret 1990, p. 150, No. 11, ill.

Exhibitions
Paris 1920, No. 56; Nagoya–Hiroshima–Nara 1988–1989, No. 29, ill.; *European Painting and Sculpture from the Philadelphia Museum of Art: Towards the Twentieth Century*, Hokkaido Museum of Modern Art, Sapporo–Museum of Art, Kofu–Museum of Art, Nagoya, 1992, No. 27, ill.

185

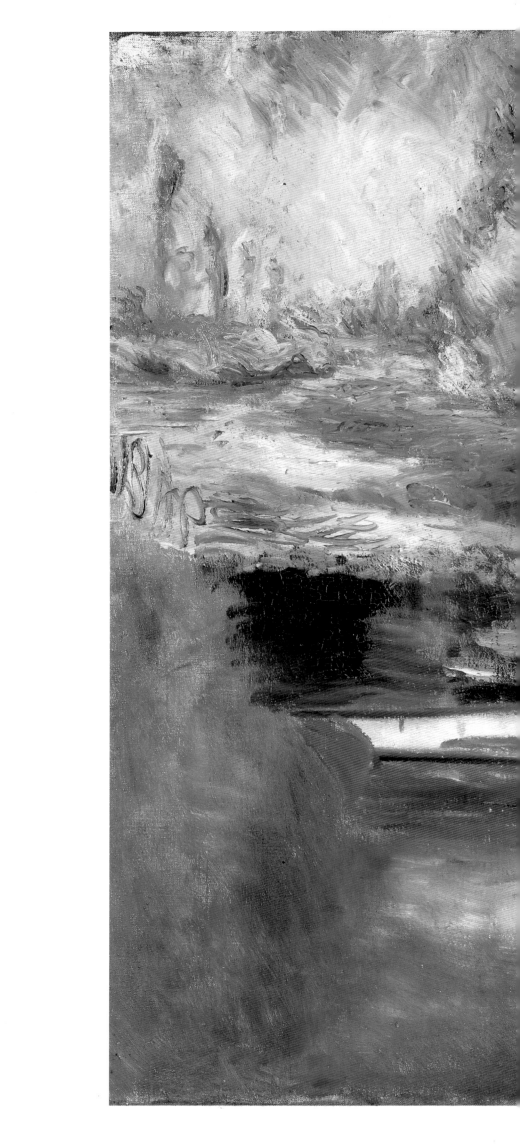

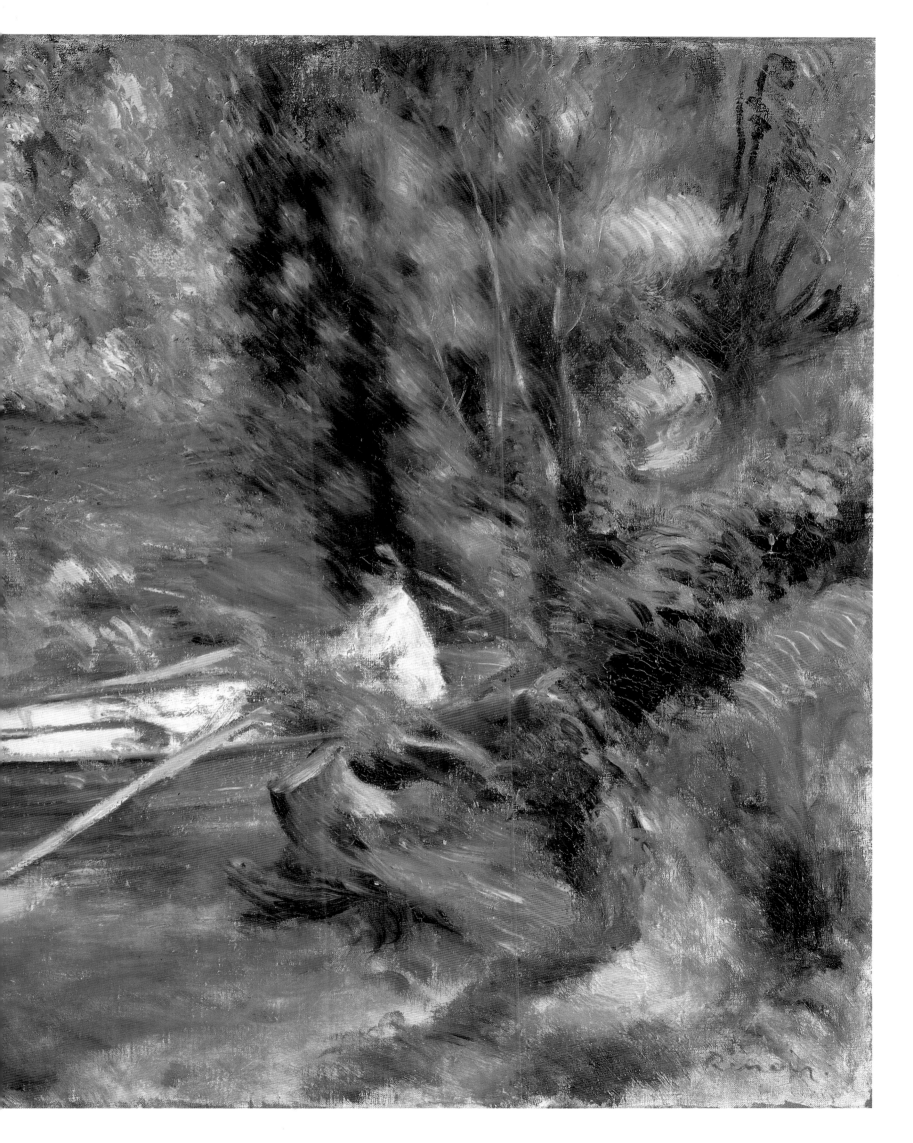

52 On the Banks of the Seine near Argenteuil 1878–1880
Au bord de la Seine à Argenteuil

Oil on canvas
46 × 55.5 cm
Signed, lower left:
Renoir.
Stiftung Langmatt
Sidney and Jenny Brown
(Inv. no. 180/GZ),
Baden, Switzerland

This view of the Seine, painted shortly before the crisis of Impressionism by one of its founding fathers, focuses all the symptoms that had caused the movement to blossom for a brief moment in history. Nearing its end, the decade of leisurely Sunday *joie de vivre*, of swarming reflections of light and a carefree style of painting devoted to the beauty of the moment found one final and powerful expression in this painting.

The gently animated image of a couple at the riverside embankment bears an unmistakable resemblance to Renoir's Seine landscape with rowers of 1879 (ill. p. 190). Renoir painted the latter image near Chatou, while this smaller impression presumably shows the broad span of the road bridge at Argenteuil in the background. The choice of location made it possible for the artist to paint the two figures standing in the foreground of a riverside landscape that fades into the depths of the painting. The light-colored water, its surface dotted with the shadowy reflections of several boats tied to the riverbank, is confined to the right-hand portion of the scene. Bushes and trees appear on the left, their branches and leaves extending out over the water and surrounding a young woman who faces the viewer. Wearing a fashionable dress and hat, she appears to wait in cheerful anticipation while her companion handles the towline of a boat in preparation for a shared excursion on the river.

The idyllic scene in its natural setting is enriched with blue and reddish-brown hues that appear in the water, in the air or among the branches of the trees, ultimately uniting in the purple of the woman's elegant clothing and the distant span of the bridge. This colorful "bridgehead" between the near and the distant, serving also to link the left and the right halves of the painting, is based on formal considerations as well. The painter used the standing figure to give vertical stability to the breathtaking fury of his brushwork, augmenting the effect in the horizontal through the addition of the bridge. The vitality of the contrast between the strict orthogonal construction and the vigorous painting technique anticipates the tension-filled balance of the geometric compositions of Georges Seurat's Seine landscapes after 1883.

Provenance
Ambroise Vollard, Paris; Galerie Neupert, Zurich; Sidney W. Brown and Jenny Brown-Sulzer, Baden; acquired in 1918.

References
Vollard 1918, I, p. 76, No. 301, ill.; Deuchler 1990, pp. 180f., ill.

Exhibitions
La peinture française du XIX^e siècle en Suisse, Galerie Beaux-Arts, Paris, 1938, No. 95.

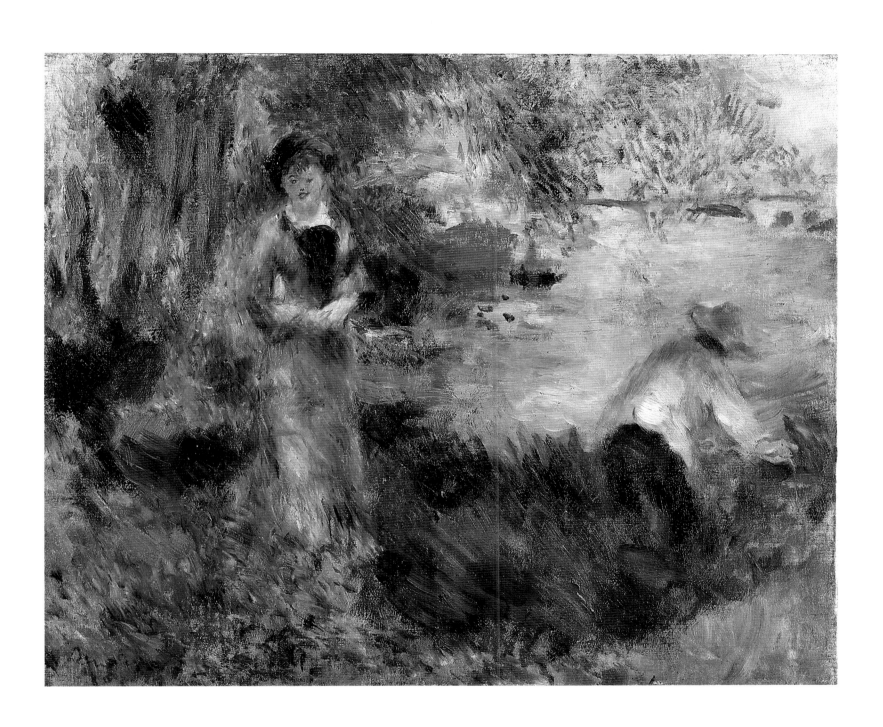

53 The Skiff　1878–1880
La barque

Oil on canvas
54.5 × 65.5 cm
Signed, lower left:
Renoir
Stiftung Langmatt
Sidney and Jenny Brown
(Inv. no. 183/GZ),
Baden, Switzerland

Boats on the water and people handling them were one of Renoir's favorite motifs even during his early years (cat. nos. 2, 10, 16, 33, 51, 52, 66). Here as well, it was the artist's love of life that enabled him to reconcile a variety of pictorial elements within a splendidly colored composition. The painting shows a view from the shadows of an abundant vegetation toward a body of water reflecting the blue of the sky. Framed by the cool water and the surrounding leaves and branches is a boat occupied by a female figure dressed in white. She appears as an integral part of the natural setting forming a dense thicket around her, enclosing her and the gently rocking skiff within a kind of arbor. Thoroughly assimilated into an idyllic scene of security and comfort, the human figure in this painting is not yet interpreted as a foreign body in a nature subject to the ravages of rapid, progressive industrialization. Renoir's splendidly colored brushstrokes, leading upward in the lower segment of the painting and downward in the hanging branches of the weeping willow, evoke an image of luscious green vegetation permeated by sun and sky.

Provenance
Ambroise Vollard; Sidney W. Brown and Jenny Brown-Sulzer, Baden; acquired in 1917.

References
Vollard 1918, I, p. 34, No. 133, ill.; Pierre Courthion, "Les collections privées en Suisse: La collection Brown-Boveri," in *L'amour de l'art*, January 1926, p. 30, ill.; Deuchler 1990, pp. 182f, ill.

Renoir, *Rowers near Chatou*,
1879, National Gallery of Art,
Washington

Exhibitions
Zurich 1917, No. 207; Luxembourg 1995, No. 140, ill., pp. 162, 167, ill.

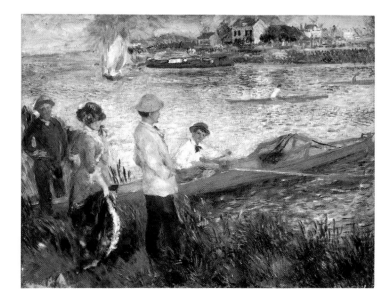

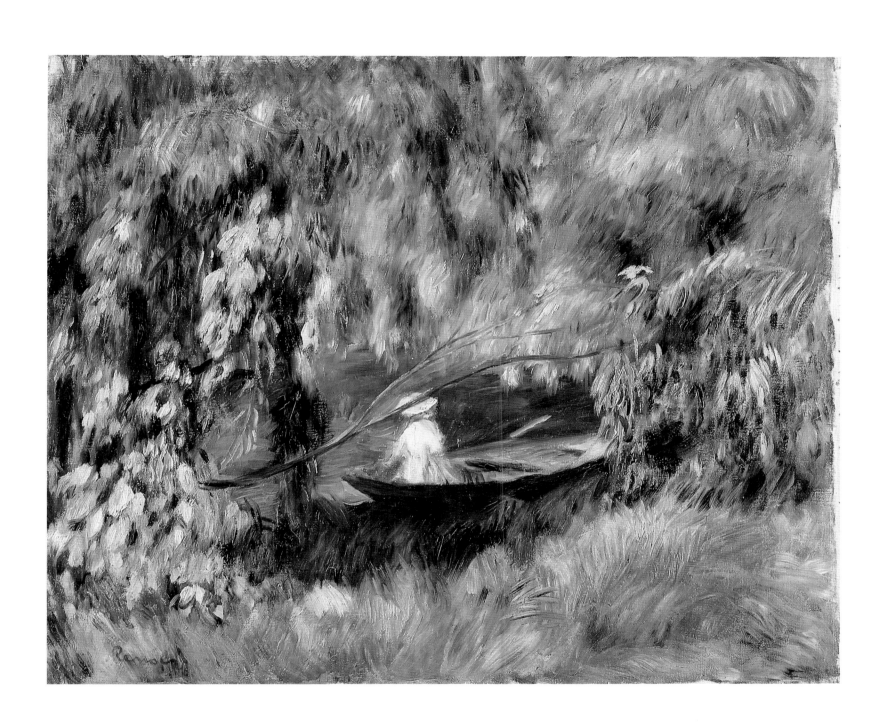

54 Cliffs on the Coast near Pourville 1879
Falaises à Pourville

Oil on canvas
54 × 65.5 cm
Signed and dated, lower
right: Renoir. 79.
Private collection,
courtesy of
Galerie Nathan, Zurich

Renoir first visited Paul Bérard at Wargemont Castle, his estate not far from Dieppe in Normandy, from July to September of 1879. He had been introduced to the diplomat and banker, who would eventually become one of his most important patrons, by the collector Charles Deudon in March of the same year.[1] During his stay at Wargemont he painted several wall panels for the dining hall, library and other rooms with floral motifs and hunting scenes. Of even greater importance was his role as the Bérards' portraitist (cat. no. 70). He completed a total of eight family portraits for them in 1879 alone.[2]

His work with landscapes in the outdoors (cat. nos. 55–57) provided welcome relief from the rigors of painting these more or less representative commissioned works. For the most part, the landscapes he produced during this period were impressions painted in thinly applied colors. They document the Parisian artist's enthusiasm for the Channel coastline and its imposing features, beauties of which he had long been unaware. Through the Bérards, Renoir also met Madame Blanche, whom he often visited at her summer residence in Dieppe to give painting lessons to her son Jacques-Emile. Only a short distance to the west of Dieppe lay the coastal village of Pourville, where he painted this breathtaking view of bleached cliffs and the wide expanse of sea beneath an open sky. Renoir's decision to immortalize the figure gazing intently at the wondrous drama of nature in the left foreground—possibly his student Jacques-Emile—may have been influenced by the emergence of the postcard industry at about the same time (ill. p. 193). By confronting the abruptly rising cliffs with the gentle expanse of the sea and balancing the unusual relationships of scale through the use of figures of varying sizes, he succeeded in illustrating the possibilities inherent in landscape composition for the benefit of Jacques-Emile Blanche.

Renoir's choice of this striking panorama pointed the way for Monet, who discovered Pourville and Varengeville at his prompting in 1882 and painted the unique rock formations from vantage points at the foot of the cliffs or from their towering heights.

Cliffs on the Coast near Pourville was the last of Renoir's paintings purchased by Victor Chocquet for his collection (cat. no. 26).

1 Duret 1924, pp. 62ff.

2 Daulte 1971, Nos. 279–286

Provenance
Victor Chocquet, Paris; Auction *Chocquet*, Hôtel Drouot, Paris, July 1, 1899; Durand-Ruel, Paris; Hugo Nathan, Frankfurt am Main; Dr. Fritz Nathan, St. Gallen.

References
Kunst und Künstler, XX, 1922, p. 315, ill.; Drucker 1944, p. 53, Ill. 52, p. 201; Gaunt 1952, p. 10, Ill. 46; Fezzi 1972, p. 105, No. 359, ill.; Gaunt-Adler 1982, pp. 17f, Ill. 5.

55 Seascape. Woman at the Seaside 1879–1880
Marine. Femme au bord de la mer

Renoir spent the summer months of the years 1879 to 1882 at the home of Paul Bérard in Wargemont on the coast of Normandy (cat. nos. 54, 56, 57). During these periods he made frequent visits to Madame Blanche and her son Jacques-Emile in Dieppe. He and Durand-Ruel also visited Monet in Pourville in 1882. Greatly impressed by the expansive horizons, the artist completed a series of delicate impressions in which he dealt with the ethereal interplay of land, air and water at various times of the day and under changing weather conditions. Striving to capture aspects of atmosphere, he restricted his palette to unusually subdued colors applied in thin layers of paint.

Expressive of vastness and distance, Renoir's translucent tone-in-tone painting composed of sea, sky and coastline likewise originated in this context. It calls to mind the sea studies conceived by Whistler in Trouville in 1865. White clouds against the airy blue of the sky cast shadows onto the alternating blues and greens of the water's surface and the olive green of a small grass-covered hill. Almost lost in the vast expanse, the tiny human figure seated there serves as a reminder of the true dimensions of nature.

Oil on canvas
50.5 x 61.5 cm
Signed, lower left:
Renoir
Kunsthaus (Inv. no. 2634),
Zurich

Provenance
Theodor Fischer, Lucerne; acquired in 1943.

References
Vollard 1918, II, p. 83, ill. (No. 1135).

Exhibitions
Europäische Malerei, 13.–20. Jahrhundert, Kunsthaus, Zurich 1955, p. 27.

Postcard view of the cliffs at Varengeville

995. *Varengeville.* — Sur les Falaises

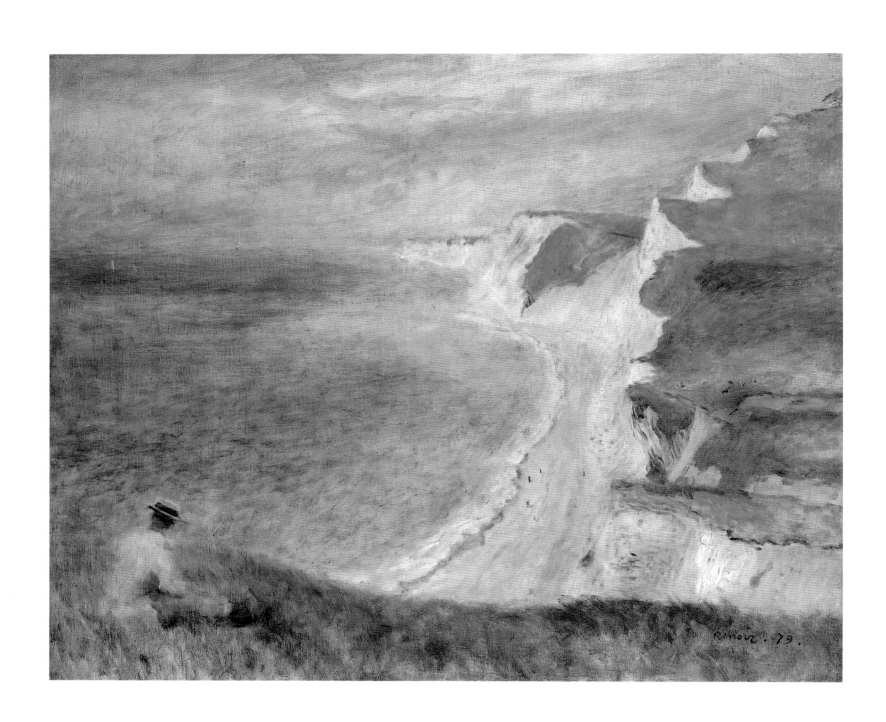

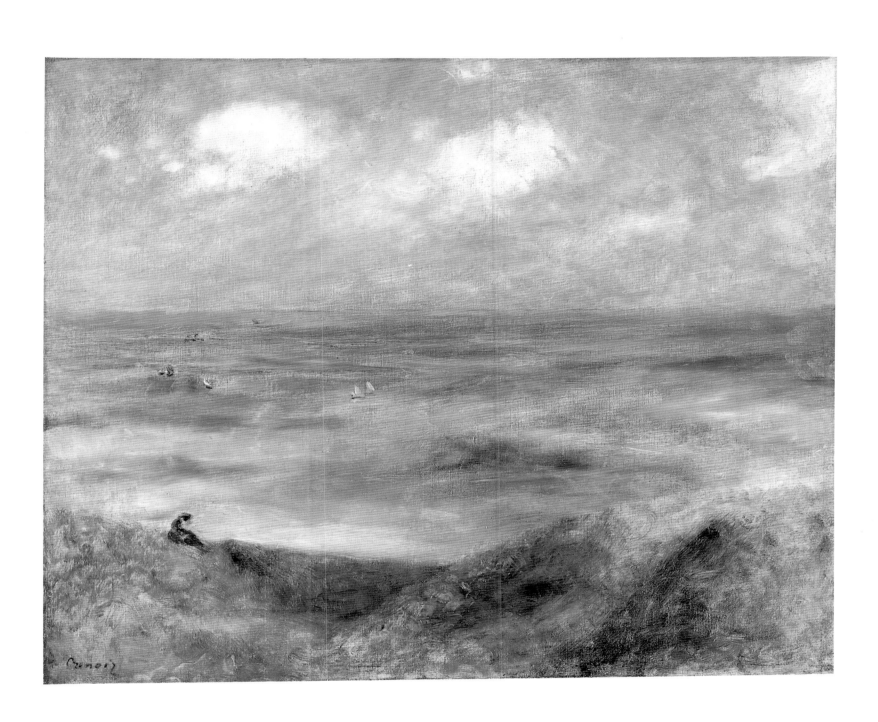

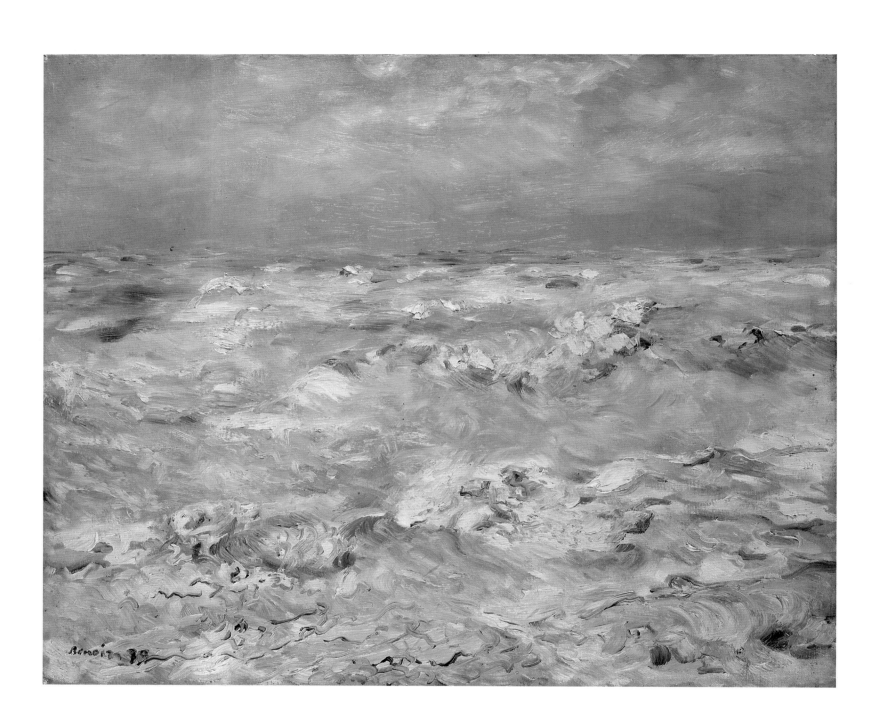

56 Seascape near Berneval 1879
Marine à Berneval

The threatening side of nature is manifested in this atmospheric seascape, a subject Monet treated extensively after 1880, albeit in a much more moderate way.[1] Its setting was very similar to that of the preceding seascape (cat. no. 54): Berneval, a town on the Channel coast, is only a few kilometers northeast of Wargemont, where Renoir spent the summer of 1879.

Renoir painted only a very few pictures in which natural phenomena are presented with such immediacy within a narrow field of vision. As in Courbet's seascapes from Trouville (1865) and Etretat (1869), the central focus of this painting is the violent pathos of the churning waves beneath a clouded sky. Streaks of color—gray, yellow and blue heightened by the white of foam—advance with untamed, eruptive force toward the foreground. Renoir gained command of the elements of air and water with the vigorous, rugged brushstrokes of a Fauve "avant le fauvisme."

Oil on canvas
54 × 65 cm
Signed and dated,
lower left: Renoir. 79
Private collection,
courtesy of
Galerie Nathan, Zurich

1 Wildenstein 1974, Nos. 623, 624, 661–663.

Provenance
Durand-Ruel, Paris; Justin K. Thannhauser, New York and Berne; Dr. Fritz Nathan and Dr. Peter Nathan, Zurich; private collection, Switzerland.

References
Fezzi 1972, p. 106, No. 390, ill.

Exhibitions
Los Angeles–San Francisco 1955; Brisbane–Melbourne–Sidney 1994–1995, No. 13, ill.

Gustave Courbet, *The Wave*, 1869–1870, Staatliche Museen zu Berlin, Nationalgalerie

57 View of the Normandy Coast near Wargemont 1880
Vue de la côte près de Wargemont, en Normandie

Oil on canvas
50.5 × 62.2 cm
Signed and dated,
lower right: Renoir. 80.
Lent by The
Metropolitan Museum of
Art (Bequest of
Julia E. Emmons, 1956,
Inv. no. 56.135.7),
New York

1 Daulte 1971, No. 339.

2 In a letter from Chatou in 1880, for example, he complained to Bérard about the demands imposed upon him by rich female clients who were difficult to satisfy: "I must continue to work on this damned painting because of this dizzy society woman who had the gall to come to Chatou to have her portrait painted; it cost me two weeks, and the outcome was that I destroyed it today I have no idea where I stand at the moment, except that I am growing more and more upset" (Renoir 1968, p. 4).

The coastal landscape around Dieppe was one of the most important artistic advantages of Renoir's visit to his patron Paul Bérard at Wargemont in June and early July of 1880. Renoir had just completed Bérard's portrait,[1] and the vast panoramas of the Normandy coast (cat. nos. 54–56) appear to have made up for some of the annoyances he suffered as an increasingly popular portraitist.[2]

He set up his easel at a fair distance from the coast, with a view toward a hilly plateau rising steeply up from the sea. The high horizon provided a horizontal contrast to the oblique lines of the landscape. Although parts of several houses are visible behind the hills, no human figures appear in the scene. Sailboats, recognizable as tiny daubs of color, are seen on the surface of a deep sapphire-blue sea whose color changes to emerald-green and turquoise in the shallower waters near the coastline. The landscape stands out in a colorful array of light and shadow against the cool background in the distance. Fields, meadows, houses and farmland are rendered in an ochre that periodically shifts into golden yellow, radiant violet-blue, luscious green and isolated patches of reddish-brown. It was only a short while later that Monet, working from similar vantage points, followed suit in his own landscapes, enlivening them with patches of light and rendering them in dense, splendidly colored textures.

Provenance
Durand-Ruel, Paris and New York; Arthur B. Emmons, New York; Julia E. Emmons, New York; presented as a gift in 1956.

References
Charles Sterling and Margaretta Salinger, *The Metropolitan Museum of Art. French Paintings XIX–XX Centuries*, III, New York 1967, p. 153, ill.; Fezzi 1972, p. 107, No. 420, ill.; Alice Bellony-Rewald, *The Lost World of the Impressionists*, London 1976, pp. 68f., ill.

Exhibitions
New York 1969, No. 34, ill.; *Landscape Painting in the East and West*, Prefectural Museum of Art, Shizuoka–City Museum, Kobe, 1986, No. 15; Brisbane–Melbourne–Sidney 1994–1995, No. 17, ill., p. 21.

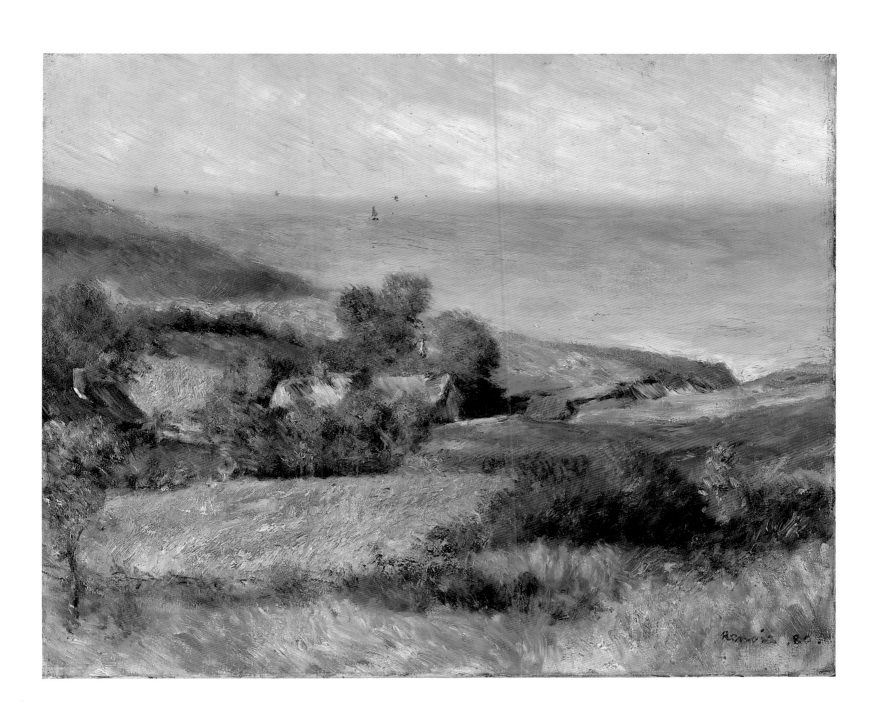

58 Aline Charigot with a Dog 1880
Aline Charigot au chien

Oil on canvas
32 × 41 cm
Signed, lower right:
Renoir.
Prêt obtenu par
l'intermédiaire de
Durand-Ruel et Cie, Paris
Daulte 1971, No. 355

Renoir achieved his first public success—the only one for many years—at the 1879 Salon exhibition with a showpiece society portrait done in the Impressionist style, a work that was well received in high-society circles (ill. p. 39). The next year, however, the artist created a very personal contrasting piece in this uncomplicated declaration of love to Aline-Victorine Charigot (1859–1915), a woman eighteen years his junior. With the joyful eagerness of a visually-oriented man who recognized no obligation to convention, he made painting an end in itself in the spirit of Impressionism. The staccato rhythms of vigorous brushstrokes vibrating in the light, only occasionally punctuated by moments of relative calm, establish a lively concord between form and content, between nature and the human figure—and even between artificial and natural floral decoration. Here the young milliner, who according to Renoir could "run through the grass without harming it,"[1] had sat down in a meadow with her little dog (ill. p. 40), stretching out her legs with little concern for decorum.[2]

Aline Charigot, shown here in a Sunday dress and a straw hat quite possibly of her own creation, forged ties with the Parisian artist-bohemian community around 1879 as it pursued its amusements on the rural-suburban fringe of the great metropolis around Chatou or on the island of Croissy (cat. no. 16). A native of Essoyes, a village in the Département Aube, Aline lived in the Rue Saint-Georges with her mother, who had found work as a seamstress in Paris after her husband's emigration to America. Renoir met her at the restaurant "Chez Camille" across from his own rooms in the Rue Saint-Georges and engaged her as a model. Their working relationship soon developed into a love affair that was legitimized by marriage in 1890 (cat. nos. 76–78).

No one has described the relationship between the two with greater sensitivity and insight than the film maker Jean Renoir, who based his remarks on his parents' recollections: ". . . Aline Charigot had eyes only for this painter, a man no longer young who hadn't a penny to his name. 'And when he had a few, he soon got rid of them!' He was forty, she nineteen. She liked nothing better than to pose as his model. 'I know nothing about such things, but I do so enjoy watching him paint.' . . . Apparently, the lovers spent most of their time on the banks of the Seine. They would meet at the Restaurant Fournaise [ill. p. 40], which was quite nearby. They could walk down the Rue Saint-Georges, cross over the Rue Saint-Lazare and be at the station within five minutes. Trains to Saint-Germaine left every half hour and stopped in Chatou. At the Fournaise they could expect to meet a throng of acquaintances who followed their idyll with great sympathy and interest. The painter Caillebotte protected Aline Charigot like a younger sister. Ellen André

1 Renoir 1981, p. 191

2 See the portrait identified in Daulte 1971 as No. 465 and the related examples of portraits by Monet in Wildenstein 1974 (Nos. 205, 405, 407).

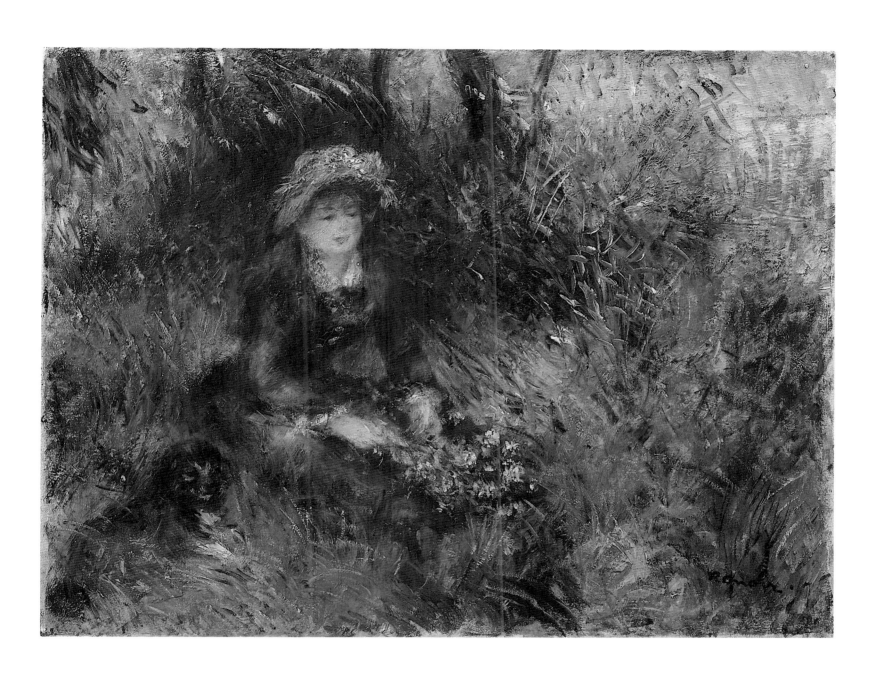

and Mademoiselle Henriot (cat. nos. 29, 30) accepted her into their circle and took it upon themselves to 'give this delightful peasant child some polish.' She would listen to them and was touched by their demonstrations of friendship, but she did only as she pleased. 'I didn't want to give up my accent and become a false Parisian.' The place was wonderful! A never-ending feast. She loved rowing and was on the water constantly. Renoir admired her skill. 'She could really do things with her hands.'"[3]

3 Renoir 1981, pp. 188ff.

Provenance
Auction, Maître Chevallier, Paris, May 9, 1898, No. 47; Durand-Ruel, Paris.

References
Rouart 1954, p. 52, ill.; Claude Roger-Marx, *Le commerce des tableaux sous l'impressionnisme et à la fin du XIXe siècle*, Paris 1958, p. 20, ill.; François Daulte, "Renoir. Son œuvre regardé comme un album de famille," in *Connaissance des Arts*, November 1964, p. 76, Ill. 4; Daulte 1971, No. 355, ill., p. 411; Fezzi 1972, pp. 106f., No. 407, ill.; Daulte 1973, p. 38, ill.

Exhibitions
Nice 1952, No. 7; Arles 1952, No. 3; Lyon 1952, No. 10; Paris 1958, No. 11; Munich 1958, No. 9, ill.; Stockholm 1964, No. 40; Paris 1969, No. 9, ill.; Tokyo–Fukuoka–Kobe 1971–1972, No. 13, ill.; Paris 1974, No. 47, ill.

59 Young Girl Reading 1880
Jeune fille lisant

Oil on canvas
55.5 × 46.5 cm
Signed, lower left:
Renoir.
Städtische Galerie im
Städelschen Kunstinstitut
(Inv. no. SG 177),
Frankfurt am Main
Daulte 1971, No. 333

The epitome of a carefree style of painting dedicated entirely to sensual invigoration, Renoir's art is also characterized by a strange sense of earnestness. Although his colors are radiant, the facial expressions of his subjects are seldom animated by a smile and never by the kind of hearty laughter that would seem appropriate to his themes. From his male viewpoint, the artist glorified women as symbols of youthful beauty, yet he showed little interest in their physiological or psychological condition. He was enamored of their presence as objects of observation in domestic settings or as figures lost in the pictorial space of natural surroundings. Renoir was thoroughly convinced that "women are innocent. Life becomes very simple when we are with them. They give everything its rightful place and know full well that their laundry is just as important as the founding of the German Empire. One is in good hands with them."[1]

The "grande peinture" and the jubilant coloration of this image stand in marked contrast to the more subdued intimacy of the depic-

1 Renoir 1981, p. 76.

202

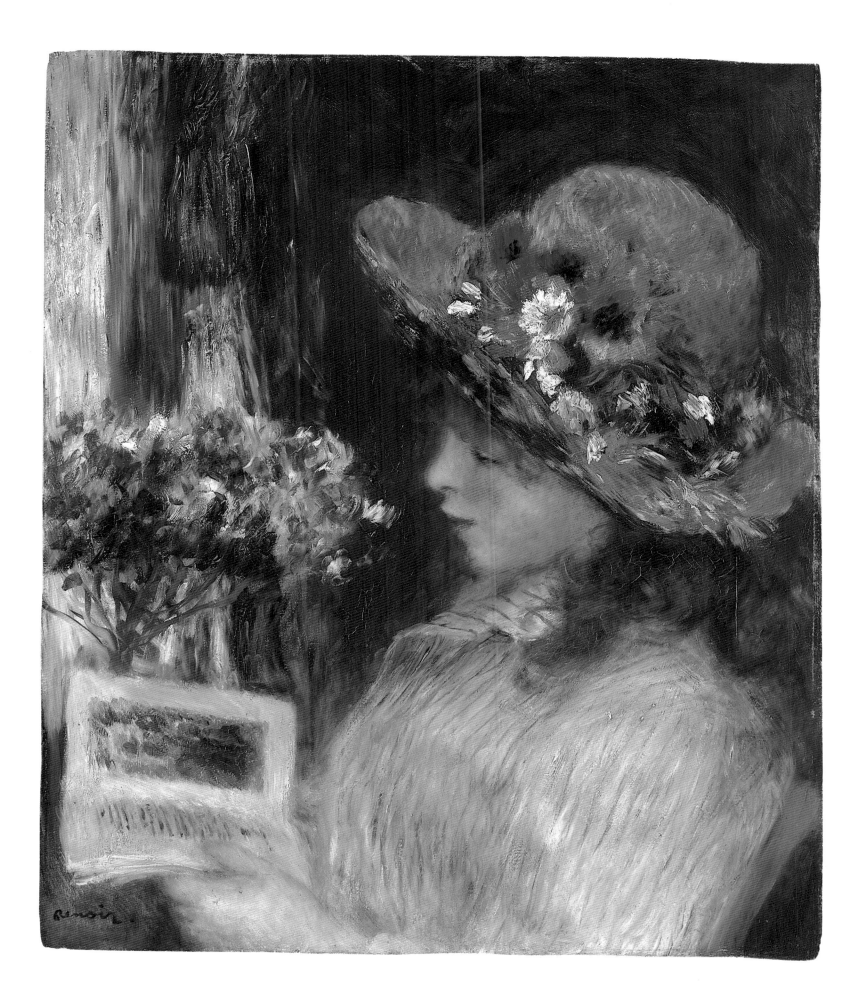

tion of a young woman seated at a window reading an illustrated book. The artist evidently found it helpful to place books in the hands of his models in order to distract them from the task of posing. Thus for Renoir, who was skeptical of all literary influences in visual art,[2] the image of people in the act of reading became an important recurring motif (cat. nos. 17, 18, 23, 70, 79, 80, 95).

Yet he was concerned not only with occupying his models, but also with posing them in such a way that he could explore every detail of their outward appearance. He gave instructions to this effect on September 17, 1880: "Come to Chatou tomorrow with a pretty summer hat. A light dress to go out in, but with something underneath; it is growing cool Do you still have that big hat that you look so nice in? If so, I'd like that, the gray one, the one you wore in Argenteuil."[3] And on another occasion Renoir confessed his weakness for "beautiful fabrics, shimmering silks, sparkling diamonds—though the thought of adorning myself with them is horrifying! So I am grateful to others when they do so—provided I am permitted to paint them! . . . By the way, I am just as happy painting glass beads and cotton cloth at two sous a meter. The painter makes the model."[4]

In this case, Renoir "made the model" by choosing the straw hat with its arrangement of summer flowers, its radiant blue ribbon clearly upstaging nature in the form of a rather unspectacular pink-blossomed azalea bush.[5] The model's colorful costume was a welcome means to an end. It gave credibility to the radiance of the artist's palette and his opaque brushstrokes and enhanced the effect of the pink tones of the face and azalea blossoms, framed between the deep blue of the background and the white and blue stripes of the blouse.

Renoir's *Young Girl Reading* and his *La fin du déjeuner*[6] were sold by the Galerie Durand-Ruel to the Städtische Galerie in Frankfurt am Main on June 20, 1910, making the latter the second German museum—after the Nationalgalerie in Berlin (cat. nos. 8, 70)—to acquire a major work by Renoir. While the price for the multi-figure genre scene rose from 5,000 francs in 1899 to 125,000 francs in 1910, the smaller painting remained moderate in price at 2,000 francs.

2 The phrase "pas trop de littérature, pas trop de figures qui pensent" (not too much literature, not too many figures who think) is attributed to the aged Renoir (André 1919, p. 32).

3 Ehrlich White 1984, p. 103.

4 Renoir 1981, p. 91.

5 The model appears a second time wearing the same hat in a painting of the same size dated 1880 (ill. below).

6 Daulte 1971, No. 288.

Renoir, *Girl with a Flowered Hat*, 1880, private collection

Provenance
M. Havioud, Paris; Auction *Havioud*, Paris, March 23, 1898; Durand-Ruel, Paris; acquired in 1910.

References
C. Gebhardt, "Die Neuerwerbungen französischer Malerei im Staedelschen Kunstinstitut," in *Der Cicerone*, October 15, 1912, p. 769, Ill. 8; Wilhelm Hausenstein, "La peinture française au XIX^e siècle au Musée de Francfort," in *L'amour d l'art*, 1926, p. 311, ill.; Barnes-de Mazia 1935, pp. 105, 107, 298, 396, 416f, 460, No. 186, ill.; Daulte 1971, No. 333, ill.; Fezzi 1972, p. 108, No. 431, ill.; London–Paris–Boston 1985–1986, p. 29.

Exhibitions
Monet, Pissarro, Renoir et Sisley, Durand-Ruel, Paris, 1899, No. 78; London 1905, No. 253; *Meisterwerke Deutscher und Französischer Malerei des 19. Jahrhunderts*, Kunstverein, Düsseldorf, 1930, No. 73; *Correspondances. Französische Malerei aus dem Musée d'Orsay*, Städtische Galerie im Städelschen Kunstinstitut, Frankfurt am Main, 1990, p. 26, ill.

60 Bouquets of Flowers ca. 1880
Gerbes de fleurs

In this narrow horizontal painting, Renoir combined a discarded bouquet of autumnal garden flowers with a green-glazed vase resembling those frequently used as props in the still lifes of Cézanne.[1] Its shape corresponds to the pattern described by the blossoms laid artlessly on the table beside it. The cut flowers achieve their full decorative effect against a neutral background rendered in vertical brushstrokes.

Although it is unlikely that the artist intended to evoke such thoughts, the blossoms in their rich autumn colors, removed from their life-giving roots and subjected to the inevitable process of wilting, are also expressive of the eternal transience of natural life. Their progress from bud to fallen petal is traced with vivid opulence in this painting.

In fact, however, the painter was less interested in this thematic aspect, addressed by artists since the 17th century, than in the rhythm of chromatic sequences, the diversity of forms and the contours ascending from left to right, presenting a clear view of the painting's layered structure and setting it off against the plain background.

Oil on canvas
38.7 x 61 cm
Signed, lower right:
Renoir.
Private collection

1 Venturi 1936, Nos. 496–498, 511, 513, 597, 598, 617, 618.

Provenance
Bernheim-Jeune, Paris; Paul Cassirer, Berlin; M. Vollemi, Brussels; Galerie Matthiesen, Berlin; Justin K. Thannhauser, Berlin; Alice Tully, New York; Auction, Christie's, New York, November 9, 1994, No. 15.

References
Meier-Graefe 1929, p. 137, Ill. 128; Fezzi 1972, p. 108, No. 449, ill.; Auction catalogue, *Impressionist and Modern Paintings, Drawings and Sculpture (Part I)*, Christie's, New York, November 9, 1994, No. 15, ill.

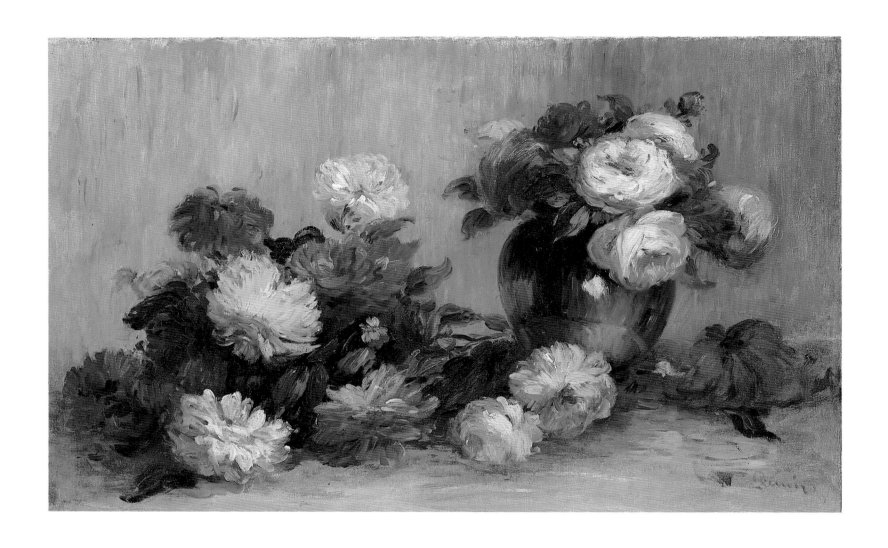

61 Still Life with Pheasant and Partridge ca. 1880
Nature morte avec faisan et perdrix

Oil on canvas
40.5 x 65 cm
Signed, upper left:
Renoir.
Stiftung Sammlung
E. G. Bührle, Zurich

Only rarely did Renoir paint still lifes with hunting motifs, a theme to which his fellow artists Monet, Sisley and Bazille had devoted considerable attention since 1862. In 1867, he painted Bazille at his easel working on a still life with game birds; in the same year, he depicted his first large nude as a goddess of the hunt with dead game at her feet.[1] While Monet returned frequently to the subject, completing a series of similar still lifes with pheasants in 1869 and again in 1879,[2] Renoir showed little interest in such motifs before receiving a commis-

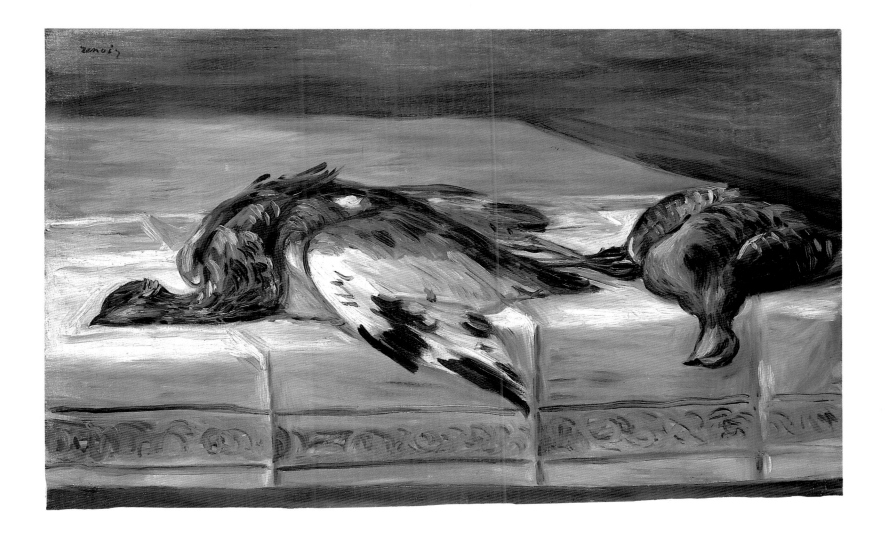

sion from Paul Bérard in 1879 to decorate several rooms at Wargemont Castle with hunting scenes. This painting, an unpretentious presentation of game birds laid out on a white tablecloth, was undoubtedly created in this context. The work derives its appeal above all from the contrast between the finely nuanced feathers of the dead birds and the simple spatial structure defined by the folds and edges of the tablecloth.

1 Daulte 1971, Nos. 28, 30.

2 Wildenstein 1974, Nos. 141, 549–551.

Provenance
Ambroise Vollard, Paris; Martin Fabiani, Paris; Emil Georg Bührle, Zurich; acquired in 1954.

References
Vollard 1918, II, p. 65, ill. (No. 1033); Reidemeister 1973, pp. 164f., ill.

Exhibitions
Zurich 1958, No. 171; Berlin 1958, No. 33; Munich, 1958/1959, No. 134.

62 Woman with a Fan ca. 1880
La femme à l'éventail

Oil on canvas
65 × 50 cm
Signed, upper right:
Renoir.
The State Hermitage
(Inv. no. 6507),
St. Petersburg
Daulte 1971, No. 332

1 Other works by Renoir in the Morosov collection included the landscape *Baignade dans la Seine*, likewise acquired in 1908, *La Grenouillère* of 1869 and the portraits identified in Daulte 1971 as Nos. 192, 197, 229, 357 and 471.

Draner (Jules Renard), caricature in *Le Charivari*, March 9, 1882

The full range of Renoir's skill is revealed in the carefully conceived structure of this half-length portrait. The picture derives its power from the harmonious interaction of violet-blue, luminous red and white applied with differing consistencies against a sunny yellow background. The facial features and the hair are precisely detailed with a pointed brush, giving the woman's head a remarkable quality of immediacy. Inclined at a slight angle to the vertical axis of the painting, the oval shape of the head rests upon the rounded curve described by the shoulders, a shape that is echoed by the open fan and the back of the chair in a clever interplay of foreground and background forms. Although the two patches of red to the left and right join only in the viewer's imagination to form the back of the chair, the torso, largely obscured by the circle segment of the fan, gains needed support from them.

The painting gains spatial depth from the color sequence alone, which moves from the white of the fan—on which all the hues in the picture are mirrored in a kind of rainbow pattern (cat. no. 24)—to the translucent violet-blue of the dress to the red and yellow of the background. Greatest prominence is given to the most subdued of these colors, the dark violet-blue of the hair and the eyes, the frame of the fan and the dark portion of the dress below the lace collar. Since the painter reserved the radiance of yellow for the background, he was forced to place the sitter's fresh complexion within an equally light field of color. With this color combination, however, he paved the way for his greatest admirer, Henri Matisse, who may have seen this painting at the Galerie Durand-Ruel or somewhat later in the collection of his Russian patron Ivan A. Morosov. *Woman with a Fan* was sold by Paul Durand-Ruel, who had purchased it from Renoir on July 25, 1891, to Morosov for his Moscow collection on October 1, 1908, for the price of 30,000 francs.[1]

According to Daulte, Alphonsine Fournaise (1846–1937) posed as the model for this painting in 1880. In the late summer of that year, Renoir had begun preparatory work for his group portrait *Le déjeuner des canotiers* (ill. p. 40) at a restaurant owned by Père Fournaise on the Seine island near Chatou, a popular gathering place for artists. Among the figures shown in that painting was the restaurant owner's daughter Alphonsine. There is some doubt as to whether the woman in the group portrait is really the same one depicted in *Woman with a Fan*, since Alphonsine, born in Paris in 1846, could hardly have looked as youthful in 1880 as the woman portrayed here.

On February 26, 1882, Renoir wrote to Durand-Ruel from L'Estaque, informing him that he would not participate in the *7e exposition des artistes indépendants*, i.e. the seventh Impressionist exhibition. He

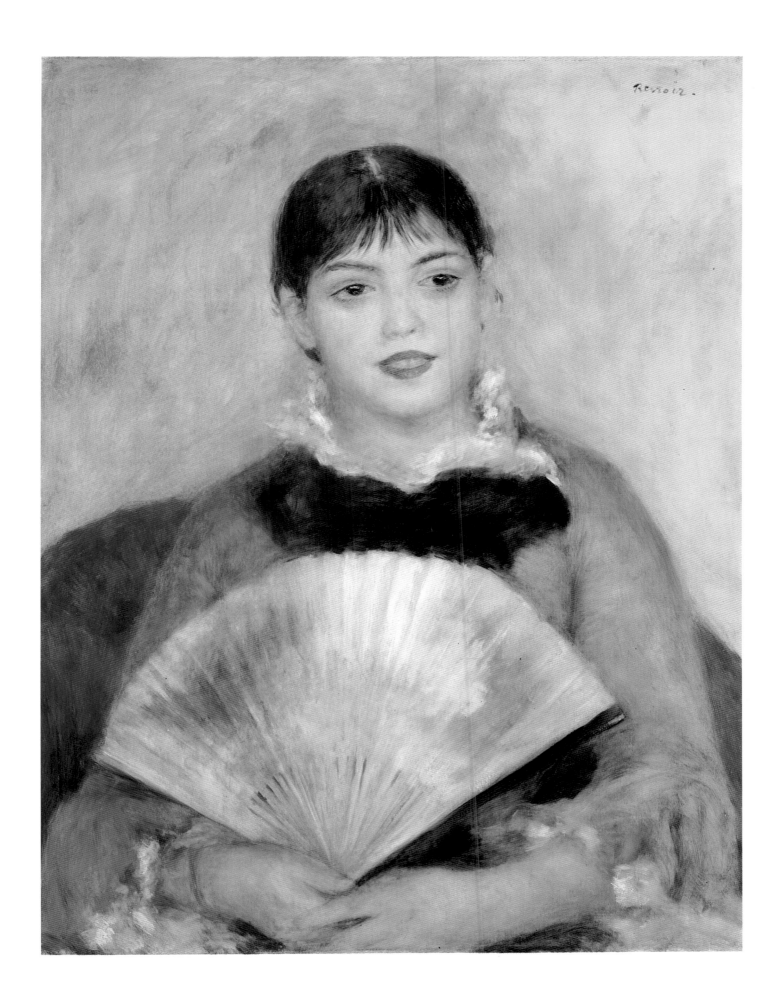

explained that he wanted to take part in the Salon exhibition and that it would be impossible to exhibit at both shows.[2] He had previously refused to participate in the Impressionist exhibitions of 1879, 1880 and 1881. Ultimately, however, the artist did not prevent the art dealer, once again the primary organizer of the Impressionist exhibition in 1882, from exhibiting 25 of his paintings at the show. His *Femme à l'éventail*, presented as Number 160, attracted some critical attention. The March 9 issue of the journal *Le Charivari* printed a caricature of the portrait (ill. p. 208), and the critic Joris Karl Huysmans gave it even higher marks than the *Déjeuner des canotiers* in his review: "She is enchanting, with her big, sparkling, black eyes."[3]

2 Venturi 1939, I, p. 121.

3 *Impressionisten und Post-impressionisten aus sowjetischen Museen*, II, Collection Thyssen-Bornemisza, Lugano 1987, p. 52.

Provenance
Durand-Ruel, Paris; Ivan A. Morosov, Moscow; Museum of New Western Art, Moscow; State Hermitage, Leningrad–St. Petersburg since 1930.

References
André 1919, Ill. 14; Rivière 1921, p. 103, ill.; Vollard 1924, ill. pp. 144–145; Coquiot 1925, p. 226; Venturi 1939, I, p. 131, II, p. 269; Graber 1943, p. 132; A. N. Isergina, *Meisterwerke aus der Eremitage*, Prague 1966, Ill. 39; Daulte 1971, No. 332, ill., p. 413; Fezzi 1972, pp. 106f., No. 409, ill.; Gaunt-Adler 1982, No. 35, ill.; Ehrlich White 1984, pp. 121, 124, ill.; *Impressionisten und Postimpressionisten in den Museen der Sowjetunion*, Wiesbaden 1986, p. 348, Ill. 55.

Exhibitions
7ᵉ exposition des artistes indépendants, 251 Rue Saint-Honoré, Paris, 1882, No. 160; *Les Impressionnistes*, Durand-Ruel, Paris, 1888, No. 15; Paris 1892, No. 96; Paris 1899, No. 96; Salon d'Automne, Grand Palais, Paris, 1904, No. 17; London 1905, No. 237; *Impressionisten und Postimpressionisten aus sowjetischen Museen*, II, Collection Thyssen-Bornemisza, Lugano 1987, No. 11, ill.; Tokyo–Kyoto–Kasama 1993, No. 2, ill.

63 Portrait of Mademoiselle Irène Cahen d'Anvers 1880
Portrait de Mademoiselle Irène Cahen d'Anvers

Oil on canvas
64 x 54 cm
Signed and dated,
upper right: Renoir. 80.
Stiftung Sammlung
E. G. Bührle, Zurich
Daulte 1971, No. 338

Renoir, who had reached the zenith of his artistic career around 1880, needed only two sittings to complete this masterpiece, certainly one of his finest portraits. Irène Cahen d'Anvers (1872–1963), the eldest daughter of the Paris banker Louis Cahen d'Anvers, sat for him in a light blue Sunday dress at her parents' home in the Rue Bassano. Though not a momentary impression recorded in the open air, the artist conceived the leaf-green of the background as a complementary contrast to the reddish-brown of the girl's hair, which falls in a loose, broad swath across her shoulders and down her back. This portrait of the future Comtesse Sampieri is carefully arranged with a view to distinction, as if by a 19th-century photographer. In its structure and posture,

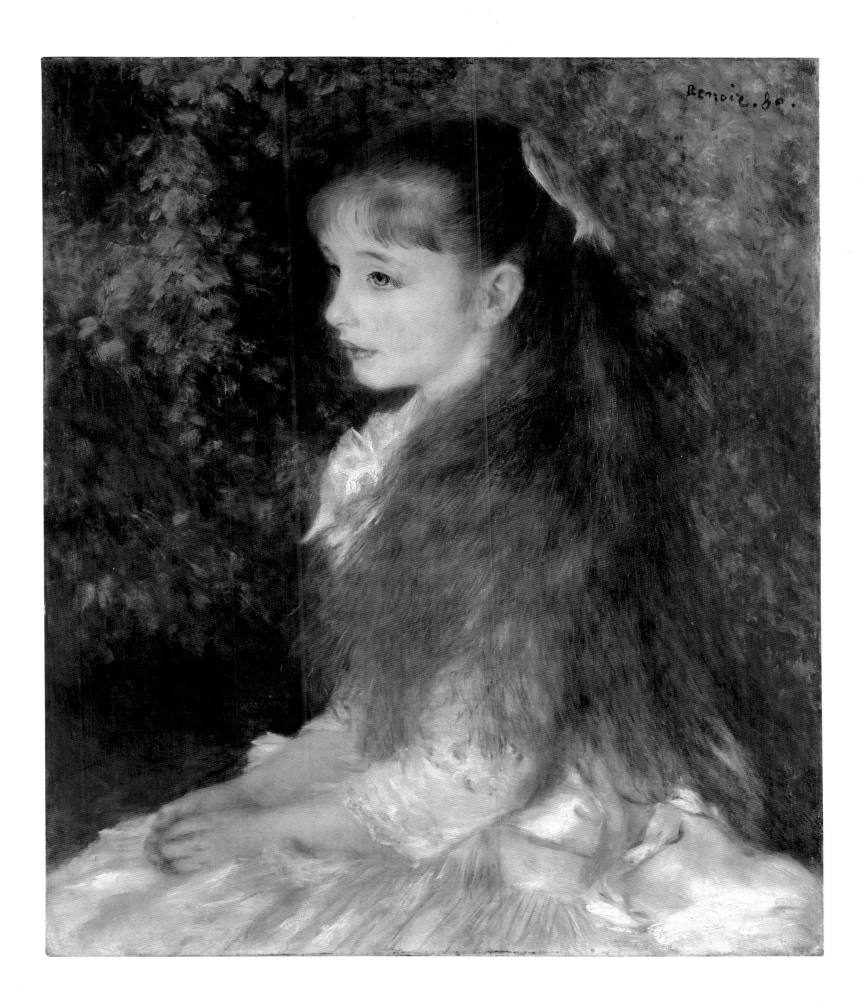

it surely met the expectations of Renoir's client, a man who found no fault with the modified Impressionist undertones of the picture. The composition is distinguished by its clear balance, unpretentious, loose painting style and its splendid coloration.

For a brief period after the success of his family portrait (ill. p. 39) at the 1879 Salon exhibition, Renoir found his gifts as a portraitist in demand among the *grand bourgeois* of Paris. Even Cézanne, who thanks to his father's wealth was never forced to seek commissions, remarked to Zola on July 4, 1880, that "Renoir is said to have obtained several good commissions for portraits."[1] Théodore Duret has described the complicated path that led to the artist's acquaintance with the Cahen d'Anvers family.[2] Duret recalled taking Renoir to the receptions hosted by the orientalist and collector Henri Cernuschi. There he met the painter Charles Ephrussi, director of the art journal *Gazette des Beaux-Arts*, who in turn introduced him to Madame Cahen d'Anvers. Aware of his friendship with the publisher Charpentier, she regarded Renoir as the right man to paint portraits of her three daughters Irène, Elisabeth and Alice (cat. no. 64).

It was Duret, as well, who wrote the catalogue text for Renoir's first solo exhibition, presented April 1–15, 1883 by the Galerie Durand-Ruel on the Boulevard de la Madeleine. The show featured 70 works done between 1874 and 1883, including 25 portraits, 21 figure paintings, 13 landscapes, 7 still lifes and 4 nudes. The profile portrait of Irène Cahen d'Anvers, whose precisely drawn eyelids contrast somewhat unexpectedly with her dreamy gaze, was the best of the portraits Renoir had selected in an effort to gain recognition as a portraitist. Of his friends, Pissarro was full of praise for the exhibition: "Renoir has a wonderful exhibition and, of course, great artistic success; here one can ask for no more. I shall appear quite meager, dull and gloomy after such magnificence."[3]

1 Cézanne 1962, p. 180.

2 Duret 1924, pp. 61f.

3 Pissarro 1953, p. 24.

Provenance
Louis Cahen d'Anvers, Paris; Comtesse Irène de Sampieri, née Cahen d'Anvers, Paris; Léon Reinach, Paris; confiscated by German occupation troops by order of Hermann Göring in 1941; private collection, France; Walter Feuz, Clarens; Emil Georg Bührle, Zurich; acquired in 1949.

References
Barnes-de Mazia 1935, pp. 77f., 264, 402, 452, No. 104, ill.; Drucker 1944, Ill. 59, pp. 185, 202; J. Cassou, *Renoir. Peintures 1868–1895*, Paris 1950, title page ill.; Bünemann 1959, p. 157, ill.; Robida 1959, p. 21, ill.; Fosca 1961, p. 125, ill.; Daulte 1971, p. 23, No. 338, ill., p. 410; Fezzi 1972, Ill. LV, pp. 107f., No. 428, ill.; Reidemeister 1973, pp. 162f., ill.; Ehrlich White 1984, p. 101, ill.; Shimada 1985, Ill. 30, p. 80, ill.; London–Paris–Boston 1985–1986, p. 224; Keller 1987, p. 79, Ill. 60; Munich 1989, p. 122, ill.; Bade 1989, pp. 98f., ill.; Monneret 1990, pp. 84f., ill.

Exhibitions
Paris 1883, No. 6; Paris 1933, No. 57, Ill. XXXVI; Paris 1938, No. 13; *Les cent chefs-d'œuvre de l'art français*, Musée de Louvre, Paris, 1945; *Les chefs-d'œuvre des collections privées françaises retrouvées en Allemagne*, Musée de l'Orangerie, Paris, 1946, No. 41, ill.; Zurich 1958, No. 169, Ill. 50; Berlin 1958, No. 31; Munich 1958/1959, No. 132; Edinburgh–London 1961, No. 50, Ill. 9; Washington–Montreal–Yokohama–London 1990–1991, No. 52, ill.

64 The Daughters Cahen d'Anvers.
Pink and Blue 1881
Les demoiselles Cahen d'Anvers. Rose et bleu

The elaborate full-figure portrait of children against a background of pompous drapery was a baroque invention. Developed by Velázquez in his portraits of the Spanish Infantas to a high art suitable for the Hapsburg dynasty, van Dyck gave it the elegance appropriate to the representational needs of the 17th and 18th centuries, which in turn proved well-suited to the aspirations of the newly wealthy bourgeoisie of the 19th century.

Renoir had no intention of breaking away from this established pattern, especially since he—unlike Degas, who was himself an innovator in the field—was compelled to cater to the wishes of his clientele. We may safely assume that he was doing just that when he painted the large-scale double portrait of the blonde-haired Elisabeth Cahen d'Anvers, the future Comtesse de Forceville (1874–1945), and her red-haired sister Alice, who later acquired the title of Lady Townsend of Kut (1876–1965). He presented the young girls, dressed perfectly in the fashion of the time, with their sweet faces and their hair neatly combed down over their foreheads "à la chien," in the traditional context of courtly family portraits. In contrast to the portrait of their older sister completed the previous year, in which the girl's profile stood out against a neutral foliage background (cat. no. 63), the younger girls posed dutifully in their accustomed interior setting. Aside from the patterned carpet, a few toys in the background and the wall hangings, there is very little in the portrait that recalls the ambience of their parents' home in the Rue Bassano. Nevertheless, the majestic purple and golden yellow convey a sense of the taste and standing of the Jewish banker Louis Cahen d'Anvers and his wife.

The painting evinces an appealing contrast between the fragrant coloration of the two figures and the dark, somber interior background. The light underground tone is reflected from the ribbons in the girls' hair down to their stockings in delicate nuances of pale pink and light blue.[1] Renoir's interpretation of the sisters' postures and facial expressions reveals a great deal of sensitivity. Only the attitudes of their hands betray differences in the age and character of the two. Renoir presented the smaller girl, who was five years old at the time, facing the viewer in a posture of down-to-earth simplicity. Her head is turned slightly to one side. She is obviously tired of posing, and her gaze has wandered into the distance. Her older sister seeks eye contact; already the coquette, she knows how to present herself to advantage. A discrepancy becomes apparent in the contrast between the porcelain-glazed smoothness of the girls' skin and the Impressionist technique used to render their lace dresses.[2] Thus the painting as a whole takes on a cer-

Oil on canvas
119 x 74 cm
Signed and dated,
lower right: Renoir. 81.
Museu de Arte de
São Paulo
Assis Chateaubriand,
São Paulo
Daulte 1971, No. 361

1 The pronounced use of blue, white and red could be interpreted as a concealed reference to the French national colors and therewith to the nationalist leanings of the girls' parents.

2 Cézanne referred to "a certain mother-of-pearl quality" that stayed with Renoir "in spite of his immense talent" (*Joachim Gasquet's Cézanne*, Introduction by Richard Shiff, London 1991, p. 164).

tain hand-crafted quality, which may explain the uncertainty the artist expressed to Duret on March 4, 1881, when he stated his doubts as to whether the picture was a success.[3] Nor was the portrait, completed in late February 1881, particularly well received in the banker's home. It disappeared to the floor occupied by the servants, where it remained until it was rediscovered in 1900 at its creator's initiative to be shown under the title *Rose et bleu* at an exhibition in the Galerie Bernheim. Tensions between the Cahen d'Anvers family and Renoir arose not least of all in connection with the payment for the portrait by Albert Cahen d'Anvers, the girls' uncle.[4] The painter complained to Charles Deudon on February 19, 1882: "As far as the 1500 francs from the Cahens is concerned, I must tell you that this is extremely difficult for me to swallow. Can anyone really be so stingy? I shall certainly never do business with Jews again."[5]

While Renoir's displeasure may have been justified, his language is indicative of the latent anti-Semitism that surfaced in an alarmingly blatant form in France during the Dreyfus affair, even among such artists as Degas and Cézanne. Hermann Göring's seizure of the portrait of the Jewish girl Irène Cahen d'Anvers (cat. no. 63) and the deportation and murder of her younger sister Elisabeth—here shown as the little blonde-haired girl in blue—by the Nazis at the age of over 70 are facts from a different, entirely German page of history.

3 Ehrlich White 1984, p. 105.

4 Daulte 1971, No. 362.

5 Schneider 1945, p. 99.

Provenance
Louis Cahen d'Anvers, Paris; Bernheim-Jeune, Paris; Gaston Bernheim de Villers, Monte Carlo; Francisco de Assis Chateaubriand, São Paulo; acquired in 1952.

References
Vollard 1981, I, p. 95, No. 382, ill.; Duret 1924, Ill. 10; Coquiot 1925, p. 227; Barnes-de Mazia 1935, pp. 51, 77, 79, 268, 405, 453, No. 117, ill.; Florisoone 1937, p. 40; Graber 1943, p. 85; Drucker 1944, p. 186; Schneider 1945, p. 99; Gaunt 1952, p. 12, Ill. 39; Zurich 1958, p. 108; Bünemann 1959, p. 65, ill.; Ehrlich White 1969, pp. 335, 338; Daulte 1971, p. 46, ill., No. 361, ill. p. 410; Fezzi 1972, p. 108, No. 458, ill.; Gaunt-Adler 1982, p. 22; Ehrlich White 1984, pp. 105, 108, ill. p. 255; Shimada 1985, p. 81, ill.; Monneret 1990, pp. 13, 153, No. 18, ill.; Washington–Montreal–Yokohama–London 1990–1991, at No. 52, ill.; Brisbane–Melbourne–Sidney 1994–1995, p. 35, ill.

Exhibitions
Paris 1900, No. 15; Paris 1913, No. 20; Paris 1927, No. 45; *Cent ans de peinture française*. Georges Petit, Paris, 1930, No. 23; *Le décor de la vie sous la IIIᵉ Republique de 1870 à 1900*, Pavillon de Marsan, Paris, 1933, No. 285; *Renoir, Cézanne and their Contemporaries*, Reid & Lefevre, London, 1934, No. 28, ill.; *Portraits de femmes et d'enfants*, Bernheim-Jeune, Paris, 1936, No. 30; Paris 1938, No. 16, ill.; *Chefs-d'œuvre de Musée de São Paulo*, Musée de l'Orangerie, Paris, 1953/1954, No. 47, ill.; *Meisterwerke des Museums São Paulo*, Kunstmuseum, Berne, 1954, No. 41, ill.; London 1954, No. 54; London–Paris–Boston 1985–1986, No. 53, ill. pp. 225, 261; Munich 1989, pp. 121ff., ill.

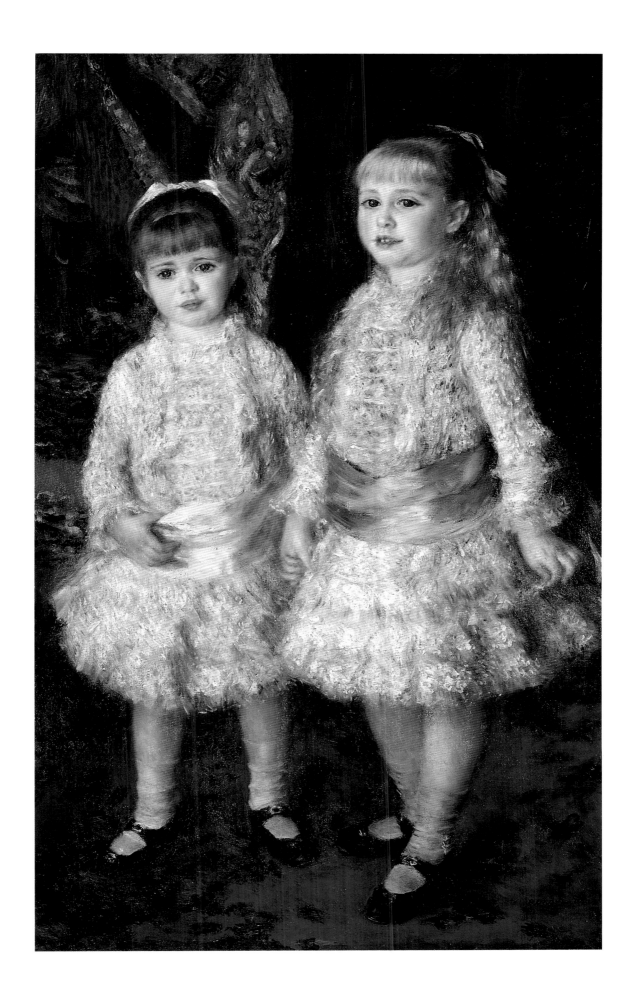

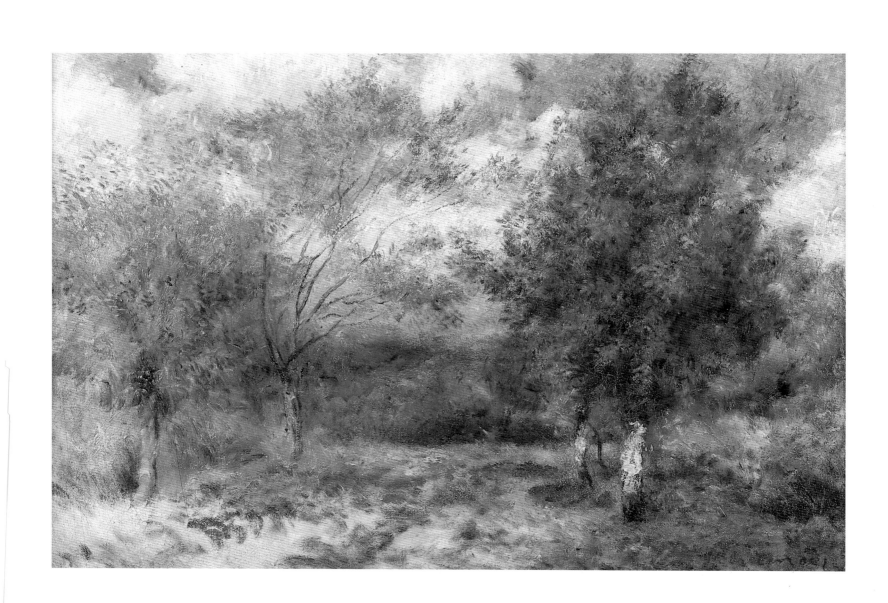

65 Landscape in the Sun
1880–1881
Paysage ensoleillé

Renoir never forgot his debt to Corot, a landscape painter whom he greatly admired. Again and again he painted landscapes like this fragrant, light impression in the hazy sunlit air of summer, seeking to measure himself against his predecessor (cat. no. 98). The vibrant, colorful harmony of this painting is achieved with the aid of remarkably modest means. Delicate foliage spreads out in a filigree pattern against the diffuse, white-clouded blue of the sky. Here and there, strokes of yellow thinly applied with a pointed brush over the blue turn to green before evaporating into the distance. As if covered by a silver-blue veil, even the foreground evokes a distant atmosphere. Yellow and brown suggest a path leading into depth. Nature needs no human figures.

Far removed from Cézanne's spatial constructions with their refracted perspective and the intensely expressive landscape visions later created by van Gogh, Renoir avoided expansive views. He was content with momentary details that brought to life not only the trees and meadows, but the very material of color itself. Although, or perhaps even because Monet, Pissarro and Renoir had come to resemble each other so closely in their brushwork and handling of paint, Renoir used paintings such as this one to distance himself from Impressionist concerns after more than a decade and to search for new ways to give greater weight to formal components vis-à-vis the dissolution of form in color.

Oil on canvas
39 × 56 cm
Signed, lower right:
Renoir
Private collection,
Switzerland, courtesy of
Salis & Vertes,
Munich–Salzburg

Exhibitions
London 1995, No. 56, ill.

66 Gondola in Venice 1881
Gondole à Venise

In a letter to Bérard written from Venice on November 1, 1881, Renoir formulated another decidedly Impressionist credo, expressing at the same time his doubts as to whether it could be put into practice: "I love the sun and the reflections in the water, and I would travel round the world to paint them. Yet when I actually take up my brush do so, I real-

Oil on canvas
59.5 × 75 cm
Signed, lower right:
Renoir.
Private collection

ize how powerless I am Why search for the sun, when everything I do is but a mere caricature of it Sculptors are fortunate people, for their statues stand in the sun, and if they are simply designed they become a part of the light and exist in nature like a tree. As for us, we are restricted to indoor spaces, and we run the risk of living for only a few days, like flowers that wilt. Why did I become a painter when I can only admire, without ever imitating, unless it is from a very great distance? . . . Ah, Paris, with its pretty women's hats, with its life, whose sun makes it possible to paint it, why did I ever leave you?"[1]

Venice was the first stop on Renoir's tour of Italy in late October and early November of 1881. The sketchlike character of this view stands out among the scenes he painted there—mostly brightly-colored renditions of such popular motifs as the Piazza San Marco, the Doge's Palace and the Grand Canal.[2] Renoir never revised the painting in his Paris studio to make it "marketable," leaving it in an early stage reflecting an impression dissipating into the fog as he had perceived it in Venice. Hardly suitable for sale, this image of a gondola on the Canale della Guidecca was not among the Venice motifs purchased by Durand-Ruel for presentation at the seventh Impressionist exhibition following Renoir's return to Paris in 1882.[3] The hardness of its form and color contrasts distinguishes this painting—to its credit—from the excessively bright Venetian coloration of the works Durand-Ruel found suitable for his own purposes.

The heavy, dark bluish-black of the gondola making its way through the waves of the canal leaves behind a reflected wake of shadow in an otherwise light color scheme. Renoir's vivacious brushstrokes do not completely cover the light canvas ground. The open patches of canvas thus come to represent the translucent white fog lying over the lagoon, revealing only a shadow of the tower of the old customs office with its golden orb and the dome of Santa Maria della Salute behind it. The painter had positioned himself on the Isola di San Giorgio Maggiore. Sketched with just a few vertical strokes, the distant shapes of the Doge's Palace and the Riva degli Schiavoni disappear almost completely above the water.

1 Ehrlich White 1984, pp. 108, 112.

2 It is presumably related to *The Gondola*, a painting formerly held in Kramarsky Collection in New York.

3 These included the two paintings *Canale Grande* (Museum of Fine Arts, Boston) and *The Doge's Palace* (Sterling and Francine Clark Art Institute, Williamstown).

Provenance
Ambroise Vollard, Paris; Robert de Galéa, Paris; Mrs. R. van der Klip; Jean-Louis Barthelemy, Paris; Auction, Sotheby's, London, April 26, 1967, No. 16; private collection, England; Auction, Sotheby's, London, November 29, 1994, No. 33.

References
Vollard 1918, I, p. 3, No. 11, ill.; Ehrlich White 1969, p. 345, No. 2; Fezzi 1972, p. 110, No. 480 A, ill.; auction catalogue, *Impressionist and Modern Paintings, Drawings and Sculptures (Part I)*, Sotheby's, London, November 29, 1994, No. 33, ill

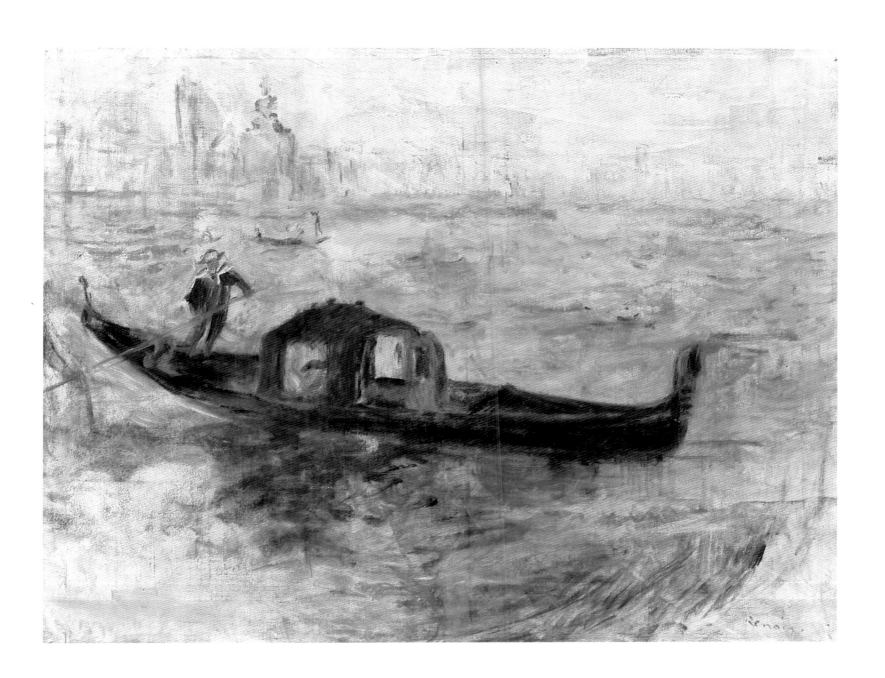

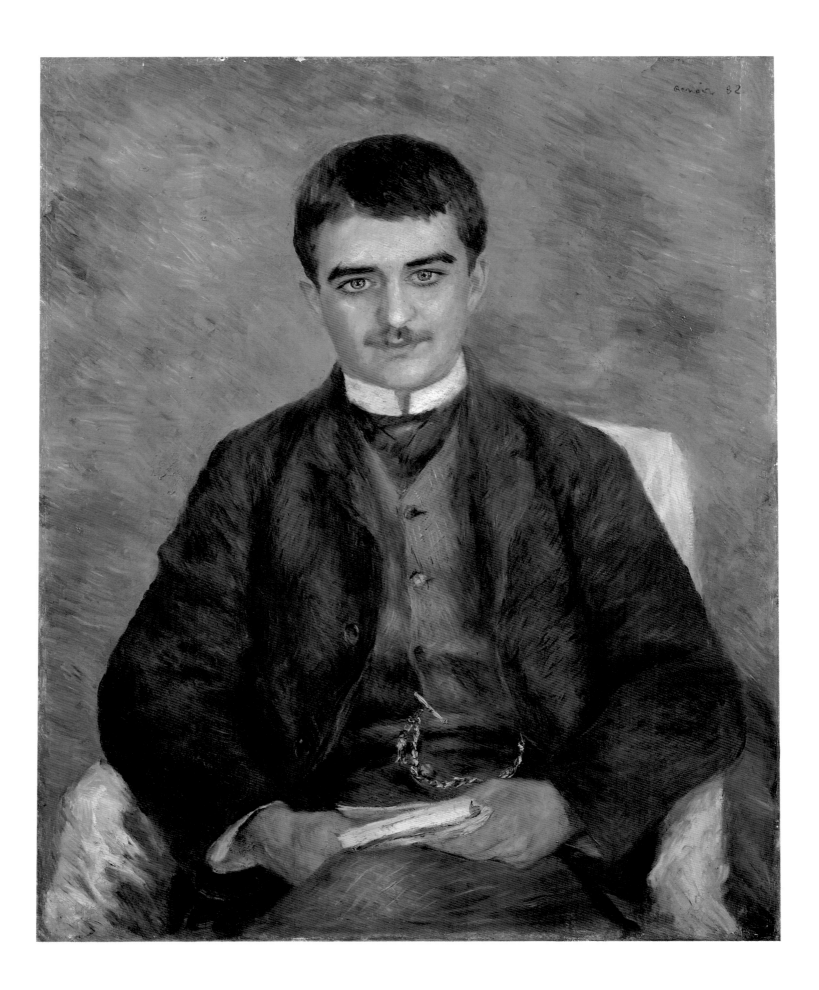

67 Portrait of Joseph Durand-Ruel 1882
Portrait de Joseph Durand-Ruel

The art dealer Paul Durand-Ruel had actively supported Pissarro, Monet, Renoir and Sisley since 1872 and in so doing become the champion of the Impressionist movement in an art market which—largely due to his own efforts—had become a truly international one (cat. no. 102). In 1882 he asked Renoir, who had been receiving a regular income from him for about a year, to paint portraits of his three sons and two daughters (cat. no. 68).[1] For this purpose, the artist traveled to Dieppe in mid-September, where Durand-Ruel was spending the summer with his family.

As an interior scene with a neutral background, the portrait of the eldest son Joseph-Marie-Pierre Durand-Ruel (1862–1928) is the most conventional of the family portraits, the others of which were done outdoors. Dressed as a businessman with a heavy watch-chain at his waist and a book in his hands, the 20-year-old is seated facing the viewer, upon whom he appears to have fixed his gaze.

To portray Joseph Durand-Ruel under the open sky would perhaps have been less appropriate to the image of the future entrepreneur as a reputable businessman. The solid volume of the body with its dark clothing stands out against the light slipcover of an armchair, serving to emphasize the rather stiff elegance of the figure.

Although the portraitist did everything in his power to underscore the growing reputation and businesslike manner of his subject, Joseph Durand-Ruel was relegated to the role of crown prince for almost 30 years. Not until 1911 did his father entrust him with the management of the family business in Paris and New York.

From Jean Renoir we learn that Renoir enjoyed very friendly relations with Durand-Ruel's sons and that he looked upon them not as businessmen, but as sons of his own.[2]

"Renoir appreciated Joseph Durand-Ruel for his dependability. His father had changed the character of the business from its original function of decorating the houses of rich art lovers to one of speculating in art. Together with several other important businessmen, Joseph and my godfather Georges (cat. no. 68) developed the market for paintings in such a way that it became much like the stock exchange.

"Today, paintings rise and fall in price like shares, without regard for prevailing tastes, a phenomenon due in part to Durand-Ruel. Is that an advantage or a disadvantage? My father was against such speculation, although he realized that it would make painters rich. His distrust of big business did not affect his sincere feelings of friendship for the 'Durand sons' in the least. In his opinion, people who wanted to be something had to be in tune with their times."[3]

Oil on canvas
81 x 65 cm
Signed and dated,
upper right: Renoir 82
Prêt obtenu par
l'intermédiaire de
Durand-Ruel et Cie, Paris
Daulte 1971, No. 408

1 The following portraits of the two daughters were completed between 1876 and 1888: Daulte 1971, Nos. 179, 409, 411, 549.

2 Renoir 1981, p. 399.

3 Ibid., p. 291.

Provenance
Paul Durand-Ruel, Paris; Joseph Durand-Ruel, Paris; Charles Durand-Ruel, Paris.

References
André 1919, Ill. 19; Venturi 1939, I, p. 62; Daulte 1971, No. 408, ill., p. 412; Fezzi 1972, pp. 111, 113, No. 527, ill.; Daulte 1973, p. 46; Ehrlich White 1984, p. 128, ill.

Exhibitions
Berlin 1912, No. 12; Paris 1912, No. 5; Munich 1913, No. 12; New York 1939, No. 3; Paris 1958, No. 21; Munich 1958, No. 17, ill.; Marseille 1963, No. 60, ill.; Paris 1969, No. 14, ill.; New York 1969, No. 46, ill.; Tokyo–Fukuoka–Kobe 1971–1972, No. 17, ill.; Paris 1974, No. 49, ill.

68 Portrait of Charles and Georges Durand-Ruel 1882
Portraits de Charles et Georges Durand-Ruel

Oil on canvas
65 × 81 cm
Signed and dated,
upper right: Renoir. 82.
Prêt obtenu par
l'intermédiaire de
Durand-Ruel et Cie, Paris
Daulte 1971, No. 410

This double portrait of the two younger sons of Paul Durand-Ruel is more colorful than the likeness of their brother Joseph (cat. no. 67). While the oldest of the three had to represent a certain standing within his father's business, his brothers—Charles-Marie-Paul, who died young (1865–1892), and Georges-Marie-Jean (1866–1931), who eventually took charge of the company's transatlantic operations and became the godfather of Renoir's second son Jean—could afford to project a more relaxed image of themselves.[1] Like their sisters Marie-Thérèse and Jeanne,[2] they posed on a bench in the garden of the summer house in Dieppe, rented by the family as a vacation home in 1882. At Paul Durand-Ruel's request, Renoir visited the family there in mid-September of that year to paint portraits of the five children. Jacques-Emile Blanche, himself a resident of Dieppe, tells us more about the circumstances in which the portraits originated: "The Durand-Ruel children sat for him in a garden on the Côte de Rouen beneath the dancing leaves of chestnut trees. The sunlight created reflections in their faces that were incompatible with the pretty, 'smooth modeling' of studio light."[3]

Applied in short brushstrokes, the colors, which Renoir had previously used to reflect the constantly changing quality of the sunlight and which tended to dissolve elements of form, now serve to distinguish the bodies more clearly from the freely rendered foliage of the background, enhancing their three-dimensional quality and giving their finely executed facial features an individual character. With its somewhat staged look, the presentation of the two fashionably dressed adolescents derives a special quality from the interplay of vigorous, compact color modulations and sharply delineated outlines.

1 See Venturi 1939, II, pp. 215f.

2 Daulte 1971, No. 411.

3 Blanche 1927, p. 64.

222

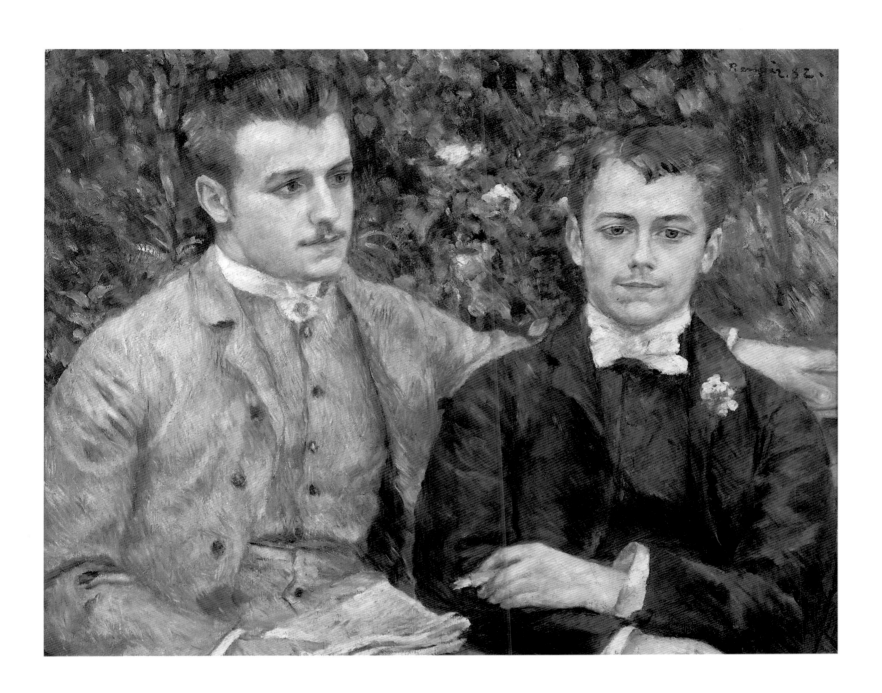

The work is Renoir's only treatment of the half-length double portrait in this "egalitarian" form. This portrait type, which can be traced back to the Italian High Renaissance, is found among the courtly portraits of the 17th century and was used by many French painters of the 19th century, including Degas.[4] Manet's double portrait of the Guillemets in their conservatory, shown at the 1879 Salon exhibition where Renoir enjoyed such great success with his portrait of Madame Charpentier (ill. p. 39), probably made quite an impression on him. The positions of the two elegantly dressed subjects against a background of leaves, their diverging gazes and the particular emphasis placed upon the hands are likely to have left their imprint upon Renoir's memory.

Although Durand-Ruel did not retract his commission, he was apparently not completely satisfied with the results. In any event, in letter to Paul Bérard in October 1882 the artist indicated that "things are not going especially well at the moment I don't think Durand-Ruel is very happy with his [portraits]. Well, all of that needs to be thought through more thoroughly, and I do not exaggerate when I say that I need to be careful if I want to avoid losing public esteem I have spent too much time away Don't speak to me any more of portraits in the sunlight. Pretty, dark backgrounds—that is the thing!"[5]

4 See Lemoisne 1946, II, Nos. 45, 59, 116, 126, 164, 169, 288, 639; and Atsushi Miura, "Un double portrait par Carolus-Duran: Fantin-Latour et Oulevay," in *Gazette des Beaux-Arts*, CXXIV, July–August 1994, pp. 25ff.

5 Ehrlich White 1984, pp. 126f.

Provenance
Paul Durand-Ruel, Paris; Georges Durand-Ruel, Paris; Charles Durand-Ruel, Paris.

References
Blanche 1927, p. 64; Meier-Graefe 1929, p. 170, Ill. 155; Venturi 1939, I, p. 62; Pach 1951, pp. 80f., ill.; Pach 1958, pp. 82f., ill.; Fosca 1961, p. 177, ill.; Daulte 1971, No. 410, ill., p. 412; Fezzi 1972, pp. 111, 113, No. 529, ill.; Daulte 1973, p. 42, ill., p. 46; Ehrlich White 1984, p. 128, ill.; Keller 1987, p. 89, Ill. 68, p. 91; Bade 1989, pp. 110f., ill.; Monneret 1990, p. 153, No. 24, ill.; Distel 1993, p. 84, ill.; Brisbane–Melbourne–Sidney 1994–1995, p. 36, ill.

Exhibitions
Berlin 1912, No. 11; Paris 1912, No. 44; Munich 1913, No. 11; New York 1939, No. 4; Paris 1958, No. 22; Munich 1958, No. 16; Marseille 1963, No. 60, ill.; Stockholm 1964, No. 42; Paris 1969, No. 15; New York 1969, No. 47, ill.; Tokyo–Fukuoka–Kobe 1971–1972, No. 18, ill.; Chicago 1973, No. 40, ill.; Paris 1974, No. 50, ill.; London–Paris–Boston 1985–1986, No. 66, ill., p. 238.

Edouard Manet, *In the Conservatory*, 1879, Staatliche Museen zu Berlin, Nationalgalerie

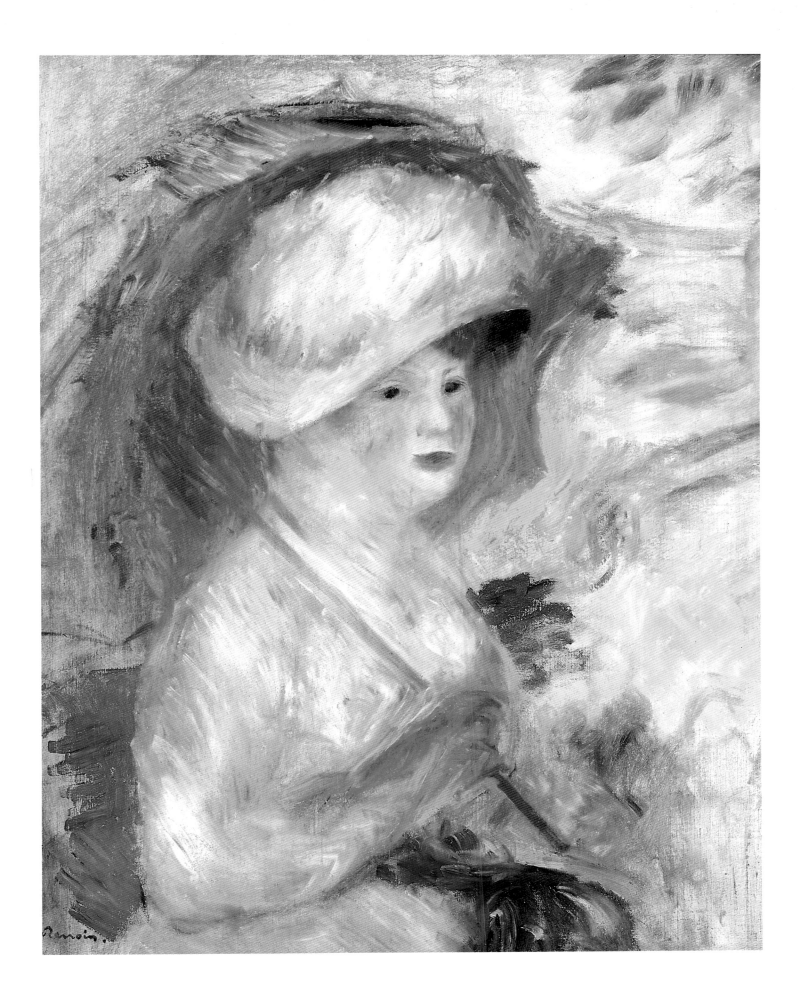

69 Woman with a Parasol 1883–1885
Femme à l'ombrelle

Oil on canvas
72.3 × 57.3 cm
Signed, lower left:
Renoir.
Private collection,
Switzerland

This picture of a young woman sitting on a green bench holding a red parasol marks a departure from the other, more carefully elaborated compositions painted by Renoir during this period. Here, the artist has sketched his motif in a rudimentary fashion, seeking to highlight the radiant power of his palette in light, translucent yellows and reds. As his son Jean later described it, Renoir's method—his way of gradually circling and approaching his pictorial subject—reveals itself clearly in such sketchlike works that have not yet been given their "final polish":

"Renoir actually did begin to paint with incomprehensible layers of color on the white ground, which did not even represent forms of any kind. Sometimes there was so much liquid, linseed oil and turpentine, in proportion to pigment that it dripped from the canvas. Renoir called it the 'juice.' With the aid of this juice he was able to suggest the overall color scheme with just a few brushstrokes. This covered the surface of the canvas for the most part; or, to be more precise, it covered the surface of the painting-to-be, for Renoir often left a portion of the white ground uncovered. These patches were indispensable indicators of value for him. The ground had to be very clean and smooth. I often prepared canvases for my father with lead carbonate and a mixture of one-third linseed oil and two-thirds turpentine. After that, they had to be left to dry for several days He never worked with right angles or straight lines. His strokes were rounded, as if he were tracing the outlines of a young girl's breast. 'There is no straight line in nature.' At no point in the painting's progress was there a lack of balance He courted his motif like a lover courting a girl who demurs before surrendering. There was something of the hunter in his approach. The anxious haste of his brushstrokes, the sudden, sharp, momentary halt in his penetrating gaze reminded me of the zigzag flight of a swallow pursuing a mosquito He nearly always mixed his paint on the canvas. He invested a great deal of effort in giving his painting a sense of transparency at every phase of its development. As I have already said, he worked on the entire surface at one time, and with each brushstroke his motif emerged more and more clearly from the seeming confusion, like a photograph appearing on a plate."[1]

1 Renoir 1981, pp. 176f., 348.

226

70 Children's Afternoon in Wargemont 1884
L'après-midi des enfants à Wargemont

During the first months of 1884, Renoir was plagued by financial difficulties. In a letter to Monet of February 24, the collector de Bellio lamented that Renoir had not even been able to afford to purchase a memento of his deceased friend Manet at the auction of paintings in the latter's estate.[1] There were several reasons for his precarious situation. First of all, he was compelled to support his brother Victor, who had returned home from Russia bankrupt. In the aftermath of a bank crash in May his agent Durand-Ruel was threatened with bankruptcy as well. As Renoir and Monet saw it, Durand-Ruel had no choice but to sell off their paintings to the highest bidder.[2]

Thus the invitation of his patron Paul-Antoine Bérard to spend the summer at Wargemont Castle near Dieppe and paint a group portrait of the Bérards' three daughters came none too soon for Renoir. It was the most lucrative order he ever received from the Bérard family and, with the exception of his painting of Charpentier family (ill. p. 39), his most ambitious group portrait.[3]

The artist had been introduced by Charles Deudon to Bérard, the son of a Protestant banking family, and his wife Marguerite Girod at the home of the Charpentiers in March of 1879 (cat. no. 54). Bérard, eight years older than Renoir, was a secretary in the diplomatic corps. He became the artist's friend and client, acquiring no less than 32 of his works, as well as an important supplier of new customers. The painter was a frequent guest at Bérard's Paris home at Rue Pigalle 20 and at Wargemont Castle, the family's summer residence, until the diplomat's death in 1905.[4] Within only five years—from 1879 to 1884—he painted a total of 14 portraits of members of the Bérard family. This scene featuring the three sisters proved to be his largest and most significant commission.

Already entrusted with household duties at the age of 14, Marthe, the eldest of the Bérard daughters, appears on the right, completely immersed in her work.[5] Standing in front of her and holding a doll is Lucie, born in 1880.[6] Ten-year-old Marguerite is seated on a striped canapé reading a picture-book.[7] Jacques-Emile Blanche, a neighbor of the Bérards, described the girls as "incorrigible little savages who refused to learn to read or write and much preferred running off with wind-tangled hair to the fields to milk the cows."[8] Renoir showed no hint of such outbreaks of temperament in his composition. Instead, it would seem as if the girls had endured the sessions with the patience and grace one would expect of the daughters of the well-to-do, as if to enable the artist to undertake his sensitive analysis of their different characters and ages. Thus more than any other work by Renoir, this painting, now in the Nationalgalerie in Berlin, reveals his capacity to grasp the essence of childhood without sentimentality and to reveal its

Oil on canvas
127 × 173 cm
Signed and dated,
center right:
Renoir. 84.
Staatliche Museen zu
Berlin, Nationalgalerie
(Inv. no. A I 696), Berlin
Daulte 1971, No. 457

1 Wildenstein 1979, II, p. 27.

2 Venturi 1939, I, p. 71.

3 See the rather conventional portrait of the daughters of Catulle Mendès (Daulte 1971, No. 545).

4 See Maurice Bérard, *Renoir à Wargemont*, Paris 1938, and "Un diplomate, ami de Renoir," in *Revue d'histoire diplomatique*, July–September 1956, pp. 239ff.

5 Four portraits of her were done in the years 1879 and 1881 (Daulte 1971, Nos. 279, 281, 282, 365).

6 See the portraits of Lucie Bérard painted in 1881, 1883 and 1884 (ibid., Nos. 365, 449, 456).

7 See the two portraits of Marguerite Bérard, who married her cousin Alfred Bérard in 1896 (ibid., Nos. 286, 365).

8 Jacques-Emile Blanche, *Portraits of a Lifetime*, London 1937, pp. 37f.

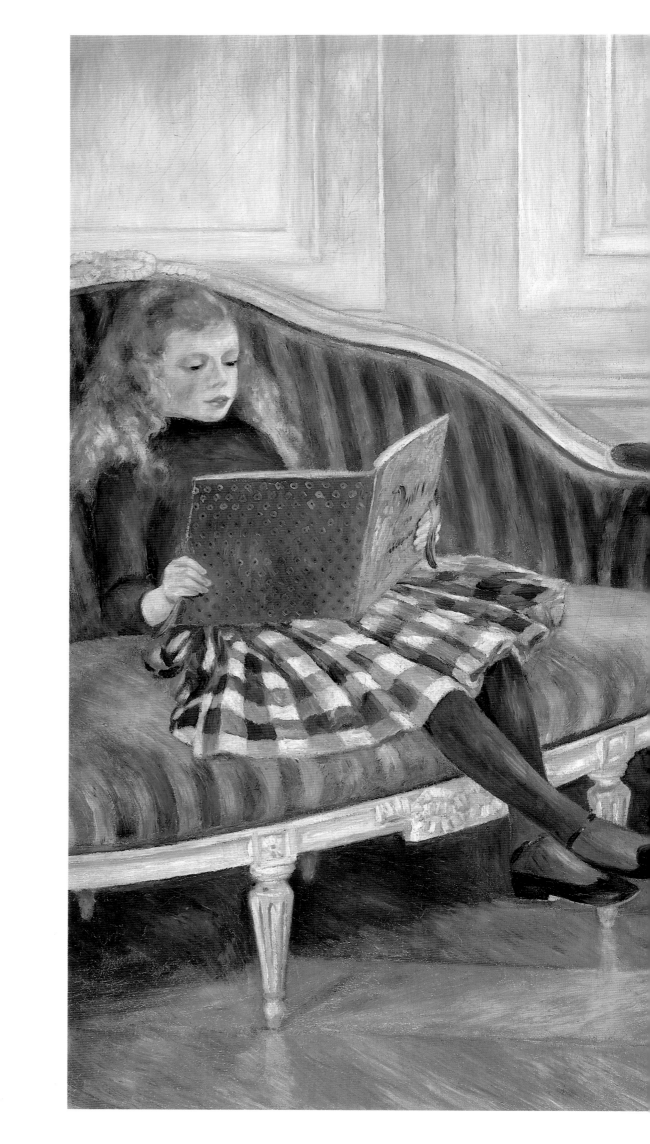

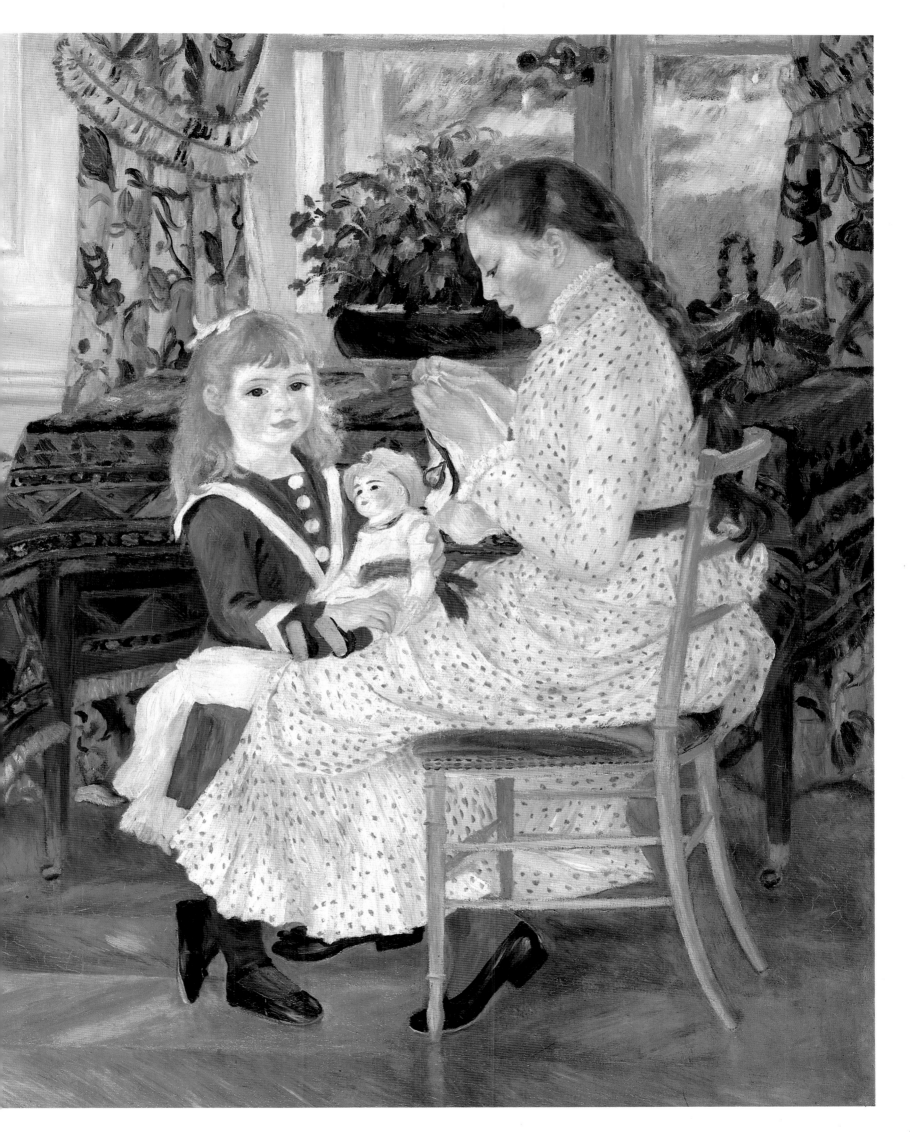

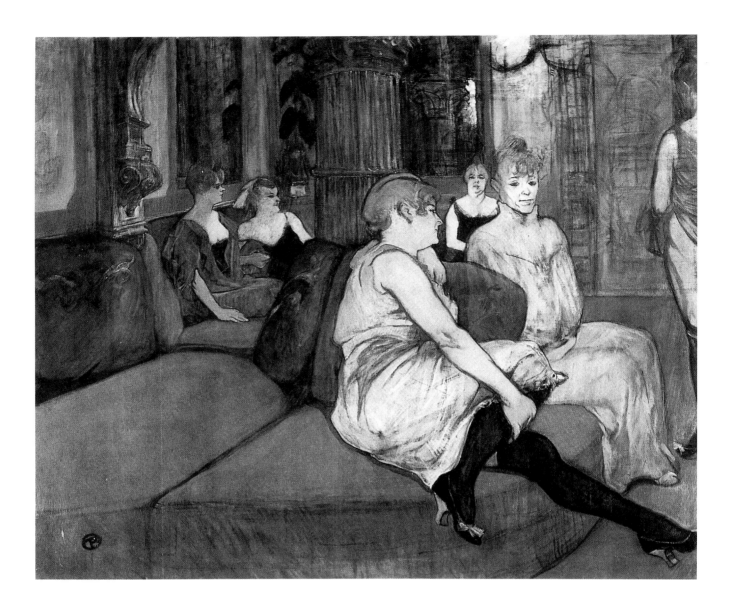

unique, innocent naiveté. It is the long-past, yet never forgotten image
of a joyfully recollected, carefree childhood in complete security. It
could be an image recalled by Proust, shaping the slow passage of time
into an art form in an ambience of bourgeois wealth illuminated by the
noonday light. The tone of the scene is cool; the silence and calm of the
figures keeps the viewer at a distance. Like dolls in a doll house, each
girl is occupied with herself, her thoughts focused far away from a
room whose silence is audible only in the creaking of the wood floor.
At the same time, however, Renoir's "Demoiselles de Wargemont"
presents an image of an era near its end, a time Toulouse-Lautrec
would rebel against only a few years later in his *Demoiselles de la rue
des Moulins* and which Picasso, with his *Demoiselles d'Avignon*,
would finally lay to rest.

With the exception of Degas, no other Impressionist dealt as exten-
sively with the interior as Renoir, and none of his other works express
the clarity evident in this interior scene, for which he interrupted his
ambitious program of classical nudes in outdoor settings begun in 1884

(cat. no. 71). In this painting, the often overbearing softness of some of his other genre scenes gives way to a subtle objectivity. The diffused light is closely bound to form and space. The stability of formal relationships takes priority over the richness of color, whose splendor could have overburdened the pictorial structure as a whole. The composition derives its tension from the juxtaposition of solid and void, of the interior and an exterior that intrudes through the window, of cool, localized bluish-grays and contrasting opaque areas of warm yellow, red-orange and reddish-brown. The somewhat ostentatious luxury of the Charpentier family (ill. p. 39) gives way here to a more sober sense of distinction. In this work, the open, Impressionist pictorial form of the former painting is abandoned in favor of a self-contained structure of complex interrelationships. Renoir replaced the diagonal structure, a device used to create movement since the baroque period, with an orthogonal framework reminiscent of Ingres' arrangements of figures on a single pictorial plane. The rococo-style features evident in the one painting have here given way to neo-classical ones. Thus it is no surprise that the one went to New York and the other to Berlin.

This major work of art, which according to the art critic Meier-Graefe "will always be regarded as Renoir's most original,"[9] was sold for 14,000 francs at the auction of the Bérard collection at the gallery of Georges Petit on May 8, 1905. It had been optimistically appraised at 20,000 francs. The purchaser was the art dealer Bernheim-Jeune. Not long after, it was sold through Josse Hessel to Paul Cassirer in Berlin,[10] where Hugo von Tschudi acquired it on June 24 for the Berlin National-galerie for 25,000 marks.[11]

9 Meier-Graefe 1929, p. 219.

10 Paul Cassirer regularly exhibited works by Renoir at his Berlin gallery beginning in 1901. See Georg Brühl, *Die Cassirers*, Leipzig 1991, pp. 154ff.

11 Duret 1924, pp. 67f.; Paul 1993, p. 368.

Provenance
Paul Bérard, Paris; Auction *Bérard*, Georges Petit, Paris, May 8, 1905, No. 15; Bernheim-Jeune, Paris; Josse Hessel, Paris; Paul Cassirer, Berlin; acquired in 1905 by Hugo von Tschudi through a donation by Karl Hagen (1906).

References
Duret 1906, p. 290; Meier-Graefe 1911, pp. 58, 107, 131ff., ill., pp. 148f.; Fosca 1923, pp. 35f.; Duret 1924, Ill. 19, pp. 64f., 67f., 118; Meier-Graefe 1929, pp. 201ff., Ill. 169, pp. 235, 281; Barnes-de Mazia 1935, pp. 88, 91f., 97, 104, 204, 282, 405, 409ff., 419, 456, No. 144, ill.; Florisoone 1937, pp. 17, 22, 84, ill.; Maurice Bérard, *Renoir à Wargemont*, Paris 1938, ill.; Terrasse 1941, ill.; Graber 1943, pp. 76, 124, ill. pp. 148–149, p. 183; Drucker 1944, pp. 48, 65, Ill. 77, pp. 187, 205; Rouart 1954, p. 69; Bünemann 1959, pp. 85ff., ill., pp. 155, 198ff.; Fosca 1961, p. 74, ill.; Perruchot 1964, pp. 201, 301; Daulte 1971, No. 457, ill., p. 409; Fezzi 1972, p. 116, No. 602, ill.; Daulte 1973, p. 92, ill.; Wheldon 1975, pp. 89f., Ill. 67; Alice Bellony-Rewald, *The Lost World of the Impressionists*, London 1976, p. 71; Callen 1978, p. 79, ill.; Ehrlich White 1984, pp. 148ff., ill., pp. 154, 184, 230; Rouart 1985, p. 74, ill.; Keller 1987, pp. 105ff., Ill. 82; Bade 1989, pp. 116f., ill.; Monneret 1990, pp. 16, 154, No. 15, ill., p. 156; Distel 1990, pp. 162ff., ill., p. 168; Paul 1993, pp. 194, 220, 368, No. 70, Ill. 55, Ill. VIII; Brisbane–Melbourne–Sidney 1994–1995, p. 37, ill.

Exhibitions
Paris 1933, No. 75, Ill. XLIII; *Die Welt des Impressionismus*, Museum zu Allerheiligen, Schaffhausen, 1963, No. 104; Chicago 1973, No. 47, ill.; London–Paris–Boston 1985–1986, No. 74, ill., pp. 22, 25, 230, 242.

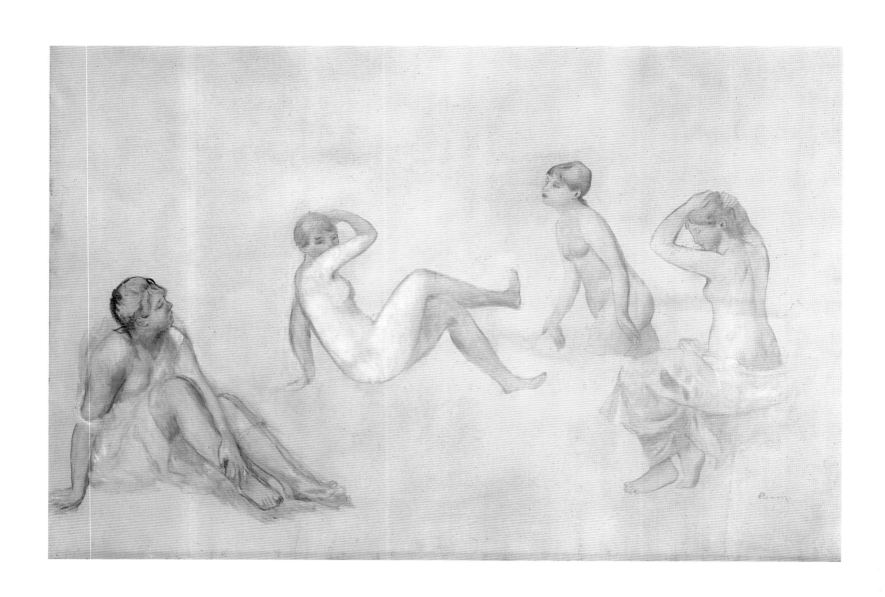

71 Study for The Large Bathers 1884–1885
Esquisse pour *Les grandes baigneuses*

The female nude, a favorite theme of Renoir from his early years (cat. no. 10), took on even greater importance in his œuvre in the early 1880s. Renoir showed little interest in compositions with multiple nudes before beginning his large studio painting, *Les grandes baigneuses* (ill. p. 46) in 1884,[1] which was to occupy him intensely until its completion in the spring of 1887. The individual figures randomly arranged on this canvas presumably represent intensive preparatory studies for *Les grandes baigneuses*. They appear in more or less modified variations both in that painting and in his *Baigneuses dans la forêt*, a work completed about ten years later. Placed in typical models' poses as symbols of beauty on display—without male counterparts— the nude figures personify an image of humankind presented in a suitable artistic form. Their surface-bound gestures and the somewhat theatrical grace of their movements solidify into intricate arabesques of shape and line.

Beginning in 1882, still influenced by his Neapolitan impressions of Pompeiian frescoes uniting a classical approach to the human body with an almost Impressionist technique and by the harmonious chords of Raphael's Farnesina frescoes in Rome,[2] Renoir ventured forth in search of a unity of formal ideal and reality. By employing traditional formulas for the expression of grace and beauty developed by painters from Girardon (ill. p. 46) to Ingres and the rear guard of the Paris Salon, he deliberately distanced himself from Impressionism. It was his hope that in this way—by focusing upon formal stringency, a disciplined use of color and a polished corporeality—he could secure his place in the history of French art. Never before, and later only in his *Maternité* (cat. no. 78), did the artist go to such lengths to lay the groundwork for a composition compiled from models' poses in drawings. Renoir worked out the individual attitudes and movements of his figures in *Les grandes baigneuses* in more than 20 studies and variations, exploring anew the relationships between precise contour and color, body and space, drawing and painting. Along the way he also developed a special painting technique. In order to achieve optimal precision in the rendering of the forms on canvas, he found it necessary to do a large number of detail studies, which then—in most cases in an improved form—were transferred to the final

Oil on canvas
62 x 95 cm
Signed, lower right:
Renoir.
Private collection, Paris
Daulte 1971, No. 477

1 See pp. 46ff.

2 See p. 43.

3 The painter made occasional use of tracing for "purposes of reproduction" later in his career as well. Jean Renoir recalled that "such [tracing] was used only when my father was dissatisfied with the placement of a body or

Renoir, *Female Bathers in the Forest*, ca. 1897, The Barnes Foundation, Merion

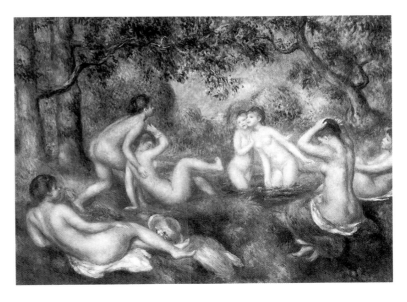

a group but not with the manner in which it harmonized with the background In order to avoid having to start all over again in order to make his model 'actually sit on her rear end,' he would make a tracing, lay it aside and go on to other works. Only some time later would he take up the tracing again and use it for a new painting It is common knowledge that he painted the same motifs several times But in his eyes each variation of an old motif was always a new picture. The question of the 'object' never concerned him at all, as we know. He told me once that he regretted never having painted the same image—he meant the same object—twice in his whole life" (Renoir 1981, pp. 350f.).

4 Morisot 1950, p. 128.

painting as tracings.[3] Having established the context in this way, he could then apply his paint in subdued, enamel-like tones in an approach that had nothing in common with his earlier Impressionist style.

After visiting Renoir's studio at Rue Laval 37, Berthe Morisot remarked in her diary entry of January 11, 1886: "I think it would be impossible to render form in drawing more perfectly than Renoir has done. These naked women wading into the water are as enchanting to me as the nudes of Ingres. Renoir said that he considered the nude an indispensable form of expression in art."[4]

Provenance
Ambroise Vollard, Paris; Etienne Bignou, Paris; Paul Pétridès, Paris.

References
Vollard 1918, I, p. 48, No. 192, ill.; Daulte 1971, No. 477, ill.; Daulte 1973, pp. 44f., ill.; Ehrlich White 1984, pp. 166, 170, ill.; Monneret 1990, p. 106, ill.

Exhibitions
Hommage à Renoir, Galerie Paul Pétridès, Paris, 1950, No. 37; Paris 1954, No. 79; *50 Toiles de Maîtres*, Galerie Paul Pétridès, Paris, 1959, No. 25, ill.

72 Bather 1884–1885
Baigneuse

Oil on canvas
60 × 54 cm
Signed, upper left:
Renoir.
Nasjonalgalleriet
(Inv. no. NG. M. 01166),
Oslo
Daulte 1971, No. 488

The woman who sat for this half-figure nude with a towel wrapped around her waist was typical of the well-proportioned models with rosy complexions and reddish-blonde hair who embodied Renoir's ideal of feminine beauty. Her round face, slightly parted lips and almond-shaped eyes were also quite in keeping with the sentimental image of female beauty that prevailed during the period.

The particular appeal of this painting derives less from the model's charm than from the artist's impulsive painting style, which sets the carefully modeled body apart from the background like a silhouette. Forceful yellow, gray and salmon-pink brushstrokes reminiscent of de Kooning suggest the features of an open-air scene in which blue waves break against the red of the model's hair. Renoir's vigorous brushwork becomes calmer where the color contrasts grow strongest near the woman's long, tumbling locks. Aside from the fact that it would have been considered indecent for a woman to pose in the nude outdoors,

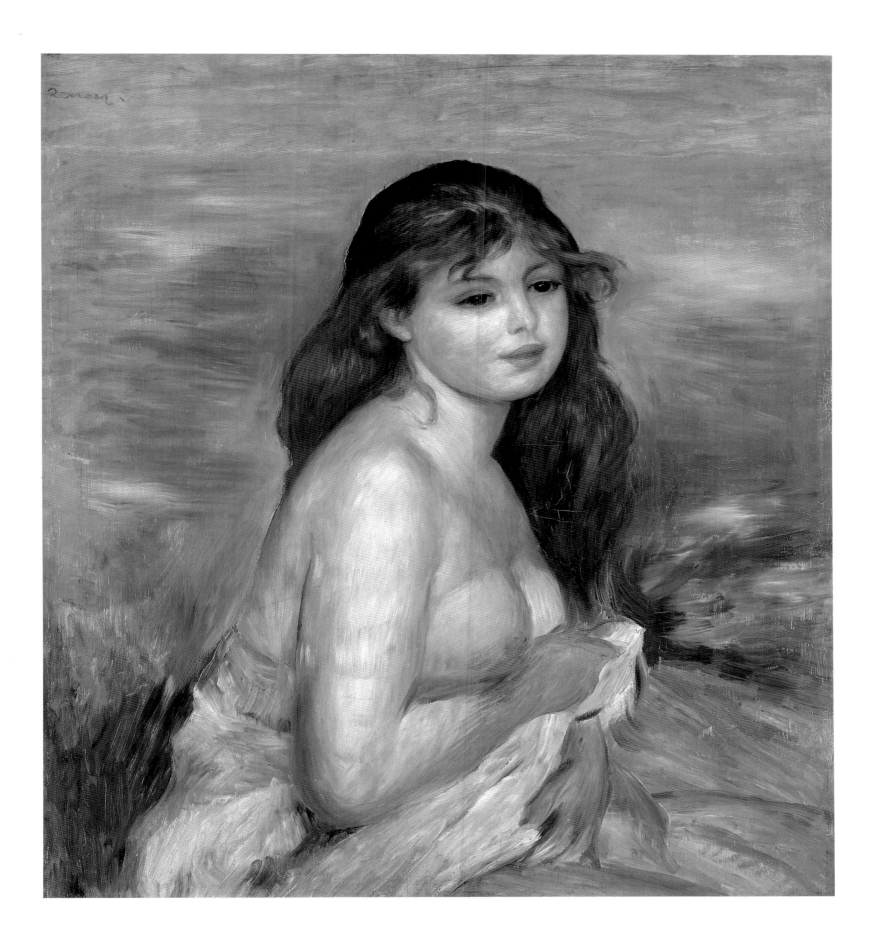

the obvious discrepancy between the figure and its surroundings as well as the uniform quality of the light clearly mark this work as a studio piece. The painting leaves some details unresolved in the area of the breasts, the legs and the hands, suggesting that the painting was still unfinished when it left Renoir's studio bearing his signature.

Provenance
Galerie Levesque, Paris; Trygve Sagen, Oslo; presented as a gift in 1917.

References
Régnier 1923, Ill. 15; Barnes-de Mazia 1935, pp. 72, 85, 104, 298, 459, No. 181, ill.; Drucker 1944, p. 78, Ill. 87, pp. 187, 207; Gaunt 1952, p. 10, Ill. 62; *Franske Malere*, Nasjonalgalleriet, Oslo 1959, p. 29, ill.; Daulte 1971, No. 488, ill.; Fezzi 1972, p. 117, No. 629, ill.; Rouart 1985, pp. 80, 83, ill.; Keller 1987, p. 130, Ill. 105; Wadley 1987, p. 166, ill.

Exhibitions
St. Petersburg 1912, No. 523; *Fransk maler Kunst*, Nasjonalgalleriet, Oslo, 1914, No. 23; Paris 1933, No. 77; Lyon 1952, No. 17, Ill. 6; Nagoya–Hiroshima–Nara 1988–1989, No. 31, ill.; Brisbane–Melbourne–Sidney 1994–1995, No. 28, ill.

73 Landscape with Female Bathers
ca. 1885
Paysage avec baigneuses

Oil on canvas
31 × 40 cm
Signed, lower left:
Renoir
Private collection

The idea of incorporating female nudes into a landscape on the banks of a river or lake in the classical manner most likely derives from Cézanne, who had begun to develop the theme of bathers as an independent genre around 1875 (ill. p. 238). Using both male and female nudes, Cézanne created figural arrangements of great formal discipline that express something of the oneness of beginning and end as archetypal symbols of the vital unity of man and nature. Set apart from the stages of real human life, they give shape to a now classless human condition that remains eternally anonymous.

Renoir's painting focuses less on the figures than on landscape, in which several nudes appear on an embankment along the waterside. Nonetheless, we recognize aspects of theme and style also evident in the work of Cézanne, pointing to the possibility of a closer connection between the two artists. Indeed, Renoir and Cézanne worked together during both the spring of 1882 and the summer of 1885. In late January 1882, on his return journey from Italy where he had spent several

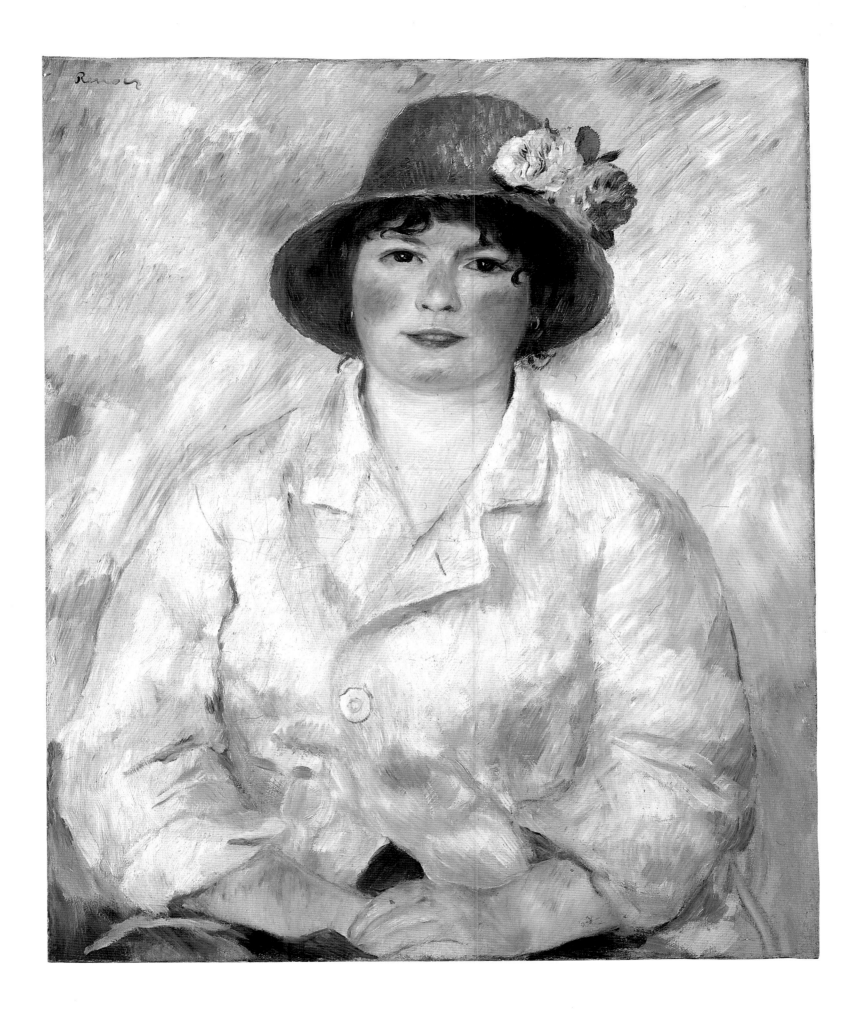

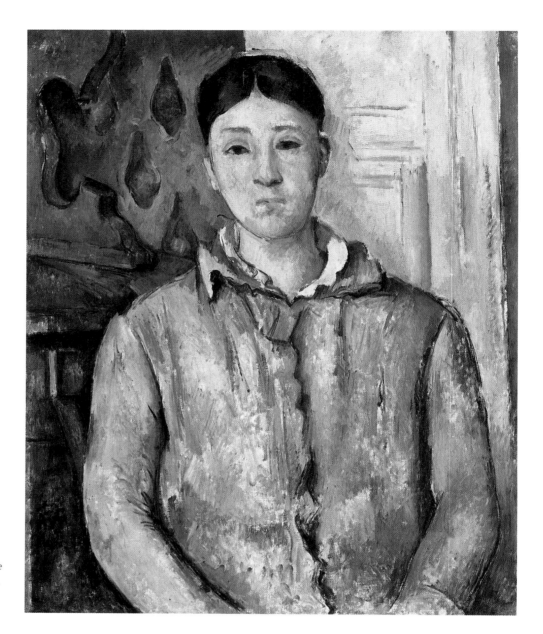

Paul Cézanne, *Madame Cézanne Wearing a Blue Jacket*, ca. 1886, The Museum of Fine Arts, Houston

Mallarmé: "I cannot possibly describe to you the astonishment I felt when confronted with such a heavy person, whom I had imagined, I don't know why, as being quite like her husband's painting. I shall point her out to you this winter."[1] It is certain, however, that Aline Charigot came very close to the ideal of womanhood of which Renoir often spoke in conversations with his son Jean in later years. Jean Renoir vividly recalls his father's thoughts on the subject in his memoirs: "I shall try to give you an idea of the ideal proportions of the head as Renoir described them: the eyes at the halfway point between the crown of the skull and the chin. He regarded any shift in this balance in favor of the half that lay above the midline as a sign of uncontrolled growth of the brain, 'the brain of a person with delusions of grandeur or simply of an intellectual, to say nothing of hydrocephalics.' He viewed upper faces that were too small as evidence of simple

1 Morisot 1950, p. 163.

stupidity, while excessively large lower faces betrayed stubbornness. 'Never marry a woman with a large chin. She would rather be cut to pieces than admit the obvious!' He liked women with a tendency to put on weight but felt differently about men, whom he preferred slim. He liked small noses better than large ones, and made no secret of his weakness for wide mouths and full lips—though not bulging—or his preference for small teeth, light skin and blonde hair. 'Lips like a chicken's rear end suggest affectation; thin lips express mistrust!' Having outlined all the rules and, most importantly, emphasized the significance of the location of the eyes in the middle of the face, he added: 'And now just follow your own instincts. The rules can lead you into real trouble. I have known wonderful girls with pointed chins and insufferable beasts whose faces were symmetry in perfection!' Fate willed that Aline Charigot was not an insufferable beast; that the proportions of her features and her body met the requirements of Renoir's canon; that her slightly almond-shaped eyes could transmit her impressions to a well-balanced brain; that her gait was energetic—'she ran through the grass without harming it'; that she retained the strength of the east wind that blows across the heights of her home country; and that she could stick a wayward curl back into the knot of her hair with a natural, unaffected motion that Renoir loved to watch, because it 'was truly perfectly round' My mother appears well-rounded even in my earliest childhood memories. I can imagine her as a 20-year-old, already well padded but with the waist of a wasp. The pictures in which she appears help me to clarify my own idea of her. I have already mentioned how strongly Renoir was attracted to the 'cat' type. Aline personified the genre perfectly. 'One had an urge to scratch her throat.' On the basis of my father's bashful allusions to that phase of his life I imagined a deep, mutual love. Rivière remarked: 'It could easily happen that he would set aside his brush and palette and simply look at her instead of painting, because he thought to himself: why torture myself when what I wanted to paint was already there in complete perfection!'"[2]

The portrait of his wife, whom he married in 1890 and who bore him three sons, remained in the artist's possession until his death, when it was inherited by his oldest son Pierre.[3]

2 Renoir 1981, pp. 190f., 189.

3 In 1915, after the death of his wife, Renoir commissioned a life-size bronze bust for her grave in Essoyes based on this portrait of 30 years before.

Provenance
Pierre Renoir, Paris; Marie Harriman Gallery, New York; Georg W. Elkins, Philadelphia.

References
André 1919, Ill. 27; André 1931, I, No. 16, ill.; Terrasse 1941, Ill. 27; Barnes-de Mazia 1935, pp. 88, 403, 412, 456, No. 148; Graber 1943, ill. pp. 156–157; Daulte 1971, No. 484, ill., p. 411; Callen 1978, p. 19; Renoir 1981, Ill. 15; Ehrlich White 1984, p. 153, ill.; Keller 1987, p. 135, Ill. 111; Monneret 1990, pp. 102f., ill.; *Paintings from Europe and the Americas in the Philadelphia Museum of Art*, Philadelphia 1994, p. 153, ill.

Exhibitions
Berlin 1927, No. 1; New York 1950, No. 49, ill.; Los Angeles–San Francisco 1955, No. 36, ill.; New York 1969, No. 60, ill.; Chicago 1973, No. 51, ill.; New York 1974, No. 32, ill.; London–Paris–Boston 1985–1986, No. 78, ill., pp. 12, 34, 223, 228, 237, 249; Brisbane–Melbourne–Sidney 1994–1995, No. 25, ill., pp. 40f., ill., p. 46.

77 Motherhood. Mother Nursing her Child 1885
Maternité. Femme allaitant son enfant

During the winter of 1885–1886 in Paris, Renoir worked on a series of drawings and paintings on the theme of *Maternité* (cat. no. 78). The inspiration for this subject came from his companion Aline Charigot (cat. nos. 58, 76) and their barely six-month-old son Pierre (1885–1952) during their stay in Aline's home village of Essoyes in September or October of 1885. After visiting Renoir in his studio at Rue Laval 37 on January 11, 1886, Berthe Morisot wrote in her diary: "Visited Renoir. On an easel was a drawing in red and white chalk of a young mother nursing her child; delightful in its grace and delicacy. I admired it, and so he showed me a series of works featuring the same model in virtually the same pose. He is a first-class draftsman. It would be interesting to present all of these painting studies to the public, which is generally of the opinion that the Impressionists' approach is free and simple."[1]

This description could refer to one of two red-chalk drawings highlighted with white: the one shown here and a version more closely related to the final canvas painting at the Musée d'Art Moderne et Contemporain in Strasbourg.[2] The accuracy of Berthe Morisot's admiring conclusion that Renoir was a first-rate draftsman, however, is open to question. Strictly speaking, Degas and Cézanne were the only Impressionist artists qualified to bear this title. Morisot must have been aware, moreover, that Renoir was first and foremost a gifted painter who, like most of the Impressionists, was only peripherally concerned with drawing in any form, aside from the colored medium of pastels.

Very few of Renoir's major works were as thoroughly prepared and accompanied by drawings as this picture of the nursing mother. This drawing probably represents an early phase of preparation. It matches the format of the following painting (cat. no. 78) almost perfectly, although the position of the child and the rudimentary execution of the mother's clothing are still relatively far removed from the canvas work. To the left and right of the figure are two minutely detailed studies of the child's mouth suckling at its mother's breast.

Red and white chalk on paper (mounted on canvas)
71.5 x 51.4 cm
Signed, lower right:
Renoir
Prof. Dr. h. c. Hermann Schnabel, Hamburg

1 Morisot 1950, p. 128.

2 See also the two drawings cited in Vollard 1918, I, Nos. 132, 146.

Provenance
Auction, Sotheby's, New York, May 10, 1989, No. 113.

References
Auction catalogue, *Impressionist and Modern Drawings and Watercolors*, Sotheby's, New York, May 10, 1989, No. 113, ill.

78 Motherhood. Mother Nursing her Child 1886
Maternité. Femme allaitant son enfant

Oil on canvas
74 × 54 cm
Signed and dated,
lower left: Renoir. 86.
Prof. Dr. h. c. Hermann
Schnabel, Hamburg
Daulte 1971, No. 497

1 During his journey through
Italy in the fall of 1881, Renoir
had seen Raphael's *Madonna
della Sedia* at the Palazzo Pitti in
Florence, an experience he later
recalled in vivid terms: "I looked
at this painting because I wanted
to laugh about it; and suddenly I
found myself standing in front of
the most wonderfully simple and
lifelike painting one can imagine—
arms and legs of flesh and blood,
and this touching expression of
maternal tenderness" (Vollard
1961, p. 61).

2 Daulte 1971, Nos. 485, 496,
497. A variation dating to the last
years of his life is found in the col-
lection of the Barnes Foundation,
Merion.

When Degas established the motif of the *Femme allaitant* as a legitimate contemporary theme in 1869, he did so within the sober context of a racetrack scene (ill. p. 252). Seated in a public carriage under the interested gazes of her parents and a bulldog perched on the coachman's seat, the wet nurse is shown stilling the hunger of a baby boy. Degas created a family scene beneath the open sky, turning its intimacy into a random happening that takes place off to one side of a public event. Renoir was surely familiar with the painting, as it had been shown at the first Impressionist exhibition in 1874. He may have recalled it years later when he clothed his *Maria lactans* in modern garb and devoted his attention to the intimate mother-child relationship, a motif that had attracted his interest even during his early years (cat. no. 3) and would continue to captivate him from that time on.[1] As was to be expected, he replaced Degas' genre scene with a family portrait of his wife-to-be Aline Charigot (cat. nos. 58, 76) and their first-born son Pierre. In Renoir's work, Degas' depiction of a mundane event gives way to an idyll of traditional rural mores. Although an interior setting would have been more appropriate for this very private moment, both artists opted for outdoor scenes. Renoir placed his models, in whose intimacy he shares through the mother's loving gaze, in the rural surroundings he had come to know in Essoyes during his first visit to Aline's native village in September and October 1885.

Pierre, born in Paris on March 21, 1885, is proudly presented by his father in all his maleness. The godchild of Caillebot, he later pursued a successful career as an actor. He was six months old when Renoir portrayed him here, nursing at his mother's breast. The conceptual groundwork for the composition, dated 1886, had been laid in extensive studies (cat. no. 77) done in the early fall of the previous year. Renoir completed three painted versions of the scene, distinguished primarily by their differing backgrounds.[2] Since the first version, the one that most accurately reproduces the village surroundings, is dated 1885, we may conclude that the intimate physical and emotional bond between mother and child had been in the foreground of his thoughts for some months by the time he completed this most painstakingly executed and highly monumentalized variation in his Paris studio in the spring of 1886. Compared to the rustic quality of the first version, in which Aline is shown wearing wooden shoes and sitting on a fallen tree trunk outside the door of a peasant's hut, the two replicas were given a more "noble" character. The trunk was replaced by a chair and Aline's wooden clogs with laced shoes. The backgrounds are more expansive, and Renoir employed a more distinctive painting technique. This change of heart probably resulted from Renoir's plans to exhibit one of the later versions at the *5ᵉ exposition internationale de peinture et de*

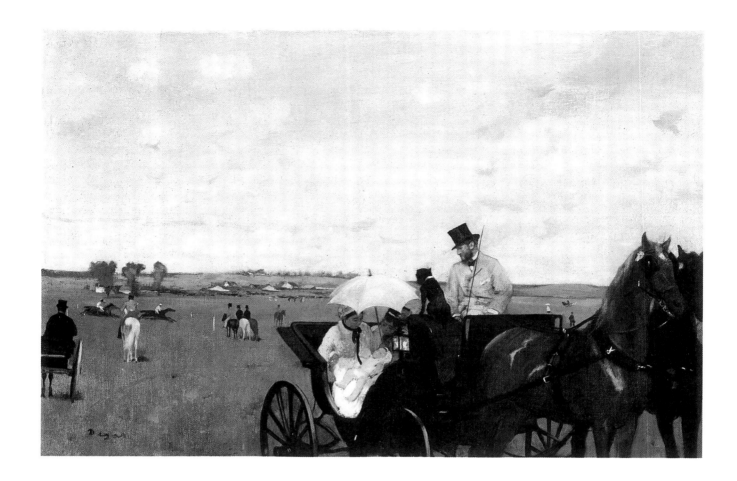

Edgar Degas, *At the Race Track*, 1869, Museum of Fine Arts, Boston

3 Octave Mirbeau, "Impressions d'art," in *Le Gaulois*, June 16, 1886 (Ehrlich White 1984, p. 165).

4 Ibid., p. 165. Renoir's presentation of his *Grandes baigneuses* at the gallery of Georges Petit in 1887 (ill. p. 46) failed to deliver such proof.

5 Félix Fénéon, *Au-delà de l'Impressionnisme*, Paris 1966, p. 69.

6 Venturi 1939, I, pp. 77ff.

sculpture at the elegant gallery of Georges Petit. Apparently he selected the final version, a fully signed and dated piece to which he had added a cat, to be shown under the title *L'enfant au sein* at the exhibition opening on June 15, 1886.

After years of crisis and often fruitless experimentation, Renoir now presented himself to the Paris public with this work, his most recent creation. The response, however, was ambivalent. In a review dated June 16, the art critic Octave Mirbeau commented that "in its originality," the admirable "*Woman with Child* had the charm of the primitive, the clarity of the Japanese and the mastery of Ingres."[3] Renoir thanked the critic two days later for his positive reception: "I have just read your courageous article on the title page of *Le Gaulois*. You honor me by placing me alongside the two greatest artists of the era [Rodin and Monet]. I am no smart-aleck. I am very proud and grateful to you for giving me new courage to prove to everyone that you are right at the next exhibition."[4] Félix Fénéon, the most perceptive spokesman of Neoimpressionist art, criticized Renoir's development and advised the "radiant painter of the Parisian epidermis" to return to his earlier painting style.[5] Durand-Ruel, who had just returned from New York having enjoyed initial success in his efforts to promote the Impressionists,[6] was also disappointed, presumably because Renoir and Monet had exhibited their work with his competitor Georges Petit.

Pissarro remarked in a letter to his son Lucien on July 27, 1886 that "Durand was at Petit's and saw the Renoirs. He is not at all pleased with his new style of painting."[7]

It is likely that the critics were confused by both the simplicity of the triangular composition and the finely hatched modeling that called to mind the former porcelain painter. They may have been irritated by the discrepancy between the formal solidity of the ripe, rounded, self-content figures, for whom the most intense color constellations were reserved, and the openness of the surrounding setting with its thinly applied hatching, small pointillist-style dots and light canvas ground showing through in many places. Renoir's attempt to resolve the glaring oppositions that separated the colorists and the linearists—stylistic tendencies most recently personified in the antipodes Delacroix and Ingres—was not to be crowned with success.

Ultimately, the wonderfully natural pose may also have ruffled a few feathers. Hands played a role in Renoir's judgments about people, and he placed great emphasis on their depiction.[8] Here he focused upon the infant's hand shown grasping its raised foot and on the soft, gentle hands of the mother that support the child as well as its source of nourishment. The delightful interplay of the intricately detailed hands and feet inevitably remind us of Picasso—not the early Picasso who so meaningfully glorified the image of motherhood, but the body-conscious artist of his classicist years. Only he could imbue bodily extremities with the same significance and sensual joy as Renoir.

7 Pissarro 1953, p. 86.

8 "He never ceased to talk of 'the hand.' He judged people by their hands. 'Did you see that guy . . . the way he opened his box of cigarettes . . . [he is] a lout . . . and the way that woman pulled her hair back with her index finger . . . a sweet girl.' He also spoke of dumb hands, spirited hands, middle-class hands, whores' hands. Renoir looked at hands the way some people look into others' eyes to find out if they are being sincere" (Renoir 1981, p. 15).

Pablo Picasso, *Mother and Child*, 1921, private collection

Provenance
Durand-Ruel, Paris and New York; Henry Sayles, Boston; Arthur B. Emmons, New York; Auction *Emmons*, American Art Association, New York, January 14, 1920, No. 51; Scott and Fowles, New York; Hunt Henderson, New Orleans; Auction, Sotheby's, New York, May 10, 1988, No. 23.

References
Thadée Natanson, "Renoir," in *La Revue blanche*, June 15, 1896, p. 549; Vollard 1918, I, p. 85, No. 338, ill.; André 1919, Ill. 34; Meier-Graefe 1929, p. 238; Barnes-de Mazia 1935, pp. 93, 435, 457, No. 159; Roger-Marx 1937, p. 109, ill.; Terrasse 1941, Ill. 27; Daulte 1971, No. 497, ill. p. 411; Ehrlich White 1984, pp. 158, 160ff., ill., pp. 165, 174; Rouart 1985, p. 77, ill.; auction catalogue, *Impressionist and Modern Paintings and Sculpture (Part I)*, Sotheby's, New York, May 10, 1988, No. 23, ill.; Nagoya–Hiroshima–Nara 1988–1989, p. 28. ill.

Exhibitions
5ᵉ exposition internationale de peinture et de sculpture, Georges Petit, Paris, 1886, No. 126; Paris 1892, No. 75; New York 1937, No. 45, ill.; New York 1941, No. 57, ill.; *Early Masters of Modern Art*, Isaac Delgado Museum of Art, New Orleans, 1959, No. 38, ill.; London–Paris–Boston 1985–1986, No. 79, ill., pp. 12, 16, 34, 223, 242f., 245, 253f., 282.

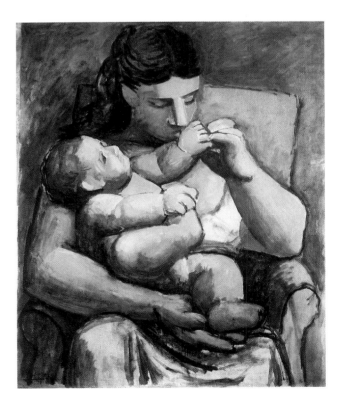

79 The Two Sisters 1889
Les deux sœurs

Oil on canvas
64 x 54 cm
Signed, lower right:
A. Renoir.
Private collection
Daulte 1971, No. 562

1 Meier-Graefe 1929, p. 166, Ill. 147.

Renoir, *The Piano Lesson*, ca. 1889, Joslyn Art Museum, Omaha

On December 28, 1889, Paul Durand-Ruel acquired from the artist this painting of two sisters reading. Only four weeks later, on January 31, 1890, he purchased the picture of the two girls at a piano, an indication that the paintings must have been completed only a short time before. The two sisters were portrayed a third time, leafing through an album in the same bright red dresses with dark trim and insets.[1]

In all three of these paintings, the artist avoided individualizing his young models, instead depicting them as types. In this way he made genre scenes of the double portraits, placing his thematic focus on the concentrated activity of the two figures and the effects of their radiant red dresses on the overall harmony of the composition. Never before and seldom afterwards was the color red elevated so triumphantly to the status of a visual event in its own right. As an illustrative element, it also bespeaks the social position of the two musically inclined daughters from an upper middle-class family. Their proper poses, reminiscent of Dutch and French paintings of the 17th and 18th centuries, are also typical of photographs of the period. It is entirely possible that the painter used a visual aid of this kind in order to spare the two girls the ordeal of sitting for him.

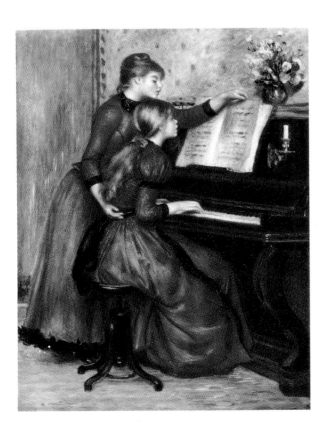

Provenance
Durand-Ruel, Paris; M. Boy, Paris; Vente *Boy*, Paris, May 25, 1904, No. 25; Durand-Ruel, Paris; Georges Bernheim, Paris; C. Tetzen-Lund, Copenhagen; Paul Cassirer, Berlin; Wildenstein, New York; Charles R. Lachmann, New York.

References
Daulte 1971, No. 562, ill.; Ehrlich White 1984, p. 190, ill.; London–Paris–Boston 1985–1986, p. 256.

Exhibitions
Auguste Renoir, Stockholm–Copenhagen–Nasjonalgalleriet, Oslo, 1921, No. 27, ill.; New York 1958, No. 43, ill.; *Four Masters of Impressionism*, Acquavella Galleries, New York, 1968, No. 40, ill.; New York 1969, No. 70, ill.; New York 1974, No. 44, ill.

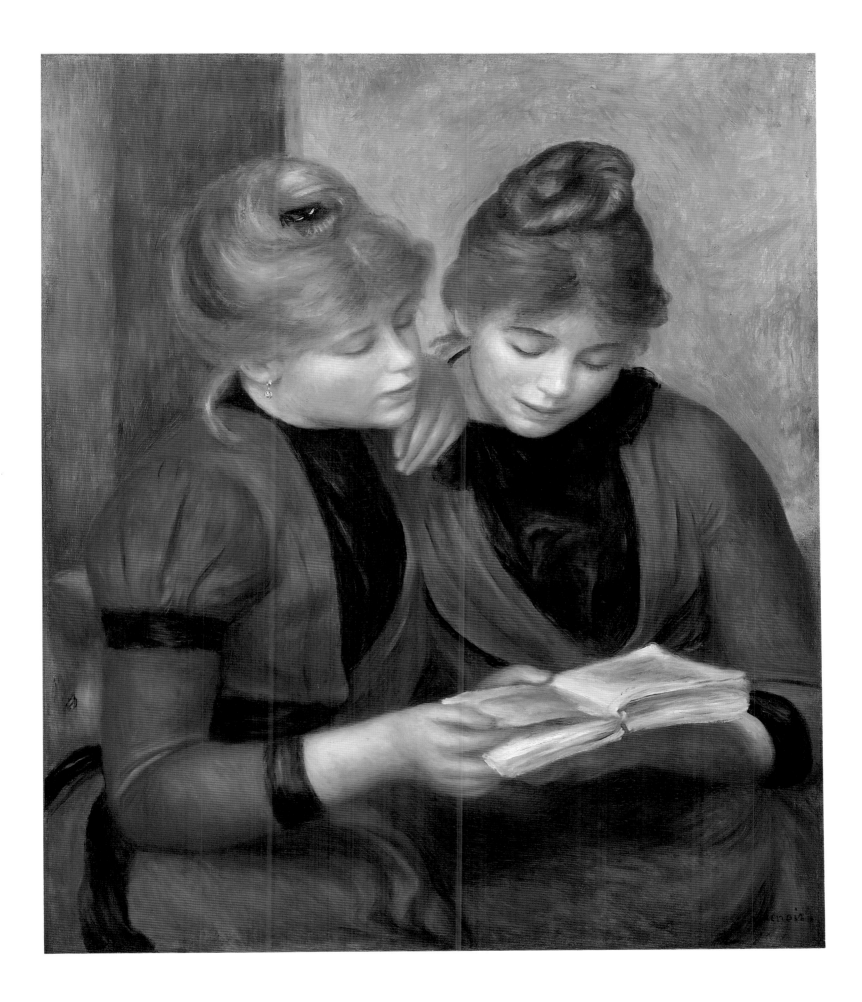

80 Two Girls Reading ca. 1890
Deux fillettes lisant

Pastel on paper
29.5 x 37.5 cm
Signed, lower left:
Renoir
Private collection

As mentioned earlier, Renoir regarded pastel as the graphic medium best suited to making line a bearer of color and color a defining component of line (cat. nos. 41–43). This drawing of two girls reading clearly illustrates his use of pastel sticks of varying hardness. Because of the rough, fibery texture of the paper, the color material remains visible as a grainy substance. Renoir selected such paper in order to give the dry pigment, which derived its consistency from a water-soluble binder, an adequate bonding surface. In certain places, he rubbed the material with his fingertip to achieve specific painterly affects and often applied the pastel stick at an angle so as to cover the paper ground with a more uniform layer of color. A variety of interesting color mixtures was obtained by wiping away patches of superimposed color, particularly in the green and blue of the background. Boldly intertwining colors and lines, culminating in the white highlighting of the dresses, the black and blonde of the hair, the lemon yellow of the hat and the isolated pale-red accents, are concentrated primarily in the middle of the drawing. Areas of the slightly tinted paper not covered by the pastel material served a pictorial strategy also pursued by Cézanne in his watercolors, an approach that relied upon contrasts between the open areas and those with a dense material quality.

1 Daulte 1971, Nos. 452, 453, 487, 562, 582, 599–602, 609, 610, 639, 640.

Renoir, *Two Girls Reading*, ca. 1890, private collection

Pairs of young girls seated at the waterside or engaged in reading, drawing, picking or arranging flowers appeared occasionally in Renoir's work during the 1880s, becoming an integral part of his iconography by the end of the decade.[1] According to Daulte, Renoir's slightly larger painted version likewise dates to around 1890, though it fails to achieve the evocative openness of the pastel.

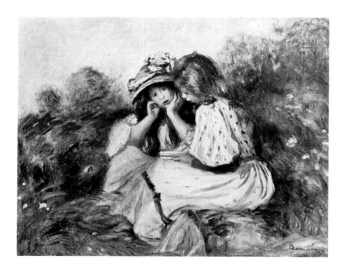

Provenance
Paul Cassirer, Berlin; Otto Gerstenberg, Berlin.

References
Hausenstein 1920, Ill. 14; J. Leymarie, *Les pastels, dessins et aquarelles de Renoir*, Paris 1949, Ill. 19; François Daulte, *Pierre-Auguste Renoir. Aquarelles, pastels et dessins en couleurs*, Basle 1958, p. 8, ill.

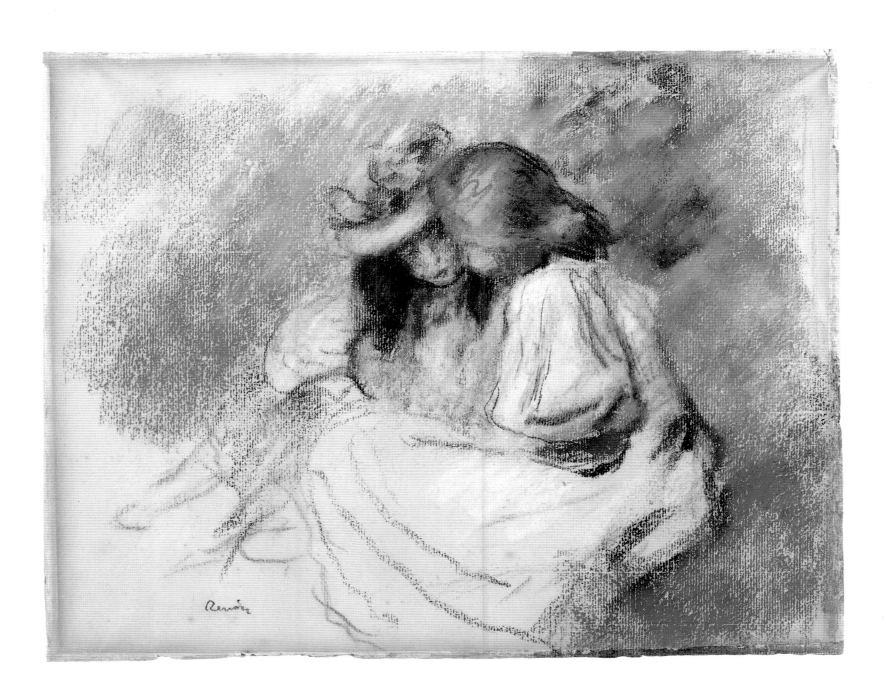

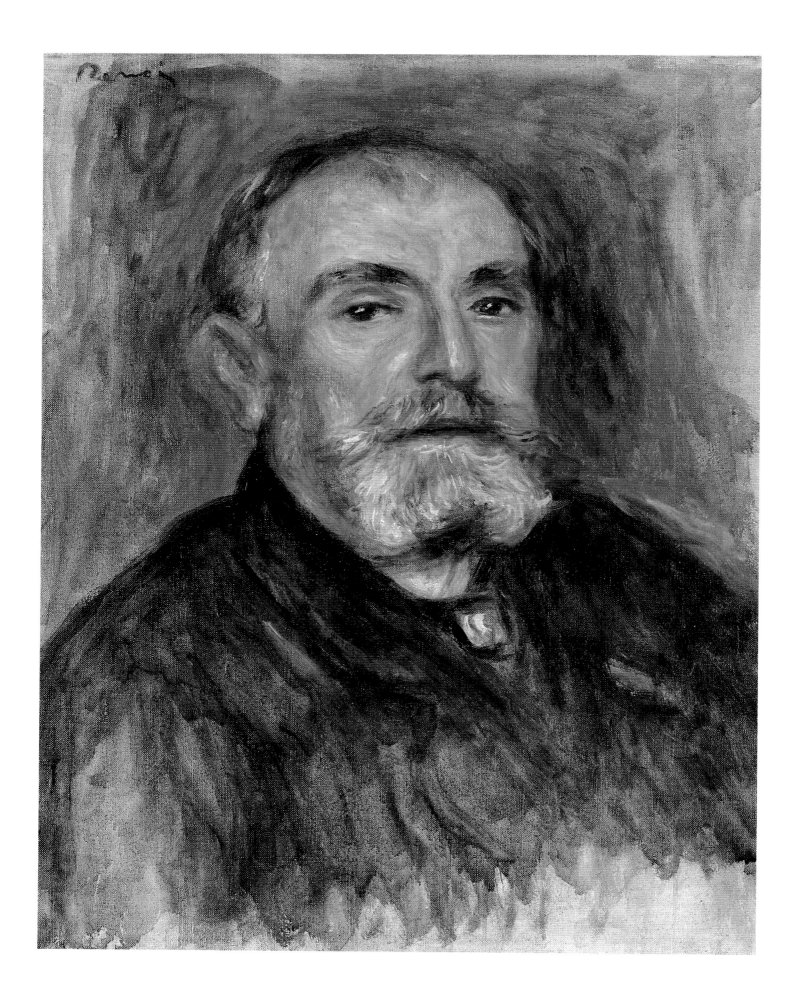

81 Portrait of the Painter Henri Lerolle 1890–1895
Portrait du peintre Henri Lerolle

This bust portrait of the history, landscape and genre painter Henri Lerolle (1848–1929), an artist who also enjoyed some success with frescoes on religious themes, is a strikingly expressive work. Using only a few swiftly applied colors that give clarity solely to the plasticity of the head, Renoir achieved an expression of great physical presence. The finely painted facial features and the gray-streaked beard stand out clearly against the uneven, watery areas of color that merely sketch out the dark violet-blue of the coat and the shades of the background. The texture of the light-colored canvas ground is clearly visible toward the edges of the painting.

Although the portrait appears as a self-contained composition and is signed on the upper left, its original form was somewhat different. When the painting was auctioned by Lerolle's heirs in 1960, it was listed in the catalogue issued by the Galerie Charpentier in Paris under the title *Portrait du peintre H.-L., aux roses*. At that time, the painting measured 51 cm in width and featured a garland of roses added rather arbitrarily at the left-hand edge. The artist probably used this floral device simply to fill an oversized canvas.[1] Later, sometime between 1960 and a subsequent auction in 1973, the superfluous rose motif was cut away from the portrait.

Lerolle, shown wearing the badge of the Legion of Honor, was a close friend of Degas and a collector of his works. Renoir had met the painter in the mid–1880s at one of the weekly dinners hosted by Berthe Morisot. Frequent visitors to the Paris salon of Lerolle and his wife,

Oil on canvas
46 x 35 cm
Signed, upper left:
Renoir
Fondation Rau
(Inv. no. GR 1671)

1 The artist used a similar approach in numerous other paintings as well. See Vollard 1918, I, Nos. 58, 127, 172, 304, 415, 529, 591, 628, 642, 643, etc.

Renoir, *Yvonne and Christine Lerolle at the Piano*, ca. 1898, Musée d'Orsay, Paris

Renoir, *Christine Lerolle Embroidering*, ca. 1896, private collection

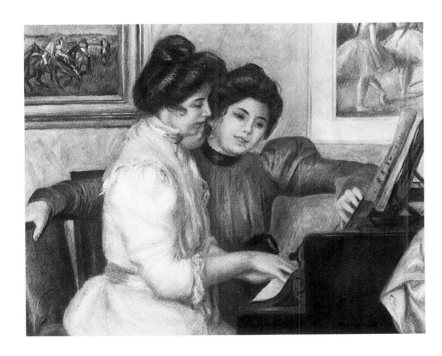

2 Lemoisne 1946, II, Nos. 702, 486.

3 Daulte 1971, No. 618.

who pursued diverse musical and literary interests, included Degas, Puvis de Chavannes, Maurice Denis, Debussy, Claudel, Valéry and Gide. Renoir made reference to Lerolle's collection in two portraits of his daughters. Paintings of jockeys and dancers by Degas appear on the wall in one of them (ill. p. 259),[2] while the other shows the collector Henri Rouart and the Belgian sculptor Louis-Henri Devillez examining a nude by Renoir (ill. p. 259).[3]

Provenance
Henri Lerolle, Paris; Mme Henri Lerolle, Paris; Jacques Lerolle, Paris; Auction, Charpentier, Paris, June 17, 1960, No. 101bis; Auction, Christie's, London, March 27, 1973, No. 50.

References
Auction catalogue, *Vente de tableaux divers*, Charpentier, Paris, June 17, 1960, No. 101bis, Ill. XXVIIbis; Auction catalogue, Christie's, London, March 27, 1973, No. 50, ill.

82 Mediterranean Landscape 1889–1891
Paysage méditerranéen

Oil on canvas
53.7 x 65.3 cm
Signed, lower right:
Renoir.
Bayerische Staatsgemälde-
sammlungen,
Neue Pinakothek
(Inv. no. 14217), Munich

Renoir made lengthy visits to the south of France during the summer of 1889 and the spring of 1891. This densely thicketed landscape scene, which Durand-Ruel purchased from the artist for 500 francs on November 27, 1894, was presumably painted on location during one of these stays. Except for the few points at which it reveals a view to the sky, the painting is covered completely with wildly proliferating Mediterranean flora. Creating an added spatial dimension, the gnarled, dry branches of a partially defoliated tree extend up and over the splendid expanse of bushes, grasses and shrubs. While one long branch extends well into the foreground, a path draws the viewer's gaze at a slant through successive layers into the dusky depths of the scene (cat. no. 32). Reddish-brown and golden yellow singed by the sunlight are interwoven with precious emerald green in the tangled foliage. In a strikingly immediate way, this painting confronts the viewer with an almost tropical landscape of luscious green set aglow by the Mediterranean sun.

Provenance
Durand-Ruel, Paris; Justin K. Thannhauser, Berlin; Elly Koehler, Gauting; presented as a gift in 1971.

References
"Erwerbungsbericht," in *Münchner Jahrbuch*, 3, XXII, 1971, p. 270; Fezzi 1972, p. 115, No. 592, ill.; *Neue Pinakothek. Erläuterungen zu den ausgestellten Werken*, Munich 1982, p. 274, ill.; Keller 1987, pp. 148, 156, Ill. 131.

Exhibitions
Munich 1958, No. 26, ill.

83 Church of the Holy Trinity in Paris 1892–1893
L'Eglise de la Trinité, à Paris

Oil on canvas
65.3 x 54.2 cm
Signed, lower right:
Renoir.
Hiroshima Museum of Art,
Hiroshima

1 See the horizontal paintings with virtually identical views cited in Rivière 1921, p. 143, ill., and Meier-Graefe 1929, p. 163, Ill. 145.

2 The Robinson collection also included Renoir's *Fillette au chapeau à plume rose* (Daulte 1971, No. 196).

3 Here in 1880, the actress Jeanne Samary, a friend of Renoir, married the financier Paul Lagarde in a wedding that attracted great public attention.

With a very successful year behind him—in April, the French government had made its first purchase of a Renoir painting, while in May Durand-Ruel had organized a very well-received retrospective exhibition featuring 110 of his works—Renoir moved into a new studio at Rue Tourlaque 7 in the fall of 1892. Although he traveled frequently during this period, he took advantage of the opportunity to capture the nearby Place de la Trinité in several pictures.[1] The foliage in this version, which once belonged to Hollywood star Edward G. Robinson,[2] has already begun to turn golden-brown, suggesting that Renoir set out to explore the architectural attractions of his surroundings immediately after settling into his new studio, depicting them as he saw them at the time.

This view from the elevated vantage point of the Rue Morlot shows the square with its pedestrians and horse-drawn carriages, the park, the adjacent houses and the towering structure of the Eglise de la Trinité. The afternoon light falls through the spaces between the buildings from the left onto the façades and the square, which teems with rapidly sketched figures and vehicles passing to and fro. We find similarly abstract renderings of the scene in Dufy's fashionable miniatures done decades later. Broken up into a diaphanous pattern by its many windows, the façade of the church, a Renaissance-style edifice erected in 1863,[3] stands out as a prominent silhouette against the hazy blue-and-white Parisian sky.

Provenance
Ambroise Vollard, Paris; Edward G. Robinson, Beverly Hills.

References
Vollard 1918, I, p. 29, No. 115, ill.; Meier-Graefe 1929, p. 91; Vevey 1956, p. 18; Fezzi 1972, p. 119, No. 663, ill.; Takaya Fukaya, *Painting Technique of Renoir*, Tokyo 1995, pp. 104f., ill.

Exhibitions
New York 1933, No. 32, ill.; *Views of Paris*, Knoedler, New York, 1939, No.. 33, ill.; *Forty Paintings from the Edward G. Robinson Collection*, The Museum of Modern Art, New York, 1953, No. 25, ill.; *The Gladys Lloyd Robinson and Edward G. Robinson Collection*, County Museum of Art, Los Angeles—California Palace of the Legion of Honor, San Francisco, 1956–1957, No. 46, ill.; *Masterpieces of French Painting from Robinson Collection*, Nichido Salon, Tokyo—Galerie Nichido, Paris, 1973–1974, No. 17; *Masterpieces of Hiroshima Museum of Art*, Bridgestone Museum of Art, Tokyo, 1984, No. 14; Nagoya–Hiroshima–Nara 1988–1989, No. 41, ill.; *Masterpieces of Hiroshima Museum of Art*, City Museum of Art, Nagoya, 1991, No. 21; *Masterpieces of Hiroshima Museum of Art*, Sogo Museum of Art, Chiba, 1994, No. 13.

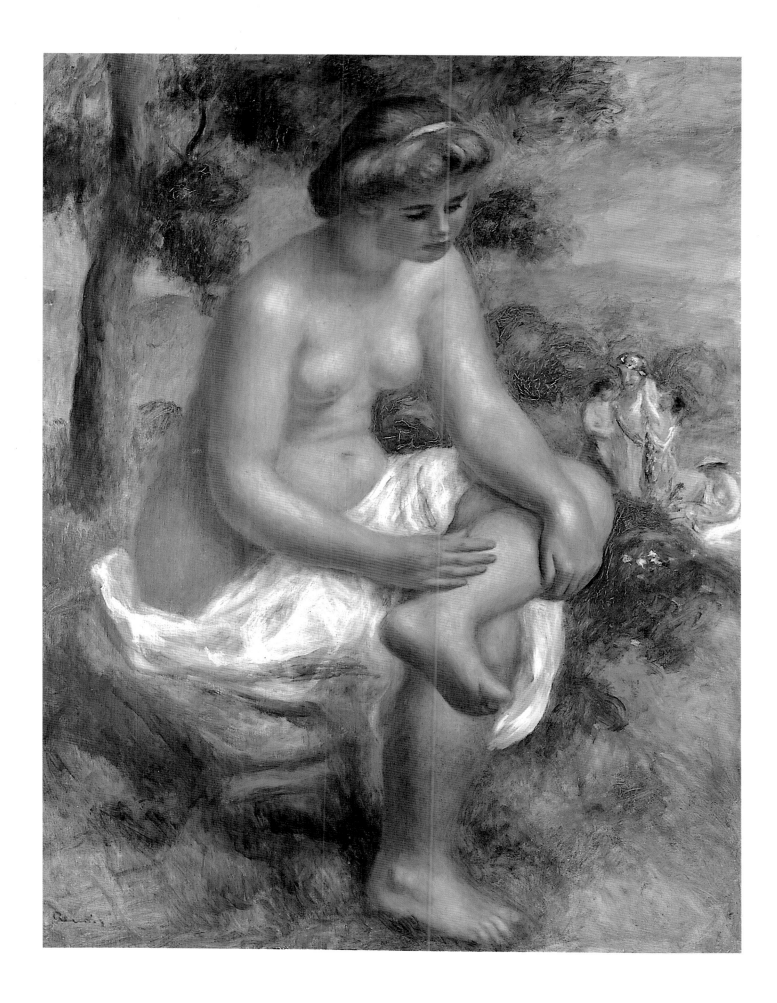

Provenance
Ambroise Vollard, Paris; Paul Rosenberg, Paris; Pablo Picasso, Paris.

References
J. Vernoy, "La Triennale, exposition d'art français," in *Les Arts*, April 1916, p. 154, ill.; Daulte 1971, No. 392, ill.; S. Mayer, *Ancient Mediterranean Sources in the Works of Picasso, 1892–1937*, New York 1980; *Picasso Museum Paris. Bestandskatalog*, Munich 1985, No. T 62, ill.; Monneret 1990, p. 133, ill. (reversed).

Exhibitions
La Triennale, Galerie Nationale du Jeu de Paume, Paris, 1916, No. 151; Paris 1917, No. 65; *Donation Picasso. La collection personelle de Picasso*, Musée du Louvre, Paris, 1978, No. 28, ill.; *On Classic Ground, Picasso, Léger, de Chirico and the New Classicism 1910–1930*, Tate Gallery, London, 1990, No. 147, ill.

86 Three Bathers with a Crab ca. 1897
Trois baigneuses au crabe

Oil on canvas
45 x 65 cm
Signed, lower right:
Renoir.
Cleveland Museum of Art
(Purchase from the
J. H. Wade Fund),
Cleveland, Ohio

In Renoir's œuvre, such animated scenes appear only in the few compositions featuring female bathers (ill. p. 46). The mood of cheerful play in an outdoor setting recalls works by French baroque and rococo masters such as Girardon (ill. p. 46), Boucher or Fragonard. While those artists chose goddesses or nymphs for such lively occasions, Renoir contented himself with an ordinary event. His "three graces" amuse themselves in a well-conceived figural composition arranged along two axes against the background of a coastal landscape in the south of France. Their spirited play is anything but divine. Instead of exhibiting herself to the painter "Paris" in all her beauty, the nude in the center thrusts a crab with both hands into the face of her reclining companion, who is startled and attempts to fend off the attack, while the third figure in the group and the two figures in the background look on in astonishment.[1] The liveliness of the action is matched by the intense colors of the discarded articles of clothing, in which the full white, blue and red tones respond to the rhythms of the moving bodies.

Renoir regarded most of the young women he selected as models—street girls, maids or governesses—primarily in terms of the beauty of their displayed bodies. His aim was to convey their sensual appeal in painting. He was less interested in individual facial features than in a quality of naturalness that only color could express, a quality he found

1 See the similar compositions cited in Vollard 1918, I, II, Nos. 73, 85, (1065) and Meier-Graefe 1911, p. 167, ill.

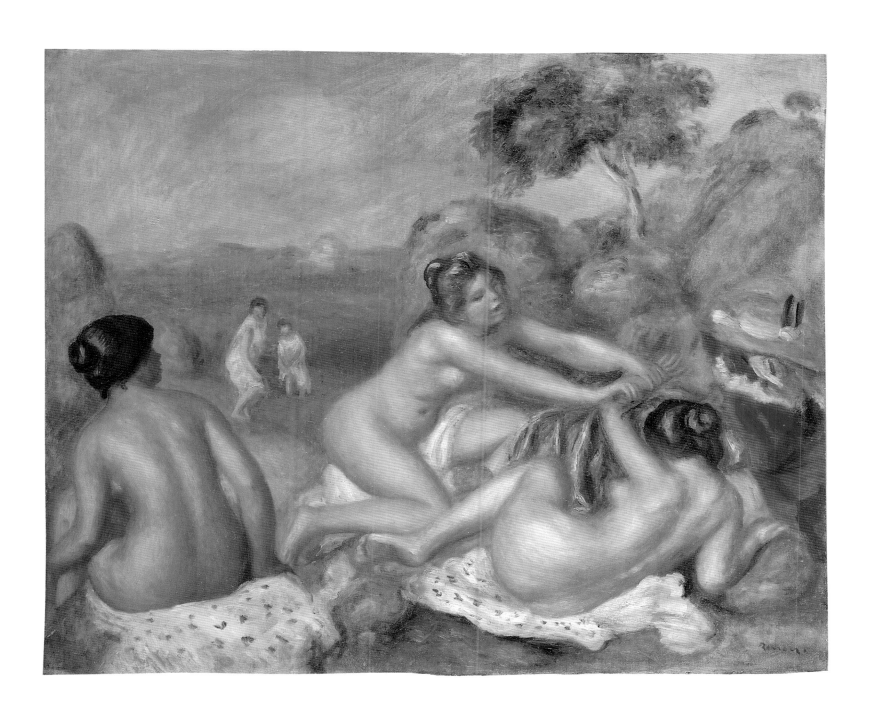

not only in a pretty face but in the rounded curves of shoulders and arms, in firm breasts or broad hips. Above all, he sought models with skin that took in the light: "I had a few that were really quite beautifully built and posed like angels. I must say that I do not ask for a great deal. I can manage with the next best behind . . . provided it has a skin that doesn't throw the light back at me."[2]

2 Vollard 1961, pp. 8f.

Provenance
Ambroise Vollard, Paris; Ralph M. Coe, Cleveland.

References
Meier-Graefe 1929, p. 264, Ill. 255; Rouart 1954, p. 88, ill.; Pach 1958, pp. 102f., ill.; Fezzi 1972, p. 120, No. 690, ill.; Daulte 1973, p. 81, ill.; Wheldon 1975, p. 108, Ill. 84; Gauthier 1977, cover ill.; Rouart 1985, p. 100, ill.; Monneret 1990, p. 155, No. 5., ill.

87 Woman Sleeping ca. 1900
Dormeuse

Oil on canvas
67 × 55 cm
Signed, upper right:
Renoir.
Private collection

The robust sensuality of the female nude became a dominant theme in Renoir's late work. In the truest sense of the word, he glorified the female body as "God's most beautiful creation."[1] The elderly painter saw the most fundamental expression of nature in the full roundness of the feminine forms evident in this sleeping nude figure, from the weary, inclined head to the curve of the neck and shoulders to the arm resting on her broad hip.

The generous bulges around the midriff culminate in the breasts and are echoed in the folds of the bath towel. The soft contours and unconstrained sweeping curves encounter no resistance. The body, surrendered to sleep, is at rest within itself.

1 Renoir 1981, p. 354.

Provenance
Ambroise Vollard, Paris; Dr. Arthur Hahnloser and Hedy Hahnloser-Bühler, Winterthur.

References
Vollard 1918, I. p. 25, No. 98, ill.; Meier-Graefe 1929, p. 263, Ill. 262.

Exhibitions
Ausstellung Französischer Malerei, Kunstverein, Winterthur, 1916, No. 27; Luxembourg 1995, No. 147, ill.

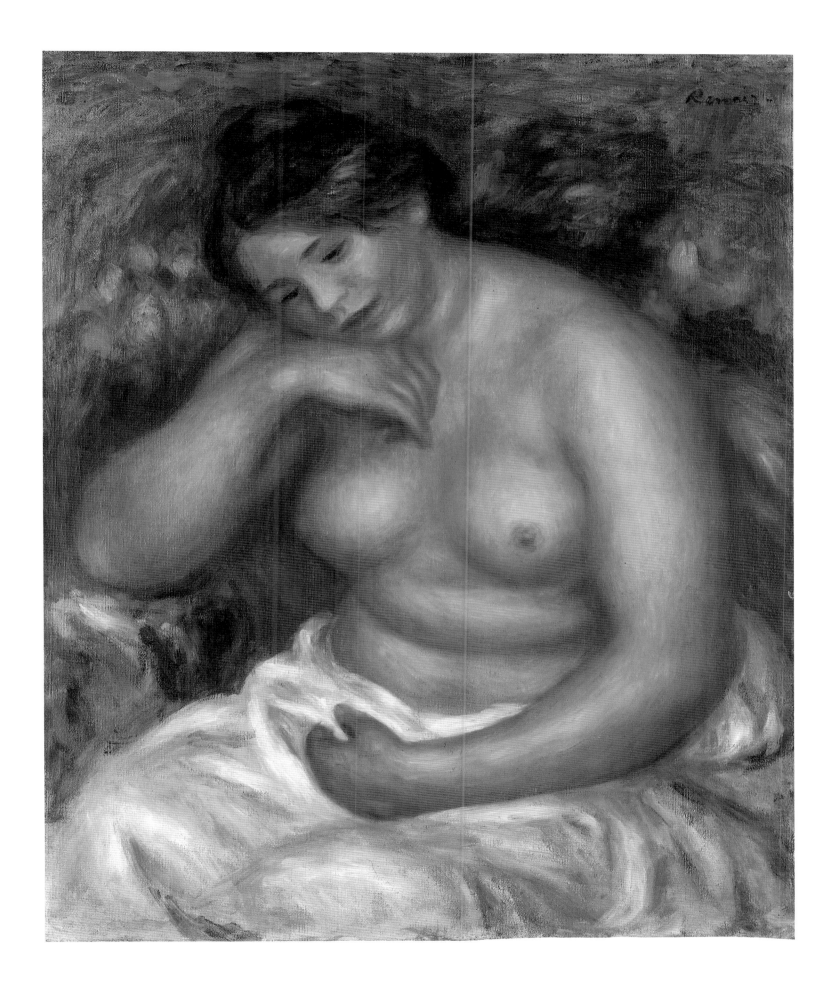

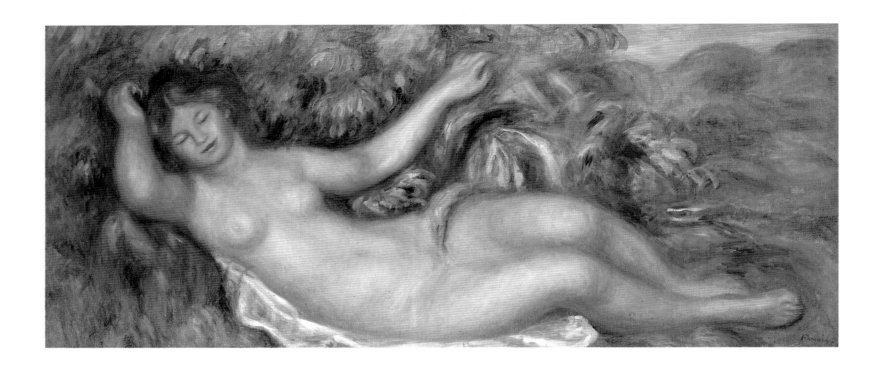

88 The Spring. Reclining Nude 1902–1903
La source. Nu allongé

Oil on canvas
67.3 × 154 cm
Signed, lower right:
Renoir.
Private collection,
courtesy of
Galerie Beyeler, Basle

1 Ehrlich White 1984, p. 196.

2 Renoir 1981, p. 58.

3 See Daulte 1971, No. 555; a
version painted around 1910 is in
the possession of the Barnes
Foundation in Merion. Confined
by his severe illness to his chair

In a letter to Paul Bérard written in Beaulieu-sur-Mer on April 27, 1893, Renoir mentioned that he was working on "several fabulous Jean Goujons."[1] This ironic reference presumably alludes to an elongated horizontal painting of a water nymph framed by illusionist scenery (ill. p. 273), a work intended as a wall decoration for the house of Paul Gallimard, director of the Théâtre des Variétés. Apparently, the painter had been inspired by the five reliefs with nymphs by Jean Goujon on the *Fontaine des Innocents* (ill. p. 273), erected by Pierre Lescot between 1547 and 1549. He had been familiar with them since his youth.[2]

Many years later, for whatever reason, Renoir painted variations of a similar size on the figure of the nude naiad lying on a cloth at a mountain spring.[3] The reclining female nude, a motif that had experienced countless formal and substantive interpretations at the hands of artists such as Giorgione, Titian, Rubens, the French painters of the 18th century, Goya and Manet, becomes a rounded body whose wave-like configuration pays eloquent tribute to the allegory of the spring. Both the figure and the references to nature bubbling up out of the

color are rendered in a smoothly flowing style. Strokes of thin, liquid color trace the long, softly modeled limbs. There is no sign of sharpness anywhere. Slumbering in a contented reverie and embedded in a timeless Arcadian setting, the nymph allows the waters of the spring to take their course. She has given herself over to the painter's brush, to be imbued with the primal forces of nature by means of color alone.

According to Matisse, who visited Renoir quite often from December 1917 to May 1918, the painter preferred "slightly diluted paints and glaze paints . . . he painted with liquid: oil and turpentine (2/3 poppy oil and 1/3 turpentine, I assume), quite fresh and not syrupy, oxidized in the air, otherwise it would never dry. I saw a female figure representing a spring at Renoir's place in Cagnes; it was 20 years old and still not dry."[4]

for ever longer periods of time, the painter found it increasingly difficult to raise his right arm and had less trouble painting such unusual horizontal formats on a lowered easel.

4 Matisse 1982, p. 133.

Provenance
Paul Rosenberg, Paris and New York; The Museum of Modern Art, New York; Thomas Amann, Zurich.

References
Vollard 1918, I. p. 46, No. 183, ill.; Vollard 1924, ill. pp. 224–225; Meier-Graefe 1929, p. 259, Ill. 244; Pach 1951, pp. 96f., ill.; *The Museum of Modern Art Bulletin*, 24, 4, 1957, p. 3., ill.; Pach 1958, pp. 106f., ill.; Alfred H. Barr, *Painting and Sculpture in the Museum of Modern Art*, New York 1967, p. 16, ill.; Tokyo–Kyoto 1979, ill.; Alicia Legg, *Painting and Sculpture in the Museum of Modern Art. Catalogue of the Collection*, New York 1988, p. 122.

Exhibitions
New York 1954, No. 2, ill.; Chicago 1973, No. 72, ill.; *L'éternel féminin*, Galerie Beyeler, Basle, 1990, No. 61, ill.

Jean Goujon, *Nymphs, Fontaine des Innocents*, 1547–1549, stone relief, Musée du Louvre, Paris

Renoir, *The Spring*, 1895–1897, The Barnes Foundation, Merion

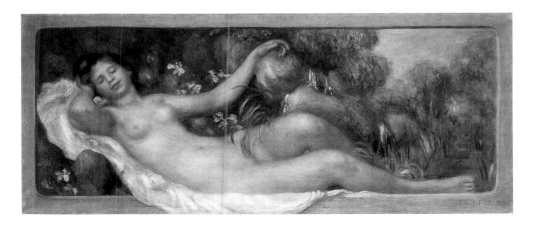

89 Still Life with Anemones ca. 1900
Nature morte aux anémones

Oil on canvas
55 x 47 cm
Signed at right above
table: Renoir.
Private collection,
courtesy of
Galerie Nathan, Zurich

1 "My brain is at rest when I
paint flowers. I don't expend as
much mental effort on them as
when I am standing before a
model. When I paint flowers I set
tones, experiment boldly with
values without worrying whether
I might ruin a canvas. I would
never dare do such a thing with a
figure, for fear of spoiling every-
thing. And the experience I gain
from these experiments I can
apply later to my figures" (Rivière
1921, p. 81).

2 Matisse 1982, p. 199.

Renoir loved the different shades of red in anemones. In his later years, he used them frequently as props in his paintings (cat. no. 91), for they also helped him find the right skin tones for his nudes.[1] Ordinarily, he needed only a few olive-greens as complementary contrasts to bring to life the delicate pink, carmine red, purple and dark Bordeaux-red of the blossoms. Even as a still life, a composition such as this one expresses the natural vitality of Renoir's work, a quality that never ceased to fascinate artists like Matisse.

With regard to his own still life compositions, Matisse recalled a piece of advice Renoir had once given him: "Walking through the garden, I pick flower after flower and gather them one after another as they come in my arm. Then I go into the house with the intention of painting them. I arrange them according to my fancy—and what a disappointment: they have lost all of their magic in the arrangement. But what has happened? The unconscious arrangement made as I pick them, based upon the impulse of taste that leads me from one flower to the next, has been replaced by a willed arrangement. This is influenced by memories of bouquets that have long since wilted but whose charm has stayed in my memory and guides me in putting together the new bouquet. Renoir said to me, "When I have arranged a bouquet in order to paint it, I look at it from every angle and remain standing at the side I hadn't thought of."[2]

Provenance
Karl Sachs, Breslau; Dr. Fritz Nathan, St. Gallen; Private collection, Zurich.

References
Karl Scheffler, Breslauer Kunstleben, in *Kunst und Künstler*, XXI, 1923, pp. 131, 136, ill.

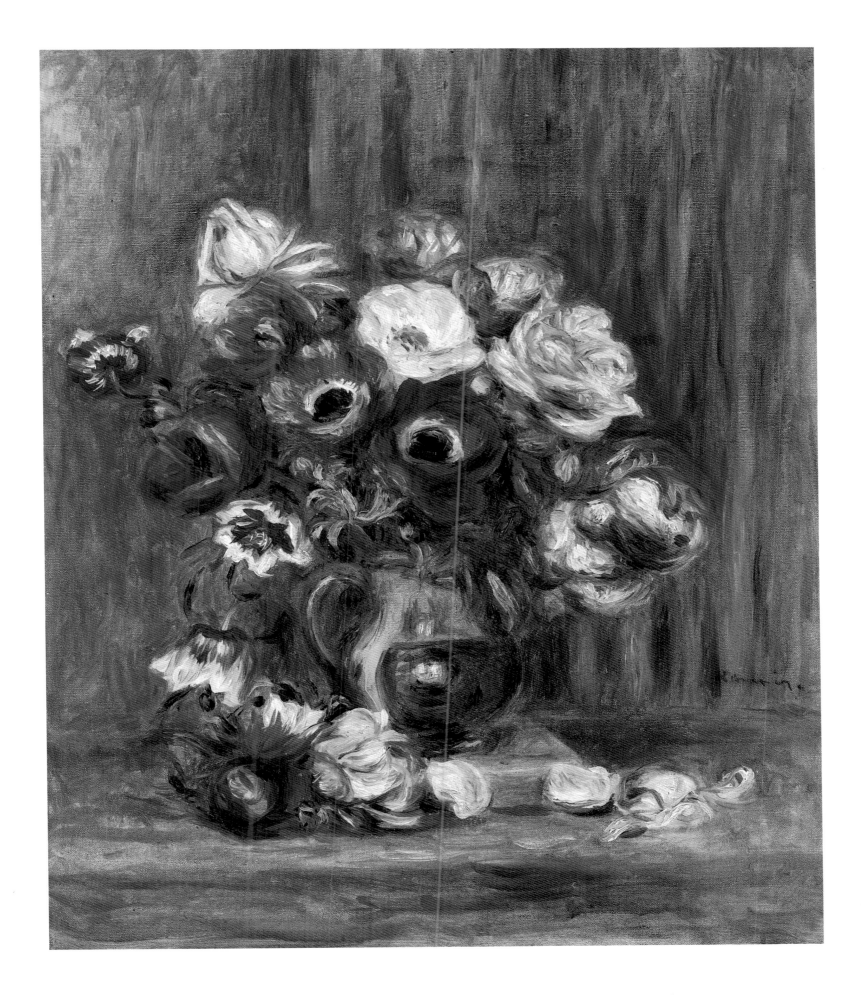

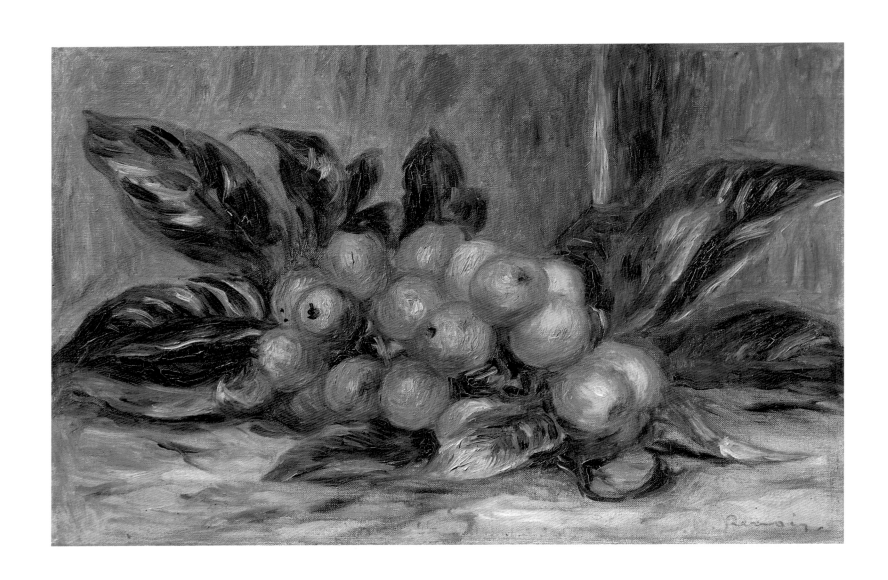

90 Medlar Branch ca. 1900
Nèfle

Renoir ordinarily arranged the objects for his still lifes on a table covered with a light-colored cloth, thus dividing the pictorial space into two distinct halves (cat. nos. 60, 61, 89, 91). As in this piece, the older painter loved to play off reds, olive-greens and orange-yellows against each other in spontaneous strokes of the brush. The simple context of the table and the wall provides the framework in which the firm, finely modeled fruits are displayed.

As still lifes had become a coveted commodity by the 1890s, Durand-Ruel was compelled to accept even less elaborately executed studies in order to keep up with demand. "If I had not been forced to sell paintings in order to make a living, I could easily have spent my entire life without painting things like this; but my old friend Durand-Ruel was watchful and always reminded me that he was waiting for my pictures."[1]

Oil on canvas
29 x 43 cm
Signed, lower right:
Renoir.
Private collection,
courtesy of
Galerie Nathan, Zurich

1 André 1919, pp. 49f.

Provenance
Adele Wolde, St. Magnus.

References
Coquiot 1925, ill. pp. 232–233; Meier-Graefe 1929, p. 307, Ill. 336; Florisoone 1937, p. 154, ill.

Renoir in Cagnes, 1905

91 Anemones 1905
Anémones

Oil on canvas
32.5 x 23 cm
Signed, lower right:
Renoir.
Private collection, London,
courtesy of Salis & Vertes,
Munich-Salzburg

This small flower piece was chosen by Georges Rivière, the artist's long-time friend (cat. nos. 28, 46), as the frontispiece for his 1921 biography of Renoir. The painterly brilliance of the work was justification in itself for this honor. As so often in Renoir's floral still lifes, the olive-green background was only hastily applied to the light ground of the canvas in a thin layer of pigment, causing the magnificent blossoms to stand out all the more prominently against it. The flowers and the vase evince the full range of colors most frequently used by the artist during the last two decades of his creative life. Aside from the dominant reds, including carmine, Venetian, French cinnabar and madder, Renoir's palette during these years was comprised of Naples yellow, ochre and raw umber, emerald green, cobalt blue, white and ebony black.

Provenance
Ambroise Vollard, Paris.

References
Rivière 1921, ill. frontispiece.

Portrait of a Young Woman in White 1901
Portrait d'une jeune femme en blanc

According to François Daulte, this painting is a portrait of a relative of the poet Paul Alexis.[1] In September of 1890, Renoir had moved with his family into the so-called "Castle of Fog," one of several buildings comprising an 18th-century estate at Rue Girardon 13 in Montmartre. At this address, he was not far from the home of the poet Alexis, a friend of Zola and Cézanne from their youth.

In keeping with contemporary taste, the work represents a society portrait in the best sense of the term. It features an attractive young woman, seated facing the viewer. Her arm is supported on a table in front of a sheer curtain rendered in transparent blues and yellows, which overlaps a bordered drape on the right. The white of the dress, adorned with rose-colored ribbons, stands in stark contrast to the even facial features and the smoothly painted background, whose shadowed surfaces brilliantly recapitulate all the colors of the painting. The sense of lightness and transparency in the fabrics is achieved through a loose combination of impasto strokes applied with relatively dry paint and areas of thin, liquid color.

The painting was shown under the title *A Young Lady,* 1901, at an Impressionist exhibition at the Grafton Galleries in London in early 1905. With a total of 315 works of art, including 59 by Renoir alone, this was the most extensive exhibition of its kind ever shown. Paul Durand-Ruel, who organized the show, selected this portrait for exhibition after having purchased it from Renoir for 1,000 francs on October 26, 1901.[2]

Oil on canvas
65 × 54 cm
Signed, upper right:
Renoir.
Private collection,
Switzerland

1 Letter to the owner dated February 14, 1991.

2 Ibid.

Provenance
Durand-Ruel, Paris; Bernheim-Jeune, Paris; Justin K. Thannhauser, Lucerne; Bernhard Mayer, Zurich; Ernst Mayer, New York; stored at the Kunsthaus Zurich since 1962.

References
Meier-Graefe 1929, p. 319, Ill. 282.

Exhibitions
London 1905, No. 264; Tokyo–Kyoto–Kasama 1993, No. 25, ill.; London 1995, No. 61, ill.

93 Portrait of Claude Renoir.
Coco with a Flounced Bonnet 1902
Portrait de Claude Renoir. Coco à la Charlotte

Oil on canvas
41.2 x 32.3 cm
Signature stamp,
upper right: Renoir.
Private collection,
Switzerland

After the birth of his first son in 1885, Renoir increasingly recruited his models from his own household—his wife Aline, their sons Pierre, Jean and Claude and various domestic servants (cat. nos. 76–78, 94–97). Renoir was 60 and his wife 42 when their third son Claude, known as Coco, was born in Essoyes on August 4, 1901. The painter's relatively advanced age and his poor health may explain why he followed the development of his youngest son with such intensity and devotion. On the verge of old age, he embraced this opportunity to use the viewpoint of a child to rediscover the powers of life he saw waning in himself.

In keeping with the tastes of the time, the one-year-old Coco was dressed in a white frilled gown and a flounced, ribboned bonnet and positioned in front of a neutral, dark-green background for this portrait by his father. Since Bronzino's courtly likeness of Giovanni de Medici (ca. 1546, Uffizi, Florence), few painters besides Renoir had mastered the difficult task of portraying children in an appropriate—i.e. child-oriented—way. Renoir's own interpretations of the theme treat the child and its inner world with great caution, loving interest and a natural humanity that avoids all traces of coquettishness, affectation, or mawkish sweetness. With respect to children in particular, Renoir was a highly objective observer.

Provenance
Renoir family, Cagnes and Paris; Jakob Goldschmidt, New York; Wildenstein, New York.

References
André 1931, I, No. 270, Ill. 84.

Exhibitions
New York 1969, No. 86, ill.

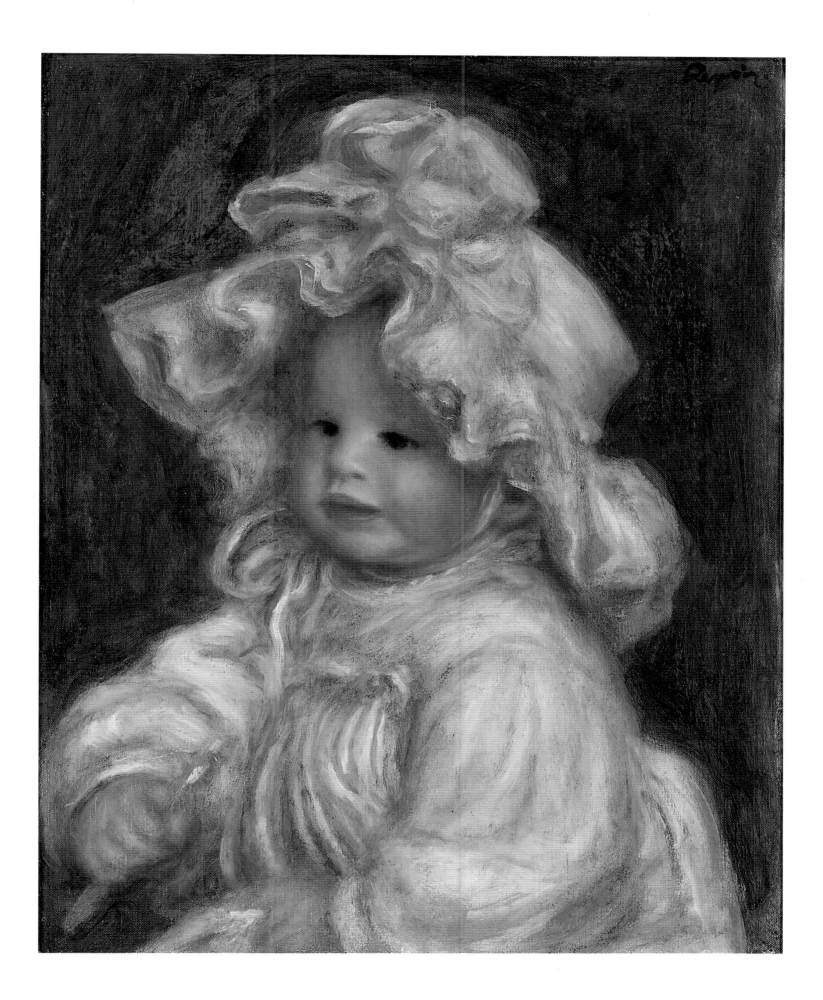

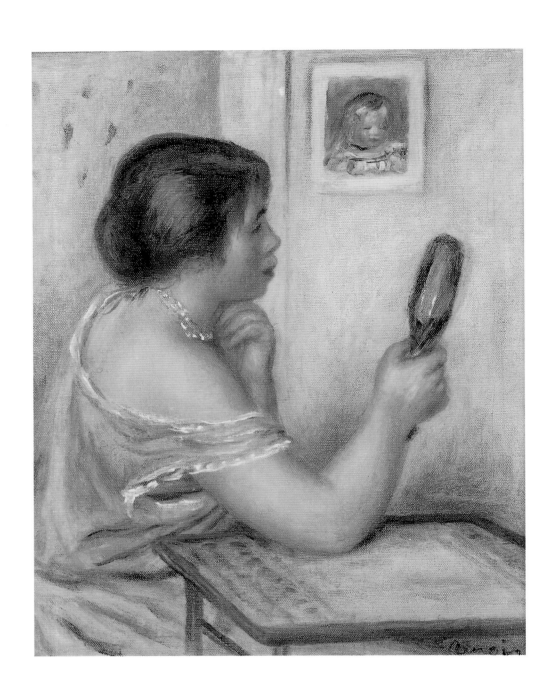

94 Marie Dupuis with a Mirror before a Portrait of Coco 1903–1905
Marie Dupuis tenant un miroir avec un portrait de Coco

The woman seated at a small table, wearing a necklace and gazing into a hand mirror, has generally been identified as Gabrielle, a governess and model in Renoir's home for many years (cat. nos. 95, 96).[1] Although the lack of similarity to existing portraits of her gives reason to doubt whether it is indeed Gabrielle who is shown here, the appealing scene can be dated with a certain degree of precision. The painting on the wall, a portrait of Renoir's youngest son Claude (born August 4, 1901; cat. nos. 93, 97) at around the age of two, clearly points to an origin after 1902.

A description by Jean Renoir suggests that Marie Dupuis, a woman referred to as the "baker lady," might have posed for this painting. "After Gabrielle, she was probably the model Renoir painted most often She was of medium height, had light, almost white skin with a few freckles, a stubby nose and a sensual mouth, small feet, small hands and a soft, well-padded, round body without angles Her full, mahogany-colored hair was always in disarray. She was one of those people who was constantly brushing back a stray lock and sticking combs in her hair. Her real name was Marie Dupuis. She came to our home a little later than Gabrielle. Renoir had met her on the Boulevard de Clichy in 1899."[2]

Oil on canvas
38 × 30 cm
Signed, lower right:
Renoir
Prof. Dr. h. c. Hermann
Schnabel, Hamburg

1 Cf. the painting entitled *La Toilette*, Musée d'Orsay, Paris.

2 Renoir 1981, p. 333.

Renoir, *Claude Renoir*, 1903–1904, Museu de Arte de São Paulo Assis Chateaubriand

Provenance
Mme Schwabb d'Hericourt, Paris; Alex Maguy, Paris; François L. Schwarz, New York; Meta C. Schwarz, Paris and New York; Auction, Sotheby's, London, March 29, 1988, No. 9.

References
François Daulte–J. Focarino, *Privately Owned Paintings and Drawings from the Collection of François L. Schwarz*, New York 1974, pp. 56f., ill.; Auction catalogue, *Impressionist and Modern Paintings and Sculpture*, Sotheby's, London, March 29, 1988, No. 9, ill.

Exhibitions
Tokyo–Kyoto 1979, No. 69, ill.

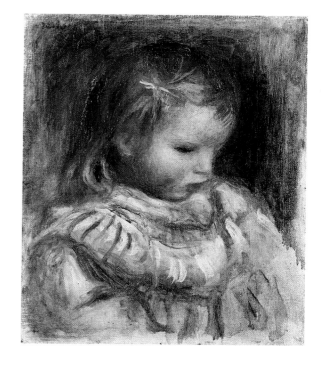

95 Gabrielle Reading 1906
Gabrielle lisant

Oil on canvas
55 × 46.5 cm
Signed, upper right:
Renoir.
Staatliche Kunsthalle
(Inv. no. 2550), Karlsruhe

1 Renoir 1981, pp. 258ff.

In the summer of 1894, Gabrielle Renard (1879–1959) came from Essoyes to Paris during Aline Renoir's second pregnancy to serve the family as a nanny.[1] Although she was originally engaged as temporary help, she stayed with the Renoirs until her marriage to the American painter Conrad Slade in 1914. A distant cousin of Madame Renoir, she spent 20 years as a member of the immediate family and became a kind of elder sister to Jean and later Claude. Renoir immortalized the dark-haired country beauty in numerous paintings (cat. no. 96).

Of the many compositions for which Gabrielle posed, this is one of the most serene. The rosy complexion of the girl, shown reading a book with a blue binding, mediates between the white of the sleeveless blouse, the dark hair and the red hues of the background. The fresh coloration, enhanced with intense purple and brick-red, is applied thinly, allowing the surface of the canvas to appear in many places. A vivid, shimmering blue provides accents in the pattern of the cushion and in the blouse.

Renoir's love of blue, white and red is no coincidence. It stands for an art that could have originated only in a land where the color harmonies of the *tricolore* had become a national symbol.

Provenance
Durand-Ruel, Paris; private collection, U.S.A.; private collection, Switzerland; acquired in 1966.

References
Jan Lauts and Werner Zimmermann, *Staatliche Kunsthalle Karlsruhe. Katalog Neuere Meister 19. und 20. Jahrhundert* (2 vols.), Karlsruhe 1971–1972, pp. 195, 336, ill.; Keller 1987, p. 145, ill.

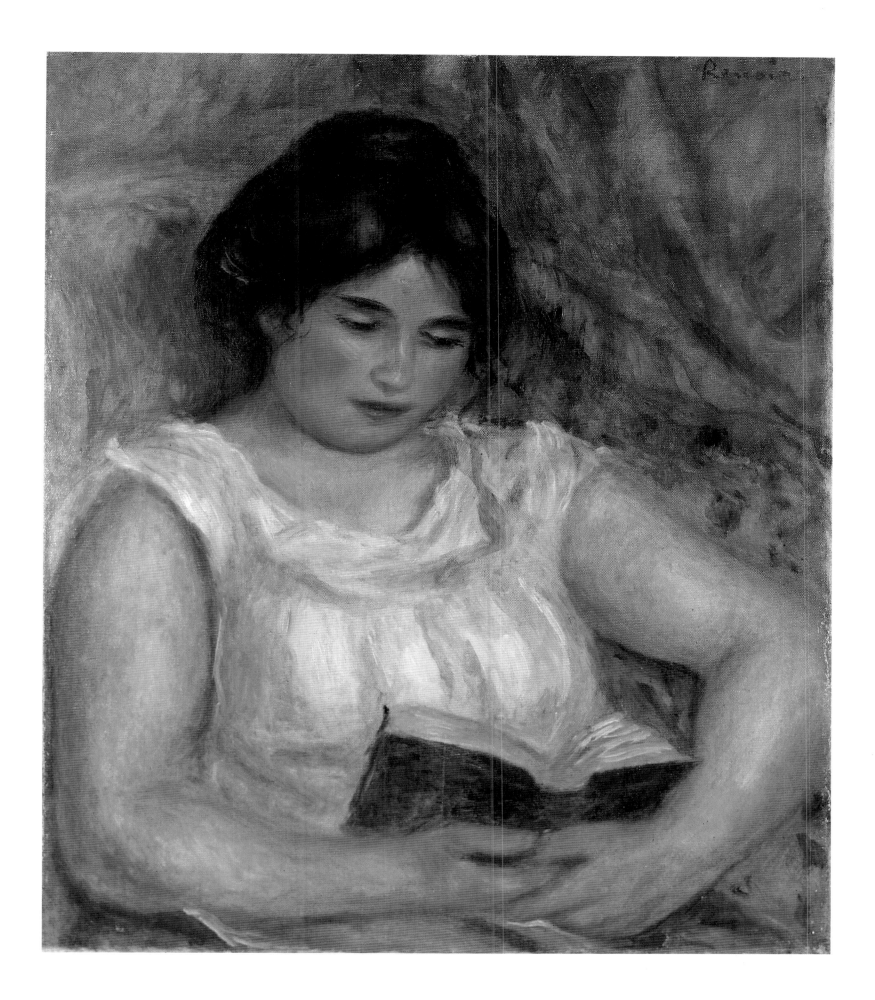

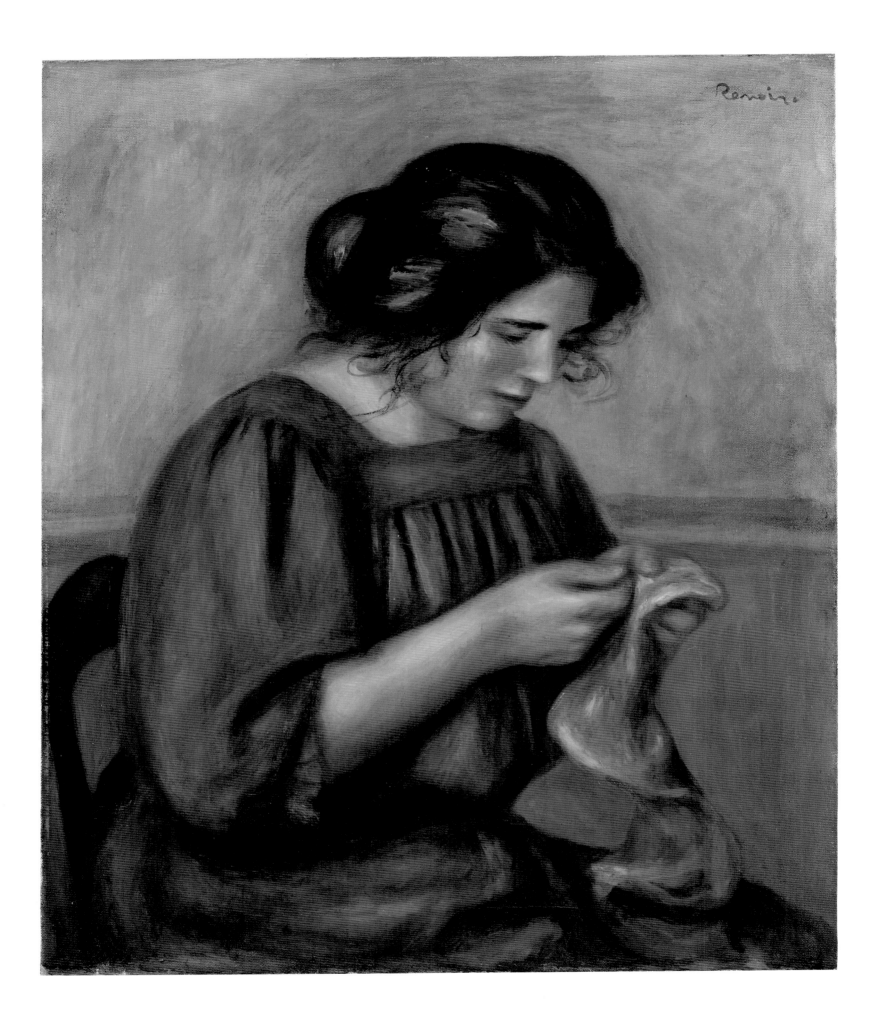

96 Gabrielle Sewing 1908
Gabrielle reprisant

The portrait of Gabrielle sewing was painted in Cagnes in 1908 (cat. no. 95). The red dress worn by the young woman in many of her portraits provided an ideal vehicle for the aging painter's preference for strong red tones, expressing a feeling of warmth and security. She served the Renoirs for 20 years as nanny, housekeeper and nurse for the ailing artist, but also played an important role in his life as his favorite model. The most beautiful portraits Renoir painted of her are the simplest. They achieve a totally natural effect without poses of any kind, quite in keeping the naturally amiable character of Gabrielle Renard, who emigrated to the United States as Mrs. Conrad Hensler Slade in 1914. Jean Renoir, who was working in Hollywood at the time, visited her shortly before her death in 1959 to exchange youthful memories of their days together.

Oil on canvas
64 × 53.5 cm
Signed, upper right:
Renoir.
Private collection,
Switzerland

Provenance
Maurice Gangnat, Paris; Auction Gangnat, Hôtel Drouot, Paris, June 24–25, 1925, No. 134; M. Desportes, Paris; Bernheim-Jeune, Paris; Henri Canonne, Paris; Jacques Canonne, Geneva.

References
Arsène Alexandre, *La collection Canonne*, Paris 1930, pp. 60f., ill.; Léon Werth, "La Collection Gangnat," in *L'amour de l'art*, III, 1925, p. 53.

97 Portrait of Claude Renoir Painting. Claude at his Easel 1907
Portrait de Claude Renoir peignant. Claude au chevalet

Oil on canvas
55 × 46 cm
Signature stamp,
lower right: Renoir.
Prof. Dr. h. c. Hermann
Schnabel, Hamburg

This profile portrait shows the Renoirs' youngest son seated at an easel, painting. Here, Claude Renoir mimics his father's métier in a highly professional manner. Undisturbed by the presence of the watchful artist, he devotes his full attention to his own artistic product, a work he is shown painting on a white canvas ground with a steady hand.[1] Appropriately attired in a painter's smock with a dirty-white brush cloth protruding from his pocket, he has apparently chosen the vase of flowers on the patterned tablecloth in the right background as his motif. Renoir's own preference for red as the dominant color in his palette was well suited to the red-cheeked charm of this child's portrait. Even the boy's blonde hair is streaked with reddish shadows, while the bluish-gray of the smock alternates with violet tones. In his role as a painter, the boy—who would later become a gifted ceramic artist—found himself in the best of company, for the only other figures ever portrayed by Renoir in the act of painting were his friends Bazille and Monet.[2]

Renoir painted numerous pictures documenting Claude's development. They show him with his nanny, at play or, as in this portrait, engaged in activities that require his full concentration. His older brother Jean Renoir, once the owner of this portrait of Claude, wrote in his reminiscences of his father: "During our years in the Rue Caulaincourt [in October 1901, Renoir rented an apartment at Rue Caulaincourt 43 and a studio nearby at No. 73, which he maintained until 1911], it was I who modeled for him most often. I was later replaced by my brother Claude, who was seven years younger than I. Coco was undoubtedly one of Renoir's most fruitful models."[3]

Claude himself commented: "My father allowed me a great deal of freedom. He did not want a model frozen in some pose, and so I could cavort about as I wished. Only occasionally did I have to stand still for a few moments. Actually, he used me as a model primarily when the weather was bad. Most of the time my father had a model available for his studio work, unless he was working on a landscape. I was more in demand for small sketches and studies or for paintings whose themes had not already been worked out."[4]

1 See the drawing entitled *Le petit peintre* cited in Vollard 1918, I, p. 68, No. 269 and Renoir's portraits of Claude's older brothers, *Pierre Renoir dessinant* (Daulte 1971, No. 552) and *Jean Renoir dessinant* (Virginia Museum, Richmond).

2 Daulte 1971, Nos. 28, 131, 132.

3 Renoir 1981, p. 351.

4 Robida 1959, p. 44.

Provenance
Jean Renoir, Paris; Etienne Vautheret, Lyon; Auction Vautheret, Hôtel Drouot, Paris, June 16, 1933, No. 18; Durand-Ruel, Paris and New York; Charles Corliss, New York; Ann Parrish Titzell, Georgetown; Josiah Titzell, Georgetown; Dr. Harold Wolff, New York; Isabel Bishop Wolff, New York; Auction, Sotheby's, New York, May 10, 1988, No. 17.

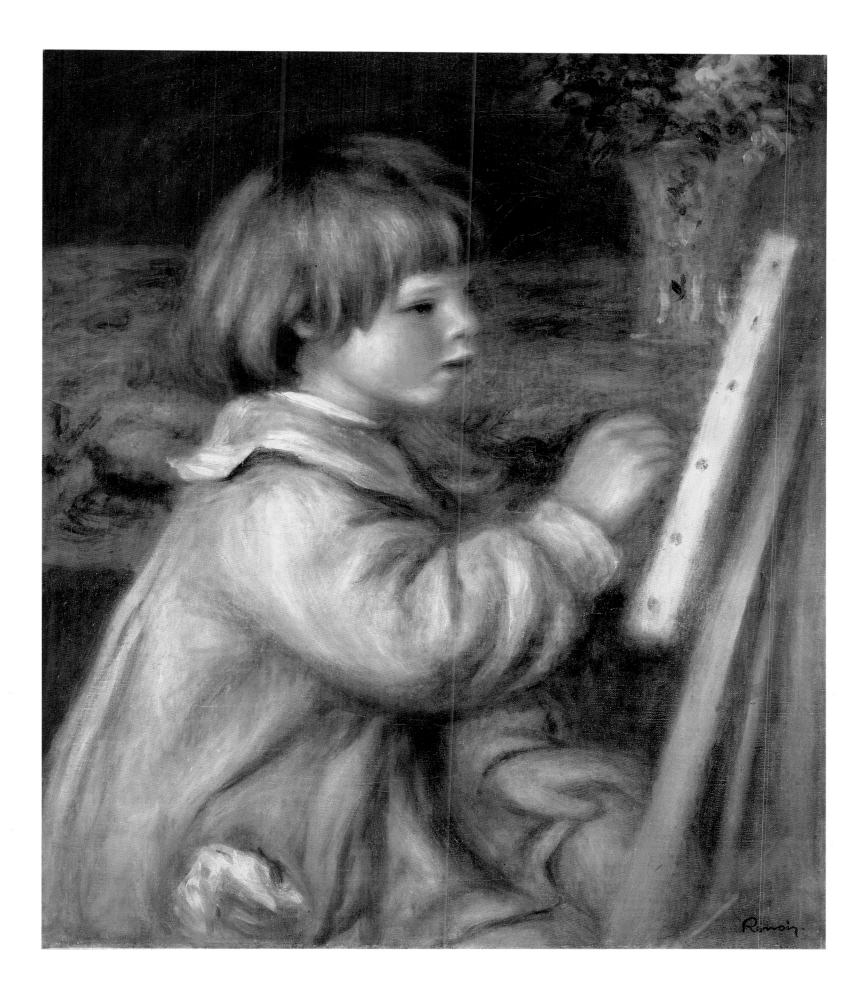

References

Mirbeau 1913, ill. at p. 56; Vollard 1918, I, p. 146, No. 580, ill.; Rivière 1921, p. 240, ill.; Vollard 1924, ill. pp. 210–211; Coquiot 1925, p. 233; Meier-Graefe 1929, p. 282, Ill. 332; André 1931, I, No. 332, ill.; Renoir 1981, Ill. 25; Rouart 1985, p. 92, ill.; Auction catalogue, *Impressionist and Modern Paintings and Sculpture (Part I)*, Sotheby's, New York, May 10, 1988, No. 17, ill.; Fell 1992, p. 80, ill.

Exhibitions

Exposition d'art moderne, Manzi-Joyant, Paris, 1915, No. 135; Berlin 1927, No. 22; *Renoir*, Durand-Ruel, New York, 1935, No. 15; New York 1937, No 58, ill.; New York 1939, No. 18; *Twentieth Century Portraits*, Museum of Modern Art, New York, 1942–1943, p. 38, ill.; *The Artist's Family*, Museum of Modern Art, New York, 1952.

98 View of Cagnes 1903–1905
Vue de Cagnes

Oil on canvas
36.7 x 49.3 cm
Signed, lower left:
Renoir
Saarland-Museum
(Inv. no. N I 1239),
Saarbrücken, Stiftung
Saarländischer
Kulturbesitz

1 Meier-Graefe 1929, p. 294, Ill. 264.

Renoir's late landscapes are relatively small in size and sketched with brushstrokes full of intense color (cat. nos. 99, 100). With this Mediterranean view of the countryside around Cagnes, the painter came very close to his professed model Corot, to whom he had paid tribute in a free copy done in 1898.[1] A few farms of the kind that gave Corot's compositions their solid structure, along with a fresh green mixed with traces of red and yellow for the trees and meadow, suffice to lend sublime form to an objectively observed scene. From the blue of the southern sky, which only Renoir ever saw in this way, the light is refracted onto the walls of gardens and houses, only to disappear among the shimmering, purple-gray mountains. The strong spatial quality of this painting enhances the impression of detached observation.

Located in the hinterland near Nice, Cagnes was the last station in Renoir's life. Having spent several weeks there in the spring of 1898 and 1899, he rented rooms at the Maison de la poste in the middle of the village in March 1903, before finally purchasing the manor Les Collettes in 1907.

Provenance

20. Auction, Stuttgarter Kunstkabinett, Stuttgart, 1954, No. 1874; acquired in 1955.

References

Moderne Galerie Saarbrücken (collection catalogue), Saarland-Museum, Saarbrücken 1968, p. 14, ill.; Fell 1992, p. 15, ill.

Exhibitions

Peintures, dessins, gravures du Musée de Sarrebruck, Luxembourg, 1956, No. 14; *Von Courbet bis Miró*, Augustinermuseum, Freiburg, 1959, No. 35; *Saarland-Museum, Meisterwerke in der Kunsthalle*, Bremen, 1963, No. 139.

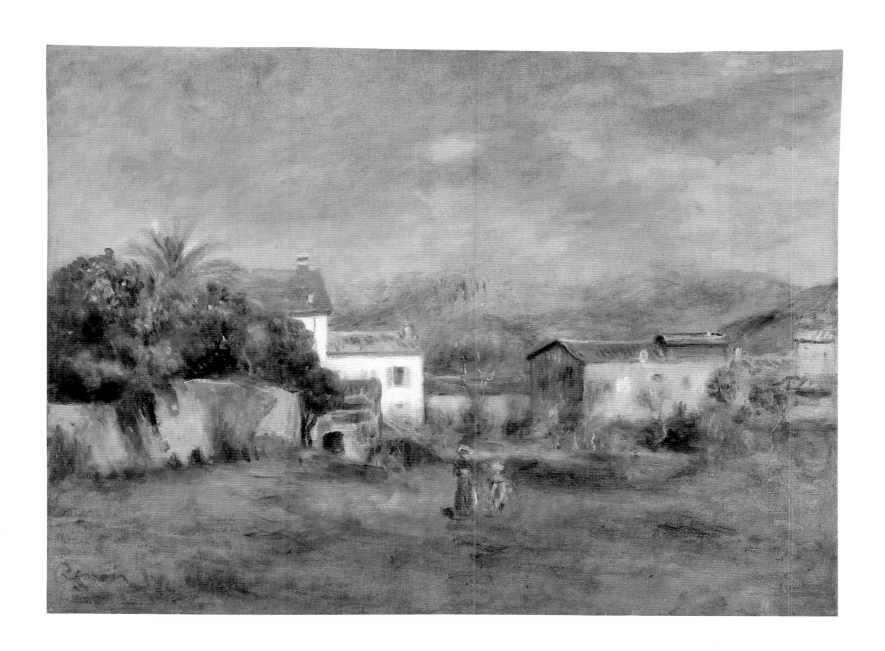

99 Landscape near Cagnes 1909–1910
Paysage autour de Cagnes

Oil on canvas
44 × 51 cm
Signed, lower right:
Renoir.
Kunsthalle
(Inv. no. 106-1927/1),
Bremen

1 André 1919, p. 29.

2 Renoir 1981, p. 392.

This landscape from the region around Cagnes in southern France (cat. nos. 98, 100), where the painter spent the last years of his life at his country manor Les Collettes, is dominated by the branches of two olive trees. The aging Renoir himself spoke of the light on the olive trees "that shines like a diamond. It is rose-colored; it is blue . . . and the sky that shines through . . . looks very much like Watteau's backgrounds."[1] His son Jean described the olive trees of Les Collettes as the most beautiful in the world: "In the course of their 500-year lives, winds and drought, storms, frost, cropping and neglect have given them the strangest shapes. Some trunks resemble barbaric divinities. Their branches bow, twisting together to form motifs that even the boldest artist would never have dared to conceive. Unlike the olive trees in the region around Aix, which are small and cropped to make harvesting easier, these have grown freely and rise proudly towards the heavens. The very tall trees have an unusual majesty and an airy weightlessness. Their silver foliage casts delicate shadows. There are no sharp contrasts between the shadows and the light. We have Francis I to thank for these trees. He had them planted in order to occupy his soldiers during a lull in the fighting against Emperor Charles V."[2]

Provenance
Donated by the Galerieverein in 1927.

References
Gerhard Gerkens and Ursula Heiderich, *Katalog der Gemälde des 19. und 20. Jahrhunderts in der Kunsthalle Bremen*, Bremen 1973, p. 279, Ill. 598; Andreas Kreul, *Kunsthalle Bremen. Verzeichnis sämtlicher Gemälde*, Wiesbaden 1994, No. 928.

Exhibitions
Französische Malerei des 19. und 20. Jahrhunderts, Graphisches Kabinett, Bremen, 1927, No. 47.

100 The Large Tree. Woman with Red Blouse in the Garden at Cagnes 1910–1912
Le grand arbre. Femme au corsage rouge dans le jardin de Cagnes

Although the aged master had at times doubted his own gifts as a landscape painter,[1] he was continually challenged by the motifs presented by his garden at Les Collettes. In contrast to his usual approach, this painting—of which two additional variations from slightly different perspectives exist[2]—focuses on a leafless trunk that marks the vertical orientation of the composition as a strikingly solitary motif. Behind it, the view opens through the dense foliage of the other trees toward the distant houses of Cagnes and the blue of the sea.

Renoir had purchased the country manor Les Collettes on June 28, 1907 (cat. nos. 98, 99). With two and a half hectares of land, it comprised ancient olive groves, orange and medlar trees, farm buildings and an oil mill. In the same year, the painter initiated construction of a large country house with a spacious studio on the second floor according to plans of his own design, and the family moved into the building in 1908. His wife Aline transformed the grounds into an expansive garden, which, however, had nothing in common with the planned garden architecture Monet had conceived in Giverny. In this setting, the severely disabled Renoir never tired of taking in an endless series of landscape impressions, deriving great enjoyment from the beautiful view of Cagnes and the nearby coastal landscape.

"Depending upon the season, the availability of light and the particular project, Renoir would have himself carried into his studio or outside, where he would either look for a new motif or work on something he had already begun. He spend very little time in the large studio inside the house, with its wall of windows facing north. The 'perfect, cold light' bothered him. He had a kind of glass cabin measuring five by five meters built, the walls of which he left completely open. Light entered from all sides It was almost as good as working in the open air, but the windows protected his health, and he could control the reflections by raising or lowering a sunshade at will. This invention of an outdoor studio with a device for regulating the light was the best possible answer to the old question of studio work versus nature. It was a combination of both."[3]

Oil on canvas
46 × 56 cm
Signed, lower left:
Renoir.
Private collection

1 Around 1918, Renoir offered the collector Richard Gimpel the following insights regarding his own experience with the landscape: "The olive tree, what a raw thing it is. If you only knew how much trouble it caused me. A tree full of color. And not large at all. And how I sweated over its small leaves. A little gust of wind, and my tree would change color. It is not the leaves that are colored but the tree in between. I know that I cannot paint nature, but I love struggling with her. A painter cannot be important without understanding the landscape. The landscape was held in contempt in the past, especially in the 18th century. Yet even that century, which I admire, produced several landscape painters. I am at one with the 18th century. In all modesty, I think that my art descends from Watteau, Fragonard and Hubert Robert and that I am one of them" (Gimpel 1963, p. 34).

2 Auction catalogue, Gangnat, Hôtel Drouot, Paris, June 24–25, 1925, Nos. 3, 76.

3 Renoir 1981, p. 409.

Provenance
Ambroise Vollard, Paris; Dr. Arthur Hahnloser and Hedy Hahnloser-Bühler, Winterthur.

Exhibitions
Die Hauptwerke der Sammlung Hahnloser, Kunstmuseum, Lucerne, 1940, No. 103; *Das gloriose Jahrzehnt. Französische Kunst 1910–1920 aus Winterthurer Besitz*, Kunstmuseum, Winterthur, 1991, p. 82, ill.; Luxembourg 1995, No. 148, ill.

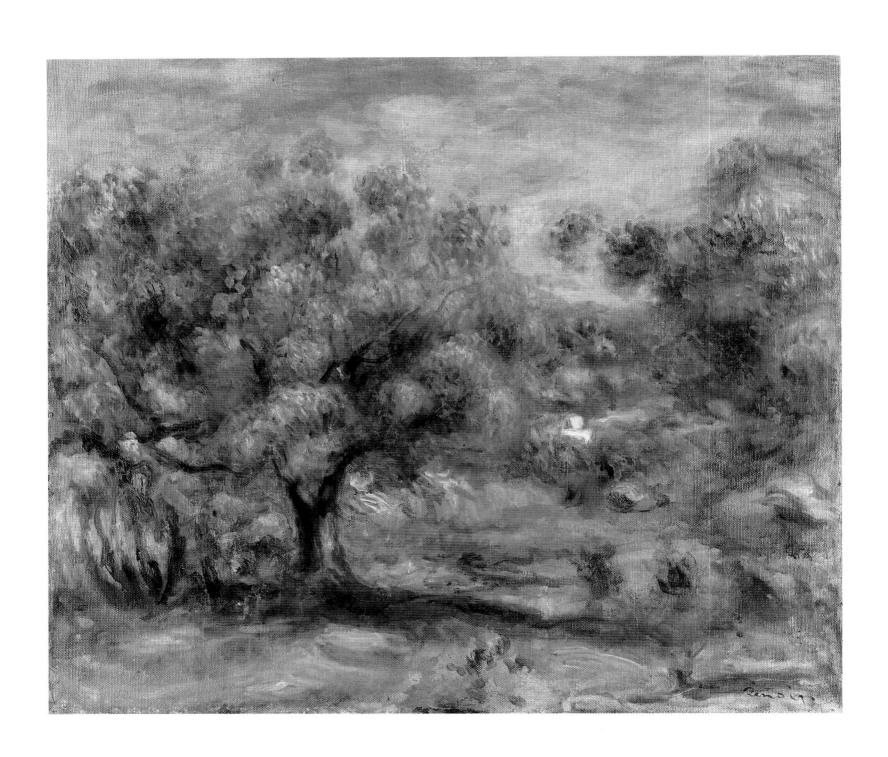

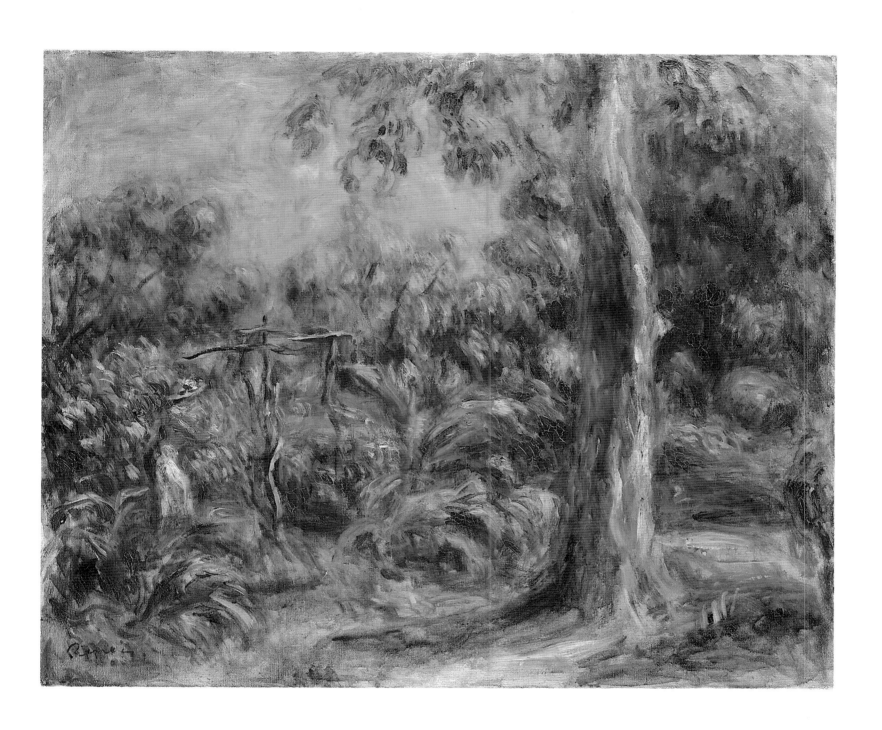

101 After the Bath 1910–1912
Au sortir du bain

Oil on canvas
67 x 52.5 cm
Signed, lower left:
Renoir.
Kunstmuseum
(Inv. no. 415),
Winterthur

Even as an old man, his own body reduced to almost skeletal proportions, Renoir continued to derive great joy from the rich, supple curves of his nudes, whom "the gods had spared those horrid sharp angles."[1] Taking his example from the painterly richness of Titian and the baroque opulence of Rubens, he imbued the heavy bodies and sluggish gestures of his models with animated rhythms through the raw power of color and sweeping curves alone: "The painting must not have the scent of the model, yet one must sense the presence of nature. A painting is not a record. I love paintings that make me want to wander through them, if they are landscapes, or run my hand over a bosom or a back, if they are female figures."[2]

This nude, which fills the rectangular canvas in a full lateral view, can be dated with relative precision, as there is another, larger version without the two other women in the background that is dated 1912 (Museu de Arte de São Paulo). That same year, Guillaume Apollinaire, the most committed apologist of the French avant-garde, argued against the Italian Futurists' demand for the abolition of the nude in painting, citing Renoir by name: "While the aged Renoir, the greatest painter of our time and one of the greatest painters of all times, is spending his last days painting wonderful and voluptuous nudes that will be the delight of times to come, our young artists are turning their back on the art of the nude, which is at least as legitimate an art as any other."[3]

The most prominent characteristic of Renoir's late nudes, indeed of his late work in general, is a warm, all-encompassing harmony composed of cinnabar red and golden yellow hues that consistently dominate the chromatic environment. In employing this color scheme, Renoir was simply expressing in painting a maxim formulated by Baudelaire decades before: "Yellow, orange and red awaken and represent ideas of wealth, fame and love."[4] Using a simplified palette, the old painter gradually intensified the preliminary suggestions of color in his sketch-like pictorial concept, employing a gently flowing technique to apply individual colors in ultra-thin layers with soft brushes that responded to the slightest movement. Rather than covering them with thick, opaque passages, he thus created a silky, shimmering enamel full of depths that shine through to the surface.

1 Renoir 1981, p. 135.

2 André 1919, p. 42.

3 LeRoy C. Breunig (ed.),
Apollinaire on Art. Essays and Reviews 1902–1918,
New York 1972, p. 204.

4 Baudelaire 1989, p. 147.

Provenance
Ambroise Vollard, Paris; acquired in 1917.

References
Vollard 1918, I, p. 50, No. 197, ill.; Vollard 1919, ill. pp. 52–53; *Hauptwerke des Kunstmuseums Winterthur,* Winterthur 1949, pp. 77ff.; Ehrlich White 1984, p. 254, ill.; Keller 1987, p. 152, Ill. 127; *Das gloriose Jahrzehnt. Französische Kunst 1910–1920 aus Winterthurer Besitz,* Kunstmuseum, Winterthur 1991, p. 20, ill.; London 1995, p. 24, Ill. 26.

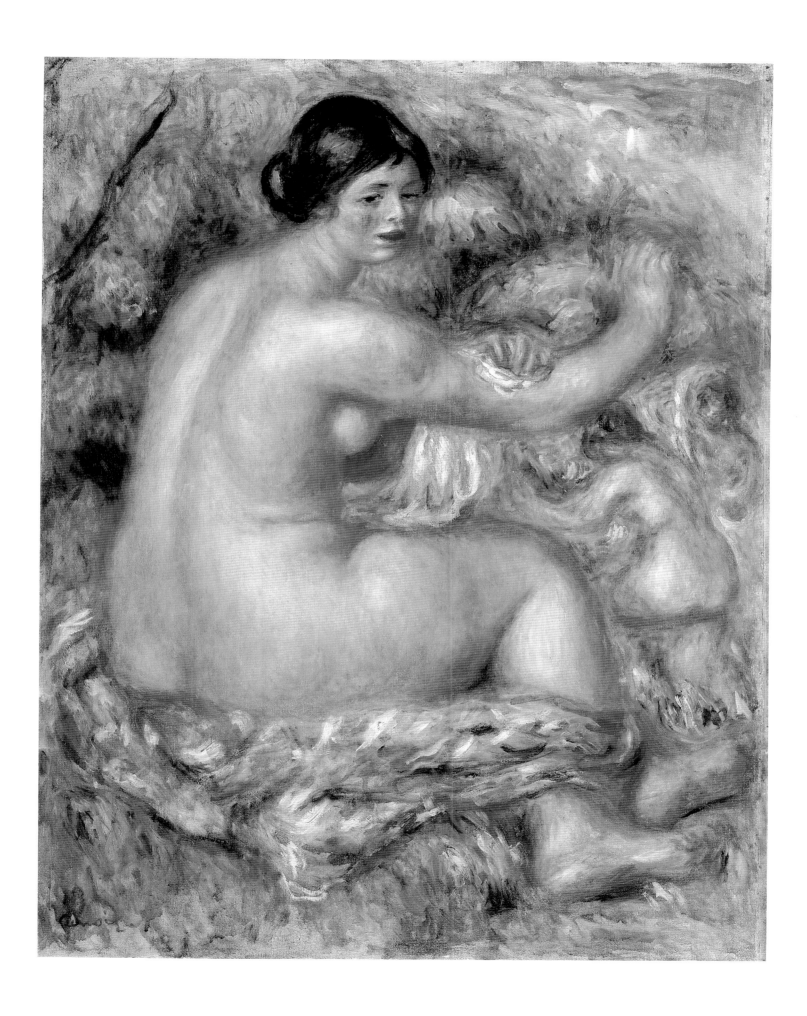

102 Portrait of Paul Durand-Ruel 1910
Portrait de Paul Durand-Ruel

Oil on canvas
65 x 54 cm
Signed and dated,
lower left: Renoir 1910.
Prêt obtenu par
l'intermédiaire de
Durand-Ruel et Cie, Paris

1 Renoir 1981, p. 291. The
name Paul Durand-Ruel came up
again and again in later conversa-
tions between Renoir and his
son: "'Papa Durand is coura-
geous; Papa Durand is a great
traveler; Papa Durand is a
church-going type.' Renoir
accepted this aspect as well. 'We
needed a reactionary to defend
our painting. The Salon people
called us revolutionaries, but they
could hardly shoot him for being
a man of the commune!' His
most frequent judgment was:
'Papa Durand is a good man!'
Later on, Vollard entered his life,
the Bernheims, Cassirer from
Berlin and other great art dealers
who were more interested in
helping to establish a style of
painting they truly believed in
than in earning money. Paul
Durand-Ruel was the first. 'I
would never have survived with-
out him.' . . . Durand-Ruel had fol-
lowed the intransigents [the
Impressionists] from the very
beginning. 'He was clever enough
to sense that something could be
gained with them. But I think he
honestly loved our painting,
Monet's in particular
Durand-Ruel was a missionary.
Fortunately for us, his religion
was painting He also made
the wrong move from time to
time. Every time I tried some-
thing new he mourned the pass-
ing of the old style, because it
seemed safer, as the connois-
seurs had already understood it.
Just put yourself in his place.

Renoir's late self-portrait (cat. no. 103) became a token of friendship when he presented it as a gift to the art dealer Paul-Marie-Joseph Durand-Ruel (1831–1922) after its completion. It was his way of expressing his gratitude to the long-time business partner and confi-dant who had stood by him with advice and active support for nearly four decades. In a companion piece of an entirely different character from the same year, Renoir painted Durand-Ruel in the study of his home in the Rue Laffitte.

While the self-portrait may be viewed as evidence of contemplation and inwardness, this portrait of a friend is representative in the truest sense. It is a character study of Durand-Ruel, who, despite his periodic difficulties, was ultimately a successful international businessman whose achievements with and on behalf of the Impressionist painters cannot be overestimated (ill. p. 303).

The artist and the art dealer, a man ten years his senior, shared a congenial partnership to which the portrait stands as a memorial. The massive base of the subject's body, spreading diagonally across the painting, derives added weight from the deep scarlet tone of the chair back. The head rises above it, inclined slightly to one side. The singu-lar hardness of the mouth vies with the warm gaze of the eyes for domi-nance in the face. The tensely bent arm ends in a paw-like hand resting heavily on the chest. As if to honor the venerable old gentleman, a few isolated blossoms embellish the otherwise unobtrusive curtain in front of the yellow wall.

Jean Renoir saw a great deal of "Papa Durand" as a child: "He was small . . . a bit corpulent, had very rosy skin à la Renoir, was well groomed and had a pleasant scent of cleanliness about him; he dressed like a 'gentleman.' Whenever I read a novel that dealt with 'refined' people, I always saw Monsieur Durand-Ruel as the head of the family I was imagining. His small, white mustache was as delicate as his movements. He smiled often. I cannot remember him ever raising his voice. I was a little bit afraid of him In spite of my respect, I trusted him"[1]

After completing his studies at the Ecole militaire de Saint-Cyr, Paul Durand-Ruel succeeded his father Jean-Marie Fortune Durand in 1865, continuing the latter's activities in support of Delacroix, Courbet, Corot and the painters of the Barbizon School.

In December 1869, he published a credo for art dealers in the *Revue internationale de l'art et de la curiosité*, a journal he edited himself: "A good art dealer must be a lover of art who is willing to sacrifice his short-term interests in favor of his aesthetic convictions, if need be, and he must also be prepared to fight against speculators rather than involve himself in their business transactions."[2]

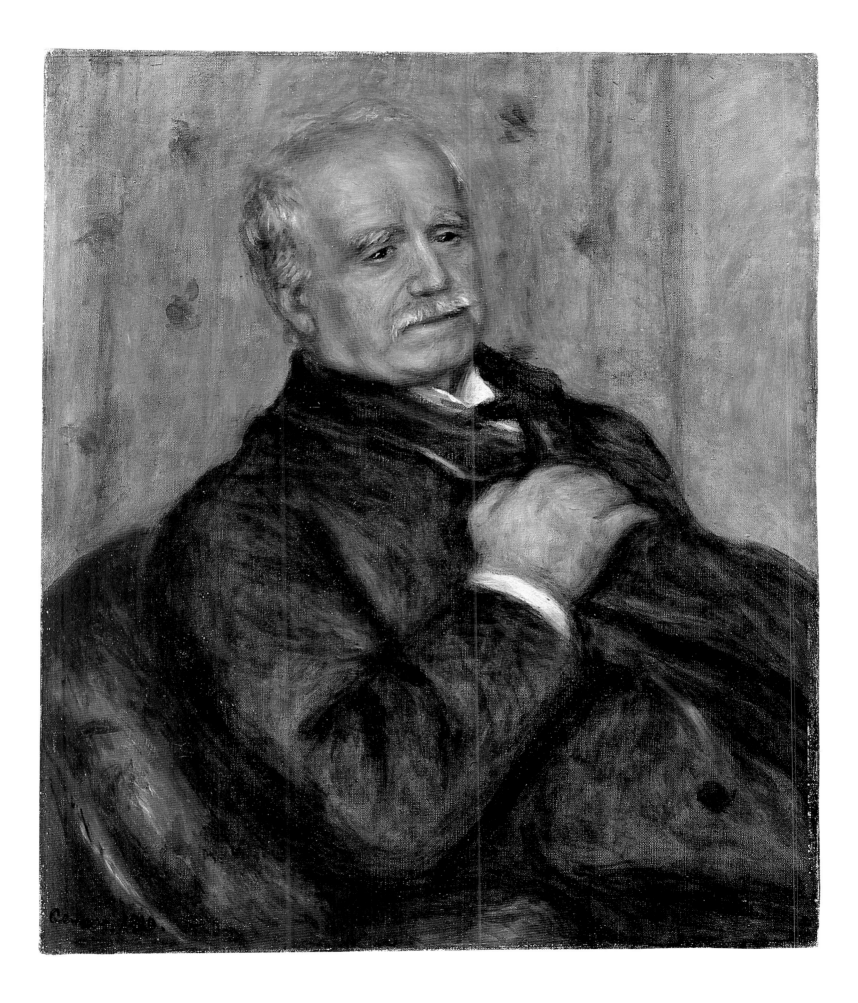

In '85 he nearly lost everything, and we right along with him . . . this upstanding citizen, model husband, model father, loyal royalist and devout Christian was a gambler. But he gambled for a good cause. His name will live on! It's a pity that there are no politicians like him' " (Ibid., pp. 136, 221f.)

2 Venturi 1939, I, pp. 17f.

3 Ibid., p. 194.

4 Daulte 1971, No. 288.

5 Venturi 1939, I, p. 199.

Durand-Ruel established initial contacts with Pissarro and Monet during the Franco-Prussian War in 1871 and met Renoir in Paris the following year. Purchases and exhibition activities in London in 1872 bear witness to his courage and dedication on behalf of the younger generation as well. From that time on, the concerns of the Impressionists corresponded closely to those of Durand-Ruel. The recession of 1874 forced the art dealer to suspend purchases temporarily and terminate his exhibition activities in London. As a result, the artists were forced to organize sales exhibitions on their own initiative, shows that generated headlines and made history as the exhibitions of the so-called Impressionists. It was not until 1881 that Durand-Ruel was in a position to provide Renoir with a regular income through purchases of groups of paintings. Two years later he presented a first extensive exhibition featuring 70 of Renoir's works in his gallery at Boulevard de la Madeleine 9. The opening of Durand-Ruel's gallery in New York in 1888 represented the first step toward international acceptance for the Impressionists. While Monet, Pissarro and Sisley also established business relations with other galleries, Renoir remained steadfastly loyal to Durand-Ruel. The dealer's younger colleagues—the Bernheims, the Rosenbergs and Ambroise Vollard (cat. no. 104)—were forced to content themselves with works of little interest to him.

Renoir's worries about his waning productive powers went hand in hand with Durand-Ruel's sales successes. "The older I get, the longer I need to complete a work," the painter complained in 1909. "I can only admire Monet, who is capable of doing such interesting things in such a short time. He has much more energy than I. It is good to know that the collectors are no longer as rebellious as they were. Better late than never. But that will not keep me from proceeding as before, as if nothing had changed."[3]

In June of 1910, the Galerie Durand-Ruel in Paris exhibited a number of Impressionist works, including 35 paintings by Renoir. Among them was his *La fin du dejeuner* of 1879, which was sold to the Städtische Galerie in Frankfurt for the record price of 125,000 francs.[4] Near the end of December the artist pressed Durand-Ruel to visit him at his estate Les Collettes in the south of France: "You have sons who work for you. See that, at least, as an advantage, and take a bit of rest, which you have surely earned. There is an age at which one must know how to work, but there is another at which one must learn how to relax. And so I hope to see you again soon."[5]

Paul Durand-Ruel's contribution to the fame and financial success of Renoir and the other Impressionists is unrivaled. In 1911, at the age of 80, he placed the management of his Paris and New York galleries in the hands of his sons Joseph and Georges (cat. nos. 67, 68).

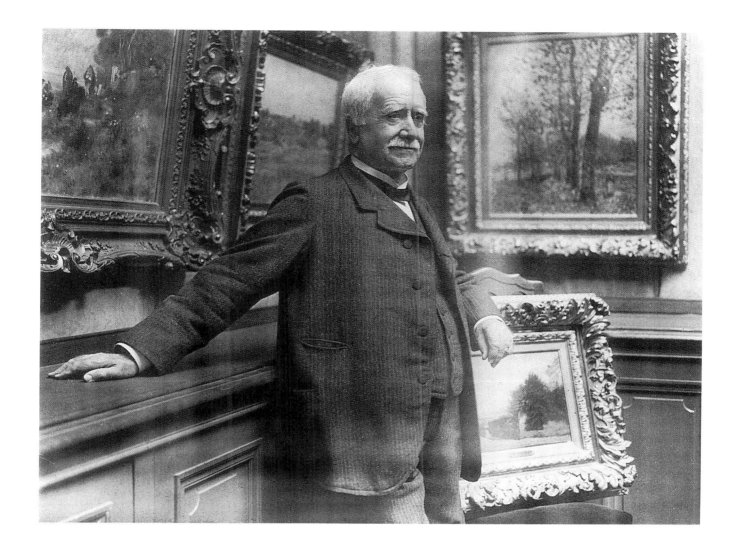

Provenance
Paul Durand-Ruel, Paris; Joseph Durand-Ruel, Paris; Charles Durand-Ruel, Paris.

References
Rivière 1921, p. 83, ill.; Duret 1924, p. 72, Ill. 33; Coquiot 1925, p. 233; Meier-Graefe 1929, p. 324, Ill. 352; Venturi 1939, I, ill. pp. 16–17; Drucker 1944, pp. 96, 190; Pach 1951, pp. 104f., ill.; Pach 1958, pp. 112f., ill.; Claude Roger-Marx, *Le commerce des tableaux sous l'impressionnisme et à la fin du XIXe siècle*, Paris 1958, p. 20, ill.; Rewald 1965, Ill. 169; Fezzi 1972, p. 122, No. 742, ill.; Daulte 1973, p. 68, ill.; Renoir 1981, Ill. 33; Ehrlich White 1984, pp. 245, 253, ill.; Peter Nathan, "Marchand de tableaux: vocation et devoirs," in *L'Œil*, June 1986, p. 70, Ill. 1; Keller 1987, pp. 124, 143, Ill. 119; Wadley 1987, Ill. 144; Monneret 1990, pp. 22, 136f., ill., p. 158; Distel 1990, p. 30, ill.; Peter Watson, *From Manet to Manhattan. The Rise of the Modern Art Market*, New York 1992, ill.; Distel 1993, p. 114, ill.; Chantal Humbert, "Paul Durand-Ruel face à la bataille impressionniste," in *Journal de l'amateur d'art*, December 1993, p. 13, ill.

Exhibitions
Berlin 1912, No. 41; Paris 1912, No. 38; Munich 1913, No. 41; *Les 10 dernières années de Renoir*, Paul Rosenberg, Paris, 1934, No. 9; New York 1939, No. 21; *140th Anniversary 1803–1943*, Durand-Ruel, New York, 1943, No. 20, ill.; *Gustave Geffroy et l'art moderne*, Bibliothèque Nationale, Paris, 1957, No. 106; Paris 1958, No. 53; Munich 1958, No. 44, ill.; Marseille 1963, No. 61, ill.; Stockholm 1964, No. 43, ill.; *Von David bis Cézanne*, Haus der Kunst, Munich, 1964–1965, No. 225, ill.; Paris 1969, No. 54, ill.; *One Hundred Years of Impressionism*, Wildenstein, New York, 1970, No. 100, ill.; *Französische Impressionisten*, Kunstverein, Hamburg, 1970–1971, No. 43, ill.; Tokyo–Fukuoka–Kobe 1971–1972, No. 46, ill.; Chicago 1973, No. 78, ill.; Paris 1974, No. 56, ill.; London–Paris–Boston 1985–1986, No. 113, ill.

103 Portrait of the Artist with a White Hat 1910
Portrait de l'artiste au chapeau blanc

Oil on canvas
42 × 33 cm
Signed, lower left:
Renoir.
Private collection

1 Daulte 1971, No. 157.

2 Ibid., Nos. 191, 293; the two
later self-portraits are now in the
possession of the Sterling and
Francine Clark Art Institute,
Williamstown and a private
collection in Paris, respectively.

Aristide Maillol, *Auguste Renoir*,
1908, terra-cotta, Bayerische
Staatsgemäldesammlungen,
Neue Pinakothek, Munich

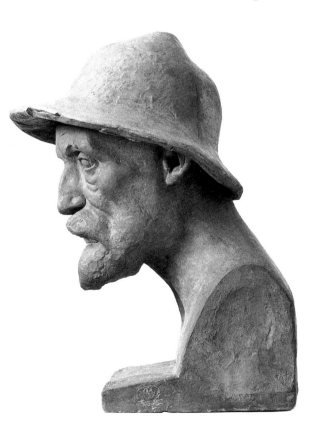

The greatest of the Impressionist portraitists, Renoir showed little interest in his own likeness. His first self-portrait was a small bust painting executed in 1875 at the age of 35;[1] his last was this only slightly larger profile portrait of himself, done as he neared the age of 70. He painted only four other such works dated to the years 1876, 1879, 1899 and 1910, all portraits that bear witness to a restless temperament.[2] Common to them all is a tendency to explore the depths of the psyche that is not found in his other work, a gaze that exposes aspects of nervous, thin-skinned sensitivity. There is nothing in Renoir's self-portraits that relates to his vocation or his personal surroundings. This selflessness stands in stark contrast to the image of the self-assured genius in artists' self-portraits since Courbet, an approach that even Cézanne found impossible to resist.

The portrait is a classical bust presentation of the bearded head turned towards the left. The stoic calm of old age is inscribed in the features of the face. The portrait bears a close resemblance to the bust of Renoir commissioned by the art dealer Vollard and sculpted by Aristide Maillol in Essoyes in mid-July 1908. This pain-ridden profile of an old man completed just two years later presents an even clearer picture the debilitating infirmity that sapped his strength and substance to the point that he was barely able to walk after 1910. Jean Renoir later confirmed much of what the painting suggests in a description of his father: "My father now had something of the look of an old Arab and an unmistakable resemblance to a French peasant, if one disregards the color of his skin. Because he needed to shade his canvas against reflections that 'are always getting in the way,' his skin had remained as pale as a young boy's. Those who saw him for the first time were struck most of all by the appearance of his eyes and his hands. The eyes were light brown, almost yellowish, his gaze penetrating His expression might be imagined as a mixture of irony and warmth, high spirits and sensibility. His eyes seemed to be laughing always, as if they discovered a funny side in everything they saw. Yet it was a tender, loving laugh. It may even have been a mask. Renoir was extremely modest and preferred to conceal his emotions His hands were horribly misshapen. Rheumatism had destroyed his joints, driven his thumb into his palm and curled the other fingers up to his wrist He was 1.76 meters tall before the paralysis began. Near the end of his life he would surely have been shorter, if he had even been able to stand upright; his spine had become somewhat compressed. His once light brown hair still covered the back of

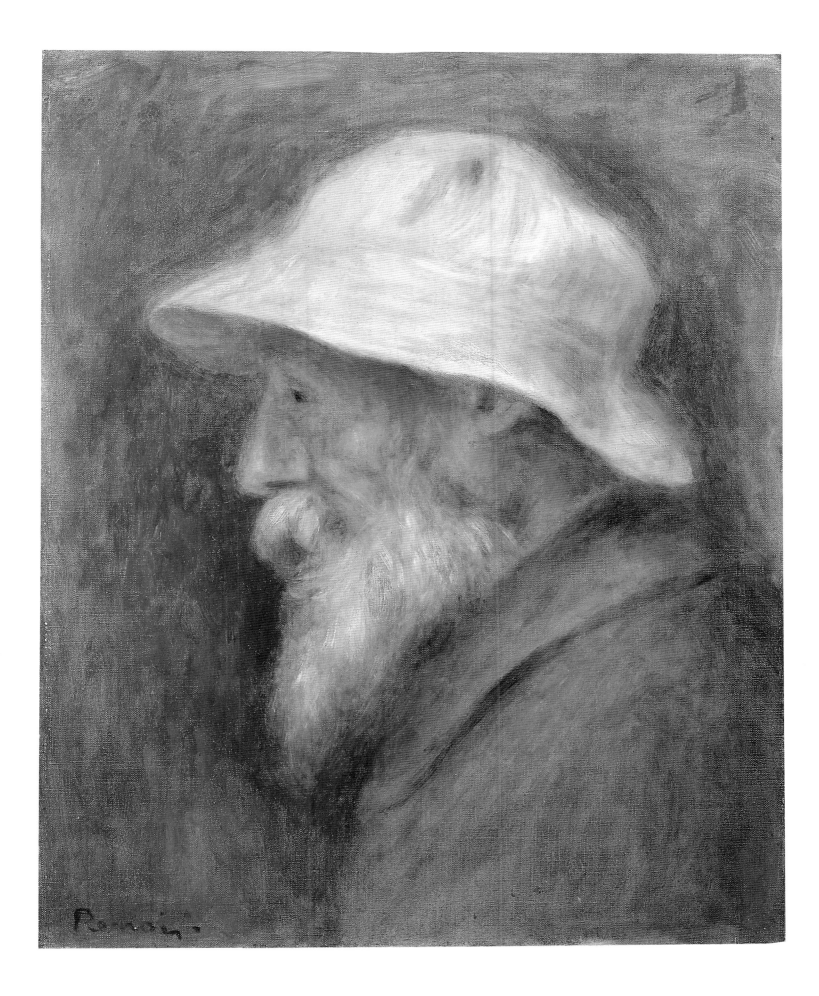

3 Renoir 1981, pp. 27ff.

4 Like Cézanne, Renoir rejected all forms of technical progress, and like both Cézanne and Degas, he made no secret of his anti-Semitism, a prejudice he found confirmed in the Dreyfus affair. His sometimes reactionary views were recorded by Julie Manet, the daughter of Berthe Morisot, in her diary for the year 1897: "Renoir attacked all of the new machines, saying that we live in a decadent age in which people have nothing else on their minds but traveling many kilometers in an hour, that it was all so senseless, that the automobile was an idiotic thing, that we had no need to move so fast, that all of that was just so much cause for confusion" A year later, the following entries describe the passionate discussions of the Dreyfus affair kindled by Zola's courageous statement and Renoir's stereotyped, anti-Semitic responses: "'Many of them are in the army, for Jews love parading around decorated with officers' medals. They are being expelled from countries everywhere for good reason, and they should not be allowed to play such an important role in France.' Monsieur Renoir speaks of Pissarro in the same way—'a Jew,' whose sons come from nowhere and also do their military service nowhere. 'This Jewish race is tough. Pissarro's wife is not [Jewish], but all of the children are even more Jewish than their father' " (Julie Manet, *Journal (1893–1899)*, Paris 1979, pp. 133, 148).

5 Sophie Monneret, *L'Impressionnisme et son époque*, II, Paris 1979, p. 177.

his head in dense, white locks. The front of his head was completely bald, although one never saw it, as he never failed to wear a hat, even inside the house. He had a strong eagle's nose and a beautiful, white full beard that one of us would trim to a point for him Outdoors, he wore a light linen hat to protect against the sun He didn't look at all like a contemporary; he sometimes reminded us of an Italian Renaissance monk."[3]

Expressed from the viewpoint of a son, this characterization may have been rather one-sided. Jean Renoir makes no mention of the expression of resignation or melancholy evident in the three later self-portraits, a state of mind surely brought on not only by his illness, but by a sense of isolation in a time that was not longer his.[4] Odilon Redon, a more detached observer, characterized Renoir in 1896 as "shy, anxious and devoid of all charm He must have suffered a great deal. One must take the first step to reach out to him; he deserves that. He speaks openly; we got along well together. He kept all of his tenderness concealed within himself, but one could sense it."[5]

Provenance
Paul Durand-Ruel, Paris; Joseph Durand-Ruel, Paris; Pierre Durand-Ruel, Paris.

References
Rivière 1921, p. 245, ill.; Meier-Graefe 1929, p. 379, Ill. 355; Barnes-de Mazia 1935, p. 466, No. 253, ill. frontispiece; Pach 1951, pp. 108f., ill.; Gaunt 1952, Ill. 93; Rouart 1954, p. 99, ill.; Schneider 1957, ill. frontispiece; Pach 1958, ill. frontispiece; Perruchot 1964, ill. frontispiece; Fezzi 1972, p. 122, No. 739, ill.; Daulte 1973, p. 61, ill.; Gauthier 1977, ill. frontispiece; Tokyo–Kyoto 1979, ill.; Renoir 1981, Ill. 40; Ehrlich White 1984, p. 249, ill.; Rouart 1985, p. 112, ill.; Shimada 1985, Ill. 60; London–Paris–Boston 1985–1986, p. 280; Monneret 1990, p. 136, ill.; Fell 1992, p. 5, ill.

Exhibitions
Paris 1933, No. 120; Paris 1958, No. 54, ill.; New York 1969, No. 91, ill.; Chicago 1973, No. 77, ill.

104 Portrait of Ambroise Vollard
in the Costume of a Toreador 1917
Portrait d'Ambroise Vollard,
en costume de toréador

Ambroise Vollard (1868–1939) succeeded Paul-Durand-Ruel (cat. no. 102) as a leading art dealer of his time. He shared his predecessor's willingness to take risks, his good judgment and his acute business sense. Yet it would be hard to imagine two more radically different personalities than these two men, each of whom, in his own inimitable way, influenced the course of art history. Renoir portrayed the one as a gentleman upon whom the wisdom of age rested comfortably, the other as an actor in his prime who—as evidenced by his strange costume— had chosen a role for which he was ill suited.

Vollard was born of Creole parents on the French island of Réunion. The son of an attorney, he studied law in Montpellier and Paris before turning his attention exclusively to the pursuit of his interest in contemporary art. He launched his career as an art dealer in a small shop in Montmartre's Rue Laffitte, where he set up his own living quarters in the basement. Stories abound concerning this unconventional art entrepreneur who nonetheless exhibited a knack for business, a man who sought contact with Renoir while still in his mid-twenties and subsequently presented the first Cézanne exhibition in his shop in 1895.[1]

Matisse provided the following account of Vollard's encounter with Renoir: "I don't know how he managed to get close to Renoir. He snooped about everywhere. From time to time he would visit him in the evenings. Renoir often had to throw him out so that he could work. One day he said to him; 'You should do something for Cézanne. He is really a great artist, believe me.' The Cézanne exhibition took place. Nearly everyone was against it. No one had any faith in it. It was looked upon with horror. People who know that they know nothing about art—they ignored not only Cézanne but Renoir, Bonnard and many others as well—the people said that Cézanne's painting did not accord with the Greek ideal But this Vollard was clever, an adventurer, and he had a nose . . . for business."[2]

Over the years Vollard worked on behalf of Pissarro, Degas, Bonnard and Vuillard, for van Gogh, Picasso or Matisse, acting as an agent, publisher and highly imaginative biographer.[3] Alongside the Durand-Ruels and the Bernheims, Vollard became increasingly indispensable to Renoir in his later years.[4]

Renoir demonstrated his trust in Vollard by commissioning him to compile an inventory of his paintings remaining in Paris for testamentary purposes in late 1915. This effort resulted in two copious catalogue volumes edited by Vollard in 1918. Thus it is no surprise that

Oil on canvas
103 × 83 cm
Signed and dated,
lower left: Renoir 1917.
Nippon Television
Network Corporation,
Japan

1 Renoir 1981, pp. 275 f., 358f., 399.

2 Matisse 1982, p. 258. Renoir was impressed with the young man in spite of his pushiness: "'He had the weary stride of a Carthaginian general.' He was even more impressed with his response to a few paintings he showed to him. 'People generally make sage comments, look for comparisons, drag out the whole history of art before they express a judgment. This young man behaved towards paintings like a hunting dog in the presence of game.' My father would have given him a few paintings, even after Vollard had admitted with the false innocence for which he later became famous that he could not pay for them. But he was afraid that Papa Durand would never forgive him for accepting this rival" (Renoir 1981, pp. 275f.).

3 According to Jean Renoir, the artist had reservations about Vollard's biography: "I admire Vollard's book tremendously; but it cannot be taken as gospel. For one thing, Renoir enjoyed 'pulling the art dealer's leg.' It must also be said that Vollard, the great enthusiast businessman, lived entirely within a dream world. My father's comment on the book: 'Vollard's book about Vol-

lard is excellent.' He also found it rather childish to write about him. 'If if gives him enjoyment, I don't mind.' To this he added: 'Since no one is going to read it anyway' " (ibid., p. 14).

4 Since Paul Durand-Ruel owned the exclusive rights to all new works by Renoir, Vollard hit upon the idea in 1913 of encouraging the artist to have sculptures made from his motifs. According to Renoir, the sculptures were to be done by Richard Guino, a former colleague of Maillol. Despite his initial hesitation, Renoir agreed to Vollard's proposal and granted him unrestricted reproduction rights to his sculptural œuvre, which grew in the course of his cooperation with Guino to encompass a total of 14 works by 1917.

5 "Vollard was very vain and had himself dressed by a leading Paris tailor. Renoir shook his head sadly. 'You look like you're wearing a costume!' He later got used to Vollard's elegance" (Renoir 1981, p. 359).

6 "I remember vividly the shop with its ochre-yellow walls. And I see everything connected with Vollard in this color, more or less subdued, from his suits of beautiful chestnut tweed to the Mediterranean tone of his skin" (Ibid., p. 359).

7 Françoise Gilot and Carlton Lake, *Leben mit Picasso*, Munich 1980, p. 36.

8 Venturi 1939, I, p. 444.

9 Ehrlich White 1984, p. 280.

Renoir dedicated his last, elaborate portrait to Vollard, or rather to Vollard's notorious vanity.[5] He had already immortalized the art dealer in 1908 in a painting showing him as a connoisseur examining a statuette by Maillol (ill. p. 310).

Vollard visited the Renoir family in Essoyes in August 1917. He had brought along a toreador's suit purchased shortly before in Barcelona, which he wanted to wear for his portrait. The very fact that Renoir permitted Vollard to clothe his voluminous, rather stocky Parisian businessman's body in the splendid costume reserved for a mounted bull-fighter is evidence of the scornful undertone informing this large-scale portrait.

The diagonal composition is structured in such a way that the feet appear larger than the head, which is relegated to the upper left-hand corner of the painting. In this way, the artist was able to direct his full attention to the pompous effects of the green garments lavishly adorned with gold and silver and to the ochre-yellow tenor of the whole, a tone that Jean Renoir also associated with Vollard in his memoirs.[6] In an ironic aside, Renoir placed a plain rose at the feet of the imposingly attired model posed within the decorated walls of an interior.

Hardly less vain than his art dealer, Picasso later voiced his claim to authorship of the Vollard portrait: "Even the most beautiful woman in the world was never painted, drawn or etched more often than Vollard—by Cézanne, Renoir, Rouault, Bonnard, Forain, indeed by just about everyone. I think they all painted him out of jealousy; each one wanted to do it better than the other. This man was as vain as a woman. Renoir portrayed him as a toreador, but he stole the theme from me. But my Cubist portrait of him is the best of them all" (ill. p. 310).[7]

Although art history has proven Picasso right, the aging Renoir demonstrated the full range of his skills as a painter and a masterful command of tension and balance in pictorial composition in his portrait of Vollard as a toreador—all the more remarkable in view of the effort it must have cost the severely ill artist to execute a portrait of this size and complexity.

Monet surely had good reason for expressing his admiration to Georges Durand-Ruel in December of 1916: "As for Renoir, he is still amazing. He is said to be seriously ill, and suddenly one hears that he is working and forcing himself, in spite of everything, to continue his work. He is simply wonderful."[8]

In 1917, having completed this portrait, Renoir felt utterly exhausted: "Apart from the fact that I am extraordinarily tired—very, very tired—I would not mind at all if I could rest for a moment, so poorly do I feel; life is too complicated for people of my age . . . and I am approaching the point at which I can no longer keep myself busy with painting or sculpture or pottery, although I would still like to do all of that . . . "[9]

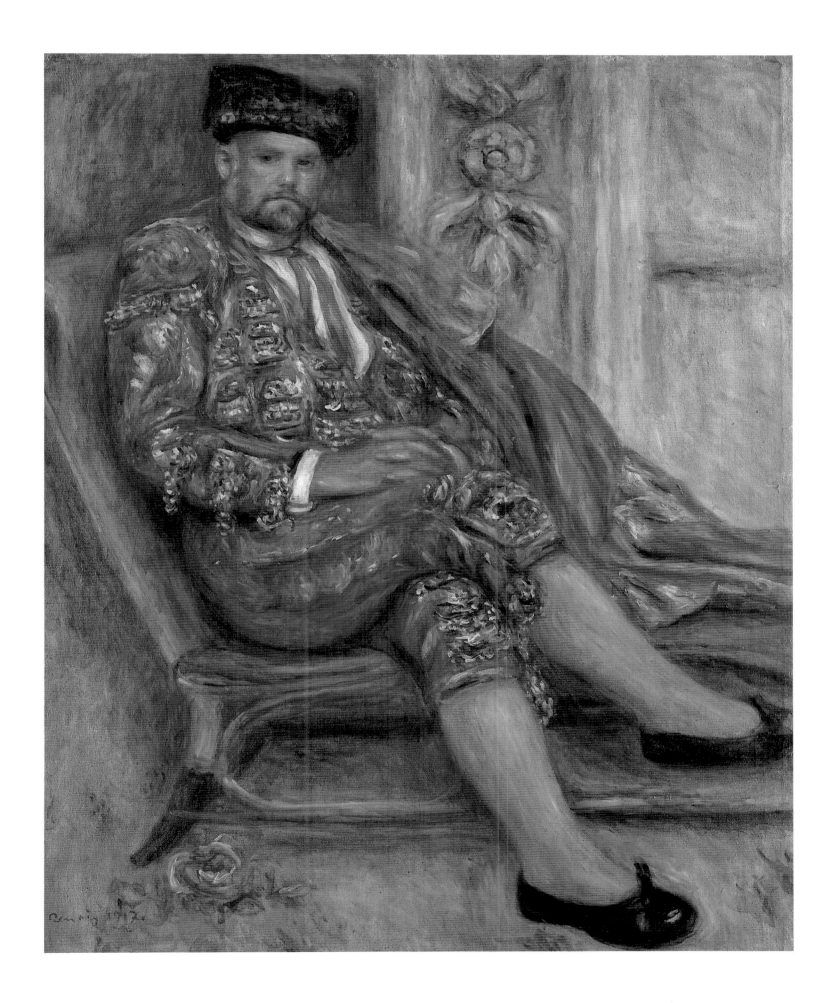

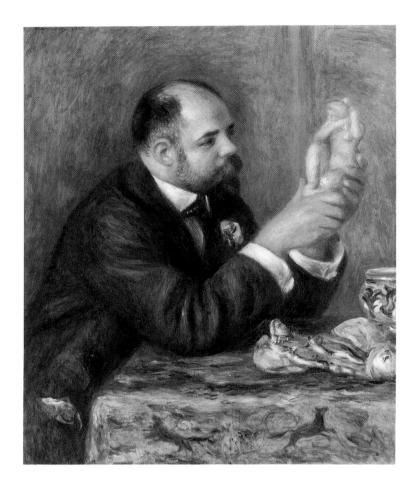

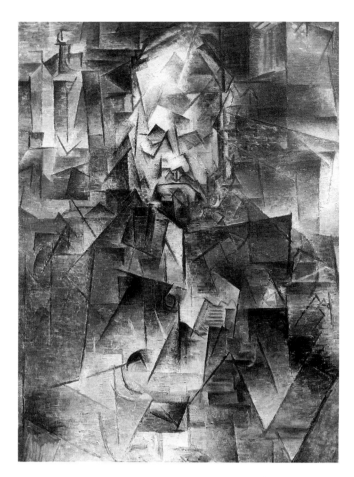

Renoir, *Portrait of Ambroise Vollard*, 1908, Courtauld Institute Galleries, London

Pablo Picasso, *Ambroise Vollard*, 1909–1910, Pushkin Museum, Moscow

Provenance
Ambroise Vollard, Paris; Edouard Jonas, Paris; Walter F. Chrysler, Jr., New York; Auction *Chrysler*, Sotheby's, London, July 1, 1959, No. 32; B. E. Bensinger, Chicago; Stephan Hahn, New York.

References
Vollard 1918, I, p. 98, No. 391, ill.; Vollard 1919, ill. pp. 238–239; Rivière 1921, p. 225, ill.; Vollard 1924, p. 230, ill. p. 232–233; Duret 1924, p. 73; Coquiot 1925, p. 234; Meier-Graefe 1929, p. 327; Drucker 1944, p. 97, Ill. 159, pp. 191, 215; Chamson 1949, Ill. 53; Gaunt 1952, Ill. 103; Vollard 1961, p. 30, Ill. 6, p. 100; Fezzi 1972, pp. 123f., No. 763, ill.; Renoir 1981, Ill. 49; Ehrlich White 1984, p. 278, ill., p. 280; Monneret 1990, p. 155, No. 23, ill.

Exhibitions
Renoir, Galerie d'Art Braun, Paris, 1932, No. 26, ill.; New York 1933, No. 40, ill.; *Portraits français de 1400 à 1900*, Galerie Seligmann, Paris, 1936, No. 144; Nice 1952, No. 31, ill.; *Paintings from the Collection of Walter F. Chrysler, Jr.*, Museum of Art, Portland, 1956, No. 95, ill.; New York 1958, No. 68, ill.; *Faces from the World of Impressionism and Post-Impressionism*, Wildenstein, New York, 1972, No. 58, ill.; Chicago 1973, No. 86, ill.; Tokyo–Kyoto 1979, No. 83, ill.

Bibliography
Exhibitions
Biographical Notes

Bibliographical References

The art dealer Ambroise Vollard compiled the first catalogue of Renoir's works, indexing and reproducing—without reference to any identifiable principle of order—the 1,739 paintings, pastels and drawings known to him in two volumes published in 1918. A catalogue comprising 720 works found in the artist's studio after his death, most of them completed after 1890, appeared under the title *L'Atelier de Renoir* in 1931. A true catalogue of Renoir's complete œuvre is now being edited by François Daulte. Upon completion, it will consist of five volumes containing 6,000 numbered items. The first and only volume completed to date was published in Lausanne in 1971 and bears the title *Auguste Renoir. Catalogue raisonné de l'œuvre peint, I, Figures 1860–1890*. It also contains an extensive bibliography covering publications up to and including the year 1970 (pp. 57ff.).

André 1919	Albert André, *Renoir* (Paris: 1919).
André 1931	Albert André, *L'Atelier de Renoir, I, II,* with a preface by Marc Elder (Paris: 1931).
Bade 1989	Patrick Bade, *Renoir* (Vaduz: 1989).
Barnes-de Mazia 1935	Albert C. Barnes and Violetta de Mazia, *The Art of Renoir* (New York: 1935).
Baudelaire 1977	Charles Baudelaire, *Sämtliche Werke. Juvenilia, Kunstkritik 1832–1846*, edited by Friedhelm Kemp et al. (Munich: 1977).
Baudelaire 1989	Charles Baudelaire, *Sämtliche Werke. Aufsätze zur Literatur und Kunst 1857–1860*, edited by Friedhelm Kemp et al. (Munich–Vienna: 1989).
Baudot 1949	J. Baudot, *Renoir, ses amis, ses modèles* (Paris: 1949).
Besson 1929	Georges Besson, *Renoir* (Paris: 1929).
Blanche 1927	Jacques-Emile Blanche, *Dieppe* (Paris: 1927).
Bodelsen 1968	Merete Bodelsen, "Early Impressionist Sales 1874–94 in the Light of some Unpublished 'procès-verbaux,'" in *The Burlington Magazine*, CX, 783, June 1968, pp. 331ff.
Bünemann 1959	Hermann Bünemann, *Renoir* (Ettal: 1959).
Callen 1978	Anthea Callen, *Renoir* (London: 1978).
Callen 1983	Anthea Callen, *Techniques of the Impressionists* (London: 1983).
Cézanne 1962	*Paul Cézanne. Briefe,* edited by John Rewald (Zurich: 1962).
Champa 1973	Kermit S. Champa, *Studies in Early Impressionism* (New Haven–London: 1973).
Chamson 1949	André Chamson, *Renoir* (Lausanne: 1949).
Cooper 1959	Douglas Cooper, "Renoir, Lise and the Le Cœur Family. A Study of Renoir's Early Development," in *The Burlington Magazine*, 101, May, September/October, 1959, pp. 163ff., 322ff.
Coquiot 1925	Gustave Coquiot, *Renoir* (Paris: 1925).
Daulte 1971	François Daulte, *Auguste Renoir. Catalogue raisonné de l'œuvre peint, I, Figures 1860–1890* (Lausanne: 1971).
Daulte 1973	François Daulte, *Auguste Renoir* (Munich: 1973).
Deuchler 1990	Florens Deuchler, *Die französischen Impressionisten und ihre Vorläufer, Sammlungskataloge I*, published by the Stiftung Langmatt, Sidney and Jenny Brown (Baden: 1990).
Distel 1990	Anne Distel, *Impressionism. The First Collectors* (New York: 1990).

Distel 1993 Anne Distel, *Renoir* (Paris: 1993).

Drucker 1944 Michel Drucker, *Renoir* (Paris: 1944).

Duret 1906 Théodore Duret, "Renoir," in *Kunst und Künstler*, IV, VII, April 1906, pp. 281ff.

Duret 1922 Théodore Duret, *Histoire des peintres impressionnistes* (Paris: 1922).

Duret 1924 Théodore Duret, *Renoir* (Paris: 1924).

Ehrlich White 1969 Barbara Ehrlich White, "Renoir's Trip to Italy," in *The Art Bulletin*, 51, December 1969, pp. 333ff.

Ehrlich White 1984 Barbara Ehrlich White, *Renoir, His Life, Art and Letters* (New York: 1984).

Fell 1992 Derek Fell, *Le Jardin de Renoir* (Paris: 1992).

Fezzi 1972 Elda Fezzi, *L'Opera completa di Renoir nel periodo impressionista 1869–1883* (Milan: 1972).

Florisoone 1937 Michel Florisoone, *Renoir* (Paris: 1937).

Florisoone 1938 Michel Florisoone, "Renoir et la famille Charpentier. Lettres inédites," in *L'amour de l'art*, 19, February 1938, pp. 31ff.

Fosca 1923 François Fosca, *Renoir* (Paris: 1923).

Fosca 1961 François Fosca, *Renoir. L'homme et son œuvre* (Paris: 1961).

Gaunt 1952 William Gaunt, *Renoir* (London: 1952).

Gaunt–Adler 1982 William Gaunt and Kathleen Adler, *Renoir* (Oxford: 1982).

Gauthier 1977 Maximilien Gauthier, *Renoir* (Munich: 1977).

Gimpel 1963 Richard Gimpel, *Journal d'un collectionneur, marchand de tableaux* (Paris: 1963).

Glaser 1920 Kurt Glaser, "Der alte Renoir," in *Zeitschrift für bildende Kunst*, XXXI, 55, February–March 1920, pp. 104ff.

Graber 1943 Hans Graber, *Auguste Renoir. Nach eigenen und fremden Zeugnissen* (Basle: 1943).

Hausenstein 1920 Wilhelm Hausenstein, *Renoir. Faksimiles nach Zeichnungen, Aquarellen und Pastellen* (Munich: 1920).

Jedlicka 1947 Gotthard Jedlicka, *Renoir* (Berne: 1947).

Keller 1987 Horst Keller, *Auguste Renoir* (Munich: 1987).

Lemoisne 1946 Paul-André Lemoisne, *Degas et son œuvre, I–IV* (Paris: 1946).

Matisse 1982 Henri Matisse, *Über Kunst*, edited by Jack D. Flam (Zurich: 1982).

Meier-Graefe 1911 Julius Meier-Graefe, *Auguste Renoir* (Munich: 1911).

Meier-Graefe 1912 Julius Meier-Graefe, *Auguste Renoir* (Paris: 1912).

Meier-Graefe 1929 Julius Meier-Graefe, *Renoir* (Leipzig: 1929).

Mirbeau 1913 Octave Mirbeau, *Renoir* (Paris: 1913).

Monneret 1990 Sophie Monneret, *Renoir* (Cologne: 1990).

Morisot 1950 Berthe Morisot, *Correspondance de Berthe Morisot* (Paris: 1950).

Pach 1951 Walter Pach, *Pierre-Auguste Renoir* (London: 1951).

Pach 1958 Walter Pach, *Pierre-Auguste Renoir* (Cologne: 1958).

Paul 1993 Barbara Paul, *Hugo von Tschudi und die moderne französiche Kunst im Deutschen Kaiserreich* (Mainz: 1993).

Perruchot 1964 Henri Perruchot, *La vie de Renoir* (Paris: 1964).

Pissarro 1953 *Camille Pissarro, Briefe an seinen Sohn Lucien,* edited by John Rewald (Erlenbach-Zurich: 1953).

Pissarro 1980 *Correspondance de Camille Pissarro 1865–1885, I,* edited by Janine Bailly-Herzberg (Paris: 1980).

Poulain 1932	Gaston Poulain, *Bazille et ses amis* (Paris: 1932).
Régnier 1923	Henri de Régnier, *Renoir, peintre du nu* (Paris: 1923).
Reidemeister 1973	Leopold Reidemeister et al., *Stiftung Sammlung Emil G. Bührle* (Zurich-Munich: 1973).
Renoir 1968	"Lettres de Renoir à Paul Bérard (1879–1891)," edited by Maurice Bérard, in *La Revue de Paris*, December 1968.
Renoir 1981	Jean Renoir, *Mein Vater Auguste Renoir* (Zurich: 1981).
Rewald 1965	John Rewald, *Die Geschichte des Impressionismus* (Cologne: 1965).
Rivière 1921	Georges Rivière, *Renoir es ses amis* (Paris: 1921).
Robida 1958	Michel Robida, *Le Salon Charpentier et les impressionnistes* (Paris: 1958).
Robida 1959	Michel Robida, *Renoir. Enfants* (Lausanne: 1959).
Roger-Marx 1937	Claude Roger-Marx, *Renoir* (Paris: 1937).
Rouart 1954	Denis Rouart, *Pierre-Auguste Renoir* (Geneva: 1954).
Rouart-Wildenstein 1975	Denis Rouart and Daniel Wildenstein, *Edouard Manet. Catalogue raisonné, I, Peintures* (Lausanne-Paris: 1975).
Rouart 1985	Denis Rouart, *Renoir* (London: 1985).
Schneider 1945	Marcel Schneider, "Lettres de Renoir sur l'Italie," in *L'Age d'Or–Etudes* 1, 1945, pp. 95ff.
Schneider 1957	Bruno F. Schneider, *Renoir* (Berlin: 1957).
Schneider 1985	Cynthia P. Schneider, "Renoir. Le peintre de figures comme paysagiste," in *Apollo*, 122, July 1985.
Shimada 1985	Norio Shimada, *Renoir* (Tokyo: 1985).
Terrasse 1941	Charles Terrasse, *Cinquante portraits de Renoir* (Paris: 1941).
Venturi 1936	Lionello Venturi, *Cézanne, son art, son œuvre* (Paris: 1936).
Venturi 1939	Lionello Venturi, *Les archives de l'Impressionnisme. Lettres de Renoir, Monet, Pissarro, Sisley et autres. Mémoires de Paul Durand-Ruel. Documents, I, II* (Paris–New York: 1939).
Vollard 1918	Ambroise Vollard, *Tableaux, pastels et dessins de Pierre-Auguste Renoir I, II* (Paris: 1918).
Vollard 1919	Ambroise Vollard, *La vie et l'œuvre de Pierre-Auguste Renoir* (Paris: 1919).
Vollard 1924	Ambroise Vollard, *Auguste Renoir* (Berlin: 1924).
Vollard 1961	Ambroise Vollard, *Auguste Renoir. Gespräche und Erinnerungen* (Zurich: 1961).
Wadley 1987	Nicholas Wadley, *Renoir. A Retrospective* (New York: 1987).
Wheldon 1975	Keith Wheldon, *Renoir and his Art* (London: 1975).
Wildenstein 1974	Daniel Wildenstein, *Claude Monet. Biographie et catalogue raisonné, I, 1840–1881 Peintures* (Geneva: 1974).
Wildenstein 1979	Daniel Wildenstein, *Claude Monet. Biographie et catalogue raisonné, II, 1882–1886 Peintures* (Geneva: 1979).

Exhibitions and Exhibition Catalogues

Arles 1952 *Renoir*, Musée Reattu, Arles, 1952

Basle 1943 *Pierre-Auguste Renoir*, Kunsthalle, Basle, 1943 (text by Lucas Lichtenhan)

Berlin 1901 *IV. Jahrgang der Kunstausstellung*, Galerie Paul Cassirer, Berlin, 1901

Berlin 1912 *Ausstellung Auguste Renoir*, Galerie Paul Cassirer, Berlin, 1912

Berlin 1925 *Herbstausstellung Impressionisten*, Galerie Paul Cassirer, Berlin, 1925

Berlin 1927 *Renoir*, Galerie Alfred Flechtheim, Berlin, 1927 (texts by Alfred Flechtheim, Albert André, Carl Einstein)

Berlin 1958 *Französische Malerei. Von Manet bis Matisse. Aus der Sammlung Emil G. Bührle*, Schloß Charlottenburg, Berlin, 1958

Brisbane–Melbourne–Sydney 1994–1995 *Renoir. Master Impressionist*, Queensland Art Gallery, Brisbane–National Gallery of Victoria, Melbourne–Art Gallery of New South Wales, Sydney, 1994–1995 (catalogue edited by John House)

Brussels 1935 *L'Impressionnisme*, Palais de Beaux-Arts, Brussels, 1935

Chicago 1973 *Paintings by Renoir*, The Art Institute, Chicago, 1973

Düsseldorf 1956 *Renoir Sammlung Gangnat*, Städtische Kunsthalle, Düsseldorf, 1956 (texts by Georges Besson, Elie Faure, Julius Meier-Graefe)

Edinburgh 1953 *Renoir*, Edinburgh Festival, Edinburgh, 1953

Edinburgh–London 1961 *Masterpieces of French Painting from the Bührle Collection*, The Royal Scottish Academy, Edinburgh–National Gallery, London, 1961

Limoges 1952 *Hommage à Berthe Morisot et Pierre-Auguste Renoir*, Musée Municipal, Limoges, 1952 (texts by Serge Gauthier, Denis Rouart)

London 1905 *Pictures by Boudin, Cézanne, Degas, Manet, Monet, Morisot, Pissarro, Renoir, Sisley*, The Grafton Galleries, London, 1905

London 1948 *Renoir*, The Lefevre Gallery, London, 1948

London 1953 *Renoir*, Tate Gallery, London, 1953 (texts by Philip James, John Rothenstein)

London 1954 *Masterpieces from the São Paulo Museum of Art*, Tate Gallery, London, 1954

London 1956 *Renoir*, Marlborough Fine Art, London, 1956

London–Paris–Boston 1985–1986 *Auguste Renoir*, Hayward Gallery, London–Galeries Nationales du Grand Palais, Paris–Museum of Fine Arts, Boston, 1985–1986 (catalogue edited by Anne Distel, John House)

London 1995 *From Manet to Gauguin. Masterpieces from Swiss Private Collections*, Royal Academy of Arts, London, 1995

Los Angeles–San Francisco 1955 *Pierre-Auguste Renoir*, County Museum, Los Angeles–Museum of Art, San Francisco, 1955 (texts by Jean Renoir, Richard F. Brown)

Lucerne 1963 *Sammlung Emil Georg Bührle, Französische Meister von Delacroix bis Matisse*, Kunstmuseum, Lucerne, 1963

Luxembourg 1995 *Luxe, calme et volupté. Regards sur le Post-Impressionnisme*, Casino, Luxembourg, 1995

Lyon 1952 *Renoir*, Musée des Beaux-Arts, Lyon, 1952 (text by René Jullian)

Marseille 1963 *Renoir, peintre et sculpteur*, Musée Cantini, Marseille, 1963 (catalogue edited by François Daulte)

Munich 1913 *Ausstellung Auguste Renoir*, Moderne Galerie Heinrich Thannhauser, Munich, 1913

Munich 1958 *Auguste Renoir*, Städtische Galerie, Munich, 1958

Munich 1958/1959	*Hauptwerke der Sammlung Emil Georg Bührle*, Haus der Kunst, Munich, 1958/1959
Munich 1989	*Von Courbet bis Picasso. Schätze des Museums São Paulo*, Villa Stuck, Munich, 1989 (catalogue edited by Ettore Camesasca)
Nagoya–Hiroshima–Nara 1988–1989	*Renoir Retrospective*, City Art Museum, Nagoya–Museum of Art, Hiroshima–Prefectural Museum of Art, Nara, 1988–1989 (catalogue edited by Alexandra R. Murphy et al.)
New York 1908	*Exhibition of Paintings by Auguste Renoir*, Galeries Durand-Ruel, New York, 1908
New York 1933	*Exhibition of Paintings from the Ambroise Vollard Collection*, Knoedler Galleries, New York, 1933
New York 1937	*Renoir. A Special Exhibition of his Paintings*, The Metropolitan Museum of Art, New York, 1937
New York 1939	*Loan Exhibition of Portraits by Renoir*, Galeries Durand-Ruel, New York, 1939
New York 1941	*Renoir. Centennial Loan Exhibition*, Duveen Galleries, New York, 1941
New York 1950	*A Loan Exhibition of Renoir*, Galerie Wildenstein, New York, 1950
New York 1954	*The Last Twenty Years of Renoir's Life*, Galerie Paul Rosenberg & Co., New York, 1954
New York 1958	*Loan Exhibition Renoir*, Galerie Wildenstein, New York, 1958 (texts by Jean Renoir, Edmond Renoir, John Rewald)
New York 1969	*A Loan Exhibition Renoir*, Galerie Wildenstein, New York, 1969 (text by Charles Durand-Ruel, catalogue edited by François Daulte)
New York 1974	*Renoir, the Gentle Rebel*, Galerie Wildenstein, New York, 1974
Nice 1952	*Renoir*, Galerie des Ponchettes, Nice, 1952 (text by Germain Bazin)
Paris 1883	*Exposition Renoir*, Galeries Durand-Ruel, Paris, 1883 (text by Théodore Duret)
Paris 1892	*Exposition A. Renoir*, Galeries Durand-Ruel, Paris, 1892 (text Arsène Alexandre)
Paris 1899	*Tableaux de Monet, Pissarro, Renoir et Sisley*, Galeries Durand-Ruel, Paris, 1899
Paris 1900	*Exposition A. Renoir*, Galerie Bernheim-Jeune, Paris, 1900
Paris 1902	*Exposition A. Renoir*, Galeries Durand-Ruel, Paris, 1902
Paris 1907	*L'Atelier de Sisley*, Galerie Bernheim-Jeune, Paris, 1907
Paris 1907/1908	*Portraits d'hommes*, Galerie Bernheim-Jeune, Paris, 1907/1908
Paris 1912	*Portraits par Renoir*, Galeries Durand-Ruel, Paris, 1912
Paris 1913	*Exposition Renoir*, Galerie Bernheim-Jeune, Paris, 1913 (text by Octave Mirbeau)
Paris 1917	*Exposition d'art français du XIXe siècle*, Galerie Paul Rosenberg, Paris, 1917
Paris 1920	*Tableaux, pastels et dessins par Renoir*, Galeries Durand-Ruel, Paris, 1920
Paris 1923	*Œuvres de Renoir*, Galerie E. Druet, Paris, 1923
Paris 1927	*Cinquante Renoirs choisis parmi les nus, les fleurs, les enfants*, Galerie Bernheim-Jeune, Paris, 1927
Paris 1931	*Œuvres importantes de grands maîtres du XIXe siècle*, Galerie Paul Rosenberg, Paris, 1931
Paris 1933	*Exposition Renoir 1841–1919*, Musée de l'Orangerie, Paris, 1933 (catalogue edited by Charles Sterling)

Paris 1937	*Chefs-d'œuvre de l'art français*, Palais National des Arts, Paris, 1937
Paris 1938	*Renoir portraitiste*, Galerie Bernheim-Jeune, Paris, 1938
Paris 1950	*Hommage à Renoir*, Galerie Paul Pétridès, Paris, 1950 (text by Waldemar George)
Paris 1954	*Chefs-d'œuvre de Renoir dans les collections particulières françaises*, Galerie Beaux-Arts, Paris, 1954 (text by Jean Renoir)
Paris 1958	*Hommage à Renoir*, Galeries Durand-Ruel, Paris, 1958 (text by Georges Besson)
Paris 1969	*Renoir intime*, Galeries Durand-Ruel, Paris, 1969 (texts by Jean Renoir, François Daulte)
Paris 1974	*Hommage à Paul Durand-Ruel. Cent ans d'impressionnisme*, Galeries Durand-Ruel, Paris, 1974
Paris–New York 1983	*Manet 1832–1883*, Galeries Nationales du Grand Palais, Paris–The Metropolitan Museum of Art, New York, 1983 (catalogue edited by Françoise Cachin, Charles S. Moffett, Juliet Wilson Bareau)
Paris–New York 1994–1995	*Origins of Impressionism*, Galeries Nationales du Grand Palais, Paris–The Metropolitan Museum of Art, New York, 1994–1995 (catalogue edited by Gary Tinterow, Henri Loyrette)
Philadelphia 1933	*Manet and Renoir*, Museum of Art, Philadelphia, 1933
San Francisco 1944	*Painting by Auguste Renoir*, California Palace of the Legion of Honor, San Francisco, 1944
St. Petersburg 1912	*Centennale de l'art français. 1892–1912*, Institut Français, St. Petersburg, 1912
Stockholm 1964	*La Douce France*, Nationalmuseum, Stockholm, 1964
Tokyo–Fukuoka–Kobe 1971–1972	*Renoir*, The National Museum of Western Art, Tokyo–Art Museum, Fukuoka–Hyogo Prefectural Museum of Modern Art, Kobe, 1971–1972
Tokyo–Kyoto 1979	*Renoir,* Isetan Museum, Tokyo–Municipal Museum, Kyoto, 1979 (catalogue edited by François Daulte)
Tokyo–Kyoto–Kasama 1993	*Exposition Auguste Renoir*, Museum of Art Tobu, Tokyo–Municipal Museum, Kyoto–Museum Nichido, Kasama, 1993 (catalogue edited by Marc Restellini)
Troyes 1969	*Renoir et ses amis*, Musée des Beaux Arts, Troyes, 1969
Vevey 1956	*Auguste Renoir*, Musée Jenisch, Vevey, 1956 (cat. ed. François Daulte)
Washington–San Francisco 1989	*The New Painting. Impressionism 1874–1886*, National Gallery of Art, Washington–Fine Arts Museum, San Francisco, 1986 (catalogue edited by Charles Moffett)
Washington–Montreal–Yokohama–London 1990–1991	*Meisterwerke der Sammlung Emil G. Bührle, Zürich,* National Gallery of Art, Washington–The Museum of Fine Arts, Montreal–Museum of Art, Yokohama–Royal Academy of Arts, London, 1990–1991, Zurich–Munich, 1990 (catalogue edited by Charles S. Moffett et al.)
Winterthur 1916	*Ausstellung Französischer Malerei*, Kunstmuseum, Winterthur, 1916 (text by Théodore Duret)
Winterthur 1935	*Werke von Auguste Renoir aus Winterthurer Privatbesitz*, Kunstmuseum, Winterthur, 1935
Zurich 1917	*Französische Kunst des XIX. and XX. Jahrhunderts*, Kunsthaus, Zurich, 1917 (text by Maurice Denis)
Zurich 1958	*Sammlung Emil G. Bührle*, Kunsthaus, Zurich, 1958 (catalogue edited by Eduard Hüttinger)

Biographical Notes

1841 Pierre-Auguste Renoir is born in Limoges, Boulevard Sainte-Catherine 35, on February 25th. He is the sixth of seven children born to the tailor Léonard Renoir (1799–1874) and his wife Marguerite Merlet (1807–1896).

1844 The Renoirs move to Paris, Rue de la Bibliothèque 16.

1848 Enrollment in school; attends school until 1854.

1849 Birth of Renoir's brother Edmond Victor.

1854 Renoir begins an apprenticeship as a porcelain painter at Levy frères et Compagnie, Rue des Fossès-du-Temple 76 in Paris, continuing until 1858. He takes courses in drawing under the sculptor Callouette at the Ecole gratuite de dessin et d'arts décoratifs in the Rue des Petits-Carreaux.

1855 Renoir's family moves into rooms at Rue d'Argenteuil 23.

1858 The invention of inexpensive printing techniques costs Renoir his job as a porcelain painter. He works for his eldest brother Henri, an engraver, until he finds a position with the decorative painter Gilbert at Rue du Bac 63 in 1859. There he produces uplifting religious scroll paintings intended for export to the colonies, receiving 30 francs per painting in a mass-production operation.

1860 On January 24th Renoir is granted a permit to copy paintings in the Louvre. His permit is renewed annually until 1864.

1861 Lessons in the studio of Charles Gleyre, where some 30 students paint from models and take instruction from Gleyre. Renoir meets Monet, Sisley and Bazille there.

1862 Renoir is admitted to studies at the Ecole Impériale et Spéciale des Beaux-Arts on April 1st. During the summer he paints alongside friends from Gleyre's studio in the forest of Fontainebleau. He meets Diaz during one of these sessions, who advises him to use lighter colors. Renoir serves in the military from October 1st to December 31st.

1863 Renoir resumes his studies at the Ecole des Beaux-Arts; meets Pissarro and Cézanne, who are working on model studies at the "Académie Suisse."

1864 Military service from January 5th to March 5th. Gleyre is forced to discontinue his instruction for financial reasons. Renoir resumes his studies at the Ecole des Beaux-Arts. He makes his first appearance at the

annual Salon exhibition at the Palais de l'Industrie in May and June, presenting his history painting *La Esmeralda*.

1865 Renoir is again admitted to the Salon exhibition. He lives temporarily in Sisley's studio at Avenue de Neuilly 31 and often paints with Sisley, Monet and Pissarro in the forest of Fontainebleau, where their mutual friend Jules Le Cœur has purchased a house in Marlotte. There Renoir meets Lise Tréhot, who becomes his mistress and poses often as his model until 1872.

1866 Le Cœur secures an invitation for Renoir to exhibit three paintings with the Société des Amis des Beaux-Arts at the museum in Pau. Renoir makes frequent visits to Marlotte with Le Cœur and Sisley. Despite the intercession of Corot and Daubigny on his behalf, Renoir's submission to the Salon jury is rejected.

1867 Renoir takes up temporary residence with Bazille at Rue Visconti 20; Monet joins them later. His next submission to the Salon is also rejected. He cooperates with Bazille, Pissarro and Sisley in promoting an alternative "Salon of Rejected Artists." Renoir spends the summer in Chantilly.

1868 Renoir moves with Sisley to the Rue La Condamine at the foot of Montmartre near the Café Guerbois, where Manet regularly meets with his friends. Prince Bibesco commissions Renoir to do two ceiling paintings in the rococo style. His painting *Lise*, shown at the Salon exhibition, is well-received in press reviews by Castagnary, Zola, Astruc and others. Renoir's parents move to Voisins-Louveciennes during the summer.

1869 Renoir exhibits at the Salon along with Degas, Pissarro and Bazille; spends the summer at his parents' home in Voisins-Louveciennes. He meets with Monet, who has settled in the nearby town of Saint Michel, nearly every day. Renoir completes his first Impressionist paintings along the banks of the Seine. He is offered the opportunity to exhibit several paintings at the shop of the frame and paint retailer Carpentier on the Boulevard Montmartre.

1870 Temporary stays with Bazille at Rue des Beaux-Arts 8 and Edmond Maître at Rue Taranne 5. Following the French declaration of war on Prussia, Renoir is drafted into military service with the cavalry on August 26th and stationed in southwestern France. Bazille is killed near Beaune-la-Rolande on November 28th.

1871 Renoir is discharged on March 10th and returns to Paris—a city now under the control of the commune—sometime in April. He rents living quarters and a studio at Rue Notre-Dame-des-Champs 34.

1872 The art dealer Paul Durand-Ruel purchases his first two paintings from Renoir in March and May: a cityscape for 200 francs and a floral still

life for 300 francs. Lise Tréhot marries the architect Brière de l'Isle. After the rejection of their submissions to the Salon, Renoir, Monet, Pissarro, Cézanne and others demand a second alternative "Salon of Rejected Artists." The cityscape purchased by Durand-Ruel is exhibited in London in November.

| 1873 | The journalist Théodore Duret acquires two paintings by Renoir. Renoir participates in the so-called "Salon of Rejected Artists." He spends the summer months painting with Monet in Argenteuil and later rents a flat with a studio at Rue Saint-Georges 35, which will remain his primary domicile until the early 1880s. An independent artists' group is formed near the end of the year, with Renoir, Manet, Degas, Cézanne, Pissarro, Sisley and Monet as members. |

| 1874 | Renoir exhibits six oil paintings and a pastel at the first exhibition of the "Independents." The members, ridiculed as Impressionists, show their pictures at the studio run by the photographer Nadar at Boulevard des Capucines 35. During the summer Renoir visits Monet in Argenteuil, where Manet and Sisley have also rented temporary accommodations. Renoir is a frequent guest at the Café de la Nouvelle Athènes in Montmartre, a gathering place for painters, literary figures, journalists and musicians. |

| 1875 | Renoir organizes an auction of his own paintings and those of his friends Monet, Sisley and Morisot on March 23rd and 24th, hoping in this way to bring in enough money to defray the costs of the first Impressionist exhibition. The event triggers violent demonstrations, and the police are forced to intervene. Renoir sells 20 paintings at prices ranging from 50 to 300 francs. He meets the collector Victor Chocquet. After spending his summer months in Chatou, he rents an additional studio in the Rue Cortot in Montmartre. |

| 1876 | In April, Renoir shows 15 paintings at the second Impressionist exhibition. He meets the publisher Charpentier and continues work on his major opus, *Dance at the Moulin de la Galette* in Montmartre. He visits Alphonse Daudet in Champrosay. |

| 1877 | The third Impressionist exhibition in April features 21 works by Renoir. Renoir and Georges Rivière launch the journal *l'Impressionniste*, of which only a few issues are published. He, Sisley, Pissarro and Caillebotte hold a second auction at which sixteen works by Renoir are sold for a total of 2,005 francs. |

| 1878 | Renoir is represented once again at the official Salon exhibition with his painting *Le café*. Duret publishes *Les peintres impressionnistes*. |

| 1879 | Like Cézanne and Sisley, Renoir declines to participate in the fourth Impressionist exhibition. Instead, he makes a successful appearance at |

the Salon with four portraits, including his large *Portrait of Madame Charpentier and her Children*. Renoir's first solo exhibition (featuring primarily pastels) is held at the offices of the journal *La Vie Moderne*. He accepts the banker Paul Bérard's invitation to spend the summer at Wargemont Castle in Normandy.

1880	Renoir chooses not to exhibit works at the fifth Impressionist exhibition, opting instead for a presentation at the Salon exhibition in May and June. He visits the Bérards in Wargemont in June and July and meets Aline Charigot (1859–1915), who will later become his wife. Renoir begins work on his large canvas entitled *The Rowers' Breakfast* in Chatou during the fall.
1881	Travels with friends to Algeria in April and May, followed by another visit to Chatou. Renoir shows two portraits at the Salon but is absent from the sixth Impressionist exhibition. He visits the Bérards in Wargemont during the summer and embarks upon a tour of Italy in late October, stopping in Venice, Florence, Rome, Naples, Capri and Palermo.
1882	Renoir visits L'Estaque on his return journey in late January to work with Cézanne. He contracts a severe case of pneumonia and is nursed back to health by Cézanne and his elderly mother. Although Renoir once again declines to participate in the seventh Impressionist exhibition, hoping to be represented at the Salon instead, he is unable to prevent Durand-Ruel from exhibiting 25 of his paintings at the Impressionist show. He spends the summer on the Normandy coast.
1883	Durand-Ruel presents 70 works at the first extensive Renoir exhibition at his gallery at Boulevard de la Madeleine 9. A small catalogue containing a foreword by Duret is published to accompany the show. Thanks to Durand-Ruel's efforts, works by Renoir are also exhibited in London, Boston and Berlin (Galerie Gurlitt). The artist spends the summer months in Etrétat, Dieppe, Le Havre, Wargemont, Trépart and the Channel Islands; travels with Monet to the French Riviera in December.
1884	Durand-Ruel, who has provided Renoir with a regular income through purchases since 1881, is beset by financial difficulties of his own in May. Renoir and Monet advise him to sell off their paintings at low prices. Renoir makes plans for a new artists' group—the *Société des irrégularistes*. He spends part of the summer with the Bérards in Wargemont.
1885	Renoir's son Pierre is born at Rue Houdon 18 on March 21st. The artist spends the summer with Aline Charigot and their son Pierre in La Roche-Guyon near Giverny. Cézanne accepts Renoir's invitation to bring his family there for a visit. The Renoirs end the summer with a stay in Essoyes, Aline's home town in the Champagne region.
1886	April through June, Durand-Ruel organizes an exhibition of contempo-

rary French art (including 38 works by Renoir) in New York. Renoir does not take part in the eighth and last Impressionist exhibition in May. He visits La Roche-Guyon in July and later travels to Brittany.

1887	Durand-Ruel pursues further exhibition projects in New York. Renoir spends the month of August in Le Vésinet, later commuting between Paris and Louveciennes, as his mother has been taken ill. He meets with Pissarro in Auvers-sur-Oise in the fall.
1888	Renoir visits Cézanne in Aix-en-Provence in the spring. Durand-Ruel exhibits nineteen paintings and five pastels by Renoir at his gallery in the Rue le Peletier in May and June. The artist spends the summer working in Argenteuil and Bougival, moving on to Essoyes in the fall. He suffers an attack of rheumatism and facial paralysis in late December.
1889	Renoir now maintains two studio rooms at Boulevard de Clichy 11. He declines to participate in the presentation of 19th-century French art planned for the World's Fair. The artist spends the summer near Aix-en-Provence, where he rents a house from Cézanne's brother-in-law.
1890	Renoir and Aline Charigot, the mother of his son Pierre, are married on April 14th. Renoir makes his last appearance at a Salon exhibition in May and June. After a stay in La Rochelle, he visits Berthe Morisot and Eugène Manet in Mézy in September. He moves his family into a flat at Rue Girardon 13 in October.
1891	Travels to Toulon, Tamaris-sur-Mer, Le Lavandon and Nîmes. Durand-Ruel exhibits recent paintings from the years 1890–1891 in July. Renoir visits Berthe Morisot in Mézy and Caillebotte in Petit-Gennevilliers.
1892	Thanks to Mallarmé's intervention, the French government purchases Renoir's *Two Girls at a Piano*, a work painted by Renoir early in the year, for the contemporary art collection of the Musée du Luxembourg. The Galerie Durand-Ruel shows a Renoir retrospective featuring 110 works by the artist in May. The artist travels to Spain and admires the works of Titian, Velázquez and Goya at the Prado in Madrid. The Renoir family spends the summer in Brittany.
1893	Renoir journeys to Benerville, Essoyes and Pont-Aven following a stay on the Mediterranean coast.
1894	Renoir's studio is now located at Rue Tourlaque 7. Caillebotte dies on February 21st. Renoir is named executor of his will and thereby entrusted with the thankless task of persuading the French government to accept as a gift at least a part of Caillebotte's magnificent collection of Impressionist works, today proudly exhibited at the Musée d'Orsay. Chronic attacks of gout force Renoir to take frequent cures at thermal baths. His son Jean is born at Rue Girardon 13 on September 15th.

The young art dealer Ambroise Vollard makes initial contacts with Renoir.

1895	Renoir flees the cold Parisian weather for the warmer climate of the Provence; spends the summer with his family in Brittany. On Renoir's recommendation, Vollard organizes the first exhibition of Cézanne's works in his small Montmartre gallery. The Renoirs purchase a house in Essoyes in December.
1896	Renoir, Monet and Degas put together a Morisot retrospective at Durand-Ruel's gallery. Durand-Ruel later exhibits 42 works by Renoir. The artist travels to Bayreuth to attend the theater festival but is bored by Wagner's music and proceeds to Dresden, where he visits the local collections. He rents a studio at Rue de la Rochefoucauld 64. Renoir's mother dies in Louveciennes on November 11th at the age of 89.
1897	After years of battling with government authorities, Renoir finally succeeds in having a part of Caillebotte's Impressionist collection accepted at the Musée du Luxembourg. He spends most of the summer and fall in Essoyes.
1898	Renoir makes what is probably his first visit to Cagnes on the French Mediterranean coast and then spends the summer months in Berneval. He journeys to Holland to see the Rembrandt exhibition in Amsterdam in October. He suffers another severe attack of rheumatism resulting in the partial paralysis of his right arm in December.
1899	Renoir spends the months of February through May convalescing in Cagnes. He is represented with 42 paintings at an exhibition including works by Monet, Pissarro, Sisley organized by Durand-Ruel. He spends the summer in Saint-Cloud, with stays for curative treatment in Aix-les-Bains.
1900	The artist spends the winter in Grasse and Magagnosc in the south of France. The Galerie Bernheim-Jeune presents 68 works by Renoir during January and February. He journeys for cures to Saint-Laurent-les-Bains in May and June, proceeding later to Louveciennes and returning to Magagnosc in the fall.
1901	Renoir's increasingly severe rheumatism requires frequent curative treatments. He journeys to Essoyes in June and is present for the birth of son Claude on August 4th. He rents a flat at Rue Caulaincourt 43 and a studio nearby in October. Paul Cassirer exhibits 23 works by Renoir at his Berlin gallery.
1902	Renoir's health deteriorates rapidly. He moves with Aline, Jean and Claude to Le Cannet near Cannes.
1903	Having spent the winter in Le Cannet, Renoir travels to Cagnes. The painter now spends most of his time on the Mediterranean coast during the cooler months of the year, making only occasional summer visits to Paris or Essoyes.

1904	A room at the Paris Fall Salon is devoted entirely to 35 works by Renoir. He takes courage from such signs of success.
1905	Durand-Ruel organizes an Impressionist exhibition featuring 59 works by Renoir at the Grafton Galleries in London.
1906	Renoir spends most of the year in Cagnes, with a summer visit to Essoyes; he meets Monet in Paris in October.
1907	The New York Metropolitan Museum of Art purchases Renoir's *Portrait of Madame Charpentier with her Children* for 84,000 francs. Renoir buys the country manor Les Collettes in Cagnes on June 28th. He has a villa with a spacious studio built according to his own plans, and his family occupies its new home in the fall of 1908.
1908	Maillol visits Renoir in Essoyes in mid-July to sculpt a bust of the artist. The Durand-Ruel Galleries of New York show a Renoir exhibition comprising 41 works in the fall. Monet visits Renoir at Les Collettes in December.
1909	With the exception of brief stays in Paris and Essoyes, Renoir spends most of the year at his estate Les Collettes.
1910	A Renoir retrospective is presented at the Venice Biennale. Renoir suffers paralysis in both legs following his return from a trip to Munich.
1911	Renoir is confined to a wheelchair. He rents a new studio at Boulevard Rochechouart 38. Meier-Graefe publishes his book on Renoir.
1912	The artist rents additional living and studio space in Nice. Paul Cassirer and Heinrich Thannhauser present 41 works by Renoir in Berlin and Munich (early 1913), respectively. Durand-Ruel exhibits works by Renoir in New York during the spring; 74 Renoirs are shown at his galleries in Paris in April and May, followed by a presentation of 58 portraits in June. Renoir suffers further attacks of rheumatism that lead to paralysis in his arms.
1913	Renoir is represented with five paintings at the legendary Armory Show in New York. During the summer in Essoyes he agrees to Vollard's proposal that he have sculptures done by Richard Guino, a student of Maillol's, according to his drawings and instructions.
1914	Rodin visits Renoir in Cagnes. Three paintings by Renoir are accepted into the Louvre collection on June 4th as a part of a bequest by the collector Isaac de Camondo, who died in 1911. Germany declares war on France on August 3rd. Renoir's sons Pierre and Jean are drafted into military service.

1915	Jean is seriously wounded in April. Aline Renoir dies in Nice on June 27th after visiting her son in the hospital. In December, Renoir asks Durand-Ruel and Vollard to prepare an inventory of the paintings remaining in Paris and Essoyes.
1916	Renoir makes a visit to Paris in June before proceeding to Essoyes.
1917	Renoir is in Paris and Essoyes during July and August. The Kunsthaus Zürich exhibits 60 works by Renoir as part of an exhibition of French art of the 19th and 20th centuries in the months of October and November. Renoir discontinues his work with Guino. Matisse visits Renoir in Cagnes on December 31st.
1918	Vollard publishes an opulent two-volume catalogue of the works of Renoir known to him at the time.
1919	Renoir spends the months of July through September with his sons in Essoyes and Paris. He is carried one last time through the halls of the Louvre. Pierre-Auguste Renoir succumbs to pneumonia at Les Collettes in Cagnes on December 3rd. He is buried alongside his wife in Essoyes on the 6th of the month.

Renoir with his model Andrée Heuschling, who later married his son Jean, in the artist's studio at Les Collettes in Cagnes, ca. 1915

Index

The index covers names mentioned in all the texts and footnotes; references to provenance, literature and exhibitions in each of the catalogue entries, however, are not included.

Photo and Copyright Credits